Broken Time, Fragmented Space

A Cultural Map for Postwar Italy

ANNA MARIA TORRIGLIA

Broken Time, Fragmented Space: A Cultural Map for Postwar Italy examines how the artists and intellectuals of postwar Italy dealt with the painful heritage of their Fascist upbringing and education by trying to craft a new cultural identity for themselves and the country. The continuities between the Fascist and post-Fascist periods were, however, far greater than intellectuals were ready to admit, and this situation created a distant, sometimes detached, attitude to time, as an attempt to erase the past.

Drawing on a variety of critical approaches, Anna Maria Torriglia investigates postwar efforts to reconstruct personal as well as collective identity in this analysis of both canonical and lesser-known cinematic and literary texts. Organized around four main themes – the use of language, the interaction between personal and public spheres, the perceptual categories of history and memory, and the reconstruction of the female identity – the study also includes historical background and sociological commentary that provide a broad and captivating picture of the cultural production in 1950s Italy, a period that has not yet been extensively studied.

ANNA MARIA TORRIGLIA teaches at the Centro Studi Università di California, Padua.

T0366474

BROKEN TIME, FRAGMENTED SPACE

A Cultural Map for Postwar Italy

Anna Maria Torriglia

UNIVERSITY OF TORONTO PRESS
Toronto Buffalo London

© University of Toronto Press Incorporated 2002
Toronto Buffalo London
Reprinted 2017

ISBN 978-0-8020-3604-9 (cloth)
ISBN 978-1-4875-8722-2 (paper)

Printed on acid-free paper

Toronto Italian Studies

National Library of Canada Cataloguing in Publication Data

Torriglia, Anna Maria
Broken time, fragmented space : a cultural map for postwar Italy

(Toronto Italian studies)
Includes bibliographical references and index.
ISBN 978-0-8020-3604-9 (bound). – ISBN 978-1-4875-8722-2 (pbk.)

1. Italy – Social life and customs – 1945– 2. Italy – Intellectual
life – 20th century. I. Title. II. Series.

DG451.T67 2002 945.092 C2001-903102-5

University of Toronto Press acknowledges the financial assistance to
its publishing program of the Canada Council for the Arts and
the Ontario Arts Council.

University of Toronto Press acknowledges the financial support for
its publishing activities of the Government of Canada through
the Book Publishing Industry Development Program (BPIDP).

Cover illustration : Vittorio Dr Sica, *Ladri di biciclette* (*Bicycle
Thieves*, 1948). Courtesy of British Film Institute Stills, Posters

For the women of my family:

Maria Luisa, Giampaola, Cinzia, and Surur Eloisa

CONTENTS

PREFACE

For the critic must attempt to fully realize, and take responsibility for, the unspoken, unrepresented pasts that haunt the historical present.

HOMI BHABHA

In May 2000 the historian Angelo d'Orsi, who teaches History of Political Thought at the University of Turin, published a book entitled *La cultura a Torino tra le due guerre*.[1] The volume represents the final achievement of twenty years of study, and its findings are well documented and quite exhaustive. In a few instances they had been anticipated and discussed in previous articles by the same author. As the title suggests, the book – based on archival research and on oral interviews alike – analyses the cultural climate prevailing in Turin between the two world wars, and it does so by being quite specific and detailed, and by falling, at times, into a perhaps much too accurate microhistory. It considers the public school system, and in particular the famous Liceo Monti attended by a generation of anti-Fascists-to-be, the Publishing House Einaudi, and some of the most influential intellectuals of the times, including Monti, Gobetti, Ginzburg, and Bobbio. It also examines Catholic groups, or the early Fascist ones, and the artistic life of the city – theatres, exhibits, newspapers, and the like.

There is nothing strange up to here. It is the job of academics – as it is painfully known – to publish books. The problem begins with the debate that d'Orsi's book elicited among other scholars, politicians, and journalists.[2] Most of them wrote controversial, polemic reviews of the volume, often labelling it as *revisionista*, a derogatory adjective used in

current Italian to designate a tendency to retell the past from a conservative, right-wing point of view. The author himself could not imagine that his work would stir up a hasty, 'judiciary' debate, as it did, about a period of Italian life, the Fascist *Ventennio*, that it is, evidently, still impossible to approach – for some intellectuals – with a degree of serene objectivity. The stakes are, probably, too high. According to d'Orsi, the political heirs of antifascism cannot tolerate that their founding fathers could be represented as less than perfect, that is, as harbouring contradictions and weaknesses. Conversely, centre and right thinkers and politicians are (maliciously) eager to trace back, in the behaviours of adherents to the (leftist) movements of *Giustizia e Libertà* and *Partito d'Azione*, the signs of an incipient duplicity and of moral inadequacy. Worse, the author insists, nobody has really read the 'accused' book,[3] a fact that turns the *querelle* into a mere ideological battlefield, unrelated to the – anyhow always debatable – historical findings by the scholar.

Controversies of this kind are not unusual in Italian cultural life,[4] and signal that – unlike France or Germany[5] – Italy is not ready yet, fifty years distant from the Second World War and the fall of Fascism, to come to terms with its historical past. The reasons are varied, but in my opinion one reason – disavowed by quite a few Italian intellectuals, principally on the left – is particularly important: the fact that a not so evident, though substantial, continuity remained between the culture, institutions, men, and political hierarchies of the *Ventennio* and the ones of the newly born Republic – that is, what Mirco Dondi refers to as the survival of a Fascist mentality in the Republic.[6] This thesis – supported in particular by Ruth Ben-Ghiat and her convincingly researched, ground-breaking work on the culture of the 1930s and 1950s in Italy and by, for instance, the contributors to the volume (edited by Jonathan Dunnage) *After the War* – is shared mostly by foreign scholars.[7] Their 'emotional investment' – conscious or unconscious – in national history and/or any concurrent ideological framework is, of course, not as overwhelming and, I would like to add, blinding as the one haunting some Italian academics.

Such a distancing attitude with reference to the past – still embedded in Italian cultural practices, as the polemic about d'Orsi's book indicates – was, of course, far more radical in the immediate postwar years. According to various scholars,[8] it was both easy and convenient for Italian people – though not for all, particularly for the ones actively engaged in the *Resistenza* – to accept Croce's analysis of the *Ventennio*. Croce maintained that Fascism represented something foreign and

'exogenous' to Italian history: a sort of pathological 'parenthesis' that need not leave lasting traces in the development of the country. After Mussolini's fall, the nation was – according to him – ready to resume the threads of its pre-Fascist Liberal tradition.[9] In addition, a sort of 'collective amnesia' prevented many intellectuals from facing responsibility over their compliance with the Fascist regime, so that many ended up recasting a more opportune, timely, and marketable cultural self-image. But what was the cultural climate like in postwar Italy?

Another famous *querelle*, of deeper ideological implications and wider political relevance than the factious, provincial one now surrounding d'Orsi's book, involved militants of the Communist party and its higher ranks. The debate focused upon the role of culture in postwar Italy; harbinger of the dissidents was Elio Vittorini (1908–66). In 1947 the Sicilian writer published in the pages of *Il Politecnico* his reply to a letter of Togliatti (1893–1964, one of the founders, then most prominent leaders, of the Communist party) concerning the necessarily hierarchical – in the P.C.I. Secretary's opinion – relationship between politics and culture. This document followed various articles published in *Società*, *Rinascita*, and *Il Politecnico*, signalling that the debate about what culture needed to be in postwar Italy had reached its highest peak. Alarmed by a foreseeable fracture between politics and culture, Togliatti officially warned Vittorini. He claimed that it was dangerous to envision 'culture' as an abstract, encyclopedic concept, the way Vittorini, seemingly, did. Under this generic rebuke, he was eager to establish the primacy, therefore the control, of politics over culture. Vittorini, editor of the monthly *Il Politecnico*, answered that it was instead necessary, for an intellectual, to safeguard his freedom of criticism. Further, he argued, it was not a writer's duty 'to play the flute for the revolution's sake.' The article, soon to reach a wide popularity in intellectual circles, particularly on the left, sanctioned a fracture between some militant artists in the Communist party and its intelligentsia. However, by that point, a large number of writers and thinkers of different political and religious orientations, leftist, 'centrist,' and Catholic alike, had participated in the discussion.

The debate about culture had kept growing since the end of the Second World War – even earlier, since 1943 – and had quickly developed into a reassessment of the intellectual's role within Italian society.[10] Painters, writers, and intellectuals were all dealing with the uneasy task of confronting the nation's Fascist heritage and were entrapped in an effort of almost Promethean dimensions. On the one hand, they were striving to erase their individual and collective pasts; on the other, they

were willing to construct a better present and, possibly, future for themselves and the country. In addition, along with Italian civilians, they were eager to forget the emotional catastrophes and the grief the war had left behind. While economic damage and the overall death toll of the war had been relatively small compared to the losses the Italian nation had suffered during the First World War, a psychological distress that entailed disorientation and moral uprootedness was widely diffused.[11] In such a scenario 'culture' constituted the place of a possible renegotiation between the personal and public spheres – two areas of an individual's experience that Fascist rhetoric, institutions, and laws had struggled to control and make coincide. Culture, then, represented the 'locus' where a new assemblage of the national identity could happen.

Many documents, novels, and films of the period testify – not always in a straightforward, limpid, or explicit way – to a powerful desire to forget, to erase, and to deny the past. Artists and political activists alike seemed convinced, or rather wanted to convince themselves, of the fact that Italy's postwar history was something radically different from its prewar one, and that a simple act of volition could dissipate an embarrassing legacy. In effect, many writers, critics, public administrators, and politicians were busy crafting a new purity for themselves, denying their previous allegiance with Fascism and riding the horse of their late adherence to the *Resistenza*'s ideals. Others had gone through a sincere, painful process of conversion from Fascism to democracy. Many had been too young to consciously process their upbringing and their education. Yet, notwithstanding this frantic, multifaceted process, the past could not simply vanish because people wanted to forget. As I have already mentioned, the continuities between the *Ventennio* and the Republic were far more consistent than militant intellectuals were ready to admit. Indeed, attitudes and institutions – not to mention public buildings – still survived, while Fascist officials often remained in office.

My study intends to dig into this territory. I will begin by underlining how the pretended rigid fracture between the culture of the *Ventennio* and that of the postwar years was more an ideological construct that served psychosociological needs than a reality – part of a 'selective memory' that worked more through omission than through an accurate recounting of historical truth. It is in effect possible to detect the traces of presumably new and/or disruptive sociocultural postwar behaviours and artistic trends already in the culture of the thirties. This is particularly evident in the case of the narrative Realism of the 1930s – a cultural movement supported and implemented by key Fascist figures such as

Bottai (1895–1959) – that was instead read, after the war, as completely unrelated to postwar cinematographic and literary Neorealism.[12]

Neorealism was indeed constructed by its protagonists and, later, by critics and historians, as a thoroughly 'new' postwar movement, and surely carried within itself the emotional-ideological input of the years immediately following the war. Nevertheless, we can easily indicate its antecedents in both literary and cinematic realism of the 1930s. We face here a problematic issue with reference to canonization, extending to other areas of literary production. Postwar (male) critics, Pickering-Iazzi has convincingly argued,[13] manipulated the canon to erase from it important women writers of the *Ventennio*: Paola Drigo, Alba de Céspedes, Antonia Pozzi, Liala and Ada Negri among others. It is clear that the difficulties incurred by intellectuals in representing themselves after the Second World War also applied to a collective cultural self-representation, and that an extensive archival research is needed to re-establish a more accurate, ideologically less invested, picture of the *Ventennio* culture with reference to its postwar legacy. After this preliminary investigation, I will move on to explore cultural features and practices specific to the postwar period, in order to see in which ways writers and filmmakers both recorded and contributed to craft a 'new' identity for the country.

In following the meanders of postwar sensibility, I kept running into analogous, repeated motifs. One of them – time – was so consistently addressed, particularly soon after the war, that it turned into an obsessive refrain. Relation to time seemed to be crucial for the creation of a new consciousness, precisely because time, in its diachronical unfolding, provided the (albeit equivocal) continuum against which a person could carve his or her identity. We may choose to consider time from different theoretical standpoints: psychological, semiotic, narratological, or other. It nevertheless constitutes a key concept for the analysis of culture and of its textuality.

Questions of Method

Textuality of culture is a concept that I have borrowed from Jurij Lotman and, in a more generic fashion, from the Russian semioticians, as well as the Italian semiotic school headed by Umberto Eco. Within such a theoretical approach, social practices that include both behaviours (the way one eats, dresses, introduces oneself in a social space) and literary or artistic works, including films, are considered 'texts.' In order to

understand a culture we need to collect, read, and correlate – a process that entails their previous and/or concurrent codification – the different 'texts' of which it is composed. All these texts are inserted into, and partake of, an (unstable) network of signification: this because meaning is not viewed as a static, inherent property of a text, but rather as the resultant of a dynamic, and therefore shifting, relationship both with the context and with other (to further Lotman's spacial metaphor) surrounding texts.

The 'context' thus affects an individual text and its meaning, making it susceptible to different, even discordant over time, interpretations. It follows that a text can be correctly read only in relation to the social, political, and cultural environment in which it is positioned, and, conversely, that the context is also affected by the works that are situated within it.[14] According to another of Lotman's concepts, that of *isomorphism*, a single text could also be seen as representing the entire 'textual world,' since it is positioned in a sort of metonymical relationship to it. As an example, the Russian scholar refers to a face that can be seen in its entirety both in an unbroken mirror and in one of its many fragments.[15] We can sense the hermeneutic richness of this concept, in the case of Fascism, whose 'cultural language' also visibly encoded architecture, advertisement, fashion, exhibits, and so on.[16] As James Hay, who adopts a semiotic model in his brilliant *The Passing of the Rex*, upholds, 'a "textualist" analysis *has the potential for opening to discussion the broadly heterogeneous field of the filmic text*, to explore it as a nexus of political, social, aesthetic and cultural threads' (italics mine).[17]

For a semiotic model to function, however, we need to have at least two systems synchronically at work. Lotman postulates that any given culture posits a unified, uncontradictory metalanguage – a sort of superstructure always identical to itself – and a system of cultural expression that produces different artefacts: a system that works through diversification and by multiplying its possibly divergent outputs. This binary set-up, with a 'fixed' metastructure, and a 'mobile' system of cultural production, leaves room for ambivalence and for contradictoriness; and, therefore, for a quite complex, non-univocal picture or, to quote Foucault, for 'counter-discursive' practices.

Although Lotman's model, as Hay has argued, carries 'potential' for a rich, multifaceted interpretation of cultural 'texts,' a strictly semiotic approach to culture could be unsatisfactory. In and of itself, semiotics is alien to a political, sociological, or ethical evaluation of its findings. It

offers a huge amount of data that need to be further theorized, that is, inserted in other critical or ideological frameworks. The principal aim of semiotics – not to mention its privileged working paradigm – is that of constructing (and deconstructing) a well-crafted 'system.' Often concerned with binary oppositions, semiotics tends to think in terms of systems that work through couples of antinomies (systematic-antisystematic, univocal-ambivalent, centre-periphery, necessary-superfluous, male-female, etc.), and by positing extra-systematic elements as the antithesis of a newly found thesis, thus replicating the process indefinitely.[18]

In order to realize its full critical range, a semiotic approach needs to be utilized along with other theories. While maintaining textuality of culture as my working paradigm, I also adopt Homi Bhabha's notions of 'identity' and 'in-betweenness.' These notions add a psychological, 'extra-binary' dimension to my analysis, not to mention a somehow disquieting aura of uncertainty and 'provisionality.' I return hereby to the themes, so fundamental in the immediate postwar culture, of time and of how an individual positions him- or herself within it.

The Anglo-Indian scholar deals mainly with the creation of an identity in postcolonial times, and yet the way he depicts the 'unhomeliness' of individuals – that is, their feeling of displacement – in cultures that are non-native to them provides a useful paradigm for inquiring into such a painful, disconcerting time as the one following the Second World War in Italy. Bhabha examines how an individual perceives the present – a time-dimension that is both historical and psychological, both subjective and objective, and, at the same time, neither one nor the other – by trying to insert within it his or her past, cultural beliefs, upbringing, historical circumstances, and selected memories. The *present* is indeed the place through and within which an identity is created. But *present* is not the space or time that has been freed from the past and that is ready to be erased by the soon-to-happen future. Rather, it is a liminal locus of 'in-betweenness': a generative space that carves memories, feelings, and sensations out of both past and present while, at the same time, not coinciding with either.

The *present* amounts to an excruciating and distressing being-ness, whose defining boundaries are neither easily detectable, firmly traced, nor stable. It dives into personal history, the political unconscious, external contingencies, ideologies, collective archetypes, and socio-geographical maps, and refers not to a subject, whose definition according to the usual coordinates of gender, class, race, or sexual orientation

is – for Bhabha – reductive,[19] but to an *identity*. Thus, the creation of a 'new' identity, in our case postwar Italy's, can only happen in that metaphorical *locus* that does not correspond to a traditional notion of past and present, since, as Bhabha states,

> [p]rivate and public, past and present, the psyche and the social develop an interstitial intimacy. It is an intimacy that questions binary divisions through which such spheres of social experience are often spatially opposed. These spheres of life are linked through an 'inbetween' temporality that takes the measure of dwelling at home, while producing an image of the world of history.[20]

An identity is, then, a quite complex, non-discriminatory layering of different experiences – a pile in which sharp dichotomies or Manichaean oppositions do not find a place. Having gone beyond an eschatological notion of existence, beyond the binary paradigm of space and time, the hierarchical order of before and after, Homi Bhabha gets closer to a crafting of identity as structured along the uncanny directions and working anarchism of an unconscious. Such an unconscious is far more complex than in its early Freudian theorization: it is more complicated by a manifold external reality and its purpose is not only – paradoxically – that of supporting the fabrication of a self. Bhabha's paradigm is, then, particularly useful in analysing the nature of the continuities between a past (the Fascist period) that is complicated, hidden, buried over, and yet not erased by subsequent moments and the present (the postwar years). His model proves congruent with the selective, elliptical 'memory' of postwar intellectuals and with their ambiguous and ambivalent, 'feeling' relationship to the past.

Proceeding in my study, I have also utilized different theoretical approaches, as they seemed more apt, case by case, for grasping the subtleties and specificities of a single work or of a group of works. In particular, I need to introduce here the thought of the Diotima group, upon which I will amply elaborate in the second chapter. After a first wave of socially committed feminism in the seventies,[21] in which new practices such as *autocoscienza* and *terapia di gruppo* were introduced in Italian women's groups, Italian feminists started – around the eighties – to develop more sophisticated theoretical approaches to women's issues. That is, women added to what had been their empirical and often disruptive everyday practices, which questioned or even sabotaged patriarchy, a philosophical reflection that severely addressed the ways in which

gender was socially and culturally constructed. Diotima elaborated a conceptual approach that, indebted to the thought of Luce Irigaray, both denounced the alterity women were confined to and proposed to search for a self-validating approach. This search ended up in the theorizing of *pensiero della differenza*, which, as I will explain, aims at valorizing precisely that sexual difference that has been, instead, traditionally seen as a devaluing and lessening element for women. Such a theory promotes the acknowledgment and enforcement of female genealogy – a praxis that, on the one hand, strengthens women's self-perception, while, on the other, providing women with greater, more effective, social visibility. Both elements surface, with a different degree of complexity, in the production of women writers in the postwar period. I have therefore found Diotima's conceptual apparatus extremely useful in investigating their work.

As I have already announced, my research starts at an uncomfortable point: the point where many Italians – intellectuals, soldiers and civilians, women – felt that they could no longer deal with the burden of the past. The past implied twenty years of Fascist regime, the confused and confusing change of alliances on 8 September 1943, twenty months of Resistance or, conversely, fighting with the Republic of Salò, the end of the war, and the demise of the monarchy.[22] This series of events was enough to enhance a sense of disorientation and lack of certainty, to implement a tormenting laceration in the perception of one's sense of identity. In my inquiry into Italy's reconstruction I have chosen to select four main themes – all of them dealing in one way or another with time – through which Italian intellectuals, writers, and filmmakers contributed to the formation of a new identity for the country. Each theme is the subject of a distinct chapter that is, nevertheless, correlated to the others through recurrent intertextual references that – as I will later explain in more detail – centre on prevalent topics. These topics focus on the use of language, the interaction of personal and public sphere, and the opposition of memory and history – seen as elements conflicting with one another – and the restructuring of a female identity. In particular, the reworking and redefinition of female identity/identities sums up all the other themes, pointing to the not-too-extreme assumption that precisely women's discursively changed image engendered a series of broader epistemological problems.

In the first chapter my main focus is on diving into the difficult transition from the *Ventennio* and the Second World War to the Republic. A

'cultural amnesia'[23] seems to strike most intellectuals. In effect, the majority of Italians had not embraced active anti-Fascism, and Socialist and Communist dissidents usually resided abroad.[24] Even though many had converted to antifascism only in the late years of the *Ventennio*, or soon after the war, they wiped away their sense of guilt by denying their previous, either passive or active, cooperation with the regime. Their incapacity to reconcile a prewar and postwar self created a sort of generalized schizophrenia, an ideological set-up that worked mainly through dichotomies and whose illogical functioning is recorded in language. As is evident both in Germi's *Gioventù perduta* and in Rossellini's *Germania anno zero*, language becomes the displaced locus where inconsistencies, ambivalences, and structural discrepancies are played upon. In particular, the use of the passive voice turns into a 'symptomatic' indicator of a no longer cohesive, unified self. In the commonly adopted dislocating strategy, what was under judgment was not so much the way intellectuals or common people had behaved, but the Fascist higher ranks and the now disavowed, most prominent figure of Italy's recent history: Mussolini.

In the second chapter I analyse how women writers started to give shape to a female genealogy and give it pre-eminence over a patriarchally structured one by diversifying women's roles in society and also accounting for more independent ones. By adopting the theoretical framework suggested by the Diotima group, I examine how Anna Banti and Alba de Céspedes strove to legitimate themselves from within, trampling over the trappings of a language that is conceived with only a male – but presumably neuter – subject. Language becomes the litmus test of philosophical incongruities in the representation of women's subjectivity/subjectivities, and denounces its own partiality and insufficiency in describing them. With women writers there also comes to the forefront a mode of narration linked to memory: subjective, illogical, and anarchically selective from the standpoint of the time-dimension, and opposed to the more 'objective' mode of history. Memory guarantees a sense of continuity crafted along the lines of an individual's self-perception, which wins over and transforms external, historical events. Personal and public sphere also appear to be concepts that need redefining, since they can no longer, from women's perspective, be considered as opposing aspects of a person's life. The interest in different expressions of female subjectivity is not just a female author's prerogative, but a fascination that also captures and intrigues male film directors, who portray increasingly more sophisticated and psychologically diversified women

characters. We are getting closer to the fifties and women launch themselves in beauty-contest and film careers, embracing more modern, 'Americanized' behaviours.

In the third chapter I tell the story of Italy's postwar interaction with 'America' – seen as an agent of rapid modernization. The cultural relationship between the two countries dates back to the thirties, and is characterized by the 'normative' ambivalence typical of a good part of Fascist cultural policy. Yet, it is in the postwar years that, thanks to the arrival of the Allies, the encounter becomes concrete. America economically aids and, in parallel fashion, overpowers Italy, while heavily trying to supervise its political choices. But the relationship cannot be read in such a straightforward, 'hegemonic' way. It is, in effect, played out in a more subtle, uncanny fashion, through the appeal that American (mass) culture exerts over Italy, as is evident in De Santi's *Riso Amaro* and in the reminiscences of Calvino and other writers. Once again, one of the most negotiated and invested areas of interaction is female identity/identities – as they appear to be configured by, evidently freer, American women. A comparison between American and Italian women is foregrounded in De Sica's *Stazione Termini*, which also deals with linguistic issues. In this case, the idiom at stake is the filmic one, which entails a close encounter between the styles of (late) Neorealism and the Hollywood mode of production. The two idioms collide particularly in the work of Rossellini with Ingrid Bergman. In addition, the private sphere qualifies itself as an area that can no longer derogatorily be seen as a 'lessened' feminine dimension, but rather can be viewed as a heuristic dialectical moment in the creation and/or representation of one's identity. The suicide of Cesare Pavese, who, in his *La luna e i falò* adopted a female *persona*, raises issues, up to now unaddressed in critical studies,[25] of negotiation between the personal and the public in the life of a militant artist.

The fourth chapter studies the new sociogeographical map of Italy emerging in the postwar years, evident already in the fifties. Thanks to the country's progressive modernization, to the wide availability of motor scooters and, later, of the Fiat cars Seicento and Cinquecento, thanks to radio and television, Italian people could journey, both literally and metaphorically, through the country, and thus discover their own heterogeneity and strong regionalization. The main result was the emergence in national attention of the 'South': an area soon anthropologically connoted as 'primitive,' as belonging to a pre-Christian, arcane, and, ultimately, Dionysian substratum. These characteristics are

evident in Rossellini's *Viaggio in Italia* and Ortese's *Il mare non bagna Napoli*. The mass migration of thousands of southern workers to the urban, industrialized North provides visibility for a social reality largely unknown to the majority of Italians. Rapidly, the South comes to symbolize 'otherness' and to embody the horizon against which and through which Italian intellectuals draw an image of Italy's own modern 'self.' The time-frame dimension of the journey also privileges a subjective sphere of perception that favours a psychological analysis of characters and the emergence of the companionate couple as a model of close emotional relationship, and makes room for the representation of quite independent female protagonists, as is the case with Antonioni's *Le amiche*. Already halfway through the fifties, the discussion moves beyond the restricted limits of national identity to embrace a larger critique of Western culture and of its Eurocentricity, as can be evinced from the work of anthropologist Ernesto De Martino.

Last but not least I need to devote a few words to the texts I have selected. Any choice is, in and of itself, partial and questionable, but also unavoidable: it then carries an element of inevitable arbitrariness. Taking into account already existent studies, I have also been guided by the unpredictable bends of research itself. The process has unfolded in front of me as informed by an 'inner necessity,' whose findings have become, increasingly, more significant and cohesive. Needless to say, my book offers just one possible, partial, and surely debatable interpretation out of many; but this is precisely its aim – to contribute to the discussion about a period of Italian history whose complexity is just starting to be studied.

ACKNOWLEDGMENTS

The original core of this book lay, as a semi-forgotten PhD thesis, gathering dust upon a shelf. It is only thanks to the encouragement of Rebecca West, my former adviser, that I decided to pull it down, dust it off, and work on it. I wish therefore to express my deepest gratitude to Rebecca. I then want to thank many fellow students, professors, and the staff that helped me at the University of Chicago throughout the writing of my dissertation: among them, in particular, Suzanne Abrams, Peter Bondanella, Paolo Cherchi, Nathalie Esther, Armando Maggi, Suzanne Magnanini, Aileen Mandel, Ted Vial, and Elissa Weaver.

In Canada I want to acknowledge my debt to Ron Schoeffel, who supported the project of this book from the very beginning, providing professional expertise and a prompt handling of all my queries. I am thankful to the anonymous readers of this manuscript and to their critical accuracy; indeed, their constructive criticism helped me to improve it considerably. I need to mention and thank John St James, who proved to be an extremely patient, knowledgeable, and accurate editor.

In Italy I am deeply indebted to the expertise, generous advice, and friendship of Lucia Folena. I am also thankful to Paola Castagna for the research I carried out at the Centro Sperimentale di Cinematografia in Rome; to Gian Piero Brunetta, who generously offered his video archive for consultation; and to Tommaso, who made that consultation possible. In Verona I thank in particular Donatella Boni and Monica Berzacola, who efficiently guided me through the intricacies of the interlibrary loan service.

I am also grateful to Caterina Spillari, Lucia Re, and Giuseppe Sandrini, who read different portions of this manuscript and provided insightful comments. Last but not least I wish to thank Ibrahim, for his ability and patience in handling my computer illiteracy.

Portions of this book have been published previously as articles: 'From Mother to Daughter: The Emergence of a Female Genealogy in Anna Banti's Artemisia and Alba De Céspedes' Dalla parte di lei,' *Italica*, Autumn 1996 (a slightly different version has been published in Gallucci and Nerenberg, eds, *Writing beyond Fascism: Cultural Resistance in the Life and Works of Alba de Céspedes*); 'The Discovery of the South as an Alien Place and Rossellini's Precocious Critique of the West in Viaggio in Italia,' *Annali d'Italianistica*, 1997; 'Time Is No Longer the Same': Ambivalence and Denial or the Uneasy Relationship with the Past in Pietro Germi's Gioventù perduta and Roberto Rossellini's Germania anno zero,' *Forum Italicum*, Spring 1998.

BROKEN TIME, FRAGMENTED SPACE

TIME HAS CHANGED

C'è sempre una differenza fra ciò che si crede di essere e ciò che effettivamente si è. A maggior ragione, c'è sempre una differenza fra ciò che si crede di essere stati e quello che effettivamente si è stati.

There is always a difference between what one believes he is, and what one really is. Even more so, there is always a difference between what one believes he was and what one has, indeed, really been.

MARIO ALICATA

The Uneasy Relationship with the Past in the Postwar Period

The disarray of Italian artists and intellectuals of the immediate postwar period was intense, painful, and contradictory.[1] Invested with a cogent moral imperative, artists and intellectuals on the left, along with partisans of different orientations, moderates and·Catholics alike, felt called to a very challenging task. They needed to craft a transition from the Fascist regime to the Republic.[2] The job was not easy, since, at the end of the Second World War, the Fascist heritage had turned, almost overnight, into a shameful past that most wanted to forget. And yet, notwithstanding intellectuals' declarations about their thorough postwar renewal, it is possible to notice a substantial continuity between the culture of the twenties and thirties and that of the forties, between 'before' and 'after' the war. Rather than seeing a radical fracture and a deep division between the two periods, as did the intellectuals of the *Resistenza*, I want to highlight the analogies and similarities. However,

intellectuals and authors also testify to a rapport with the past that is intrinsically ambiguous, since their relationship to the past is marked by a knot of conflicting attitudes as well as emotions – a knot they are not able to undo. On the one hand, there is a need to repudiate the historical past, the *Ventennio*, and the Fascist legacy; on the other hand, the past corresponds to a period untouched by the brutality of war and, therefore, in some paradoxical sense, to a lost innocence that some authors nostalgically seek to recover.

Writers, artists, and film directors who had been active under the regime[3] were seen, after the fall of Fascism, as unequivocally guilty. The verdict was unanimous and applied both to those practically involved in Fascist cultural politics and to those who, like the influential philosopher Benedetto Croce (1866–1952), had not been active supporters of the regime, but who had not effectively opposed it either. How to deal with Fascism and how to deal with what had been one's (now) dishonourable involvement in it became fundamental issues, which stirred up heated and controversial debates in the pages of the numerous and short-lived literary magazines published after the war, as we can infer from the following brief summary.[4]

As early as 1944 the Communist paper *Rinascita* published an anonymous article that openly attacked Croceanism by saying that it was no longer possible to separate 'ideas from facts ... culture from politics ... and *art from true life*' (italics mine).[5] In reality, *Rinascita* aimed at targeting *Aretusa*, the magazine edited by Croce's disciple Francesco Flora. *Aretusa* kept alive a prewar idealistic tradition primarily by defending hermetic poetry. The complex phenomenon of Hermeticism was, from the Communist literary perspective, under a Crocean spell since it privileged a cryptic style. Such a style, deliberately enigmatic, highly formalized, and self-referential, refrained from any explicit political commitment: it thus embodied the kind of passive non-cooperation now highly criticized by intellectuals on the left. However, the Communist interpretation was clearly mistificatory, since Giuseppe Ungaretti (1888–1970), the most prominent figure of the movement, was an outspoken fervent Fascist.[6] Another leftist intellectual, Fabrizio Onofri, forcefully attacked the literature and culture of the *Ventennio* in another article published in *Rinascita*: after asking himself if the Italian prewar culture was to be condemned ('si dovrà dunque condannare tutt' intera l'arte, la letteratura, la cultura italiana del ventennio fascista?'), he unequivocally answered: 'Da un punto di vista storico ampio, la risposta non può essere dubbia. L'arte, la letteratura, la cultura italiana non

hanno fatto niente per opporsi al fascismo.'[7] His statement implied, crucially, the refusal of twenty years of Italian history. Carlo Bo, who was later to become one of the most influential Catholic intellectuals, acutely addressed what seemed to be the guilt common to all *Ventennio* writers and artists, including himself. Bo called it *assenza* (absence). 'Bisogna segnare le nostre colpe: il peccato di omissione, non era tempo di vacanza e per troppi è stato addirittura tempo di divertimenti e di dissipazione.'[8] He thus stigmatized a lack of responsibility on the side of intellectuals with reference to the regime. Following such a wave of heated radicalism, the dispute reached apocalyptic overtones when Elio Vittorini (1908–66), in the pages of *Il Politecnico*, condemned all European culture, starting from the Greeks. Vittorini argued that the culture of the West had, up to that point, performed just a 'consolatory' role for the people, and had not taught them how to prevent evils. The saying 'Give to Caesar what is Caesar's, and to God what is God's' hid a hypocritical respect for the two separate spheres of politics and religion, since it masked an indifference that prevented an alert moral consciousness from dealing with political issues.[9] Vittorini admitted that he, too, was part of the 'old' culture, but, simultaneously, he felt the necessity himself to become 'new' culture. In order to become new, culture had to go out of itself and transform itself.

Vital to the postwar controversy about the role of culture and of intellectuals was Giaime Pintor's *Ultima Lettera*: an epistle written by Pintor to his brother in 1943. The letter was first distributed widely among Partisans in typewritten form, and then published by Einaudi in 1946.[10] From then on, newspapers and magazines frequently reproduced and discussed it. Sardinian Giaime Pintor (1919–43) joined the Partisans at the end of the summer of 1943 and died in the same year while trying to cross the German lines to join the Partisans in occupied Italy. His premature death – he was only twenty-four at the time – turned the letter into a *testamento*, or testament, that brought to the forefront moral and cultural issues that the new generation was soon to embrace as its own.

In realtà la guerra, ultima fase del fascismo trionfante, ha agito su di noi più profondamente di quanto risulti a prima vista. La guerra ha distolto materialmente gli uomini dalle loro abitudini, li ha costretti a prendere atto con le mani e con gli occhi dei pericoli che minacciano i presupposti di ogni vita individuale, *li ha persuasi che non c'è possibilità di salvezza nella neutralità e nell'isolamento* ... Senza la guerra io sarei rimasto un intellettuale con interessi prevalentemente letterari ... e l'incontro con una ragazza o

un impulso qualunque alla fantasia avrebbero contato per me più di ogni
partito o dottrina.'[11] (italics mine)

The war itself and the experience of confronting death and destruc-
tion in the most basic sense marked the transition between what was
now represented as the political lethargy of the *Ventennio* and the politi-
cal and ethical engagement of the post-Fascist period, at least during the
Resistenza. Banal as it may sound, the war had tragically affected and
shaken intellectuals, who could not remain aloof from its tangible
effects and could no longer retreat into a merely artistic or literary
world. As Pintor stated, 'A un certo momento gli intellettuali devono
essere capaci di trasferire la loro esperienza sul terreno dell'utilità
comune, ciascuno deve saper prendere il suo posto in una organizzazi-
one di combattimento.' Even more poignantly, he argued, 'Musicisti e
scrittori dobbiamo rinunciare ai nostri privilegi per contribuire alla libe-
razione di tutti.'[12] Pintor's work was a true call to arms for the intellec-
tuals who were now to renounce their former privileges and isolation
and join their fellow human beings in a common battle for freedom.

But how could intellectuals possibly claim their estrangement from
the *Ventennio*'s experience and from the cultural implications of that
experience? How could they defend themselves from the humiliating
accusation of having cooperated with the regime? They did it precisely
by claiming that postwar culture was something radically new, fully unre-
lated to the one developed during the interwar years. They preferred to
fragment themselves, to dismiss a part of their previous history or to
rewrite it *tout court*, thus creating a new virginity for themselves. Such
claims were obviously absurd; and yet they constituted hard currency
and the premise upon which many recast their own pre-war persona.

Alberto Moravia (1907–98), for instance, reached wide popularity
with the publication of *Gli Indifferenti* in 1929. Contemporary Fascist
critics reviewed the book as an example of the 'new realist sensibility
in literature,' and by 1930 the volume had gone already through its
fourth printing. As Ruth Ben-Ghiat has acutely indicated, however, the
nucleus of the book took shape as a number of stories that Moravia con-
tributed to the Fascist avant-garde journals *I lupi* and *L'interplanetario*.[13]
However, 'in postwar interviews and autobiographical writings, Moravia
often emphasized his isolation from both political matters and the
fascist literary community during the years he was developing *Gli Indif-
ferenti*, and favored an interpretation of the novel as oppositional work
to the regime.'[14]

Romano Bilenchi (1909–89), who was to found the Communist magazine *Società* in 1945, had contributed in the 1930s to the prestigious journal *Critica fascista* and to the Florentine Fascist Federation weekly *Bargello*, and had written *romanzi squadristi* such as *Vita di Pisto* and *Cronaca dell'Italia meschina ovvero storia dei socialisti di Colle* – novels that he later repudiated. Notwithstanding his later dismissal of Fascism, he had been, since 1934, on the payroll of the Ministero per la stampa e la propaganda (from 1937 on, Minculpop).[15] Elio Vittorini – who disaffiliated himself from Fascism in 1937 – was personally invited by the Duce, with a telegram, to attend an international conference of European writers in Nazi Germany in 1942, and did attend.[16] On a different scale, Vittorio de Sica (1901–74) had been a brilliant actor in the 1930s and had participated in films, such as *Il Signor Max* and *Grandi Magazzini*, that represented the urban, modernizing character of the regime and its incipient self-representation as a consumerist culture. De Sica embodied one of the models of masculinity of the regime – interestingly enough not the more 'virile' type.[17] And yet, after the war he became one of the founding fathers of Neorealism, and directed films such as *Bicycle Thieves* and *Umberto D.* I will come back later to this point of shifting identities with a brief account of culture under Fascism.

If the war sanctioned an acknowledged fracture between a 'before' and an 'after,' it also, paradoxically, constituted the unavoidable *trait d'union* between the era of Mussolini and the era of the *Nuova Costituzione*, or New Constitution. That the continuities between the pre- and postwar period were far more than the discontinuities and the ruptures was already indicated in the seventies by Asor Rosa, who maintains:

> Se assumiamo a posteriori l'ipotesi che nella cultura impegnata degli anni successivi alla Resistenza le *nozioni d'impegno, popolarità, realismo e la ricerca di una tradizione ad esse adeguata* sono fondamentali e caratterizzanti, non è difficile dimostrare che *questi quattro elementi preesistevano all'esplosione della guerra e della Resistenza*, cioè ai fatti politici con cui più immediatamente dovevano poi confrontarsi scrittori e letterati negli anni fra il '43 e il '47.[18] (italics mine)

A few lines earlier in the same text, Asor Rosa had warned against interpreting literally the declaration of total renewal proclaimed by intellectuals of the *Resistenza*.[19] He then individuated the job of a critic in assessing not if, but to what extent, the war and the Resistance had influenced or carried through already effective artistic trends.

In order to detect continuities between the pre- and the postwar period, we need to describe, however briefly, a few tenets of Fascist cultural policy. One preliminary consideration concerns the fact that usually, in an oversimplifying fashion, critics refer to the *Ventennio* as to a homogeneous, compact period. In reality, Fascism changed over time. We can roughly detect a first decade, divided in two periods, through which the movement, after its original rebellious/revolutionary core 'sansepolcrista,' came into power, and attempted, more consistently after 1925, to strengthen itself. It did so thanks to a series of political and cultural initiatives (Gentile's school reform in 1923, the syndicalization of artists in 1928–9, the Lateran Treaty in 1929, Rocco's Code in 1930, etc.). The first ten years of Fascist regime were celebrated with a sumptuous exhibition in Rome that portrayed Fascism as a religion of the state, marking a landmark in the construction of public consensus.[20] We then have the years preceding the Ethiopian war (1935), in which Fascism, now firmly established, promoted its self-representation in terms of power, autarchy, and international prestige and, also, as an urban phenomenon that implemented modernization and early consumerist practices. After the colonial enterprise, and following Italy's international isolation, the tones became darker and more bellicose. In 1938 racial laws were implemented; the alliance with Germany grew stricter and more demanding. Italy turned from being an 'equal' ally to Germany into its badly considered subordinate. By the end, between 1943 and 1945, a minority of Italians took part in the Republic of Salò, whereas partisans fought in central and northern Italy.

Fascism, as we have seen, changed over time, authorizing and implementing distinct and divergent kinds of state strategies, as well as cultural practices, to maintain and elicit consent. Italian civilians and intellectuals modified their behaviour accordingly. As various studies illustrate, the Fascist regime was not as monolithic and homogeneous in cultural directives as one might have thought.[21] On the contrary, one of its pragmatic strategies was that of not privileging one group or movement over the others, thus avoiding identifying itself specifically with a given cultural current. Such an attitude is particularly clear in the case of the visual arts and architecture. In this case, extremely modern rationalist trends, common to northern European countries, lived side by side with a rhetoric of power prone to use towers and balconies as elements to subliminally infer and recall the importance and the centrality of Mussolini in the life of all Italians.[22] In addition, censorship, though present, was not implemented with the same severity in various circum-

stances, and it was at times possible to bypass it, largely because of its officials' myopia.[23] Fascism maintained an attitude of patronage through which it subsidized (and of course controlled) from the very beginning the press and journalists in particular, but also writers and visual artists.[24] The economic subsidies were distributed at large: it is revealing to see how many of the artists and writers, who – after the war – turned into active anti-Fascists, figured on the Minculpop payroll cheque.[25]

A peculiar characteristic of Fascism, in culture, consists in a sort of institutionalized ambivalence, a coherent contradictoriness, thanks to which many contrasting behaviours could coexist. A case in point is the compilation of the *Enciclopedia Treccani*, which took almost ten years to be completed and was proudly modelled after the *Encyclopedia Britannica*. Its scope was that of celebrating the greatness of Fascist Italy and its cultural achievements in the international arena. Giovanni Gentile organized and supervised the work, which began in 1929 and was completed by 1937. He called into collaboration many important scholars on the basis of their academic standing in specific disciplines, regardless of their inclination towards the regime. Some of the scholars were Jewish, like Arnaldo Momigliano (who later regretted his participation in the project), others outspoken anti-Fascists like Rodolfo Mondolfo, Gioele Solari, or Nello Rosselli.[26]

In reality most intellectuals, even the ones who later repudiated the regime, were originally drawn to it for its revolutionary promise of change. At the beginning Fascism packaged itself as a movement that aimed at attacking liberal bourgeois individualism, and at resolving privileges regarding the private sphere into a public arena institutionally and legally disciplined by the state.[27] Fascism wanted to make coincide the private and public spheres by taking charge of needs pertaining to the areas of family, maternity, sexuality, upbringing, schooling, and so on. Though intellectuals' support for the regime had started to waver since the years of the Ethiopian war, active opposition did not start for most young Italians until 1942–3.[28] (This comment obviously concerns people who had not been anti-Fascist from the beginning, like Cesare Pavese, Primo Levi, or even Eugenio Montale.)

Another area in which Fascism showed its ambivalence was its policy towards women. As is well known, its outspoken ideology aimed at confining women within the domestic space, discouraging their entering the labour force and the public arena. The original Mussolinian promise of granting women the vote (both in 1919 and in 1925) was never

pursued in the appropriate place, the Parliament. Fascism condensed its misogynist ideal of femaleness in the famous epigraphic saying *sposa e madre esemplare*, fostering a demographic campaign that prized la *donna fattrice*, the chain-reproducer-woman, one of the emblems of the government's autarchic plans. As Victoria de Grazia has summarized: 'Mussolini's regime stood for returning women to home and hearth, restoring patriarchal authority, and confining female destiny to bearing babies.'[29] As important studies have demonstrated, though, the model proposed was not unanimously championed. Women living in the countryside reacted differently than did women living in the city. The former were more inclined to follow the Duce's dictates, while urbanized females, who worked in factories or were employed as secretaries, typists, and saleswomen, showed more independence. In effect, women enacted, in their everyday life, practices of 'microresistance' that allowed for living their life in partial disagreement with Fascist dictates. Luisa Passerini reports that working women in Turin used some kind of contraceptive methods, thus reclaiming agency over their own bodies, in overt conflict with state policies.[30] Another place in which different kinds of possible women's subjectivities or positionalities were spelled out was the female press. Journals specifically addressed to women, even Catholic ones, left room for a variety of female characters that could not be reduced to the submissive *sposa e madre esemplare* stereotype.[31] Women writers who contributed their stories to the third pages of newspapers articulated a female world largely unknown to the regime. In addition, quite a few female writers, whose work has gone completely forgotten after the war, addressed hot, challenging themes in their prose fiction, trespassing the outspoken 'moral' boundaries of Fascism. This is the case with Drigo's treatment of incest and De Céspedes's allusion to a lesbian relationship.[32]

The same government policy left room for contradictions. The heavy emphasis on sports that distinguished the Fascist regime in the 1930s forged a model of young girl who was independent, strong, and self-reliant. This model so contrasted with that of a 'modest,' submissive girl that the Church strongly protested, for it saw in excessive sport practices concomitant 'nudity' and promiscuity between the sexes – a sinful occasion.[33] Edda Ciano, one of the daughters of Mussolini, who enjoyed every kind of sport and who was 'one of the first young women in Italy to wear pants and drive a car,' surely defied a traditional portrayal of woman. The participation of youth in conventions and competitions allowed for a mobility that did not match the image of 'angelo del foco-

lare' to which reactionary theoreticians such as Loffredo and Evola had referred. The Fascist regulation of free time, which entailed participation in the *sabato fascista*, but also in the summer colonies or in short OND (Organizzazione Nazionale Dopolavoro) train trips with a cultural focus, allowed for an unprecedented dynamism for young girls.

Thus, contradictory data emerge regarding the situation of women during the *Ventennio*. This is not to say that the regime did not implement misogynist practices or heavily discourage women's participation in public life. As Piero Meldini maintains, 'l'opposizione al lavoro femminile è un aspetto centrale dell'ideologia fascista della donna' ('opposing women's work is a central aspect of the fascist ideology about women') whose job is that of re-producing rather than producing.[34] Women's participation in the public arena could also – according to ideologues of the time – have a de-virilizing effect on husbands; further, in working too hard, females would run the risk of becoming sterile. Indeed, women's labour had decreased to 19 per cent in 1931 from 32.4 per cent in 1900.[35] In 1938, a decree-law 'ordered state and private offices to cut back female workers to 10 per cent of their total staff.'[36] Female workers were paid less than were their male colleagues – even though this trait is not peculiar to just the Italian economy of the period. Female teachers were also prohibited from holding positions as principals or from teaching literature and history in the prestigious pearl of Gentile's school reform: the *Liceo*. Women's level of schooling, though, steadily increased. In 1931, 53 per cent of girls were enrolled in middle school, in 1937–8 they numbered 32 per cent in the *ginnasio* and 26 per cent in the *liceo*, while in 1935 female enrolment at the university level had reached 15 per cent.[37] Overall, despite its rigidly patriarchal policies and even though a university degree did not guarantee, in and of itself, access to work, Fascism did not fully succeed in enforcing its assumptions regarding women.

As I have argued, the transition from Fascism to the postwar period did not entail a complete renewal of cultural practices. There had been holes in the web of the cultural institutions of Fascism that allowed for relatively free and uncensored self-expression, not to say camouflaged criticism of the regime. A major space for rhetorically displaced disagreement had been provided by the *littoriali della cultura* – a public arena where youth could debate given topics, and refine their rhetorical skills – and by the Gruppo Universitario Fascista (GUF), which sponsored analogous debates.[38] A magazine that can be considered 'transitional' in this respect is *Corrente di Vita Giovanile*, published in Milan

between 1938 and 1940. The magazine enjoyed the contributions of young intellectuals of different, contrasting ideological orientations. When it was closed down on Mussolini's orders, quite a few of the contributors joined the Republic of Salò, others joined the *Resistenza.* As Ruth Ben-Ghiat states, 'From start to finish, those who wrote for *Corrente* remained divided in their beliefs. This division mirrored the political discord among Italian intellectuals in the last years of the dictatorship.'[39] The goals of the journal were similar to the ones claimed as their own by postwar intellectuals, who strove to produce a 'new' culture that could be informed by moral imperatives – a culture that would focus on the lower classes, privileging Realism as its form of expression.

In parallel with *Corrente*'s closure, in 1940, Giuseppe Bottai (1815–1959), then minister of culture, founded *Primato*, a magazine with which the 'entire literary world of the time' (Asor Rosa) cooperated.[40] Bottai wanted to create a cultural space – the magazine was not exclusively literary – in which the more active forces of the country could come together and confront each other. As Bottai stated in the introductory editorial of the first issue, *Primato*'s function was one of 'chiarimento ... e inventario' (clarification and inventory). *Cinema* magazine, directed by Vittorio Mussolini (1916–97), one of the *Duce*'s sons, also provided a space for mild dissent from Fascist cultural 'autarchy,' since it was characterized by a 'disproportionate' – to orthodox Fascist eyes – admiration for American mass culture.[41] Vittorio Mussolini, who was actively involved in production and scriptwriting, was himself a passionate fan of Hollywood and visited the California Studios in 1937. He urged many artists and cultural activists to participate in the magazine. Many of these contributors would become either Neorealist directors or leftist intellectuals after the fall of the regime. Among them were Giuseppe De Santis, Carlo Lizzani, Luchino Visconti, Michelangelo Antonioni, and Mario Alicata.

Thus, traits, rhetorical devices, and – more important – concepts that contributed to the creation of a dominant culture throughout Fascism were still alive in the years after the war, as is visible, for instance, in the iconographic culture of the political manifestos.[42] Fascist traits were appropriated and rearranged by artists and writers – in some cases the very persons who had used them before 1945 – in an effort to convey new meanings. Elements of Fascist rhetoric were, ironically, employed to construct the heroic representation of *Resistenza,* to advocate a generic populism, and to craft a supposedly 'new' cultural self-representation.

The film *Giorni di gloria*, directed by Mario Serandrei and Giuseppe De Santis, provides one of the most evident and somehow typical cases of such re-conversion of signs. The film, which pedagogically explains Partisan life in occupied Italy, was shot under the supervision of the Comitato di Liberazione Nazionale (CLN), in 1943. It combines authentic footage of Partisan attacks, the episode of the *Fosse Ardeatine* (where 335 Italians were killed in retaliation for a Partisan action that killed 33 Germans), and the trial of Pietro Caruso, Rome's Fascist chief of police. To promote the reconstruction of Italy after Fascism while creating horror and repugnance for the regime and its leaders, the film appeals to the *popolo italiano* (Italian people) and to its traditional *valori* (values) in ways no different from the ones used by Mussolinian rhetoric. In *Giorni di gloria* the codes of Fascist social realism of the 1930s mingle with Eisenstein's type of montage, such that, while images of working women appear on the screen, the voice-over speaks of them as '*donne italiane, donne popolane* forti e senza enfasi' (italics mine) in a way that sounds proudly nationalistic, and clearly echoes the agrarian ideology of the *Ventennio*.

A literary example of a work in which old concepts survive in programmatically new narratives is Agnese Viganò's novel *L'Agnese va a morire*, published in 1949. Viganò's book is a canonical 'Resistential' novel, rooted in the documentarist mood that unconditionally praises Partisans over Fascists and Nazis. Agnese, an old and stout childless woman, loses her husband to the Germans. The loss motivates her to join the Partisans and to fully dedicate her life to their cause. She becomes, for everybody, an unselfish and overly generous 'big mama' – her entire character being summed up in her function: *mamma* Agnese. By thoroughly identifying with this role, she re-enacts and reinforces the prewar ideal of self-sacrificing motherhood.[43] For there is no hint that she could be a sexual desiring subject or that her femaleness could be lived in ways other than motherly.

Even the Communist paper *Rinascita* could not avoid being caught up in a cultural amalgam where elements that belonged to the Fascist *Weltanschauung* were proposed as part of a dramatically new political project. In 'La famiglia e lo Stato,' an editorial published in 1946, Leonilde Iotti (a PCI affiliate) defended the family in a striking Fascist/populist manner. Iotti intended to propose four articles for the *Costituzione della Repubblica*, which was to be approved in 1948. She starts by addressing the severe ethical and moral confusion Italy faces after the war: 'Seriamente minacciata è la sana moralità del nostro popolo, che

nella famiglia aveva particolarmente trovato, sino ad ora, le sue mani-festazioni.'[44] For Iotti it is natural that Italians, after the tragedy of the war, try to look for solidarity and inner strength within the family, and she states: 'La famiglia si presenta quindi ora più che mai come il nucleo primordiale su cui i cittadini e lo Stato possono e debbono pog-giare per il rinnovamento materiale e morale della vita italiana.'[45] But was not the family the much-vaunted master pillar of the Fascist state organization?

Although Iotti advocates a new role – independent and egalitarian – for women within the family, she champions its protection in a very tra-ditional way. For instance, among the constitutional articles she pro-poses, she lists the following: 'Lo Stato provvederà alla protezione morale e materiale della maternità, della infanzia e della gioventù e isti-tuirà gli organismi necessari a tale scopo.'[46] This statement summarizes the purposes of the Agency for Maternity and Infancy (OMNI), which, under Mussolini, provided assistance for mothers and children. In the article just mentioned, Iotti holds the state responsible for educating mothers, children, and youth in a manner very similar to that planned by Fascist institutions. The continuity between the Fascist and post-Fascist periods was also supported and/or implemented by the fact that a true political purge did not take place in Italy after the war. Almost unanimously, the majority of political forces, among them the Commu-nists headed by Togliatti, voted against submitting Fascist officials to severe punishment. In a few years, quite a few public figures of the *Ven-tennio* were back in office, partly recycled in the ranks of the Christian Democrats or in administrative positions.[47]

The 'missed purge' brings to the foreground another aspect central to the postwar reconstruction: the relationship between generations. In his *Una guerra civile: Saggio sulla moralità nella Resistenza*, Claudio Pavone observes that 'il nesso sia con l'antifascismo che con il fascismo fu vis-suto dai resistenti anche come rapporto tra le generazioni.'[48] He then moves on to explain that by 'generation' he means 'a fatto storico-culturale e non anagrafico.'[49] There are long and short generations. The former gather together people whose age might vary by up to fifteen years, but who, nevertheless, have shared psychologically shock-ing experiences such as wars or other calamities. The latter include people whose age is closer to that of one another. The anti-Fascist gen-eration is – in Pavone's opinion – a long generation in that it aggregates anti-Fascists of the interwar period and the *Resistenza*'s youth. In particu-lar, after the war younger generations accused their fathers both of

having been Fascist and of having hidden from them their pre-Fascist past. They were also deeply resentful of intellectuals, since they held them responsible for not having educated youth. In addition, we should keep in mind that Fascism explicitly targeted younger generations since it wanted to appear as a 'young' movement – consider its early ties to Futurism – that opposed the old liberal politicians.

The removal of one's past could not happen without paying at least an emotional toll – not without incurring tormenting dichotomies. If we adopt Bhabha's theory, to live the present must have amounted, for postwar intellectuals, to embracing a contradictory, shifting identity, in which traits of the past continually surfaced, mixed with a sense of bewilderment, confusion, and, paradoxically, joy; for – as we have seen with Vittorini – intellectuals harboured the desire to rewrite and recast history. The discontinuity with the past experienced by people at a subjective psychological level was intersected by the collective enthusiasm for reconstruction and imbued with those anarchic overtones that both the war and the *Resistenza* had brought to everyday life. Because time offers individuals a sense of continuity in their personal history, the disruption of identity and the various losses the war induced created an uneasy, ambivalent relationship with time itself. The theme of the 'passing of time' developed into a pervasive refrain whose repetition put into question not only personal identity, but also the learned values of Fascist rhetoric and ideology. These values hinged upon the family, patriarchy, the relationship between generations, and the sociocultural persona – male or female – constructed around one's biological gender. I will consider how these themes came to the forefront – in a cryptic or, otherwise, urgent and open way, or both – in my analysis of three texts: Germi's *Gioventù perduta*, Pratolini's *Un eroe del nostro tempo*, and Rossellini's *Germania anno zero*.

A Fatherless Generation: Pietro Germi's *Gioventù perduta*

Gioventù perduta, a relatively unknown film shot by Germi in 1947, is one of the numerous works of the *dopoguerra* that deal with the uncomfortable heritage of the past. Germi himself embodies a transition from the *Ventennio* to the Republic. Born in 1914, and therefore educated under Fascism, he had been admitted to the newly founded Centro Sperimentale di Cinematografia in 1937, and had learned his craft there. However, for his insufference of the rules and his anarchist inclinations, he had risked being expelled from the school.[50] Stylistically, he had prof-

ited more from studying the American noir and trial films than the Italian comedy, endowing his works with a rhythm uncommonly rapid in the context of national production. With *Gioventù perduta* the director calls attention to a generational problem, dramatically questioning patriarchy and the authority of the father within a patriarchal system. He also implicitly attacks Fascist education and the Gentilian school reform.

Marcello Mariani is a *reduce*, a returning soldier, who works for the police in Rome. He is covertly investigating a robbery and homicide case in the university environment. Here, on the very day of the students' enrolment, he meets Luisa, an assertive young girl whose father teaches statistics at the university. Marcello courts Luisa and is gradually introduced into her family. He thus meets Stefano, Luisa's brother, a twenty-year-old rude and selfish young man who leads a luxurious and intense nightlife. Stefano keeps expensive liquors in the closet of his room. He smokes American cigarettes – Camels – and has a lover who sings in a nightclub: a girl of 'questionable morality.' The brother is the cruel and pitiless leader of a band of four, always ready to commit the next robbery, this time in the university registrar's office. During registration, in order to avoid the long lines at the counter, Stefano goes directly to the registrar's office to be helped by Maria, a childhood sweetheart who is still hopelessly in love with him. In the office he sees the money collected for the students' applications on an open counter and plans his coup. However, during the robbery, Stefano forgets his initialled lighter in the office. Maria finds it afterward on the table, but for some instinctive reason decides not to deliver it to the police. In order to get the lighter back, Stefano invites Maria for a walk along the river and promises that he will later take her to the police to turn in the lighter. She has second thoughts about the lighter because Francesco, the university janitor wounded by the group, has since died at the hospital. Stefano shoots Maria by the river as they kiss. Meanwhile, Marcello becomes more and more convinced that Stefano is the man for whom he is looking. Caught in a dilemma between duty and personal feelings, Marcello has no other choice than to break with Luisa, who, meanwhile, has found out that he is an undercover policeman. She convinces herself that he has only used her to get information about Stefano. Despite the incriminating evidence, she cannot accept that her brother is a killer. At the end, realizing that the police are on his trail, Stefano decides to leave town. He needs money and resolves to get it by robbing the rou-

lette table at the night club 'Orfeo' where his lover works. In the final
scene, when he and Marcello confront each other, he takes his sister
Luisa, who has just arrived at the club, as a hostage and tries to shield
himself with her very body. He is finally killed and Luisa escapes
unharmed.

Gioventù perduta offers an emblematic example of how time comes to
be scrutinized in postwar cinematic texts. While close-ups of calendars,
clocks, and wristwatches constantly punctuate the narrative and thus
designate time as one of the director's biggest concerns and the film's
leitmotif, the very choice of the film genre signals a problem of an epis-
temological nature. *Gioventù perduta* is in fact a 'film noir,' and in the
film noir time is radically at stake as a narratological category per se.
While classical Hollywood cinema consistently structures its narrative in
a linear, chronological progression, the noir – which constitutes one of
its important subcategories – moves through ellipsis and diegetic enig-
mas. Film noir will, a posteriori, reassemble a chronological linearity,
since the viewer, by the end of the film, will be able to reconstruct the
cause-effect nexus that holds together the events narrated in the story.
Nevertheless, the noir as a genre challenges the assumed cohesiveness
of time at the very level of the plot's organization.[51]

Since in the noir real circumstances mingle with oneiric sequences or
nightmares, without devices that would signal this mélange to the
viewer, the former are not immediately distinguishable from the latter.
Such chronological obfuscation is achieved by employing stylistic ele-
ments that, as Place and Peterson state, tend to 'create a world that is
never stable or safe, that is always threatening to change drastically and
unexpectedly.'[52] It is then within an already structurally problematic
genre, and also thanks to it, that *Gioventù perduta* enhances the problem
of time.

The film opens with a well-crafted robbery scene whose tight timing
and sharp lighting demonstrate Germi's internalization of the American
noir style. After the robbery, the camera switches to Stefano's house.
The house is seen from the outside, then a tracking shot slowly pans
inside. The camera tracks over a clock, the dining room, and the studio,
then stops on the door through which we see Stefano descending the
stairs. The house is silent except for the ticking of the clock; then we
hear the mother's voice without seeing her. The fact that we cannot
locate the subject of the gaze, since the gaze is not generated by a char-
acter, creates a sense of unease and establishes the house, from the

beginning, as an empty stage in which Stefano and Luisa come and go as guests, while the other characters – their father and mother – also perform empty roles.

In this scenario – an empty house – the theme of time is addressed over and over. The morning after the robbery, Stefano's father wants to talk to him before he goes out, but when the young man impatiently tries to leave, he tells him: '*Tu non hai mai tempo*' and, again, 'Questi sono *tempi duri. Una volta* si stava bene in questa casa. *Oggi* ...' One day, Stefano notices Maria's new hairstyle and asks her: 'Hai cambiato petti-natura?' She replies, '*Una volta* ti piacevo pettinata così.' Stefano adds: 'E tu *sei rimasta ancora a quei tempi?*' A few nights later, she gets closer to him while he plays the piano and asks him if he would not like to be as they once were: 'Non vorresti essere *come eravamo allora?*' and Stefano answers, 'Non so, *non ricordo come eravamo allora.*'[53] Then, along the river, when Stefano has already decided to kill Maria, the same talk about time comes back. Maria recalls the era before the war and asks Stefano if he would like to be as they were. Stefano answers: '*E' passato il tempo,* c'è stata la guerra.' Maria: 'E che vuol dire? *Il tempo passa ma noi dobbiamo restare gli stessi. Io non mi sento cambiata e tu?*' Stefano: '*Io non sono più lo stesso.*'[54] Past and present clearly are juxtaposed, in Stefano's perception, as antithetical elements that can no longer be synthesized in one single life. The very process of the passing of historical ('c'è stata la guerra') as well as psychological ('io non sono più lo stesso') time affects Stefano deeply. The young man perceives an unbridgeable gulf between his previous and current selves, a gulf marked by a moral degeneration of which he himself is quite conscious.

Stefano is no longer the same, times are no longer the same, and the old, prewar structures are crumbling, starting from that 'ideologized' social cell that is the family.[55] In *Gioventù perduta* the members of the family inhabit an empty nest, and their emotional ties to each other also are threatening to fall apart. While in the Fascist family the father enjoyed a position of undisputed respect,[56] there is no communication between Stefano and his father, nor does the father exert any control over his son's life. The distance between father and son is clearly addressed the night of Stefano's birthday. In fact, the young man deeply upsets his family's feelings by questioning his parents' right to have brought him into this world: 'Strano, perchè non si chiede il parere dei figli prima di met-terli al mondo, ad ogni modo io non mi lamento.' Visibly hurt, the father replies: 'Non so se *ai miei tempi* sarei stato capace di fare dei discorsi simili

a mio padre.'[57] Stefano's father feels anxiously disappointed in what he cautiously defines as 'today's youth' and tells Stefano: 'C'è nei *giovani d'oggi* uno strano miscuglio di cinismo e pessimismo che mi spaventa.'[58] The father refers to him as 'today's youth,' and therefore as an abstraction, since Stefano – the individual – is subsumed into a generic group, youth. With this statement, Stefano's father detaches himself from his son, precisely by using time as an indexical category, while also refusing responsibility for his son's choices. Thus, he withdraws from the picture as an educator, performing something similar to what Carlo Bo had labelled *assenza.* Both Stefano's father and mother are resistant to the idea that Stefano has grown up. This resistance acquires in *Gioventù perduta* a metaphorical meaning: it turns into the older generation's inability to acknowledge that its sons and daughters are, indeed, not simply the biological but also the 'historical' offspring of its own education and, therefore, of its passive cooperation with Fascism.

In order to convey the Fascist stigma hovering over youth, Germi uses framing devices. Whenever young people are entering the university – a privileged locus of higher learning – they are filmed from inside the building, framed through the impressive, gigantic doors with their pattern of vertical and horizontal iron bars so characteristic of Fascist architecture. This framing becomes particularly suggestive in the depiction of Maria. The day after the robbery, when Maria goes to work, she is filmed not only from inside the university, but also from a high-angle point of view. She then appears in the distance, and seems small, alone, and defenceless: a victim surrounded and almost imprisoned by the *Ventennio*'s architectural signifiers.

Even though Germi implicitly accuses Fascism, it seems to me that he feels uneasy holding it responsible for everything. Germi does not know exactly how to assign responsibilities and, in assessing the postwar situation, remains somehow ambivalent. On the one hand, he refrains from considering Fascism as a desubjectivized agent responsible for the psychological and emotional disaster of an entire generation. On the other hand, he accounts for Fascism's disastrous aftermath by taking recourse, quite paradoxically, in statistics. He thus replicates, as a film director, Stefano's father's helplessness.

Stefano's father is a professor of statistics at the university. Towards the end of the film, Stefano goes to his father's class in order to leave Maria a message, asking her out so that he can retrieve his lighter. His father is giving a long lecture about crime:

Dalle cifre si possono trarre molti insegnamenti. Esse sono come *lo specchio* nel quale *si riflette l'immagine di una società* ... La vostra generazione a volte mi ispira una certa pietà. *E ciò che è più terribile della guerra* non è la perdita di vite umane o dei beni, ma *la perdita del senso morale, il crollo di tutti i valori, l'indifferenza, il cinismo che essa genera* ... Il ceto medio è forse quello più ampiamente rappresentato nella cronaca nera. *Sono le basi della società che vengono così minate* ed è tempo che le forze del bene, i singoli, le famiglie, lo Stato si sveglino e lottino per la salvezza comune.'[59] (italics mine)

Italian postwar society is then readable in concrete signs: 'cifre' and 'dati statistici.' Obviously the war is responsible – beyond the enormous loss of human lives – for the terrible loss of moral sense and moral values. Moreover, it generates 'indifferenza' and 'cinismo.' It is important to take a closer look at the syntax of the father's final statement: 'Sono le basi della società che vengono così minate.' The construction is passive. The 'basi della società' – for Germi represented by the 'ceto medio' – are the subject being acted upon. 'Vengono ... minate' is the action being performed on them, but the agent that acts is not grammatically expressed. One could say that there is an implied agent, namely the war, but, from a strictly grammatical point of view, that agent cannot be located. Indeed, there is no subject, and the professor ends his discourse with an appeal to no-better-identified 'forces of good,' to individuals, the family, and the state. The lack of an agent depersonalizes Stefano's father's statement by turning it into an 'objective,' 'documentary' evaluation of the state of things. Furthermore, as a sign of the continuity with the past I have mentioned, we can see that Germi too, like Nilde Iotti, through one of his characters invokes two structures that had been highly valued during the *Ventennio*: the family and the state.

The use of the passive voice underlines the problematic relationship, or rather lack of a relationship, between fathers and sons. Stefano's father clearly addresses the younger generation, of which his son is part ('la vostra generazione a volte mi ispira una certa pietà') and then turns to some generic evaluations expressed by using the passive voice ('il ceto medio è forse quello più ampiamente rappresentato dalla cronaca nera'). In so doing, Stefano's father refuses to adopt the empowering position of the subject, and therefore to relate to his son's generation from such an authoritative site, thus engaging it in a more direct, though hierarchical, way. In addition, Germi further analyses this relationship through the narrative syntax and conventions specific to the genre of film noir, which focus on a male hero. The noir often amounts

to a sort of filmic *Bildungsroman* for 'maladjusted' male heroes who are trying to reassert or redefine their masculinity.[60] As Frank Krutnick posits, film noir entails the redefinition of a masculine identity, often threatened by a too aggressive, mysterious female.[61] In *Gioventù perduta*, some of the terms and functions of the genre are renegotiated, so as to reflect the Italian reality. The male hero does not seem to be as threatened by the customary 'treacherous' female, in this case Stefano's lover, who turns him in to the police. For perhaps the main attack in *Gioventù perduta* is against the 'fathers,' the individuals who legitimated a status quo just ended in a war.

The protagonist of the noir in the classical Hollywood production of the mid-forties is often a returning soldier. Marcello Mariani complies with all the script conventions of the American noir: he has been a soldier in Africa and has lost six of his prime years to the war. Still, he is somebody for whom the war is not yet over. When Marcello wants to drop the case because he realizes that the killer might be Stefano and he does not want to hurt Luisa's feelings, the 'commissario' tells him: 'Io credo di conoscerti abbastanza. Tu non sei uno di quelli che si danno per vinti alle prime difficoltà, uno di quelli che mollano ... Per noi la guerra non è ancor finita.'[62] Indeed the truly 'maladjusted' hero is not Marcello, even though he is presented as such in the first sequences, but Stefano, turned into a criminal by the experience of the war. 'Io non sono più lo stesso,' he repeats several times throughout the film. His companions are also no longer the same. They represent a 'gioventù perduta': either they are cruel killers, like Stefano, or weak gregarious types, like his friends. Furthermore, their cultural upbringing – they attended that 'liceo' so dear to Gentile and to his school reform – is of no use to them. Stefano's schoolmate frequently comments on his actions through quotations of poems he's memorized or through improvised rhymes.[63] Through the character of Stefano, Germi clearly and openly attacks a Crocean idea of literary culture: 'poetry' by no means equipped these young men for life, nor did it provide them with some sort of ethical understanding of it.

The generational clash addressed in the film is a major one. The 'gioventù perduta,' trapped in the spinning spiral of violence metaphorized by the whirling water of the opening credit-sequence, is self-referential. Young men validate their *Weltanschauung* only through their own friends and are completely disconnected from the generation of their fathers. Thus, I suggest, an interesting social change is happening in Italian families that Germi's film records and analyses. The most impor-

tant ties the young people have are not – in a vertical patriarchal sense – with their parents, but – in a horizontal sense – with each other. They project a model of self-representation rooted in themselves and not validated by patriarchal ideology.

Within this sociological shift, Germi gives a particular role to Luisa, who represents along with Maria the other side of postwar youth. Luisa is in fact the only one who suspects that something is wrong with her brother and who therefore is able to read a series of quite eloquent signs. She is given the status of 'conscience of the times' while also representing a new kind of femininity. The director formally endows her with the sceptre of this new femininity in a very specific scene. Stefano has just superimposed his lover's picture over the picture of his mother. Luisa stands by the side of the two pictures in a close-up. The camera focuses only on the three women and Luisa seems to literally 'insert herself' between the two Fascist – although inherited from nineteenth-century culture – roles of femininity to which the photographs allude: 'mamma' and 'puttana,' the self-sacrificing mother and the singer/prostitute. By inserting herself between the two, Luisa indicates both an alternative to their sharp opposition to one another and a possible, and yet not unproblematic, synthesis between the two.

It is not a coincidence that the one who has to bring the news of Stefano's violent death to their parents is Luisa. When she is brought back by Marcello, Luisa is filmed on the threshold of her comfortable bourgeois house, itself a major signifier of that 'ceto medio' that helped Fascism to establish and proliferate and whose youth has been so badly affected by its aftermath. Luisa waves at Marcello – a positive, even though understated Italian model of masculinity – and tells him 'Arrivederci.' In this fairly classical Hollywood ending, Germi, with a touch of optimism, projects a wounded and painfully self-conscious couple into the future.

A Hero Astray: Vasco Pratolini's *Un eroe del nostro tempo*

While through Stefano and his friends Germi portrays the moral annihilation of a generation raised under Fascism, Vasco Pratolini examines the criminal degeneration that Fascist ideology directly triggered in adolescents who ardently believed in it. His novel *Un eroe del nostro tempo* addresses Fascism surviving the end of Fascism. Pratolini (1913–), himself a lower-class self-taught man, provides a paradigmatic example of an individual raised and educated under the regime who at a certain point

turned against it. The turning point came for him in 1937, when he co-founded, with Alfonso Gatto, the Florentine review *Campo di Marte*. Along with other literary magazines of the period – mainly based in the Florentine Fascist-Catholic milieu – *Campo di Marte* voiced the need for a deeper engagement of literature with society and real life.[64] The journal provides another example of that urge to connect more directly with reality – a claim that, as we have seen, was later advocated as a specific trait of Neorealism. Along with Vittorini, Malaparte, and Bilenchi, Pratolini defended a populist literature, whose privileged form of expression was the novel (as opposed to the more elitist hermeticist poetry). Pratolini belonged to that strain of Fascism – the so called 'leftist Fascism' – linked to the origins of the movement, which was essentially revolutionary and anti-bourgeois and part of whose adherents later participated in the *Resistenza*. In *Un eroe del nostro tempo*, a novel written in 1947 and published in 1949, he tells the story of Sandrino, a sixteen-year-old boy.

Virginia, a thirty-three-year-old woman, is the widow of a Fascist engineer murdered by Partisans after 1943. She shares an apartment with Sandrino, his mother, and a young Partisan couple, Bruna and Faliero. Since Virginia is the wife of a Fascist, a *repubblichina* – as people call her – she lives completely shut off in her room.[65] She is paranoically afraid of any contact with people and is convinced that everybody in the apartment, and also outside of it, is hostile towards her because of her husband's political choices. She comes out of her room when everybody has left the house and refuses to socialize with the other guests. One morning Sandrino, who works as a counter boy at a shop, remains at home just to get to know Virginia. The two become friends and rapidly Sandrino, who is a Fascist at heart and an ex-*marò*, turns into Virginia's unique mediator to the outside world. She spoils him completely and the two become secret lovers. Sandrino is violent and aggressive and beats Virginia, who now fully depends on his capricious behaviour and gives him all sorts of expensive gifts. One day Sandrino steals all of Virginia's money and goes to Milan to organize a Fascist revolutionary action. However, his companions deceive him, robbing him and leaving him without a penny. In the meantime, Bruna and Faliero discover Virginia's relationship with Sandrino. Although they are Partisans, they nevertheless had tried to help Sandrino by keeping him from being sent to a *riformatorio*. Virginia, now paranoid about Bruna and Faliero's prospective intervention and afraid that they might hurt the boy, flees the apartment and relocates. When Sandrino returns from Milan, he is very

angry at not finding Virginia, whom he is planning to exploit further. Instead, he meets Elena, a girl his age but of a higher social class and contrasting political ideas, whose father, a writer, has been killed by the Germans. The two fall rapidly in love, and love starts to change Sandrino's life. Virginia comes back and tells him that she is pregnant with his child. The boy sees all his hopes for personal change and a different future evaporating. He feels like the prisoner of a past he can no longer escape. In a sort of existentialist violent stroke, he kills Virginia by literally sticking her head into a spiked fence.

Unlike Stefano, Sandrino is constructed as what could be viewed – from both an anti-Fascist and a leftist point of view – as a 'genuinely' Fascist character. Not only that: he is intentionally portrayed as such, given Pratolini's ideological investment in his representation. The author was a member of the Communist party and fully adhered to the party's ideology. In a novel that is politically loaded Sandrino is thus forged as the cruel offspring of a perverted pedagogy and, through him, Pratolini openly attacks and condemns Fascism itself. The writer uses Bruna and Faliero to voice his point of view. It is usually through them – two figures who embody the Partisan's political commitment – that Pratolini comments on Sandrino's 'monstrosity.' Talking to Bruna and referring to the boy, for example, Faliero says, '*La società l'ha reso qual è. Lui era soltanto un ragazzo irrequieto, pieno di istinti, pieno di vita.*' And Bruna, talking to Virginia: 'Per noi Sandrino *era un esempio della rovina a cui il fascismo aveva condotto la gioventù,* un ragazzo da salvare.'[66] Both Bruna and Faliero tend to depict Sandrino as the innocent victim of a negative ideology.

Pratolini constructs his novel with a pedagogical agenda so overwhelming that it creates a major structural gap between the novel's first and second parts. This gap separates two periods that metaphorically correspond to 'before' and 'after' the war and that are exemplified by Sandrino's very different relationships with Virginia and Elena.[67] Towards the end of the book, Elena becomes the spokesperson for Pratolini's didactic agenda, when she literally speaks of the *vecchio*, or old, and the *nuovo*, or new, Sandrino, and alludes explicitly to his Fascist and post-Fascist phases. Pratolini's didactic intent reverberates in the character so as to undermine Sandrino's psychological cohesiveness. The old and the new Sandrino seem to be two different, unrelated characters, and, once again, the author is faced with the problem of bridging – through Sandrino – the hiatus between past and present.

How does Sandrino represent a full realization of Mussolinian ideology and educational practice? He is extremely violent and prey to a sort

of turgid irrationalism in his total dedication to the Fascist cause. Gratuitous ferociousness amounts to a true vocation for him: it represents the means by which he expresses his dominion over the world and particularly that part of the world he considers fully open to his exploitation: Virginia. She has totally surrendered to Sandrino, who exploits her psyche, her body, her belongings, and, ultimately, her physical life. Sandrino's 'colonialist' exploitation, that is, his aggressive conquest of her body, is exemplified by the violence he inflicts upon her. The protagonist's attitude towards Virginia recalls the Futurist legacy, so vital to the first affirmation of Fascism, in which colonialism and sexual violence together defined the hero's masculinity.[68]

However, Sandrino's violence could not happen without the complicity of Virginia, whose personality, Pratolini suggests, is the result of a patronizing attitude towards women.[69] Even though she is thirty-three, she is not an adult, since in her own upbringing Virginia had never been asked, or even been given the opportunity, to develop an independent personality: 'L'educazione ricevuta aveva compresso il suo istinto fino quasi ad annullarlo ... Ella era cresciuta modellandosi sul carattere della madre ... e soggiacendo al dominio, alla scontrosa affettuosità paterna fino ai ventidue anni. Per i dieci anni successivi, la volontà del marito era stata la sua stessa volontà.'[70]

Unable to interact with a world that she perceives as hostile, given her past as wife of a wealthy Fascist, Virginia masochistically surrenders to Sandrino. In the narrative economy of 'before' and 'after' that Pratolini so clearly constructs, Virginia represents a traditional, old image of femininity. On various occasions the correspondence between Virginia and Sandrino's past is clearly spelled out. The most compelling instance is revealed towards the end of the book. Sandrino has just left Elena and runs into Virginia: '*Il passato lo aggredì d'improvviso*, sull'angolo della strada in cui Sandrino abitava. Un'ombra di donna avanzò di un passo dalla parte opposta del marciapiede.'[71] The past and Virginia are thus identified, with no possible equivocation. To this woman, who is metonymically linked to the regime, Pratolini opposes Bruna, who symbolizes instead the immediate present and the *Resistenza*. While Virginia is the sad result of passive compliance with the norm Fascism set up for females, Bruna is politically engaged on the left. She is a proletarian, the daughter of a blue-collar worker who was imprisoned by the Fascists and who died in exile. Bruna joins the Partisans at age sixteen and marries a true 'compagno': Faliero. Unlike Virginia, Bruna is a 'modern' woman, a proto-feminist who has a clear perception of her social place and distinguishes between Virginia, 'persuasa che il suo compito nella vita si

esaurisse tra il letto ed i fornelli' ('convinced that her life was spent between her bed and the stove'), and herself. Paradoxically, Bruna also pictures a 'letto' (bed) and 'fornelli' (stove) for herself, but defers defining womanhood in such terms and subordinates such a definition to the goal of ending Fascism.[72] Unlike Virginia, and as a sign of her greater social awareness, Bruna is in touch with the world that surrounds her: 'Non mi succede mai nulla di cui non abbia coscienza' ('Nothing ever happens to me of which I am not aware'), she tells Virginia in a clarifying colloquium in which she tries to warn Virginia of Sandrino's evil nature.

Bruna is, with reference to the latter, haunted by remorse. One afternoon, when she meets him in order to exchange information valuable to the Partisans, she almost succumbs to his and her own erotic drive in a power struggle that starts out on political grounds and evolves into a sexual confrontation. Although she mentions the episode to her husband, Bruna never clearly refers to the erotic aspect of their encounter. Bruna and Faliero's relationship is based not just on love but also on their shared political beliefs; so much so that their political beliefs almost have primacy over their feelings. Bruna depicts her relationship with Faliero as somewhat dogmatic in her confession to Virginia. She considers honesty the measure of one's integrity in a way that fuses political and emotional issues and converts problems pertaining to sexuality and desire into problems of political orthodoxy:

> Faliero mi ama, non ci sono schermi tra lui e me, mi ritiene *la sua migliore compagna*. Oltre alla nostra vita intima, *ci legano le nostre idee*. E' una cosa che forse lei non può capire fino in fondo. Una fissazione, magari, ma che ci serve per essere quelli che siamo. *Consideriamo la reticenza il peggiore dei tradimenti. E chi mentisce*, anche per delle sciocchezze, *è un appestato*. Faliero *non è soltanto un uomo delle mie stesse idee, è anche mio marito*.[73] (italics mine)

It is clear here that the *tradimento*, the betrayal Bruna is referring to, is both emotional and ideological. When she says 'non è *soltanto* un uomo delle mie stesse idee è *anche* mio marito,' the fact that he is her husband is secondary to the fact that they share a political agenda. Through Bruna's long, extremely lucid, and rational explanation, first with Virginia and then with Faliero, Pratolini attempts to clarify the increasingly complex relationship between love and political engagement, and between the private and the public spheres. This is not coincidental, since such relationships were quite problematic in the years after the

war. The end of clandestine action forced militants to renegotiate the relationship between their ideological commitments and their feelings. This widespread uneasiness was particularly apparent in militants of the Communist party, who were urged to subordinate personal life to political action under the party's façade of serious and demanding militant engagement.

In *L'Editore Vittorini*, Giancarlo Ferretti provides a significant example of this dichotomy. Referring to the *Politecnico*, Ferretti underlines, retrospectively, the difficulties the journal faced in dealing with 'quanto di individuale, privato, segreto, rimane irrisolto nell'esperienza collettiva della militanza politica e dell'educazione culturale,'[74] and indicates how, nevertheless, individual, secret needs surface in the journal, albeit in marginal spaces, such as, for instance, that provided by the letters sent by the readers. Ferretti quotes extensively from a letter by a young woman from Parma who deals specifically with her inability to fully and radically embrace the Communist belief.[75]

After revealing some inflexibility in Bruna's 'treatise' about love, first with Virginia and then with Faliero, Pratolini switches focus. Now, through Faliero, the author clearly favours love over politics: not only that, but love seems to him the only revolutionary force capable of producing meaningful changes in people's lives. 'Penso che non si possa volere interamente il bene dell'umanità ... se non si ama anche fisicamente qualcuno. Vedi, io avrei spavento ... *se dovessi persuadermi che esistono dei compagni che non alimentano la loro fede con l'amore, ma che sono arrivati alla fede soltanto per via dei libri che hanno letto,* o delle angherie che hanno subito o del sudore che hanno versato' (italics mine).[76]

This passage is particularly meaningful, since Faliero not only paraphrases but also actually plagiarizes Gramsci. The above quote corresponds almost verbatim to an excerpt of a Gramscian letter from prison.[77] In the letter dated 9 June 1924, Gramsci writes:

> How many times have I asked myself whether it was possible to tie oneself to a mass without ever having loved anyone ... whether one could love a collectivity if one hadn't deeply loved some single human being ... Wouldn't that have made barren my qualities as a revolutionary, wouldn't it have reduced them to a pure intellectual fact, a pure mathematical calculation?'

Besides revealing Gramsci's extreme popularity, this quote also underlines the position of Pratolini and other leftist intellectuals, and princi-

pally of Vittorini, who, when faced with the PCI's insistence on the pre-eminence of the public sphere over private life, abandoned the party. Cesare Pavese was facing a similar ideological conflict when he committed suicide in 1950. On the other hand, like the young woman from Parma, Vittorini's choice to become a Communist had also been emotional rather than ideological.[78]

To come back to Faliero, we can see that he not only dismisses a merely intellectual approach to politics itself, but sees political engagement as inherently ethical: as an extension of that *bene*, the love, one feels for his or her companion. The same attitude reappears in the relationship between Sandrino and Elena. The primacy of love over politics becomes striking and frames the way in which both Sandrino and Elena come to the foreground as the new generation, that is, free from political orthodoxy or dogmatism. Like Marcello and Luisa in *Gioventù perduta*, Sandrino and Elena begin to define themselves, their present, and their potential future through each other. Still, this redefinition happens in the context of their individual relationship to their private and also historical past, represented by their fathers.

Sandrino and Elena have different kinds of fathers as well as family backgrounds. While Sandrino's father was a dedicated Fascist who fought and died in Ethiopia, Elena's father was an anti-Fascist writer who died in a concentration camp. He was not militant but, in Elena's words, 'semplicemente un uomo che amava la libertà' ('simply a man who loved freedom'). While Elena is a rich girl who attends the *liceo*, Sandrino only has a junior-high-school degree and works as a counter boy. Class difference is not an element of their relationship that Pratolini scrutinizes. Elena and Sandrino attempt to construct their identities through what is now an absent, deceased father whose probity they do not question. Each is proud of his or her father and each considers him a model for his or her actual behaviour: their fathers did, after all, propel them into society as politically aware members.

Interestingly enough, both fathers had left a legacy, a letter to their child, and they both wanted to mould their child in their own image.[79] Sandrino's father letter reads as follows: 'Onora sempre tua madre. Ma onora soprattutto, con ogni atto e pensiero della tua giornata, e col tuo sangue se sarà necessario, la più grande Madre che è la Patria. Odia i suoi nemici, tutti coloro che vorrebbero fare di essa una democrazia imbelle e rinunciataria, sottraendola così al destino imperiale che le appartiene e combattili.'[80]

The content of Elena's father's letter is not disclosed to us: we only

know that it is in two parts, one addressed to the mother and the other to Elena. When they meet, Elena and Sandrino are potential enemies, since they represent opposing worlds. It is only by forgetting the past that they can live in the present or reach into the future through an unorthodox relationship.

The overthrow of the patriarchal model enforced by Fascism automatically generates a different pattern of relationships between the sexes. This sociological shift is evident in the case of Bruna and Faliero and even more so in that of Sandrino and Elena. The possibility of an egalitarian interaction with a girl first intrigues and then fascinates Sandrino. Elena is the one who first makes a pass at him, who writes her phone number on a piece of paper, and who dictates the rhythm of the encounters and when and where they should take place. Unlike Virginia, Elena does not define herself through her partner, and even though she is in love, she is not fully overwhelmed by her feelings or erotic drive, as Virginia is. Elena, in another important shift, is the catalyst for change for Sandrino but, to really trust a Fascist and an ex-*marò*, she also has to renounce a wholehearted embrace of his father's beliefs. In the love story of Elena and Sandrino, then, Pratolini projects, as Germi does with Marcello and Luisa, a model of a new generation that legitimates itself solely from within. As Sandrino tells Elena: 'Nessuno mi aveva mai parlato come tu mi parli, *da pari a pari* ... E capisco soprattutto un fatto: *che sia tu che io non facciamo che ripetere cose che ci sono state insegnate.* Perchè non *parliamo di noi soltanto?*' (italics mine).[81] Sandrino feels the need to create an emotional dimension in his life, since his political dedication was also a search for an external source of powerful emotions. But this possibility cannot be realized if Sandrino does not formally renounce his father's heritage. This is what Elena asks him to do: 'Ti chiedo ... di rinunciare a tuo padre; ... ti ha indicato una strada di cui ti stai accorgendo ch'era sbagliata.'[82] However, to renounce the past is not easy, not to say impossible. The mere reappearance of Virginia, a signifier of the past, triggers the re-emergence of the old Sandrino and in-escapably entraps him in his older self: 'Aveva l'impressione di essere legato a Virginia come se una corda li tenesse stretti ed uniti, con le membra immobilizzate nei suoi giri.'[83] In addition, Virginia brings with her the denial of a possible future. As the narrator comments: 'Essa, con la sua presenza, *aveva bloccato il tempo* e doveva quindi volgerlo alla sua soluzione.'[84] Virginia, with her reappearance, 'freezes him' in his violent/Fascist character, and forbids him to outgrow such a past. Sandrino's ability to construct a new self is equated

with the appropriation of the future before him. He can do that by choosing Elena, but his choice implies the sacrifice of Virginia.

Ultimately, Elena – whose position seems to anticipate Homi Bhabha's thought – is right when she assumes that one cannot escape one's history or oneself: 'mica si scappa da noi stessi ... Papà diceva che ci si porta sempre dietro, come portiamo il viso. E tu vorresti già essere un altro, con tutto quello che hai ancora di scoperto dietro di te.'[85] By putting these words in Elena's mouth, Pratolini unveils his own pessimist outlook both on the past and on the future. In effect, he denies that a positive future can evolve from a Fascist past, thus also denying hope for a better, more ethical life for those teenagers who were educated according to its ideology.

The Suicide of the Future: Rossellini's *Germania anno zero*

Is there an alternative to Stefano and Sandrino, two representatives of a 'lost generation' who are equally criminal in their behaviour? In *Germania anno zero* (1948), Roberto Rossellini creates a character that is the innocent victim of unpredictable circumstances: Edmund Koeler. Like Germi, Rossellini (1906–77) learned his craft early, in his case directly on the set, thanks to important friendships, among others with Vittorio Mussolini. He began his career as assistant director to Goffredo Alessandrini, and collaborated on films dedicated to the army, with a clear patriotic slant. He achieved national recognition with two of these: *Luciano Serra pilota* and *La Nave bianca*.[86] Notwithstanding his friendship with Vittorio Mussolini and his closeness to important figures in the film business, Rossellini was neither a self-proclaimed Fascist nor an intellectual prone to political commitment. After the Neorealist period, his interest in politics declined, and he turned to a psychological, intimate characterization of his protagonists. Already with *Germania anno zero*, Rossellini goes beyond a political assessment of postwar Germany and situates himself in a sort of detached position, promoting an ethical rather than historical evaluation of events. While Stefano and Sandrino are murderers whose violence is provoked by either the *assenza*, lack of values that pervades a society polluted by Fascism, or by a full embrace of its ideology, Rossellini's character Edmund Koeler ends up a criminal, too, but for reasons completely independent of his will: he is, indeed, the product of a perverse pedagogy.

Edmund Koeler is a twelve year old who lives in postwar Berlin (the action takes place soon after the war) with his father, his sister Eva, and

his brother Karl Heinz in an apartment shared with five other families. The resentful and arrogant Mister Rademeker, the original owner of the place, supervises all. Edmund is the only breadwinner. His father is ill and bedridden, and his brother, Karl Heinz, a former Wermacht soldier, is afraid that if he presents himself to the authorities to get new papers he will be sent to a concentration camp. Eva goes out at night with American soldiers to get a few cigarettes, which she later exchanges for food. The atmosphere in the apartment, and also outside of it, is that of a brutal jungle where people, deprived of any humanity, struggle to survive by taking advantage of each other. Mister Rademeker repeatedly wishes aloud that Edmund's father would die soon because he is an economic drain on the small community. Edmund tries to do his best: he attempts to work as a gravedigger, but angry adults expel him from the place. When they realize how old he is, they feel he is 'stealing' an adult's job. Edmund tries to exchange some items for food and collects whatever he finds in the street: a lump of charcoal, a piece of meat cut from a dead horse, and the like. One day he happens to run into his former teacher, Mister Ennings, and asks if Ennings could help him earn some money. The boy is very worried about his father, but the teacher delivers a cruel speech with Darwinian overtones in which he says that the weak are bound to die and the strong to survive. Nevertheless, he sends Edmund on his behalf to sell a record of a speech by the Führer. On his way to sell the record, Edmund meets two adolescents, Jo and Christel. The two are already criminals, people who live by expedience and by robbing other people; they are also sexually promiscuous.[87] Edmund joins them and learns how to steal and deceive. Meanwhile, Edmund's father spends four days in the hospital, and everybody talks – very explicitly – about the relief that his absence brings to their hungry stomachs. The father tries to cope with his illness, but whimpers continually and asks himself, in front of his children, whether it would not be better for him to die. Overwhelmed by the entire situation and also inspired by his teacher's words, Edmund steals a vial of poison at the hospital and pours it into the tea he offers his father. While Karl Heinz has finally decided to go to the police to present himself and thus acquire the papers that would allow him to work, his father dies. Full of remorse, Edmund goes to his teacher, who is completely shocked by the murder Edmund confesses to him and calls Edmund 'crazy' and a 'monster,' all the while denying that he ever gave him ideas about killing his father. Now tragically alone, Edmund walks through a city that, in its ghostly and tragic appearance, emphasizes his existential anguish. He

reaches the skeleton of a building, climbs a few floors up inside it, and jumps out of the window to his death.

Rossellini does not gratuitously choose Germany as the setting of his film in the aftermath of the war. Germany had in fact been Italy's ally; like Italy, Germany had witnessed the rise and fall of a totalitarian political system, and, like Italy, Germany had made a major effort to educate its youth according to values that emphasized social corporativism, racial pride, and national chauvinism. Both countries looked to their leaders, respectively the *Duce* and the *Führer*, as fathers of the nation; they both used similar architectural and verbal devices to construct a mass 'culture of consensus.'[88] Even though Italy formally changed alliances in 1943, siding with the Americans and therefore becoming Germany's enemy, the identification between Italy and Germany still holds true, primarily because Rossellini focuses upon the emotional and moral desert of a generation that came of age under a totalitarian system. When Rossellini talks about Germany, he is in fact talking about Italy as well. The director himself stated: 'Ho fatto di un ragazzo il protagonista di *Germania anno zero*, per accentuare *il contrasto fra la mentalità di una generazione nata e cresciuta in un certo clima politico e quella della generazione più vecchia* rappresentata dal padre di Edmund' (italics mine).[89] Rossellini's statement thus allows us to interpret the film from the dramatic standpoint of a generational clash.

Germania anno zero revolves around a few dichotomies that are structurally embedded in the film. I stated in the introduction that the conceptual framework of dichotomy is one of the means through which artists try to cope with the embarrassing legacy of Fascism – a means through which they, unsuccessfully, endeavour to overcome the fracture between 'before' and 'after.' Dichotomy is then a logical strategy that mirrors the incapacity to assess in an objective way one's own or one's country's past. In the case of *Germania anno zero* dichotomy is active both at a discursive and at a metadiscursive level. At a discursive level, that of the story, it affects the characters' behaviour and the discrepancy between what they say and how they behave. At a metadiscursive or meta-cinematic level, there are several incongruities tied to both Rossellini's use of Neorealism and his self-collocation within it. The definition of Neorealism – which I here consider as a postwar phenomenon, therefore from a synchronic point of view – opens up a thorny question, widely addressed, and yet still not completely resolved, by critics.[90] Some scholars challenge the very notion of Neorealism as a movement per se, and talk instead of a simple Neorealist 'ambiance' and 'style.' Others

proclaim the movement, which also included literature, to be the ideo-
logical engine that drove Italy's reconstruction.[91] The discussion has, in
the last fifteen years, moved to the fact that criteria considered as
belonging – exclusively and *ex novo* – to Neorealism indeed pertain to
the cinematographic production of the thirties; this in accordance with
that continuity we have seen at work between pre- and postwar cultural
trends. Whatever position a single critic might take, there is a fairly
accepted set of criteria according to which a film could be classified as
'Neorealist,' in the historically specific postwar meaning of the term.
These traits have been well summarized by Millicent Marcus and consist
of: 'location shooting, lengthy takes, unobtrusive editing, natural light-
ing, a predominance of medium and long shots, respect for the continu-
ity of time and space, use of contemporary, true-to-life subjects, an
uncontrived, open-ended plot, working-class protagonists, a nonprofes-
sional cast, dialogue in the vernacular, active viewer involvement, and
implied social criticism.'[92]

While indicating the traits specific to Neorealism, Marcus also clarifies
that each author follows these criteria in a personal way, realizing only
some or a few of the above stylistic choices.[93] We need to add that Neo-
realism was never just a matter of aesthetics alone: it also implied a deep
ethical component that leaves its imprint as an openly stated pedagogi-
cal intent, usually reinforced by the use of a narrator or a voice-over who
explains and comments on what the viewer is seeing. Neorealist films
also have chronological limits, since they are circumscribed by the
period 1945 to 1949 and deal with the concrete socio-economic prob-
lems emerging after the Second World War.[94]

Rossellini's film has then, at first sight, all the credentials to be consid-
ered 'Neorealist,' in the historically specific sense I have just indicated,
since it is shot in destroyed Berlin, in a city reduced to wreckage by the
war, and since its narrative concerns the everyday life of war survivors.
And yet there are many features and stylistic subtexts that undermine
its surface Neorealism, thus disorienting the viewers. The setting is
undoubtedly Neorealist, for what could serve Rossellini's realist drive
better than an entire city reduced to a series of endless ruins? Nothing
could be more effective than postwar Berlin as a setting for the repre-
sentation of ethical annihilation. Still, the way Rossellini singles out
Edmund from his environment is very unusual in terms of Neorealist
style. The camera focuses persistently upon the boy's face in long and
repeated close-ups. Furthermore, when Edmund wanders through the
city, the camera constantly pans parallel to him from a variety of angles.

This use of the camera, with its numerous long takes on the same isolated character, creates a persistent interest in Edmund, thus disconnecting him from the scenario in which the city should entangle him, and in which, according to 'orthodox Neorealist criteria,' he should play a minor role. Thus, instead of being just 'one among many' – according to that 'chorality'[95] which is a distinctive feature of postwar Neorealism – Edmund stands out as a tragic character per se, thereby forcing the viewer to focus more on his psychological and personal tragedy than on the socio-economic issues of his environment.[96]

A second contradictory element in *Germania anno zero*'s Neorealism is provided by its geographical displacement from Italy to Germany. In the revisionist process that Neorealism underwent in the eighties, a formerly undervalued factor became increasingly important in critics' eyes: its *italianità* (Italian-ness). According to Alberto Farassino, Neorealist movies explore 'il paese [nel]la nuova cartografia nata dal dopoguerra e dalla Liberazione.'[97] As Farassino states, 'Non c'è solo il gran viaggio in Italia di *Paisà*, c'è tutto uno spostamento di sguardi e di iniziative che porta i cineasti italiani a percorrere per il lungo la penisola.'[98] Thus, from this geographical point of view, a genuine Neorealist attitude should entail journeying through a country and discovering its regional varieties and dialects. Rossellini, by situating his film in Germany, once again makes a non-canonical choice in the Neorealist context.[99]

Third, there is also a conflict, again at a metadiscursive level, with the viewing expectations that the voice-over establishes at the beginning of the film, for there is a significant discrepancy between what the voice-over states as the narrator's intention and what the film presents through the authoritative directorial gaze. The voice-over, referring to the film itself, says: 'Girato a Berlino nell'estate del '47 non vuole essere che un quadro *obiettivo* e fedele di questa immensa città semidistrutta ... non si tratta di un atto d'accusa contro il popolo tedesco e neppure di una difesa [è] *una serena costatazione di fatti*.'[100] However, for the viewer, it is virtually impossible to believe that the film is *obiettivo* (objective) – an adjective whose semantic sphere overlaps, in Italian, with that of *neutrale* (neutral) – and *seren[o]* (serene), that is, emotionally undisturbed. Indeed, Rossellini's pedagogical, ethically invested agenda is clearly spelled out by the narrator, who states: 'Ma se qualcuno, dopo aver assistito alla storia di Edmund Koeler penserà che bisogna fare qualcosa, che bisogna insegnare ai bambini tedeschi a riamare la vita, allora la fatica di chi ha realizzato questo film avrà avuto la sua ricompensa.'[101] Here again there is a call for an active social engagement in

the reconstruction – not only material – of the country: of Germany as well as of Italy.

Rossellini's claim to objectivity follows the Neorealist poetics prevalent in the *Resistenza* docufiction,[102] and is fully attuned to the plan of other Neorealist filmmakers. For Neorealist directors 'verità' (truth) – a sort of ontology of the real – should manifest itself, emerging directly from things. This need, not peculiar to postwar production, and aligned with the 1930s' generalized call for realism, had already been indicated by Alicata and De Santis in two well-known and often quoted articles published in *Cinema* in 1941: 'Verità e poesia: Verga e il cinema italiano,' and 'Ancora di Verga e del cinema italiano.' These articles proposed Giovanni Verga as the example for a narration steeped in reality – a narration able to react against those 'outdated' bourgeois narrative models represented by French Naturalists such as Maupassant or Flaubert. In particular in the second article, after having praised Verga's language as 'vergine, essenziale, violento' ('virgin, essential, violent'), Alicata and De Santis state that 'anche noi ... vogliamo portare la nostra macchina da presa nelle strade, nei campi, nei prati, nelle fabbriche del nostro paese' (28),[103] thus announcing a direction that was soon going to be followed by Visconti (*Ossessione*) and other filmmakers.

From the standpoint of objectivity, then, Rossellini aligns himself with the documentary trend that was quite established and common to directors such as De Sica, Visconti, and De Santis, and to his own previous movies, particularly *Roma città aperta* (1945) and *Paisà* (1946). On the other hand, by being unwilling to pass judgment and, paradoxically, by portraying himself as no more than a 'neutral' and 'faithful' witness, Rossellini declines any responsibility for assessing the historical situation of postwar Germany (and postwar Italy). And yet, by the end of the film, we realize that the author has not been just and simply making a 'documentary.' On the contrary, he did have an urgent moral agenda, consisting in his desire to do something for German children and contribute to the rebirth of Germany's youth. His film thus amounts to a dramatic act of denouncement: against the crimes of the war, the corrupt educators, and the generation of the fathers.

At a discursive level, at the level of the narrative or content, the dichotomy embedded in the film corresponds to a type of generalized schizophrenia that afflicts all the characters. All of them operate on two levels: one of wishful thinking, which can be seen as ideological, and the other empirical or utilitarian. On several occasions Eva, Karl Heinz, and their father state that Edmund is too young to provide for all of them.

The father tells Karl Heinz: 'Ti rendi conto che non è possibile che il povero Edmund, alla sua età debba provvedere a tutti noi? E' ancora un bambino lui.' Eva says to Karl Heinz: 'Non è possibile che quel bambino da solo ...' Karl Heinz asks Eva: 'Sono stato forse io a mandare Edmund a lavorare?'[104] Theoretically, everybody knows that they are asking too much of Edmund, yet they still continue to exploit him, however unwillingly. By not actually seeing Edmund's actions out on the street, they keep their conscience clean and do not question about the origin of the food they swallow. Eva, for instance, soon after she has told Karl Heinz that Edmund cannot provide for everybody, asks the boy: 'Dì, sei riuscito ad averla la tessera numero due?' ('Tell me, did you succeed in getting the number two card?') When Edmund comes back after having spent the night out, Eva takes the boy to their father, who scolds him and slaps him on the face. Soon after, Eva tells the father to take into consideration how many potatoes the boy has brought back.

This dissociation is so deep that it resembles a mental pathology because, in the same person, ideology and praxis run against each other as two opposite and irreconcilable drives. Such dissociation is reiterated by the use of the passive voice. Like Stefano's father in *Gioventù perduta*, Edmund's father, reverting to passive voice, also portrays himself as an individual 'acted upon' by events: 'Tutto mi è stato tolto, il mio denaro dall'inflazione. I miei figli da Hitler.'[105] Even though he acknowledges some personal responsibility by switching, soon after, to an active statement in the first-person singular, 'avrei dovuto ribellarmi' ('I should have rebelled'), he soon weakens that statement by reverting to the first-person plural pronoun *noi* – we: 'abbiamo visto venire la sciagura e non l'abbiamo arrestata e oggi ne subiamo le conseguenze.'[106] Thus the passive form, and even more the oscillation between active and passive forms, displaces onto itself that dichotomy between past and present with which the characters are not able to cope, yet should somehow overcome if they are to create a consistent, integrated self.

One of the champions of moral inadequacy in the film is Mister Ennings, the teacher. As usual, Rossellini combines moral despicability and sexual corruption in one individual so that the two elements negatively reinforce each other. Also, by attacking Mister Ennings, Rossellini metonymically attacks the entire 'Gentilian' educational system through the displacement of Italian events on German ground. Mr Ennings is in fact a pedophile whose sexual deviance seems – in Rossellini's suggestion – to parallel his ethical depravity.[107] Whenever Edmund goes to see him, Mr Ennings denies that he said what he actually has said. Referring

to the record he gives the boy – a record with a speech of the Führer that, not by chance, he, the teacher, entrusts to his former pupil – Mr Enning tells Edmund never to mention it to anybody. Then, when Edmund comes back after his father's death, he labels the boy a criminal. The dialogue between Mr Ennings and Edmund is worth quoting at length:

EDMUND: 'Signor Ennings posso parlarle?'
ENNINGS: 'Ma certo, vieni su.'
EDMUND: 'E' tutto fatto.'
ENNINGS: 'Tutto fatto?'
EDMUND: 'Ho ucciso mio padre.'
ENNINGS: 'Tu? E come hai potuto far questo?'
EDMUND: 'E non me l'aveva ordinato lei?'
ENNINGS: 'Io, non ti ho detto nulla, io. Sei un pazzo, un mostro ... ma sai che se si viene a sapere ... Io non ti ho detto mai nulla, bada, io non ti ho detto nulla.'[108]

Mr Ennings did not literally tell Edmund to kill his father. Still, it is what he meant when he told the boy that the weak are always eliminated by the strong, and that one should have the courage to sacrifice them. In this dialogue, Rossellini stigmatizes the total denial of any pedagogical responsibility on the teacher's side, while showing that what Edmund – the pupil – does is merely practising what he has been told to do. Edmund acts according to his teacher's implicit suggestion as he sees in his father a useless being who only weighs upon other people, that is, his own family, and turns into a competitor for food and hence survival. Germi, Pratolini, and Rossellini seem to assume that their characters – Stefano, Sandrino, and Edmund – become criminals because they put into action the teachings, or rather the lack of teachings, they were given by their educators. Stefano is the offspring of a cultural as well as political *assenza*, of a tragic lack of moral guidelines; Sandrino is brutally brainwashed by Fascist ideology; and Edmund is the innocent victim of his complete lack of direction.

In Rossellini's displacement from Italy to Germany there is an even more significant event: the patricide. That Mussolini and Hitler tried to portray themselves as fathers of their country is an indisputable sociohistorical fact. Furthermore, it is the very element upon which they based their strategy for winning uncritical mass support. Perhaps what is not so well known is the extent to which these rhetorical concepts invested

both education and everyday life. An enticing scholarly reconstruction of the myth constructed around the *Duce*, who was also a teacher ('maestro elementare'), has been provided by Luisa Passerini's *Mussolini immaginario*, while another interesting book has explored women's Oedipal fantasies of fatherhood regarding the *Duce*. This book, entitled *Caro Duce*, collects a sample of the letters that women wrote to Mussolini by the hundred of thousands, from 1922 to 1943.[109] Most of them refer to him as 'padre di tutti noi,' 'secondo padre,' 'padre di tutti gli orfani di guerra,' and the like. Mussolini's attention for schooling and for youth's free time, his institution of summer colonies, his praise and financial support – although minimum – for prolific mothers, his strategy of presenting himself as the only referent for the Italian people and, basically, the Fascist ideological attempt to make coincide public and private sphere, provide the elements for identifying the head of the nation with the head of the household. Thus, I propose, we could interpret Edmund's murder of his father as the metaphorical killing of that archetypal *padre della madrepatria* (father of the motherland) who is Mussolini and, figuratively, the historical past.[110]

However, eliminating the past through an act of violent denial represented by murder is ineffective, Rossellini implies. The killing of the father – enacted after Edmund has sought help from the agency that should have provided it, the school, and that has instead proved itself to be thoroughly corrupt – generates the suicide of the son, thus amounting to a denial of both present and future. If the only way to get rid of the past is by killing its survivors (Edmund's father), younger generations are also annihilated in the process. Soon after the war, though, in the examples considered here, there seems to be no possible – at least at a fictional level – compromise, no alternative. Sadly, there is no hope of a future for the younger generations surviving the end of Fascism.

FROM MOTHER TO DAUGHTER

J'aime d'abord et surtout la femme ... Et puis à travers la psychologie d'une femme tout devient plus poignant. On s'exprime mieux et plus vivement. Elle est un filtre qui nous permet de mieux voir et distinguer les choses.

I especially love women ... Through the psychology of women everything becomes more poignant. They express themselves better and more precisely. They are a filter that allows us to see more clearly and to distinguish things.

MICHELANGELO ANTONIONI

The Emergence of a Female Genealogy

Parallel to the symbolic killing of fathers and the condemnation of their Fascist teachings runs the re-evaluation of women – in particular the mother figure – that took place in the first decade after the Second World War, between the late forties and early fifties. A great number of novels and films of the postwar period present the image of a generous, instinctual, and passionate woman whose reproductive capacity amounts to much more than a mere biological feature, and symbolizes a possibility of rebirth and regeneration for the entire Italian society. Women had not been involved, in person, in the battlefield (apart from their experience as Partisans), and seemed to be more 'genuine,' politically 'un-tarred' subjects than men. They could therefore claim a purity – prerequisite for the country's reconstruction – men lacked. Although reproductive features constituted peculiar and expected attributes of the Fascist 'new woman,' they now change sign, for they are not read within a patriarchal framework according to which women should pro-

duce soldiers or citizens for the state. Women's capacity for reproduction is not so heavily 'ideologized,' and simply indicates their ability to overcome death and destruction: women guarantee the continuity of the species, but – this is the novel implication – not for the state's sake. In particular, in their novels of the late forties and early fifties, female writers such as Anna Banti (*Artemisia*, 1947), Alba de Céspedes (*Dalla parte di lei*, 1948), Elsa Morante (*Menzogna e sortilegio*, 1948), Natalia Ginzburg (*E' stato così*, 1949), Gianna Manzini (*Forte come un leone*, 1945; *Ho visto il tuo cuore*, 1950), Lalla Romano (*Maria*, 1953), and Anna Maria Ortese (*Il mare non bagna Napoli*, 1953) bring to the foreground female characters whose psychology and emotional life are explored in depth. This kind of scrutiny was already foreshadowed in women's novels of the thirties, as the innovative research by Robin Pickering-Iazzi has demonstrated, and as we can evince from Alba de Céspedes's paradigmatic text *Nessuno torna indietro* (1938)[1]. Postwar women novelists push themselves further into this territory. So, while some male writers such as Mario Soldati, Bruno Cicognani, or even Cesare Pavese retain a tendency to link women with the obsolete topos of instinctual 'naturality,'[2] women novelists elaborate a much more disruptive conceptual configuration: that of a female genealogy.[3] In their books, these novelists weave the threads of a female lineage that pushes itself, not always consciously, through the tight network of patriarchal language and modes of representation.

Rather than the politically connoted time steeped in the collective, and therefore objective, experience of the war, the time now at stake is a genealogical time rooted in the sphere of one's subjective experience – an experience that reverberates on social structures and attempts to change them. Within this framework, female authors strive to carve out a new meaning for the bond between mothers and daughters and then try to inscribe it within social practices at large. Their efforts are not always fully cognizant, and yet they produce an important side effect: an embryonic disruption of the existing 'symbolic order.'[4]

Through their female protagonists, texts written by women in this period challenge a traditional notion of femininity that centres on the concept of motherhood. However, the concept of motherhood that emerges in these narratives is not to be confused – I must emphasize – with the rhetoric of motherhood that Fascist ideology so pervasively tried to diffuse.[5] The shift occurs from a patriarchal concept of selfless and self-annihilating motherhood, which in the process of being put into action, entails the obliteration of the woman, to the notion of an empowering self-reproduction or, better yet, the reproduction of the self in the mother–daughter relationship. In this chapter I will consider

first how such a female genealogy is enforced in Anna Banti's *Artemisia* (1947) and Alba de Céspedes's *Dalla parte di lei* (1949),[6] according to the theories of the Italian feminist group Diotima – theories that, as I have anticipated in the preface, have proved to be particularly apt at unveiling a patriarchal subtext.[7] I will then discuss – with a cursory overview – how sympathetic male film directors portrayed women. Finally, I will analyse in detail Visconti's *Bellissima*.

Particularly in its first three multi-authored volumes, *Il pensiero della differenza, Mettere al mondo il mondo,* and *Il cielo stellato dentro di noi* (I shall refer to these books henceforth as 1, 2, 3), the Diotima group studies the impossibility of expressing female subjectivity within a language – that of the fathers – that does not allow any subjectivity other than the male one to be expressed, and therefore to exist at a symbolic level. Within Western culture and its privileged language, that of philosophy, female subjectivity represents but a subcategory of that unique and omni-comprehensive subject that Adriana Cavarero, heavily indebted to Luce Irigaray, terms the 'neutro universale.'[8] According to Cavarero, the 'I' of discourse, the 'I think' of Western philosophy, is undoubtedly male:[9] 'nel discorso che dice, ad esempio, l'uomo è mortale, l'uomo di cui si parla è anche una donna. Anzi, non è nè uomo nè donna, ma il loro neutro universale ... Uomo vale inanzitutto come sessuato maschile, ma vale anche, e proprio per questo, come neutro universale del sesso maschile e di quello femminile.'[10]

Within patriarchal culture women are voiceless, since, as Adriana Cavarero puts it, 'la donna non è il soggetto del suo linguaggio. Il suo linguaggio non è *suo*. Essa perciò si dice ... attraverso le categorie del linguaggio dell'altro.'[11] Since a woman does not own her language, it follows that when she speaks, she actually inserts herself into an already preestablished and predetermined scenario.[12] Not only is she coerced into translating herself into the language of man, or *uomo* – in speaking she uses that *neutro universale* that conceptually denies her subjectivity – she also occupies within it a place that does not exist: an 'a-topos.' For if the symbolic order structured by patriarchy does not account for her, she has no place in it. Woman is in fact trapped in a paradoxical symbolic non-existence. On the one hand, her sexual difference is denied, therefore made invisible and insignificant; on the other hand, it is made significant only from a male patriarchal point of view, in which she is symbolized as 'mother of man and phantasm of his erotic drives' (2: 93).

According to the notion of neuter universal, woman is not inherently different from man, and yet she functions as the 'other' of the male sub-

ject. Her position corresponds in fact to the symbolic place of a failed, impossible integration into the dominant discourse.[13] Within the Western philosophical tradition, woman is then marked by '*a-topia*': she belongs to no place. Further, as Adriana Cavarero suggests, her atopia also turns, into an 'a-nomia', since woman, beyond having no place of her own in the patriarchal order, is also 'extra-neous' to the process of conceiving that set of rules through which patriarchy oversees its own symbolic order. She can be inscribed within it only as an object and, in the position of object, she is scrutinized by the male gaze, which is legitimated by a juridical discourse. Fully expropriated from a place to which to belong and virtually inscribed 'outside' of the powerful legal code – or rather positioned as the passive recipient of its judgment – woman is then a perennial outsider within Western culture: an exile.

Still, women do express themselves in and through language: they speak and write. Notwithstanding an idiom that erases their sexual difference (when such an idiom does not turn it into a disgrace), women struggle to create a space of self-substantiation. However, their effort is marked by contradictions, due mainly to the impossibility of verbalizing contents (such as a feeling of identity) that are not supposed to exist – since they are 'atopical' – and are thereby marked by unreality. 'Unreality' – a feeling of not fully belonging to this world and to one's body – is therefore a woman's constant marker. The limits imposed on the portrayal of women by such an order make Banti's and de Céspedes's efforts even more fascinating. These writers' novels cast a different, gender-aware perspective onto that creation of a cultural self-representation that took place in Italy as a collective, not always fully conscious, effort in the postwar years.

The War as Emotional Setting: Anna Banti's *Artemisia*

Anna Banti, pen name of Lucia Lopresti (1895–1985), is an author who dedicated herself to writing novels, she claims, in order not to compete in her studies with her husband, the famous art historian Roberto Longhi.[14] She belonged to a prominent Florentine family, and was brought up and educated in a stimulating artistic milieu, specializing in art history. In 1950 she co-founded the prestigious literary magazine *Paragone* with her husband. Even though she was part of a restricted number of women who, between the wars, could have full access to culture and to its resources, she was always attentive to the condition of woman in society – a condition she analysed in most of her novels. *Arte-*

misia, the biography of the sixteenth-century painter Artemisia Gentiles-chi, published in 1947, is one of these. The book has a tortuous story. The novel's first version was destroyed in the spring of 1944 during a bombardment that demolished Banti's house. However, as the author states, Artemisia haunted Banti's imagination with heartbreaking obstinacy, or *ostinazione accorata*, so that the writer had to write her story once again. The writing of the second version of the book was motivated by an emotional drive, by 'personal emotions too imperious to be ignored or betrayed.'[15] In this second version, Banti situates her relationship to Artemisia within the framework of an emotional and uncontrollable excess; an excess that is, in itself, a marker of femininity within patriarchy.

The writer provides only a few lines of historical information about Artemisia in the preface, entitled significantly 'Al lettore,' that is, to the (male) reader:[16] 'Nata nel 1598, a Roma, di famiglia pisana. Figlia di Orazio, pittore eccellente. Oltraggiata, appena giovinetta, nell'onore e nell'amore. Vittima svillaneggiata di un pubblico processo di stupro. Che tenne scuola di pittura a Napoli. Che s'azzardò, verso il 1638, nella eretica Inghilterra.'[17]

These few lines contain all the basic historical information we need to know. Readers do not need further information, since Banti's purpose is not that of writing a scholarly or even a reliable biography. More important is the link that Banti establishes with Artemisia, *notwithstanding* the real circumstances of the painter's life. The lines immediately following the short biography indicate succinctly how to read the author's rapport with her character: 'una delle prime donne che sostennero colle parole e colle opere il diritto al lavoro congeniale e a una parità di spirito fra i due sessi.'[18] Artemisia offers Banti a model of self-assertion: she is a woman who strives to express herself freely, overcoming the limits imposed on her by gender and social customs.

From the beginning, Banti's relationship to Artemisia extends beyond the limits of the written text: it both precedes and survives it.[19] The relationship between Banti and Artemisia is one of an identification in which the painter functions as Banti's double. Between these two women artists there is a continuous, unheard (if only by the ears of the patriarchal order) dialogue that crosses and erases the boundaries of that historical time, represented by the three centuries that separate them. Their connection is in fact established, not along the lines of that measurable and objective medium – chronological time or history – through which patriarchy structures its own representation in a narrative form, but through a medium that, because of its subjective, emo-

tional character, both escapes and challenges history itself: memory or *la memoria*.

Banti uses history in a way very similar to that employed by Morante's *La Storia* (1974). These female authors reduce History with a capital H, to history with a small 'h.' What matters is in fact how history is subjectively experienced by their characters and not what it means in broader sociological and political terms. Patrizia Violi makes a very convincing point that supports the interpretation I here suggest of memory and history as modes of narration, which tend to be gender-specific. Violi states that relationships among men, either hierarchical (master/pupil) or among peers (group relationship and male solidarity), are socially acknowledged, thus symbolically represented. Such a symbolization

> creates a trans-individual space in which it is possible for men to identify with the collective and to inscribe their individual subjectivity into forms of collective subjectivity, such as that of groups, political parties and institutions. *This process brings with it a different perception of time, which is no longer the time of a single individual life but the historical time of a society* ... The sense of belonging to a gender and the sense of belonging to a time are thus two vital factors that distinguish male from female experience and identity.'[20] (italics mine)

According to Violi, women tend not to access the dimension of historical time both because their subjectivity lacks symbolization and because of their interpersonal rapports. This is why memory rooted in an individual and not collective experience seems to be a privileged narrative mode for women.

As suggested earlier, the relationship between Banti and Artemisia goes beyond the boundaries of the written text. Nevertheless, the metonymy through which the text turns into the character – 'ho perduto Artemisia' ('I lost Artemisia'), meaning both the book about her and Artemisia as a character who haunts the author's imagination – attributes a special meaning to Banti's writing. Since Artemisia functions as the writer's double, Banti, by writing about Artemisia, actually writing *her*, also physically inscribes herself – her (female) body – into the literary tradition.

In the senseless and atrocious disasters of the war, a dialogue begins anew: it actually imposes itself on Banti. The writer has in fact lost the manuscript, but not Artemisia. Among the ruins of the bombardments, mingled with the faces of the *profughi*, or refugees, Artemisia comes to

life once again and tells Banti 'non piangere,' don't cry – the two open-
ing words of the novel. While Artemisia emerges as a phantom among
the war's wreckage, thereby representing just one element of a multifac-
eted tragedy, she gradually becomes the privileged interlocutor of a per-
sonal rapport. The horizon shifts from social to personal – from history
to memory – and, within the collective sorrow generated by the war's
calamities, Banti isolates herself and Artemisia in an exclusive relation-
ship. Banti writes, 'i miei singhiozzi sono ora per me e per lei soltanto:
per lei nata nel millecinquecentonovantotto, anziana nella morte che ci
sta attorno, e ora sepolta nella mia fragile memoria.'[21]

It is within this private rapport that symbolic female genealogy
emerges. The genealogy here is elective, not biological, in this sense it
acquires an even more symbolic value and a challenging political reso-
nance. The challenge to the established patriarchal order consists pre-
cisely in creating an exclusive bond between a woman – Artemisia – and
her writer/double – Banti – that escapes the mediation or validation of
a male gaze. Banti succeeds in doing so by unveiling the nature of the
oppression that weighs on Artemisia, who is a woman, but also – like
Banti herself – an artist. Instead of passively submitting to or internaliz-
ing Artemisia's and, implicitly her own, a-topia and a-nomia, the writer
becomes aware of the forms their subordination takes and, at the same
time, resists them.

The first unredeemable violence that scars Artemisia is her rape at
age fourteen by Agostino Tassi. Even though her father denounces Tassi
to the proper authorities, in his and the public's eye the violence Arte-
misia has been subjected to – defloration – turns into her own fault, that
of being the object of unrestrained male desire; in fact, her fault is, *tout
court*, that of being a woman. Wrapped in blankets in her own bed after
seeing a judge who wanted her to admit either that Agostino had not
been her first lover or that she willingly submitted to his desire, Artemi-
sia curses her biological destiny. She would like to remain in the dark-
ness forever in order to erase that sexual difference so painful to carry
around. She tells herself: 'durasse per sempre il buio, nessuno mi
riconoscerebbe per donna, inferno per me, male per gli altri.'[22] This is
not the only instance in which Artemisia wishes she could dismiss the
unbearable burden of being female. Banti describes her as 'una donna
che vorrebbe essere un uomo per sfuggire se stessa,' a woman who
would like to be a man to escape from herself. Here the condition of
being a male is not desirable in itself but for what it signifies within the
patriarchal order: access to the symbolic, and therefore to one's *reality*.

To be woman amounts already to a hellish condition; to be a woman and an artist is even worse because her atopia is then doubled. In Banti's book Artemisia's father, Orazio Gentileschi, explicitly states this view. After having studied his daughter's paintings and complimented her, he tells her, 'Tu sei un pittore' ('You are a painter,' 65). By choosing the predicate noun 'pittore,' Orazio erases his daughter's sexual difference and thus creates for her an impossible persona; in fact he produces an irreconcilable duality against which Artemisia has to struggle: a male identity in a female body. Gentileschi, by defining his daughter as 'pittore' – he could easily use the word 'pittora' (which we find in Vasari), 'pittoressa,' or 'pittrice' – inscribes her, officially, into the 'neutro universale.'[23] And Artemisia deeply desires her father's recognition; a recognition that represents validation from the patriarchal order and, as such, the necessary prerequisite for existing in the world. Artemisia, linked to her father by a rapport that has a clear Oedipal slant, has difficulties assessing her worth herself. She depends on the love of a father who, after the rape, disavows her.

Furthermore, Artemisia has no female model with whom to identify, no possible genealogy in which to insert herself: 'per meditare che faccia, non le è ancora riuscito di riconoscersi e definirsi in una figura esemplare e approvata del secolo ... Questa è una donna che in ogni gesto vorrebbe ispirarsi a un modello del suo tempo, decente, nobile; e non lo trova' (109–10).[24]

Without the possibility of mirroring herself in another woman, Artemisia's life is marked even more by that *unreality* that Cavarero considers a distinctive feature of women's self-perception. Not only does Artemisia not have the possibility of mirroring herself in a woman in whom she could find validation – a possibility that is instead available to Banti, her *elective* daughter – but she is also rejected by her own biological daughter, Porziella.

Porziella is raised by nuns and becomes an example of decorous femininity. She gets very upset at her mother's negligence in form and etiquette and resents her carelessness: she simply does not love her mother. This unreciprocated love painfully wounds Artemisia. Porziella subscribes to the values that the patriarchal order has established for women, thus rejecting her mother's ec-centricity. Fully adhering to a code that considers women only as wives and (traditional) mothers or, alternatively, as nuns, she disclaims Artemisia, emotionally withdraws from her, and chooses to insert herself within an elective, patriarchally approved genealogy/household: that of the nuns and of the convent and, later, of marriage.

This is the other painful element that Banti explores: the lack of soli-
darity among women, the fact that women themselves are primarily
each other's enemies. Within the patriarchal order, they fight each
other like beasts in a circus just to get male attention; they fiercely evalu-
ate each other according to the aesthetic canons that the male gaze has
set up for them. Women deny each other the support with which they
could try to oppose their enlistment – and therefore their denial of sub-
jectivity – within the 'neutro universale.' Not even those women who
share the untraditional status of being women artists and of exploring
paths usually forbidden to them are friends with one another.

Banti portrays this frustrating truth in the rapport between Artemisia
and Annella De Rosa, a younger, beautiful Neapolitan painter invited to
one of her receptions. In their encounter, Annella treats Artemisia as an
older woman whose assets in beauty and youth are fading away. She
manipulates Artemisia's guests and wins everybody's attention; her
behaviour deeply upsets Artemisia, since she, as an older woman who
would like to build a community of like-minded females, sees her dream
evaporating: 'Vedete queste femmine ... le migliori, le più forti, quelle
che più somigliano ai valentuomini: come sono ridotte finte e sleali tra
loro, nel mondo che voi avete creato, per vostro uso e comodità. Siamo
così poche e insidiate che non sappiamo più riconoscerci e intenderci o
almeno rispettarci come voi vi rispettate.'[25]

Her thought expresses an unresolved ambiguity – one that results
precisely from women's placement in the patriarchal order. In addition,
it underscores how the better and stronger women – 'le migliori, le
più forti' – are defined according to male standards, for they are 'quelle
che più somigliano ai valentuomini' ('those who better resemble
gentlemen'). Further still, it also demonstrates how they are each
other's enemies: 'Non sappiamo più riconoscerci o intenderci o almeno
rispettarci' ('We can no longer recognize or understand or even respect
each other').

Nevertheless, by instating a genealogical relationship with Artemisia,
Banti indicates a way to resist the hellish mechanisms produced by the
patriarchal order. In so doing, she tries to isolate a model of woman-
hood – Artemisia – and of a bond – Artemisia-Banti – in which other
women can mirror themselves, gain strength, and, eventually, social visi-
bility. Not only does Banti create such a relationship, but she also turns
it into the unbreakable bond upon which she bases her narrative. Any
reader, whether male or female, has to surrender to this identification
in order to make sense of a biography rooted in Banti's persona. With-
out accepting it and without accepting the move back and forth from

Artemisia to Anna Banti, it is not possible to read, or rather understand, the book.

The bond of identification between Artemisia and Banti is unbreakable and inescapable, since it is encoded into language itself, that is to say, in its grammatical categories. Banti – her 'fictionalized' self – becomes Artemisia by simply exchanging the position of grammatical subject with her so that *She* (Artemisia) becomes *I* (Banti). Through this major, master substitution, what is predicated of the painter is predicated of the writer as well; what concerns Artemisia is also Banti's concern; what Artemisia thinks is Banti's thought.

Banti offers the first clue of such a procedure when she talks about Artemisia, who is following her father to Florence. After describing the trip Banti writes:

E ad Artemisia tornò alla memoria il marito che aveva preso, goffo e di ripiego ...

Ero sola (questa commemorazione scavalca spesso la terza persona), ero sola a Firenze la più parte del giorno. All'osteria la stanza dava su un cortiletto senza luce né buona né cattiva.[26] (italics mine)

Banti talks *about* Artemisia and then talks *as* Artemisia, notifying the reader, through the parenthetical expression, that the recollection of Artemisia (the word 'commemorazione' has, in Italian, the meaning both of remembering and of honouring a deceased person) overcomes the third person. The shift from the third – 'ad Artemisia' – to the first – 'Ero sola' – person marks, though, a logical ellipsis that readers have to accept or, rather, submit to. Without one's surrendering to this logical gap or discrepancy, the narration becomes incomprehensible. Using the code available to her – the grammar that supports the formalized language of literary tradition – Banti thus makes her voice, if not her full subjectivity, heard precisely by disrupting such a code: by making its logical coherence rupture.

An analogous way in which the relationship between Artemisia and Banti is articulated occurs when the painter regrets the fact that her daughter does not understand her:

'Figlia mia' esplode la donna, sull'alba, in *un risveglio di lagrime abbondanti*, calde, covate nel sonno 'figlia mia che sei una donna e non capisci tua madre.'

Questo risveglio di Artemisia è anche il mio risveglio.[27]

Here Banti equates Artemisia's awakening with her own, erasing any possible doubt or equivocation about the process of total confluence/coincidence between herself and Artemisia. Banti chooses Artemisia as a model of identification and therefore as a sort of symbolic mother figure – somebody who came before her and in whose lineage she situates herself – to validate her existence in the world, not just as an artist but as a *female* artist. In a sense, Artemisia's difficult, painfully lonely life paves the way for those women who aspire – as Banti writes in her address to the reader – to 'un lavoro congeniale e a una parità di spirito tra i due sessi' (i). The genealogical value of Artemisia and Banti's rapport is restated at the end of the book when, in a sort of indirect free speech, the author writes: 'Ritratto o no, una donna che dipinge nel milleseicentoquaranta è un atto di coraggio, vale per Annella [De Rosa] e per altre cento almeno, fino ad oggi. 'Vale anche per te' conclude, al lume di candela, nella stanza che la guerra ha reso fosca, un suono brusco e secco.'[28]

From the seventeenth century to the twentieth, there is a long line of women who had the courage to paint or, in a broader sense, to produce art. At the end of that line is Anna Banti. The statement between quotation marks, 'Vale anche per te,' is in fact a direct address to her from Artemisia. It is through this statement that the author represents Artemisia's choice of (fictionalized) Banti as her elective daughter. Artemisia inserts Banti in a line of women who strove to achieve the status of (female) subjects. In so doing Banti/Artemisia validates a lineage woven through the emotional, subjective category of memory, while also structuring, from within, that model of identification Artemisia so painfully desired to have in front of her. The second-singular person 'tu' also extends this possibility to any female reader, since the Artemisia-Banti colloquium expands, through this grammatical choice, to whomever is in the position of the addressee,[29] creating a vectorial line that runs from character to author to reader (where the character is also the author). By creating this female genealogy Banti succeeds in providing a symbolic place, a *topos*, where women can, albeit precariously, reside and mirror each other.

Female Solidarity: Alba de Céspedes's *Dalla parte di lei*

Alba de Céspedes's *Dalla parte di lei* bears concerns similar to Banti's and

unfolds along analogous lines. However, while Banti achieves results hermeneutically relevant without facing issues of the official political sphere, de Céspedes addresses legal problems that the writing of the New Constitution, completed by 1948, brought to national attention. She questions the legitimacy of a legal system that deprives women of any rights, enacting a de facto discrimination against them. Alba de Céspedes (1911–97)[30] had worked under the Fascist regime as a scriptwriter, a novelist, and a literary journalist. Notwithstanding Fascist censorship, her *Nessuno torna indietro* became a best-seller that went through eight reprints. She was actively involved in the struggle for the liberation of Italy: during the war she did a radio broadcast from Radio Bari with the pen name of Clorinda, and between 1946 and 1948 directed the literary magazine *Mercurio.* Her archive contains a rich epistolary that traces the profile of a woman intensely connected to the literary world of the forties and fifties.[31]

Like Banti, de Céspedes illustrates the endless suffering of women, a pain born out of their constant marginality and inequality with men, but is less able to grasp the patriarchal conceptual network that produces women's alterity. Her novel is significant precisely because it shows how women, and de Céspedes herself as an author, unconsciously situate themselves in the 'neutro universale.' While Banti creates a grammatical/logical rupture that denounces the denial of female subjectivity, de Céspedes remains overwhelmed by the epistemological incongruity of the neuter universal and also entrapped within its unclarity. Ultimately, all the contradictions stemming from the neuter universal are recorded by and inscribed into women's physical bodies. It is the body, conceptualized only as the object of male desire and guarantor of the species' continuity that women have to renounce and disavow in order to exist. Eleonora's (the protagonist's mother) suicide represents the most literal and tragic aspect of such renunciation. Yet de Céspedes, too, tries to create and legitimate a female genealogy.

Dalla parte di lei is a long confession, of almost 600 pages, written in prison by Alessandra in order to explain why she attempted to kill her husband Francesco Minelli. Alessandra is the only daughter of parents of different backgrounds and personalities. Eleonora, her mother, is a beautiful woman who lives in an immaterial world filled with art. Ariberto, her father, comes from a family of small landowners in Abruzzo. Alessandra is an only surviving child since her brother, Alessandro, drowned at age three in the Tiber River. The family lives in a poor borough in the centre of Rome, in a huge building on Paolo

Emilio Street. In the building lives also the medium Ottavia, who is periodically consulted by most of the women. Eleonora begins teaching piano to Arletta Pierce, who, unlike her handsome and talented brother Hervey, is musically ungifted. Even before Hervey returns home (to Villa Pierce) – he is studying somewhere in Europe – he becomes a true myth of artistic sensibility and superior humanity actively constructed by his mother and sister, not to mention Eleonora herself. In fact, Eleonora, guided by an indication of the medium Ottavia, expects the arrival of a *great love*. When Hervey comes back home, love blossoms between the two. Eleonora wants to leave her husband, but faced with Ariberto's refusal to let her go with their daughter drowns herself in the river, thus replicating her son's death. Alessandra is then sent to Abruzzo. Here, she becomes very close to her 'Nonna,' or grandmother, but ultimately her anomaly with reference to a traditional notion of femininity places her at odds with the environment, and she is sent back to Rome. There, Alessandra meets Francesco, whom she falls immediately in love with and marries. Expecting great happiness, she finds her married life unfulfilling. One night, totally exasperated by her husband's inattentive and unsentimental behaviour and overcome with her accumulated anger and frustration, she shoots him. She is then condemned to prison.

In *Dalla parte di lei*, women are subjected to numerous erasures, both literal and symbolic. The protagonist, Alessandra, incurs the most significant and powerful one, we are told at the outset. Born only a few months after the drowning of her little brother Alessandro, she is named after him. She is compelled, by her very name, to assume *his* identity:

> quando io nacqui, pochi mesi dopo la sua morte, mi venne imposto il nome di Alessandra per rinnovare la sua memoria e nella speranza che in me si manifestassero alcune di quelle virtù che avevano lasciato di lui un inestinguibile ricordo. Questo legame al piccolo fratello defunto pesò moltissimo sui primi anni della mia infanzia. Non riuscivo mai a liberarmene: quando mi si rimproverava era per farmi notare che avevo tradito, nonostante il mio nome, le speranze che mi erano state affidate.[32]

Alessandra thus enters the family as her brother's replacement, that is, as an already *colonized* being. She has no identity of her own; her identity is expropriated practically from birth, if not even before, by that of her brother. She is expected to be a replica of Alessandro, and her

behaviour and achievements are constantly compared to his throughout her childhood. Paradoxically, Alessandra's colonization is enforced by her mother, Eleonora, who constantly compares her daughter's actions to what Alessandro would have certainly done well, had he lived. The violence of such an invasion is internalized by Alessandra throughout the novel and culminates in the attempted murder of her husband. For she attributes her own negative impulses to Alessandro – to the ghost of her brother whom she perceives, at times, as a violently domineering force within her.

Alessandra's identity is thus split from the very beginning. It is constructed as such and shows the forced quality, as well as the force, of the symbolic androgyny to which she has to submit, which she must encompass within her own body. Within the patriarchal order, maleness and femaleness are in fact envisioned as two aggressively and permanently opposed polarities, and Alessandra sees this opposition acting both in herself, in her own male/female duality (Alessandro/Alessandra), as well as in the gender system established in the surrounding society. Significantly, Alessandra rewrites this duality, shifting the polarities and equating bad with male (her brother) and good with female (herself). While she considers the masculine – personified in her father and later in her husband and other men – as rude, insensitive, gross, disgustingly sensuous, and concupiscent, she inscribes the feminine within the realm of unreality. Thus, a striking element emerges throughout the novel: the co-opting of women in their own rejection by the patriarchal order, the fact that women *do* willingly and overtly submit to their own symbolic obliteration. Needless to say, such a painful truth marks Artemisia's life as well, especially in the relationship with her daughter Porziella.

The first model of femininity that Alessandra is presented with is that of Eleonora, her biological mother. Eleonora provides the reflecting mirror in which Alessandra constructs a sense of self by acknowledging her position within a female genealogy; a genealogy that, because of her mother's suicide, turns out to be intrinsically problematic and casts a sinister shadow that jeopardizes Alessandra's own social *persona*. Alessandra loves her mother deeply and is trapped in the ambivalent feeling of wanting to be like her – of constituting her undifferentiated duplicate – while also dreading such a resemblance. It is thus important to see how Alessandra portrays her mother and which kind of image Alessandra forges for Eleonora, since such an image constitutes the matrix of her own identity.

Eleonora is not of this world. She is an ethereal being whose immateriality is conveyed by a series of adjectives: 'harmonious,' 'gentle,' 'sweet,' 'elegant,' 'beautiful,' 'melodious,' 'tender,' 'serene,' 'gracious,' 'light', and the like. Such adjectives, combined with her profession (music teacher) and physical characteristics (blue eyes, blond hair, and fair skin), tend to configure her as an angel-like being, and as a being without a body.[33] Accordingly, then, Eleonora's enforced comparison to an angel, or portrayal as such, signals the refusal of her own corporeality and her unattachment to whatever is *material*. Such a comparison also opens up the question of her renegotiable and redefinable identity. Alessandra repeats Eleonora's rejection of the body by comparing her mother to a saint: 'a me pareva che avessimo tra le pareti della nostra casa una santa: con le sue estasi, i suoi rossori, i suoi divini colloqui.'[34] Through her constant association with both angel and saint, Eleonora thus perfectly adheres to the one of the two macro-alterities the patriarchal order produces for women: madonna and prostitute, or disembodied female entity and mere concupiscible body. Eleonora comes then to resemble more and more that archetype of femininity the West constructed in Mary, the Virgin Mother. Further, and more specifically, her being an angel recalls the tradition of the Italian *Dolce Stil Nuovo* (sweet new style), a lyrical tradition that developed in northern Italy during the last decades of the thirteenth century and forged the woman as object of an intense platonic desire.[35] Such desire turns into a self-referential burning – a burning uninterested in the achievement of its own fulfilment.[36]

As in the best *Dolce Stil Nuovo* tradition, which was forged by male writers, the only thing that moves Eleonora as, paradoxically, a desiring woman is 'amore,' and this is the way in which Alessandra, in her co-optation, understands and also shapes her mother's image: 'Compresi che null'altro la moveva' ('I understood that nothing else moved her'). Here again, a problematic androgynous status is attributed to woman, in this case Alessandra's mother, since she is *moved* as a (male) *Dolce Stil Nuovo* poet, by *Amore*, and is thus promoted to the place of the desiring subject. The incongruity of collapsing into the character of Eleonora the attributes of a disembodied/asexed and yet female being – an angel – and a male writer – a poet – raises precisely the epistemological problem Cavarero identifies. The 'neutro universale' claims to represent male subjectivity *and* its obscure, unaccounted for, other: a female subjectivity. Yet there is no specific linguistic and conceptual tool able to express such a subjectivity. The contradictions stemming from uniting

in Eleonora the attributes of both *angel* and *poet*, far from being a logical weakness on de Céspedes's side, show a paradox embedded in language itself – what I have referred to as the androgyny of Western thought.

The semantic sphere of the concept of 'amore' is defined, in the novel, according to Stilnovistic criteria and to the sensibility later claimed by nineteenth-century romantics. In fact, Eleonora expects a true dispossessing passion that will redeem her life and, paradoxically, give concreteness to her *unreality*. This love does not necessitate a body, since it is composed only of impalpable emotions and can happen exclusively in a supremely elegant environment imbued with art and music, such as the one provided by Villa Pierce. Eleonora herself erases her own body because it amounts to a physicality with which she is not allowed to coincide. Within the 'neutro universale' she is, in fact, programmed as a mere signifier of male desire. So, it is not by chance that Eleonora's partner, Hervey, is a homosexual.[37] The ethereal passion by which Eleonora wants to be possessed can only be experienced with a male who is not, according to the symbolic patriarchal order, a male: somebody whose desire does not target a female body; somebody who, being also denied a symbolic topos within patriarchy, is stigmatized by symbolic unreality.

The other half of Alessandra's female genealogy is represented by her paternal grandmother: a true matriarch. She does not have a first name, but is simply called 'Nonna,' or grandmother. This fact underlines her genealogical function more than her individual character. 'Nonna' is a respected and feared head of household, who personifies a source of female power rooted in the maternal. She wants to insert her grand-daughter into her own lineage, claiming a strong resemblance between herself and Alessandra.[38] While the grandmother denies a possible female self-expression and consequently female desire, she sees a great value in women's bodies because of their reproductive capacity. Creation of new lives is, for her, the true job of a woman, something for which a woman is also grateful to her husband. 'E' pur bello essere donna. Sono le donne che possiedono la vita, come la terra possiede i fiori e i frutti.'[39] 'Nonna' grounds her self-perception and sense of worth in a traditional notion of femininity in which she identifies woman and womb. She therefore disclaims the value of education or of any artistic pursuit for women.

Alessandra's mother and her paternal grandmother represent her role models and set her female genealogical background. Hence, while Alessandra always has a negative relationship with her father since she

sides with Eleonora, from the very beginning she establishes a rich and loving relationship with her paternal grandmother. Alessandra's connection to Nonna demonstrates the power of a female genealogy that is instituted *notwithstanding* her biological father and that overpowers even the father-daughter bond. How does Alessandra situate herself within this female genealogy? How do these female figures affect the way she understands herself and projects herself into the world? First of all, like Artemisia, Alessandra initially perceives the mere fact of being a woman as 'una colpa,' a sin. Like Artemisia, she would rather not acknowledge that she is a sexed being, that she is a female. The signs of her incipient puberty provoke in her a deep sense of shame, which is reiterated in different moments throughout the novel: 'la coscienza della mia condizione di donna mi suggeriva un sentimento di colpa. Con vergogna scoprivo sul mio corpo ogni segno che rivelasse questa condizione e la rendesse palese non solo a me stessa ma agli altri.'[40]

The uneasiness caused by her being sexed as a female is so strong that Alessandra interprets her first menstruation as an illness. As she says, 'Una volta sola, contavo poco più di undici anni, avevo temuto d'essere molto malata.' It is Sista, the maid, who reassures her that she is not sick but has simply reached womanhood.[41] Being a female amounts, in itself, to a painful and disadvantageous position: this is clear to Eleonora, whose only reason for desiring a male child, as opposed to a female one, is to protect the child from that destiny of unhappiness which awaits women. Eleonora shows how painfully aware of her gender she feels on several occasions; for instance, when she hugs Alessandra with a desperation that her daughter perceives as caused by her being a woman:

> E intanto mi stringeva. Non lo sapeva certo, ma anche il suo era un modo disperato di stringermi. Io rabbrividii, smarrita entro una improvvisa pietà per la mia condizione di donna. Eravamo, mi pareva, una specie gentile e sfortunata. *Attraverso mia madre, e la madre di lei, e le donne delle tragedie e dei romanzi, e quelle che s'affacciavano nel cortile come alle sbarre della prigione, e le altre che incontravo in istrada* e avevano occhi tristi e ventri enormi, sentivo pesare su di me una secolare infelicità, una inconso-labile solitudine.[42] (italics mine)

The quote eloquently shows how the borders between reality and fiction fade and blend into each other, designing a unique unhappy fate for both real and fictional women. As I illustrated in the relationship between Banti and Artemisia, the boundary between reality and fiction

amounts, for women, to an ephemeral, ever-shifting line. Since women belong to an oxymoronic category – that of the ontology of the unreal – there is no difference between Alessandra's perception of flesh-and-blood women and of invented characters. This is why women – in the eyes of female authors – can live off literature and create an authentic genealogical link with fictional characters, as in the case of Eleonora, who reads and loves *Madame Bovary*.[43] Further, Eleonora herself is named, not by chance since her own mother was an actress, after the protagonist of Ibsen's *The Doll's House*, Nora.

Like her mother, Alessandra expects 'the' great romantic love. Nevertheless, she experiences the turmoil of the senses very strongly. Thus, the only way in which she can justify her own desire is by attributing it to somebody else: her brother Alessandro. Alessandra wishes to live a passion similar to her mother's, which would transcend both the limits of the body and the boundaries of traditional chronological time. In effect, she expects a passion that could stop, *tout court*, time itself; and which would then take place under the stigma of unreality. Paradoxically submitting to her own objectification, Alessandra wants to be the object of an un-carnal and never-satiated desire, and she wants to establish herself as the constant spectacle of an inflamed male gaze. But she sees her husband gradually drifting away from this gaze, slowly starting to comply with a stereotypical male role that entails giving primacy to one's job, to one's public role, and to one's exclusive bond with other males. Her rage at the lack of validation from her husband, along with the sinister heritage of her mother's suicide – an event that Alessandra internalizes as her own darkness – erupts when Alessandra attempts to murder her husband.

More than Banti's *Artemisia*, Alba de Céspedes's *Dalla parte di lei* is trapped in various paradoxes and ambivalences – the main one being women's enforced and internalized androgyny – evident, for instance, in the double status of angel/poet attributed to Eleonora. Alessandra's frustrated expectations reintroduce the dichotomy between the public and private spheres that we have seen at work in the first chapter, particularly in Pratolini's *Un eroe del nostro tempo*. Following a trajectory opposed to Faliero's – who wants, in Gramsci's footsteps, to reconcile the two spheres – Alessandra's husband, Francesco, slides more and more into a split chronological framework that opposes the subjective/emotional sphere of 'love' to the objectified sphere of one's public persona. Interestingly enough, the painful dichotomy that emerges as a result of experiencing these two different (subjective-objective) times

turns out to be related to gender. In fact, it comes to constitute one of its central articulations, as suggested by the feminist psychoanalyst Jessica Benjamin.

In her pivotal book *Bonds of Love*, Jessica Benjamin offers an insightful rethinking of the dynamics of gender relations and domination. Benjamin claims that, within orthodox Freudian psychoanalysis, the process of individuation of the self happens in a dialectical father-son struggle, a struggle that is modelled on the Hegelian master-slave relationship. This one-to-one struggle between self and other 'is set in motion by the denial of recognition to *the original other, the mother who is reduced to object*' (italics mine).[44] This denial of subjectivity extends from mother to wife, since the latter shares the mother's socialized characteristics. In effect the mother/wife is conceived of, and conceptualized as, a reservoir of nurturing: as an anchor needed to guard and protect domestic values. Such feminine presence at home, both literal and symbolic, makes it possible for men to reach out and look for self-assertion in the world. Benjamin claims that the objectification of the mother is thus the very premise upon which the separation between the public and the private sphere takes place:

> The unbreakable line between public and private values rests on the tacit assumption that *women will continue to preserve and protect personal life, the task to which they have been assigned* ... The public world is conceived as a place in which direct recognition and care for others' needs is impossible – and this is tolerable as long as the private world 'cooperates.'[45] (italics mine)

Far from being unrelated to gender issues, then, the painful split between the private and public spheres that returns as a constant refrain in several texts of the postwar period hints at the beginning of a crisis in the traditional assessment of male and female roles in Italian postwar society. Even though Alba de Céspedes's novel is entangled in various paradoxes and ambivalences – the main one being women's enforced and internalized androgyny – it reveals an attempt to challenge its contemporaneous gender system. *Dalla parte di lei* is in fact a passionate defence of women's psychology. Through Alessandra's link to her mother and paternal grandmother, de Céspedes strives to legitimate a female genealogy and to make it meaningful at a social level. The entire book is conceived as a narrative that attempts to explain why Alessandra shot her husband and to illustrate Alessandra's legitimate – although invisible and incomprehensible to male and *also* female eyes – motives

for doing so.[46] It is, then, an attempt to account through the past history of Alessandra – as well as the histories of her mother and grandmother – for an only apparently unjustified 'crazy' act. Through her long, detailed account of Alessandra's past, de Céspedes also overtly challenges her contemporary legal system, questioning the right of a completely male jury to judge women and to render them 'objects' of an assumedly neutral but in fact gender-specific juridical gaze.[47] 'Io credo, perciò che nessun uomo avrebbe il diritto di giudicare una donna senza sapere di che materia diversa dagli uomini le donne sono fatte. Non ritengo giusto, ad esempio, che un tribunale composto esclusivamente di uomini decida se una donna è colpevole o no.'[48]

De Céspedes's formal acknowledgment of a female genealogy and her attempt to give it importance *over* a patriarchal lineage amount to a practice of resistance to, and even an attack on, the existing order – an attack that acquires political overtones and underlines the necessity of a change in the Italian law. In effect her husband, a committed political activist, embodies the involution of the *Resistenza* itself; the return, after a civil struggle in which women enthusiastically and actively participated, to the old, Fascist paradigm of gender.[49] With his behaviour, Francesco seems to renew a clear division between the domestic, secluded space of his wife and the public arena of his political, once again exclusively male, engagement.

Cinema Rediscovers Women

In this period, and in the following years, not only women writers focus their attention on female protagonists. A number of films signal a shift in the attention that male authors pay to their female characters. These films are *L'Onorevole Angelina* (Zampa, 1947), *Senza pietà* (Lattuada, 1948), *Assunta Spina* (Mattoli, 1948), *Amore* (Rossellini, 1948), *Roma ore 11* (De Santis, 1949), *Cronaca di un amore* (Antonioni, 1950), *Bellissima* (Visconti, 1951), *Anna* (Lattuada, 1952), *Le ragazze di Piazza di Spagna* (Emmer, 1952), *L'Oro di Napoli* (De Sica, 1953), *Celestina o Il sole negli occhi* (Pietrangeli, 1953), and *Amore in città* (Zavattini, Antonioni, et al., 1953).[50] Film directors start to share a genuine, though at times ambivalent, admiration for the female characters they portray. They are sympathetic to women and try to overcome what Patrizia Carrano has described as the 'sweet,' at times uncompromising or unproblematic, way of picturing them prevalent during the *Ventennio*.[51]

Here again we need to step back and look more closely into Fascist programs and doctrines about filmmaking, since, as Lino Miccichè has

rightly declared, the desire to erase and censor Fascist culture has also distorted the way postwar critics have perceived the *Ventennio*'s production.[52] According to David Forgacs, although Fascist *gerarchi*, and Mussolini *in primis*, understood quite soon the potential of cinema in shaping a national, Fascist culture, the cinema was not the arena most heavily controlled by the government, whose efforts were more massively directed at supervising the press and literary culture. Thus, we cannot speak of 'un "cinema di stato" fortemente e apertamente politicizzato'[53] ('a "cinema of the state," strongly and openly politicized'). The state did intervene in cinema, mainly to help a faltering industry, but did not support an overtly propagandistic strategy through films, though of course censorship was present – also enforced by the requests of the Church – in order to protect 'morality.' Because Italian cinema underwent a huge crisis in the early twenties,[54] measures were taken to revive the dwindling Italian film production, and in 1924 the Istituto Luce was founded. In 1927 the government passed a law according to which 10 per cent of films shown in movie theatres should be Italian. In 1930 the Cines complex reopened with a sound technology of American import, while in 1932 the *Mostra del cinema* was inaugurated in Venice. Cinecittà unlocked its gates in 1937. At the same time, a culture of cinema devotees spread among young intellectuals, implemented by a series of cineclubs – among them the Cineguf, which targeted university students – while various journals dedicated to films were either founded or continued to offer specialized film information, including *Bianco e Nero*, *Cinema*, *Lo Schermo*, *Cinema Illustrazione*, and *Corriere Cinematografico*. The Centro Sperimentale di Cinematografia, inaugurated by Luigi Freddi in 1935 after he visited the Californian studios, also constituted a privileged locus for the diffusion of a specialized cinematic culture, which included technicians, actors, directors, and scriptwriters. There were also occasional special screenings of foreign films for selected audiences. Although Mussolini was convinced that the cinema was 'l'arma più forte' ('the strongest weapon') in advertising the regime, as well as in promoting consensus around it – he mandated that Luce documentaries should be shown during regular film screenings – the cinema also paradoxically publicized styles of life that were in contradiction with Fascist dictates. As Ruth Ben-Ghiat remarks: 'I film fascisti mostravano anzi proprio quel tipo di glamour cosmopolita che il braccio populista del regime aveva giurato di sconfiggere, e proiettavano modelli di comportamento sociale e sessuale che contrastavano nettamente con quelli propagandati nella stampa ufficiale.'[55]

Once again, as in the case of its ideology about women, what Fascism

meant to enforce through its cinematic policy was not followed up by congruent productions, and so the cinema turned, de facto, into perhaps the main agent of change in social interactions.[56] One of the most frequently addressed topics in films of the Fascist era was the relationship between city and countryside, with the countryside praised over the city, but not in a straightforward, unambivalent way.[57] Another topic was working women – either sales girls in department stores or secretaries – and the increasing sensual freedom they might be enjoying thanks to a less socially regulated and supervised sexual economy.[58] An often approached theme also was the opportunity of social mobility an urban setting could offer, and the concomitant implications about far too uninhibited behaviours, not only in the sexual sphere but also with reference to one's honesty in the working world.[59] Other movies regarded young women brought up in boarding schools: cultivated and witty and yet eager only to embrace their future role of mothers and wives.[60] Others concerned 'fallen women' or women artists who could not aspire to a conventional married life;[61] others again pictured quite disquieting female protagonists.[62] Only a minimum part of the *Ventennio's* production was overtly propagandistic.[63] In cinema too, then, as in literature, Fascist cultural directions were not always clear and univocal. We should also keep in mind that, notwithstanding the official opposition to Hollywood production, American films circulated widely in Italy, at least up to 1938, and that their charm and optimism, their setting and montage enchanted many intellectuals – a topic I will address in the next chapter.[64]

As we have seen, women had tried, during the *Ventennio*, to access the job market and to resist the government's reproductive ideology – also massively enforced by the church – which officially pushed them back home and into the domestic sphere. By the end of the war things had drastically altered: their massive participation in the productive world – as substitutes for blue-collar workers, tram and truck drivers, and in other jobs that the participation of men at the front lines had left vacant – encouraged changes that were irreversible.[65] Even though the massive return of *reduci* from the war forced women back into the home, their experience in the highly socialized 'world out there' left permanent traces in their self-perception. Further, the right to vote, acquired in 1946, marked a new political force for women. After the war, women refused the ideologized – though by no means universally accepted – role of 'angel of the hearth' and 'exemplary wife and mother.' For instance, in *L'Onorevole Angelina*, Anna Magnani, in the leading role,

clearly addresses the issue by saying to her husband: 'Non ti ricordi quando facevi la campagna demografica a spese mie? E' roba che se non veniva il 25 luglio [*n.d.r.* data della Liberazione] io ero ancora a fabbricà fiji come una macchinetta.'[66] With this statement, Magnani recalls the role of forced re-producer to which women were subjects under the Fascist state.

In the postwar context several directors explore female psychology in depth and widen their focus to include previously ignored or under-reported aspects of women's lives. Women are situated in their everyday routine, which alternates between work, leisure, and domestic duties. The attention to the real, and to a cinematic style close to it, advertised by Zavattini as a sort of 'film inchiesta' (film inquiry), helped to 'document' various aspects of women's existence.[67] Bonds of friendship among women and of intimacy with their boyfriends, conflicts with parental figures, relations to the incipiently commodified and greatly alluring world of fashion, and infatuation with the myths of the silver screen come under close scrutiny. Such a trend reaches its highest peak perhaps in 1953 with three films that I will briefly outline: *Celestina*, *Amore in città*, and *Siamo donne*.[68]

In *Celestina*, Pietrangeli rewrites with a positive and challenging ending the obsolete story of the girl who is seduced and abandoned. Celestina comes to Rome from the provinces to work as a household servant. She falls in love with a mechanic, who loves her but decides to marry the rich sister of his employer and disappears. Celestina, now pregnant, goes to look for him and finds out that he is married. Desperate, she throws herself under a tram. Her former lover appears at the hospital, overcome by remorse and his own repressed feelings. But Celestina does not want him any longer and decides to keep the baby for herself. As one of her friends notes, recounting Celestina's words outside the hospital, Celestina claims that the baby is hers and hers alone and that she wants to keep him ('dice che il bambino è suo, solo suo e se lo vuol tenere'). Celestina no longer 'needs' or wants her boyfriend since she can count upon a very supportive network of female friends, namely, the domestics who first helped her integrate into city life and find a job, and who will keep helping her to cope with her present situation. What is at stake here is not the emotional fulfilment that a relationship could provide or relationships per se (as it is, for instance, in Antonioni's work or Rossellini's work with Bergman), but the fact that Celestina and her baby can exist without being legitimated by their – more or less official – link to a male figure. In this supportive atmosphere, Celestina's having

an 'illegitimate' child doesn't result in thorough social discredit or into her beginning a career as a prostitute.[69]

In *Celestina*, Pietrangeli investigates a fairly new sociological feature that is repeatedly addressed in other films of the time: that of peasant girls who come to the city looking for a job as domestics and who enjoy a new, heretofore unthought of, freedom. The 'Paradiso per tre ore' episode in *Amore in città* is about the life of these girls and provides data about a labour force that amounts – as a voice-over explains in the film – to 600,000 women. These girls are portrayed as both economically independent and untied to a traditional family structure; they are often, like Celestina herself, orphans. The phenomenon is represented as widely trans-regional, as shown by Pietrangeli's actresses, who speak dialects from several regions. They have Sundays free, and on Sunday they usually meet their friends in some *balera*, or ballroom, or go riding motorcycles, the vehicles that permit a new mobility and a promise of new intimacy for couples. Women thus inaugurate a new economy of (sexual) leisure, forecasting a change in habits that also affects men and paves the way to more rewarding, freer relationships between the sexes.

Amore in città is a film structured in episodes that result from the co-operation of an extremely engaging generation of young filmmakers, some of them making their debut: Zavattini, Antonioni, Fellini, Lattuada, Lizzani, Maselli, and Risi. The style is a documentary one, since the film is conceived as a sort of 'cinegiornale,' or film-newscast, entitled *Lo Spettatore* (The Spectator) that has seven episodes; each episode centres around a different aspect of love considered – with the exception of Lattuada's piece – from women's points of view.[70] The film is significant because it concentrates on female protagonists – both as individuals and as a group – in different situations and environments. Often directors take a stand and vividly denounce the social exploitations of which women are victims. For instance, in 'Un' Agenzia Matrimoniale' (Fellini), we have an undercover journalist who tries to investigate how the agency works by presenting himself on behalf of a rich friend. He wants to find a wife for a character he has invented: a friend who is mentally unbalanced and has a mysterious disease. According to an already Fellinian icon, this friend is a werewolf. Nevertheless, through the Agenzia Matrimoniale *Cibele* (another ironic name, since it refers to the homonymous orgiastic deity) he finds a very naive girl eager to sacrifice her life for this man's happiness. Even after she has found out about his various illnesses, the girl asks: 'Is he a good man? Because I get attached very

easily' ('Ma è buono? Perchè io mi affeziono'). Puzzled by the sacrificial attitude of the girl and even by her disappointment when she finds out that the character has been invented ('lo sapevo che non era per me' – 'I knew it was not for me'), the journalist wants to wake her up and tell her to be more optimistic and trusting in the possibilities of encounters that life could present to her every day ('volevo dirle di avere più fiducia in se stessa ... che aprisse gli occhi all'infinita possibilità di incontri che la vita presenta ogni giorno').

Another episode, which means to denounce women's exploitation, is the one about Caterina Rigoglioso (Zavattini/Maselli – the episode is co-directed), who plays herself. The girl comes to Rome from Sicily, is seduced and abandoned, and, in order to keep working as a domestic, gives her baby to a wet nurse. The wet nurse cannot keep the baby because Caterina does not have enough money to pay her. Having taken the baby back – after a 'chase' by the wet nurse – Caterina goes to all kinds of state and church agencies in order to find the help she is seek-ing. She cannot go back to Sicily either, since her family has rejected her. The only alternative she sees is that of abandoning her baby in a public park. The day after she abandons it, newspapers publish informa-tion about the baby having been given to an orphanage, and she goes back and asks for him. The public is moved by her dramatic story and several people offer her work. The directors, Zavattini and Maselli, give Caterina's story a Neorealist, documentary flavour and try to stir empa-thetic feelings for Caterina, who is depicted as the victim of a cruel and pitiless social system – a system that forces her to abandon her own child. Unlike what was likely to happen during the *Ventennio*, she can keep her child, without shame, and can attempt to become financially self-reliant.[71]

The third film, which analyses in detail women's motivations and psy-chology, is *Siamo Donne*. The film, whose original subject was proposed by Zavattini, is a multi-director one and recounts a Cinecittà contest for a new actress, 'Quattro attrici e una speranza.' Alfredo Guarini films the initial episode, which takes place in Cinecittà, while the ones concern-ing Isa Miranda, Alida Valli, Ingrid Bergman, and Anna Magnani, who all play themselves, are filmed by Zampa, Franciolini, Rossellini, and Vis-conti. Each actress relates an unglamorous episode of her everyday life, showing the woman who hides behind the star's mask.[72] These actresses already represent, in themselves, distinct aspects of femininity. They portray different kinds of women: the way each of them embodies femi-ninity, besides their individual character, turns out to be historically spe-

cific or, rather, defined along chronological lines. Both Miranda and Valli were famous during the *Ventennio*, whereas Bergman and Magnani undoubtedly belong – the latter as a cinema actress – to the postwar. These actresses thus offer a stimulating mixture of 'before' and 'after.'

Isa Miranda (1905–82) – the true female 'star' of the *Ventennio* – is the most old-fashioned of the four, linked as she is to an expressionist image of the *femme fatale*, modelled – unsuccessfully – after Marlene Dietrich. In 1938 she tried her fortune in the United States; her move to Beverly Hills proved unsuccessful though, and she returned to Italy. Alida Valli (1921–) during the regime played mostly the role of a young, imperti-nent, but good-hearted girl, or else that of a proud, austere lady, an abandoned lover, or a first-class prostitute. After the war, she had to wait until the huge success of *Senso* in 1954 to fully re-establish herself in the eyes of Italian critics and spectators. Ingrid Bergman (1915–82) was already internationally renowned as a Hollywood star – she had done *Casablanca* (1943) and *Notorious* (1946) – by the time she went to Rome to work with Rossellini in *Stromboli terra di Dio* (1949). Anna Magnani, as I will explain shortly, is the woman who represents Italy's postwar resur-rection.[73]

While the actresses recount one episode of their lives, hundreds of girls push each other at *Cinecittà*'s gates, pursuing their dreams of begin-ning an acting career. The director, Guarini, illustrates in particular the fantasies of Anna Amendola (co-winner of the contest with Emma Danieli). Throughout the competition, Amendola thinks of her mother and of the disagreement they had about her participation in 'Quattro attrici e una speranza.' In order to participate in the selection, Anna sleeps at a friend's place, since her mother will not allow her to come back home if she follows her dream.[74] This is the first step towards self-assertion: leaving the house, and therefore departing from, in this case, the 'castrating' authority of the mother. The mother's authority is cas-trating inasmuch as she subscribes to a male point of view in the upbringing of her daughter, thus posing as a guardian of her daughter's *serietà*. Early in the morning, while preparing herself to go in front of the mirror, we hear her voice-over explain her difficult relationship with her mother. She tells how her mother does not understand and validate her choice, and therefore how difficult it is for her to struggle with a dif-ferent image of femininity that she wants to construct for herself, and how difficult it is to have such an image approved, in genealogical terms, by one's mother. Then, when she arrives at Cinecittà, hundreds of young girls push around the gates. A few are allowed to enter, and

while they are eating in half light – a free meal is offered by the produc-
ers – the jury selects another dozen girls to be interviewed by the direc-
tor Guarini. The camera searches the room from atop, with crane shots
that zoom in on individual girls, 'gifting' them with a gaze, that of the
(male) director, that could change their life. In a very similar way to
what happens in *Bellissima,* the camera and the person who looks
behind it are endowed with a sort of omnipotence. The gaze of the cam-
era turns the aspiring girls who sit quietly at their tables into mere
objects to be scrutinized from top down as merchandise upon a shelf, so
that the process of objectification women undergo while pursuing their
dream of success is clearly noticeable in these shots.

In part documentary, in part late Neorealist, *Siamo Donne* analyses the
different aspirations and desires of these young women, showing a quite
varied group: the thirteen-year-old with braces, the voluptuous woman,
the young girl from the province accompanied by her mother, and the
independent girl. They also show a more 'humane,' less fatal aspect of
renowned actresses, thus making them more available to spectators as
simply women and not 'divae.' With their different, more or less seduc-
tive attire, the participants in the contest all explain why they are
attracted to the world of the cinema: they want to achieve success,
money, independence. By the end of the film's first section, Anna's
mother appears in a taxi just as a loudspeaker diffuses the girl's name.
The two look at each other and we can see a warm approval in the
mother's eyes. Amendola can indeed be acknowledged by her mother,
but only after she has pursued her own unconventional desire in soli-
tude and against her mother's will; when, finally, her transgression has
proved fortunate.

Celestina, Amore in città, and *Siamo donne* all focus on female protago-
nists and present their different personalities and attitudes. The spec-
trum within which they are scrutinized covers an ample range. Elements
such as class, age, social status, profession, and goals are taken into
account and contribute to the creation of an extremely rich, varied, and
heterogeneous female world. These films reflect a marked interest in
women as protagonists – I would suggest as 'subjects' – and expose some
of the domestic and social violence that oppress them. This latter aspect
is connected to a new awareness of the implications of females' exploita-
tion as sexual objects. In the episode 'L'amore che si paga' (in *Amore in
città*), prostitutes are seen as women with problems and sad personal sto-
ries. The director (Lizzani) follows them at dawn to their homes in the
outskirts of the city, usually to a squalid empty room where, in some

instances, a baby sleeps. Both Celestina and Caterina Rigoglioso are portrayed as victims of their inexperience and of their abandonment by selfish partners. Furthermore, there is a new attention paid to their aspirations and to their desire to be more independent and insert themselves into society, not only as mothers and wives.[75]

'La' Magnani, or about Motherhood and Visconti's *Bellissima*

From this polyhedral female world emerges an actress who incarnates the hopes and ideals – at least some of them – of reconstruction. This actress is Anna Magnani. Passionate, generous, fierce, aggressive, and sweet all at the same time, capable of expressing an ample range of emotions in unforgettable ways, intense yet irresistibly comical, Anna Magnani comes to the screen as an untamed force of nature: a powerful and instinctual woman. Beginning with her interpretation of Pina in Rossellini's *Roma città aperta* (1945), she incarnates the woman of Italy's reconstruction. She is portrayed as a direct and upfront character, idealistic and incapable of filthy compromises. She offers both a literal promise of rebirth – she is pregnant – and hope of moral regeneration, a regeneration that is linked by Rossellini to her lower-class status.[76] In the film Magnani – a positive female archetype – is opposed to several negative female figures: to Marina, who betrays her lover for some cocaine and – led astray by the myth of wealth and financial security – sacrifices her integrity, both sexual and moral; to her sister, who is co-opted into Marina's choices, and will more likely follow in her footsteps as a dancer and occasional prostitute; and to the German lesbian who corrupts Marina, controlling her through her drug addiction. Rossellini creates a far too explicit semiotic paradigm for his characters, in which to be foreign – in this case German – or influenced by foreigners, as in the case of Marina, amounts to being bad, and in which to being Italian amounts to being good. Rossellini's attitude thus demonstrates clearly xenophobic and particularly anti-American sentiments and corroborates Ben-Ghiat's thesis. Ben-Ghiat implies that Italians in the postwar period dealt with their sense of guilt by displacing onto some 'other,' preferably foreign, their responsibilities.[77] The director also implicitly attacks the Hollywood star system, which, according to him, induces moral degeneration and is represented by Marina's addiction to cocaine. Marina's association with Hollywood can also be inferred by her bedroom, whose furniture – particularly the shell-shaped head-frame of the bed – recalls the interior of a star's room. To the ethical derange-

ment of American women represented by their actresses, Rossellini thus opposes the spontaneous and sincere generosity of a thoroughly Italian character: Magnani.

Not yet, or perhaps not only, an eroticized body, Anna Magnani portrays a woman who has a great capacity for feeling and nurturing. She is 'the' mother. Her identification with motherhood follows a traditional role for women, evidencing a clear continuity with Fascist dictates – dictates that are, nevertheless, fading away (for instance, in the film, she is pregnant before she gets married, and desires to marry her 'Communist' lover, although she already has a child, only because of her sincere religious sentiment, and not for social conveniences). The war – Rossellini seems to suggest – has quickly changed the life of Italian families. Pina and her sister are apparently orphans; therefore they do not have to respond to a father or to a mother for their behaviour. Further, many unrelated people live in one apartment, in an evident promiscuity that renders sexual matters less private. Pina's sister's job – something in between dancer and 'entertaining woman' for German soldiers or officials – is known to everybody, but not particularly stigmatized. The element of a limitless potential for nurturing – but also for living an intense emotional relationship with her husband-to-be Francesco, as the famous scene in which she runs screaming behind the German truck that had captured him demonstrates – characterizes Magnani at this time, and she creates a protagonist who is strong, warm, combative, and courageous. These aggressive characteristics are carried on to her next film, *L'Onorevole Angelina* (Zampa, 1947), in which she – the mother of five children – guides a group of women of the *borgate* to fight for better housing, lower prices, and new opportunities for their families. Her rhetoric and belligerency fuel other women's responses and she becomes – at a time when women had just gained the right to vote – a dangerous threat to corrupted politicians and entrepreneurs.[78] In Angelina's family we witness one of the first interesting examples of gender reversal of the postwar period. Angelina's husband, who is a public official, feels helpless in his family since his role has been 'expropriated' by his wife: 'Me so accorto che non servo a niente. Uno di questi giorni me ne vado da casa.'[79] By the end of the film, though, Angelina renounces her activism. After having spent some time in prison because of her illegal occupation of some houses, she privileges her family once again. As she says, 'Per fare la politica la famiglia m'andava per aria e io ai regazzini miei ci tengo,' and 'la famiglia è una gran cosa.'[80] She thus ends up reiterating the traditional dichotomy that opposes – with no

possible conciliation – the public and the private sphere, and she defines herself essentially as a mother, an identity that clashes, at this time, with everything else. The film has a conservative – almost reactionary – ending, but nevertheless it explores the social construction of gender and illustrates the burden of those domestic duties that weighs on women – duties that are usually regarded as 'naturally' theirs.

It is in *Bellissima* (1951) that, finally, the maternal role which Magnani plays addresses more intense psychological aspects, and comes to include a genealogical bond whose intensity and emotional vigour resonates with Banti's and de Céspedes's stakes, and with Diotima's theoretical framework. In *Bellissima* Magnani both denounces and refuses women's objectification under patriarchy and claims full, exclusive agency towards her daughter. Maternal genealogy, though, is not the only concern of the film that also powerfully addresses postwar cinema consumption. The matter was extremely cogent in 1951, since going to the movies became, soon after the war, the preferred hobby of Italians, as film historian Gian Piero Brunetta documents:

> Il numero delle sale rimaste in piedi, alla fine della guerra, si aggira sulle cinquemila unità, nel 1948 è di 6.551 e nel 1956 ha raggiunto il numero di 10.500 (a cui vanno aggiunte le 5.449 sale parrocchiali che dispongono di un milione di posti.) L'incremento intende assicurare un'attività a tutti i centri italiani con almeno 5.000 abitanti ... il 1948 è un anno chiave per la corsa agli investimenti in sale cinematografiche. Rispetto al 1938 si può registrare un numero di sale doppio e un aumento del 75% dei biglietti venduti.[81]

Such an enormous consumption implies both movie-going as a practice in itself and, more particularly, the entire *immaginario* that the cinema fosters, for the cinema now teaches people how to look and how to behave in a 'modern' way.

While Italians are, in this period, the most voracious consumers of films in Europe, Cinecittà, the Italian Hollywood, becomes an alluring magnet for women by promising to make their dreams and aspirations come true.[82] Cinecittà is in fact an integral part of a large-scale 'manufacturing of dreams' (as we have seen in *Siamo Donne*), which also includes photojournals such as *Hollywood* (1945–52), *Grand Hotel* (1946–), *Bolero Film* (1947–) and *Sogno* (1947–), whose publication started in those years and encountered extraordinary success among semiliterate readers.[83] As Eve Sullerot reports:

Il fotoromanzo permise quello che né la stampa né la radio erano mai riuscite a fare in Italia: penetrò negli strati di popolazione che non erano mai stati sfiorati dai mezzi di comunicazione di massa: in modo particolare il Sud e le donne. Migliaia di donne che non avevano mai letto niente si misero a leggere con passione e frenesia le inverosimili storie in fotogrammi di *Grand Hotel, Bolero, Sogno, Tipo.*[84]

Women dream – eyes wide open – while gazing at the pictures of photojournals; parallely, their fantasies seem to have a chance to materialize thanks to a new event imported from American culture: the beauty contest. The most famous among these contests was 'Miss Italia,' which began in 1946. A good many actresses of the first decade after the war – Lucia Bosè, Sophia Loren, Gina Lollobrigida, Silvana Pampanini, and Silvana Mangano, to name only a few – were discovered through beauty contests, which soon turned into a launching pad for women in cinema.[85] For a woman to become an actress was seen as one of the ways out of a world of misery or monotony: it promised success and, more importantly, wealth, and embodied a possibility of independence and social promotion. Men, with analogous expectations, of course, also pursued these targets. Aspirations to this kind of success and wealth are clearly readable in *Bellissima*, and in what Magnani repeatedly states: 'Voglio che mia figlia diventa qualcuno. Sì, voglio che mia figlia diventa qualcuno. Ce l'avrò o no 'sto diritto o è un delitto? Non deve diventare una disgraziata mia figlia. Non deve dipendere da nessuno.'[86] Allured by the myth of fame and success, and, more specifically, of financial self-sufficiency, she presents her daughter, in the film's diegesis, to a selection contest in Cinecittà held by Alessandro Blasetti.

The choice of Blasetti (1900–87) – an element that mingles reality and fiction in a confusing way, just to underline the cinema's potential to create ephemeral illusions – is not casual.[87] Blasetti is one of the pillars of Italian cinema: one of those figures who, along with Mattoli, Soldati, and Camerini, contributed in the thirties to the creation of a national tradition. Active under Fascism and amply involved in the Centro Sperimentale di Cinematografia as a teacher, director, and critic, Blasetti was an expert in mass choreography and in epic film. Before the war, he directed some of the most impressive costume films of Cinecittà, *Ettore Fieramosca* (1938) and *La corona di Ferro* (1941). In 1948 he authored the first European co-production, *Fabiola*. Blasetti did share with Fascism a populist, patronizing attitude towards the lower classes, evident, for instance, in *Vecchia guardia* (1934). At the same time, he

gave voice to the dissatisfaction of the urban employee and showed the grayness of his daily, alienating work routine. He also directed two works that are considered forerunners of postwar Neorealism: *1860* (1934) and *Quattro passi tra le nuvole* (1942). Visconti chose Blasetti, a fundamental figure of Italian cinema, precisely because of his celebrity, in order to give a 'realistic' impact to the story he narrates. In the Italy of the time, there is no doubt that he *did* represent the cinema: this is why having him play the role of a film director is crucial for Visconti's critique of the false myths of the silver screen.[88] But let us see how the narrative unfolds and how we can connect the two main themes addressed: female genealogy and critique of the cinema as a mechanism that creates unrealistic expectations.

In the film, Blasetti is looking for a girl six to eight years old for his next film and launches a contest in Cinecittà. Hundreds of mothers show up with their daughters. Amidst them is Maddalena Cecconi, played by Anna Magnani. Married to a blue-collar worker, Maddalena works as a part-time nurse, making house visits. She lives in a huge and decrepit building, a *casamento* similar to the one described by de Céspedes in *Dalla parte di lei.* Like the other mothers, Maddalena deeply desires to have her daughter selected for the contest, and the *provino,* or screening, thus becomes an obsession for her. In direct competition with other mothers, she tries to provide Maria with everything that could help her to win: expensive pictures, dancing lessons, a special tulle outfit, acting lessons, and a new haircut. As the selection proceeds, she realizes that she needs a recommendation and resolves to ask for it from Annovazzi, a young hoodlum who lives on expedience and whom she meets on her very first day in Cinecittà. Annovazzi convinces Maddalena that he needs 50,000 lire just to send gifts to important people. He instead uses the money to buy a motor scooter for himself. Maddalena understands that Annovazzi has cheated her, but considers the money – a down payment for the house she and her husband are trying to buy – among the costs she has to incur in order to have Maria win the contest. The girl finally qualifies for her *provino.* While Blasetti and his crew evaluate all the *provini* in a special projection room, Maddalena obtains permission to hide herself with the projectionist. From her hiding place she hears the jury laugh at Maria's performance because, unable to blow out the candles on a birthday cake, she starts crying. The jury laughs and laughs and makes fun of Maria; somebody calls her a *nana,* or dwarf. Maddalena, hurt by the comments of the jury, goes downstairs to talk to Blasetti, still hoping to have her daughter considered for the role. She leaves

Cinecittà distraught. Meanwhile, Blasetti orders a rerun of the *provino* and selects Maria. When Maddalena comes back home, still tragically hurt, she sees the 'aiuto' and Annovazzi waiting for her to sign a fabulous contract for two million lire. But she refuses to sign it.

In *Bellissima* – and once again as part of women's self-inscription into their own objectification (even though through the gaze of a male director who, to complicate the picture even further, does not align himself with the gaze of Blasetti) – the mothers try to live a dream of notoriety through their daughters. It is the mothers who, according to a less-studied aspect of Freudian psychoanalytic theory, are not able to perceive themselves as differentiated from their daughters, thus felt as their alter egos. Having been unable to acquire some kind of status for themselves, the mothers now fix everything on their daughters, who embody their narcissistic self-extension. Furthermore, the mother of the film, Anna Magnani, decides what her daughter is able to do – become an actress – and enables her to pursue a desire that is essentially hers. Indeed, by legitimating her daughter, Maddalena legitimates herself and gives herself permission to pursue an otherwise hopeless dream. One of the main reasons why Maria Cecconi would be able to become an actress – 'Tu sì che la puoi fare l'attrice' ('You certainly can become an actress,)' Maddalena tells her daughter – is because she, Maddalena, is convinced that she too could have made it, had circumstances been different: 'Io pure se avessi voluto ...' ('Me too, if only I would have wanted it ...'), she says to herself in front of the mirror.

The mirror scene is crucial because it clarifies the process by which Maddalena projects her own personal aspirations onto Maria. She is alone in her bedroom. The mirror faces the viewers who, as spectators, are situated in the same position as Magnani; simultaneously, Magnani exchanges her role with us and puts herself in the position of an (invisible) spectator, thus turning her own reflection into a spectacularized image. She doubles herself, being, at the same time, her own spectator and the actress she looks at. The doubling, the multiplying of selves she lets herself fantasize about, is indicated also by a small mirror situated at the left-hand-side lower corner of the big central one. On the small mirror we see Maddalena's reflection from a slightly different angle. The editing continuously intersects shots of the big and the small mirrors, amplifying the persona she could become, while the lighting, with its subtle halo, glamorizes her face. In this doubling, she replicates the illusion of many women – among them Alessandra's mother in de Céspedes's *Dalla parte di lei* – who read novels and identify with their

heroines, thus creating for themselves 'fictional' identities. Maddalena is alone in the nuptial bedroom that signifies her position of married, and therefore dependent, woman. (Autonomy, self-sufficiency seems to be an important value for Maddalena, who desires that her daughter not depend upon anybody.) In this space of solitude, within a private sphere that is so typically female, which amounts to a moment of truth and self confession, a moment in which a woman can allow her dreams to emerge without censoring them, Maddalena interrogates herself. 'In fondo che è recità' ('What is acting, after all?'), she asks herself, combing her hair with theatrical gestures. 'Se io mo' mi credessi di essere un'altra, se facessi finta d'essere un'altra, ecco che recito.'[89]

In the isolated space of her room Maddalena creates a possible myth of herself for a few seconds: she only needs 'to imagine' to be different and she 'will' be different. To believe in the illusion makes the illusion real; to 'act' a character means to become it. Illusion provides an escapist route that is, however, precisely because of its fictional nature, extremely dangerous. On the one hand, it allows Maddalena to evade her everyday routine; on the other, it does not endow her with a coping system for coming back to real life, therefore fuelling her frustrations. As if waking herself up from a dream state, after having been self-absorbed in her potential fictional self, she remembers her daughter – the 'other' and yet 'same' self through which she can give herself a second chance – calls her close and starts checking her pronunciation. Maria stutters, and Maddalena tries to correct her but, in controlling Maria's pronunciation, she controls her own, too, in a funny echoing of 'scola'/'fcola' pronounced by her, then by her daughter, then by herself again, 'casa'/'cafa,' and the like. She checks her own pronunciation against that of her child, assuming Maria might have taken her wrong diction from her. In so doing she reiterates that symbiotic link through which mother and daughter are so connected as to be interchangeable, and thanks to which Maria represents the tool through which Maddalena pursues her own dream of economic/social redemption. After her few seconds of self-absorption, Maddalena looks at the picture of her husband – a clear call back to the reality principle – inserted in the frame of the mirror in front of her, and jokingly tells him: 'Te 'n te va, eh?' (You wouldn't like that, would you?'), thus putting an end to her dream. While Maddalena, being a married woman, could no longer try anything, Maria, who is still a child and therefore not yet inserted into an adult economy of gender (even though, paradoxically subsumed into it, because of her mother's identification with her), has more options.

She is a last resort through which her mother tries to rescue her own destiny. ('Ci ho puntato tutto su di lei,' 'I invested everything in her,' Maddalena later tells a female camera-operator.) But the daughters – this is the problematic issue – actually turn out to be as, if not more, objectified as their mothers are within patriarchy. The process of their commodification is very explicit.

In the opening sequences of *Bellissima*, the little girls line up with their mothers in a wide room in order to be considered for selection by the director Blasetti and his crew, which is exclusively male. Blasetti and his entourage become the legitimate subjects of the gaze, while the girls constitute its seemingly legitimate object. A straightforward grammar of gender (male=subject, female=object) is thus put into place at the very beginning and is followed all the way through. Within this code, women – the mothers – are completely subsumed in the neuter universal as they judge their daughters according to the standards set up by the male gaze. This is evident in the first *provino*. The girl who performs imitates Betty Grable in a very provocative way, pulling her skirt almost up to her belly and exhibiting herself in a sexy performance that, given her age, seems annoyingly fake. Still, she counts on her mother, who is by her side, for approval and confidence. In this scene there is no difference between Blasetti's and the mother's position since she evaluates the girl in the same way. The second girl, with her curly hair, side ribbon, and short dress imitates Shirley Temple. There is, then, a quite explicit hint at Hollywood and the American star system that, right away, points to a spectacularization of the female body, even in these little girls. Further, it entails a critique of Italian cinema, which, after its Neorealist, socially engaged phase, has sold itself to 'exogenous' consumerist practices.[90] The criteria for selection foster an economy of consumption that turns these children into women, since, from hair style and colour to dress and performance, these little girls strive to conform to an ageless but clearly gender-specific idea of female 'spectacle.'

While some critics see Maddalena's desire for self-assertion through her daughter as an effort to escape from an unsatisfactory marriage,[91] and therefore as an attack on the 'fallocratic, patriarchal Italian family,'[92] I believe that Visconti's attack is not directed against patriarchy itself, or a 'fallocratic' family, but against the submissive role of women within it. More subtly and piercingly, Visconti attacks the movie business – where the real fallocracy lies – and the illusion-creating world of the cinema. The director does not even scrutinize Maddalena's marital ménage, since his take on family is, overall, fairly traditional. If Mad-

dalena's desire to insert her daughter into the promising world of the cinema initially disrupts her quiet family ménage, at the very end of the film, she resorts precisely to Spartaco to re-establish order. Her husband is the authoritative figure who can validate her will, and also make others, Annovazzi and crew, respect it. What Spartaco makes publicly respected is not his own, but Maddalena's desire. Further, it is Maddalena who has, notwithstanding all the obstacles, been able to pursue her dream until the very end. It is she who has sacrificed the savings for the new house they will no longer be able to buy, now that all the money has been used for Maria.

Spartaco in effect is not a champion of aggressive maleness, and the husband–wife relationship in the film appears, underneath a superficial varnish of 'machismo,' and stereotypical male slang phrases, fairly balanced. The first time we see Spartaco at his mother's *trattoria* he is caressing a small cat and is so worried about Maddalena and Maria, who have not shown up yet, that he does not even want to go to the *partita* (game). He is a very loving father, as his tenderness and care for Maria repeatedly show. As a husband he understands his wife well enough to know that, once she has made up her mind, there is no way to make her change it. Rather than Spartaco in himself, Visconti seems then to critique a social system that pressures a man into behaving like a 'traditional' male. Such pressure is shown in the film as coming mainly from his brother and, not by chance, his mother, who turns into a guardian angel of traditional, patriarchal values. Even when it seems that Spartaco – exasperated by the upsetting of family routine that Maddalena's errands for the contest have brought about – is on the verge of hitting her, Maddalena overemphasizes her role as a victim and plays it out fairly theatrically. In a confrontation that has become public – many neighbours flood into Maddalena's apartment – she challenges Spartaco by threatening that if he takes the child with him on his way out, she will never see him again. Spartaco leaves without taking the child. Visconti does not focus as much on Spartaco's and Maddalena's relationship – Spartaco sides with Maddalena in her final decision so that we can say that actually it is Maddalena who makes the final choice – but on the commodification of women enacted by the cinema.

The critique of the cinema as machinery that creates illusions that, in the next moment, it painfully crushes, badly hurting the people who have believed in it, is pivotal throughout the film, and gets sagaciously addressed in a scene that, as Lino Miccichè has insightfully indicated, takes place exactly in the middle of the film.[93] The scene is the one in

which Maddalena and Spartaco are watching Hawks's *Red River* in the open air, in the courtyard of their building. Their attitudes are opposed to one another. Maddalena, who is fanning herself with a photo-romance(!), gets seduced by the illusion of the film and fully surrenders to it. Spartaco, closer to reality, tells her that what one sees in the film is a fable, something unreal, and that to let herself believe it is dangerous. Maddalena does not listen to him and repeats, ''n so' favole, 'n so' favole' ('they are not fables, they are not fables'), and continues to harbour her illusion of a better life connected to her daughter's success in the glamorous world of the cinema. A second instance in which Maddalena is directly 'advised' about the dangers of believing in the cinema – a true anticipation that preludes the cathartic ending of the movie – takes place towards the end of the film.

Maddalena ardently wishes to see her daughter Marias's *provino*, which is going to be shown to Blasetti and his collaborators. Through the operator she finally gets the opportunity, and watches the *provino* with Maria. Maddalena talks to a young, efficient girl, rendered quite anonymous by a black apron, and after a while recognizes her. She is the protagonist of a Neorealist film, *Sotto il sole di Roma* (Castellani, 1948). Maddalena is quite surprised to see her there, and asks if she too is working in the film with her daughter – she evidently is now convinced that Maria is going to be selected – but the young actress, Iris, tells her that she has not been chosen any more by directors after *Sotto il sole di Roma*, and that, along with her illusions, she has also lost her previous boyfriend and job. She warns Maddalena against harbouring too many illusions for herself, since the cinema has created quite a few *disgraziati*, or desperate people. Here the score is particularly important in underlining the extent of Maddalena's dream, and the tragedy of its foreshadowed collapse, since it elaborates in a minor key the theme 'Quanto è bella, quanto è cara' (from Donizetti's *Elisir d'Amore*), which plays at the very beginning of the film, while title and credits are rolling down. It thus ushers in a soft moment of tenderness – which leaves room for the loving relationship between Maddalena and her child to emerge – after the entirely loud and melodramatic business of the contest. Maddalena, quite astonished and dismayed by Iris's words, feels sorry for the young girl. Nevertheless, she soon dissociates herself and her daughter from an analogous negative ending to their adventure, and says, 'Ah, così, porella, ma mica per tutti sarà uguale, signorina mia, no? Sarebbe un guaio davvero, un guaio grosso, sì, senza rimedio. Ci ho puntato tutto su di lei. Mi dispiacerebbe ...'[94]

Within the economy of consumption – both financial and emotional – that the film sets up, the ending turns into a powerfully disruptive and anticlimactic statement. Visconti sides with Magnani and, through her, with all the women she represents.[95] As I have said, Maddalena spies on her daughter's *provino* from the projectionist's booth. Even though she is in a separate space, she shares the gaze of Blasetti and his crew. She and her daughter are a replica, only displaced upstairs, of the male audience that watches the *provini* downstairs in the movie theatre. Maddalena and her daughter on one side and Blasetti and his crowd on the other thus share an onlooking gaze that we know to be androgynous, and female obliterating. But when Maddalena realizes what everybody's laughter means – a persistent, cruel mockery – she covers her daughter's eyes, denying her daughter a position as viewer, and goes down to the theatre, overcoming all obstacles with the instinctual strength of a wounded beast. She asks what is so comical and different about her daughter. Maddalena asks if people do not have any compassion. In reality, she wants an impossible thing: that these viewers understand her and that they understand not only her sacrifices, but also the powerful dream of self-affirmation she has constructed around the contest. She asks the wrong people, though, since the group of men standing in front of her think only of women as objects inserted into an economy of consumption. When she finally realizes the true meaning of their attitude and experiences such a hurtful, irrefutable truth, Maddalena withdraws from the game. She will not sell off her daughter. To Annovazzi and the 'aiuto' who waits for her at home with a fabulous two-million-lire contract she says: 'E come la volete la regazzina, coi capelli ricci o coi capelli tesi, e ha il fischio all'esse deve zagaglià. Non vi siete divertiti abbastanza, tutti. Quanto mi dispiace perchè ... perchè mia figlia ce la tenemo. Non l'ho messa al mondo per far divertire nessuno. Per me e suo padre è tanto bella.'[96]

It is by saying 'Io non l'ho messa al mondo per far divertire nessuno' ('I did not bring her into the world to amuse anybody') that Maddalena claims full, exclusive agency over her daughter and, therefore, given her thorough identification with Maria, over herself. By saying 'E come la volete, coi capelli ricci o coi capelli tesi?' ('And how would you like her? With curly or straight hair?') – she had previously had a hairdresser cut Maria's braids – she realizes that she has completely subordinated her daughter to male approval and, in fact, commodified her. So, when her impossible dream is finally possible, when a two-million-lire contract is offered to her, she withdraws. Her rejection of the contract means much

more than a foolish economic loss, one that will cost her even the house she was going to buy with the savings all used up for Maria – a loss that her 'fallocratic' husband accepts without reluctance. Her rejection is an empowering gesture through which she – the mother – untangles herself and her daughter from a position as objects in patriarchy. She also refuses the values of a consumerist (Hollywoodian) style of life that has proved unethical – consider the scum Annovazzi – and corrupt.

Another important element comes to the foreground in her final speech, wherein she appeals to her family including, beyond her daughter, her husband. In phrases such as 'mia figlia ce la tenemo' and 'Per me e suo padre è tanto bella' ('We keep our daughter with us' and 'For me and her father she is so beautiful') she uses the first-person plural, thus reconstructing de facto that nuclear family whose peace, in her fallacious dream, she had upset.[97] The family becomes the 'sane' container of moral values. Thus, while the ending points to the restoration of a traditional order, it also entails a social-political element: class cohesiveness, carved across gender boundaries. The ordinary life of the lower classes, in its female *and* male components – Visconti suggests – is far more ethical and healthy than the life of the rich and powerful, but soulless, lords of the movie industry.

chapter three

THE MYTH OF AMERICA

A un certo punto la cultura americana divenne per noi qualcosa di molto serio e prezioso, divenne una sorta di grande laboratorio dove ... si perseguiva ... [il] compito di creare un gusto uno stile, un mondo moderni.

At a certain point American culture became for us something truly serious and precocious, a sort of huge laboratory where ... we pursued ... [the] task of creating a modern taste, style and world.

<div align="right">CESARE PAVESE</div>

The Antecedent

One of the most striking features of Italian postwar culture – and one of the main guidelines according to which it is possible to read it – is its relationship with the United States. Imitating America seems to signal Italy's transition from a traditional country still based on agriculture and ruled by conservative social interactions – overseen and disciplined by the Church – to an industrialized, increasingly more urbanized and socially more atomized one. It marks Italy's plunge into modernity, *tout court*. The interaction with America was not new; however, it was in the postwar years that the relationship became more direct, for Italy's reconstruction happened under the close guidance of the American government and with its financial aid. The massive influx of GIs in 1943, the rampant attack of Hollywood producers on the Italian film market in 1945–6, and the consistent economic support provided by the Marshall plan (from 1948 on) fuelled an American myth that had already been florid in the interwar period. The myth had shaped a generation

of intellectuals and had functioned as a sort of cultural opposition to the ideological dictates of the regime. And yet, once again, Fascist policies towards 'America' show ambivalence, to the point that we can talk not only of a Fascist anti-Americanism, but also of a 'Fascist Americanism.'[1] As Emilio Gentile frames it: 'Americanism was, for fascist culture, one of the *main mythical metaphors of modernity*, which was perceived ambivalently, as a phenomenon both terrifying and fascinating' (italics mine).[2] Particularly in the 1920s young Fascist activists such as Franco Ciarlantini or Fulvio Suvich saw a great similarity between the cultures of the United States and of Fascism because of their analogous emphasis on youth and youthfulness.[3] The virgin forces of American society, which was not burdened by the past as much as Europe was, appealed in particular to futurists, who worshipped machines, speed, technology, and adventure, that is to say, a series of icons overlapping with those coming from the United States and to a certain extent, also identified with that country. In this chapter I will overview the manner in which America was perceived under the Fascist regime, paying attention particularly to the works of two writers, Cesare Pavese and Elio Vittorini, and I will later analyse how the close interaction with 'America,' after the GIs landed in Italy, affected and changed the myth. I will then reflect particularly on the works of film directors such as De Santis, whose *Riso Amaro* delineates a representation of American popular culture; Rossellini, whose *Stromboli terra di Dio* portrays a provocative syncretism between a major representative of the Hollywood star system – Ingrid Bergman – and Neorealism; and De Sica, who ventured into Italian-American co-productions with his *Stazione Termini*. I finally will analyse Pavese's last novel, *La luna e i falò*, which was written after the American myth in which the writer had so ardently believed had broken down.

As I have suggested, the fascination with American culture was characterized by ambiguity, and the image of 'America' functioned at a double level. On the one hand, it provided a sort of specular image for how to represent modernity under the Fascist regime; on the other, it was used to disclaim a cultural model perceived as too violently materialistic and unethical.[4] Particularly in the thirties – a period in which a good fifty books were printed regarding the United States – a group of writers and intellectuals, not all of them anti-Fascist, developed a strong attraction to North America, constructing, out of their fascination, an authentic, powerful myth.[5] As Cesare Pavese (1908–50) confesses: 'Verso il 1930 ... accadde ad alcuni giovani italiani di scoprire nei suoi libri l'America,

un'America pensosa e barbarica, felice e rissosa, dissoluta, feconda, greve di tutto il passato del mondo, e insieme giovane, innocente.'[6]

Along with Elio Vittorini, Pavese was one of the major contributors to the invention of the American myth – at least at a literary level. Both authors were avid readers and translators and played a pivotal role in the discovery and diffusion of American literature.[7] While Pavese was an anti-Fascist from the beginning, and was sent to internment (*confino*) in 1935, Vittorini was one of the young writers moulded in the milieu of the 'riviste fiorentine' (Florentine magazines) – a 'fascista di sinistra' (a leftist fascist) – who broke with the party in 1936.[8] While Pavese had a sound academic formation, Vittorini was a self-taught writer with a technical high-school degree, who learned foreign languages on his own. Before and after the war, they both were cultural activists, organizers, and editors. Interestingly enough, neither had ever been to the United States, a fact that helps cast a magical spell on their 'America.' In fact, they fabricated their myth almost exclusively from literary texts.

Like other writers of their generation, Pavese and Vittorini perceived Italian literature as burdened by the weight of an obsolete and stagnating tradition. For the two writers oppressed by the pompous display of *romanità*, or Romanness, prevalent in Fascist rhetoric, 'America' offered a model of an unstructured society and of a free literature.[9] Not only did 'America' provide new material for Italian readers but, more importantly, it indicated a new language in which to express it. As Pavese wrote, 'la ricchezza espressiva di quel popolo nasceva ... da un'aspirazione severa e già antica di un secolo a costringere la vita quotidiana nella parola.'[10] The novelty of American literature resided in its constant search for a 'new' language that strove to make adequate 'il linguaggio alla nuova realtà del mondo, per creare in sostanza un nuovo linguaggio, materiale e simbolico che si giustifi[chi] unicamente in se stesso e non in alcuna tradizionale compiacenza.'[11] Such language had a rapid rhythm, was anti-rhetorical, and was moulded after the live rhythms of the street, since, as Pavese stated, the American speaker ('il parlatore americano') was 'l'uomo vivo' (the alive/living man'). In Pavese's eyes, American characters belonged to the street scene in a much more direct, anti-rhetorical way and expressed its zest and vitality forcefully and directly. While the writer perceived the Italian literature of the time as a repertoire of shallow characters – characters too pedestrian, predictable, or else too 'literary' – he discovered in American literature a far more challenging, novel, and unpredictable inventory of protagonists.

Between 1930 and 1934, on the pages of *La Cultura* – a magazine edited in Turin by Einaudi[12] – the young Pavese published a series of enthusiastic articles about American authors[13] whom he proposed as models of a new narrative form. Through his reviews of their books, Pavese sketched his own America: a continent of vast, endless, wind-swept plains, traversed by trains – icons of progress. It was the country of unionized blue-collar workers, miners, and farmers; a place of massive strikes and of a mobility that allowed the continuous reinvention of one's destiny. The characters at the centre of this fictional world were not literate upper-class men and women trapped in a confused psychology but rough men and sturdy women, hobos and loners, or lusty daughters of the prairies who learned their lessons 'on the road,' face to face with life, at the docks, on ships, and in brothels. This America – whose flip side of the coin was a puritan, obscurantist provincialism – was, presumably, the place of racial mixing, a place where both the brutality of racism and the richness provided by what came later to be termed the 'melting pot' were exposed. Pavese searched for a model of realism – a search upheld by many writers in the 1930s[14] – and a new style in this literature.

Vittorini started his career as 'co-crafter' of the American myth by translating American works.[15] Along with translation,[16] Vittorini engaged in a frenetic effort to popularize American writers through numerous articles and reviews, which he published in various magazines and dailies such as *Omnibus, Oggi, Il Mattino, Il Lavoro,* and *Letteratura.* Unlike Pavese, who was mainly a writer and a politically committed editorialist, Vittorini had the true vocation of a publisher and rapidly extended his cooperation from Einaudi to Mondadori to Bompiani, proposing new authors for translation and planning new series. Unlike Pavese, he constantly intervened in his chosen texts with editorial cuts, seeking to 'improve' the originals.[17] Vittorini aimed at appropriating America and adapting it to an Italian sociocultural code, thereby stressing his own 'fictional' contribution to the shaping of the myth.

Vittorini, in a different way than Pavese, promoted a constant circulation of ideas that culminated with his work as a journalist for *L'Unità* (Pavese and Calvino also worked for the paper) and *Milano Sera,* and, in particular, with the establishment of *Il Politecnico,* published by Einaudi between 1945 and 1947.[18] During the *Ventennio* Vittorini became one of Italy's major experts on North American literature (between 1933 and 1938 he 'translated' more than ten novels), and in 1940 he submitted a project for a vast anthology to be called *Americana* to Bompiani. The

project was ambitious and required the cooperation of many writers and journalists, but when the anthology was already printed, in 1941, it was censored by the then minister of popular culture (Minculpop), Alessandro Pavolini.[19]

The regime's increasing opposition to the translation of North American writers clarifies a central aspect of the American myth of the thirties, that is to say, the oppositional role that this myth came to play within the cultural economy of homologation fostered by Fascism. 'America' opened in fact an implicit space of dissent, as Pavese clarifies retrospectively:

> Il sapore di scandalo e di facile eresia che avvolgeva i nuovi libri e i loro argomenti, il furore di rivolta e sincerità che anche i più sventati sentivano pulsare in quelle pagine tradotte, riuscirono irresistibili a un pubblico non ancora del tutto intontito dal conformismo e dall'accademia ... Per molta gente l'incontro con Caldwell, Steinbeck, Saroyan, e perfino col vecchio Lewis, aperse il primo spiraglio di libertà, il primo sospetto che non tutto nella cultura del mondo finisse con i fasci.[20]

America functioned, then, as a collective utopia (in the etymological sense of a place that does not exist), as a dis-placed realm of the *immaginario* that allowed intellectuals to create an energetic and lively alternative to what was increasingly perceived as the grey cultural landscape of Fascism.

Not everyone, though, agreed with such a positive portrayal of America, and the same early fascination by certain Fascist intellectuals started to dwindle. Among the many works written in this period, two books stand out: Mario Soldati's *America Primo Amore* (1935) and Emilio Cecchi's *America Amara* (1938.)[21] The two volumes – both accounts of their authors' first-hand visit to the United States – worked in a direction opposite that of the Vittorini-Pavese line and deconstructed its optimistic enthusiasm. Soldati (1906–2000) arrived in America in 1929, during the Great Depression. He was only twenty-three years old and eager to start an academic career at Columbia University. His encounter with New York was ambivalent and fluctuated between passionate and depressed evaluations. Apart from the obvious lure of the city, Soldati was struck by the anonymity that marked everyone's life. In the suburbs, crowded by small houses and tiny annexed gardens, which reappeared with a monotonous regularity, Soldati perceived the desolating erasure of one's individuality. The loss of one's identity was for him particularly

painful in the case of Italian Americans. No longer Italians and not yet Americans, these people lived in a liminal state, filled by the luminous dream of one day acquiring their green card, which would have sanctioned their final integration into the United States, that is to say, would have granted them citizenship.

Emilio Cecchi – who was also an expert in English literature and in 1935 published *Scrittori inglesi e americani* – distributed his book in 1939. At the time Cecchi (1884–1966) was a more renowned public figure than Soldati. A famous editorialist for the *Corriere della Sera*, art critic, writer, and director of Cines Studios since 1931, Cecchi enjoyed a position of respect among intellectuals of the Fascist period. This was perhaps also the reason why his extended reportage from the United States ended up being aligned with the increasing anti-Americanism of the regime. In 1938, because of Italy's stricter alliance with Hitler, the government promulgated the racial laws through which it enforced its discrimination against Jews, which had been fairly mild up to that point.[22] Cecchi, with his vivid and fluid prose, talked about blacks in not completely negative terms – he denounced, for instance, the atrocities of lynching – but with a prevalently patronizing attitude, which extended to Jews as well. He showed his empathy for the regime's inclinations by criticizing all the writers that both Pavese and Vittorini praised. Moreover, he painted a thoroughly unflattering picture of American intellectuals and academics. There exist no consistent data on the circulation of Soldati's and Cecchi's books, but it seems reasonable to infer – given Cecchi's culturally outstanding position – a certain popularity for *America Amara*.[23]

Another important facet of the American myth of the thirties was cinema. Fascist guidelines, as we have seen in chapter 2, were both more loose and more ambivalent in film than in literature, at least up to 1938, when the minister of popular culture enforced an embargo against American films that drastically reduced their circulation in Italian movie theatres.[24] America became Italy's official enemy in 1942, but, as Umberto Eco recalls, 'anche nei casi di più violenta propaganda bellica, il nemico odiato era l'inglese, non l'americano.'[25] The 1938 embargo attempted, successfully, to safeguard national film production, while also opening Italian theatres to German films. In the same year the government also prohibited American characters in cartoons.[26] Italian audiences began a Hollywood 'fast' that lasted almost seven years.

The attitude of Fascism towards American cinema was complex and many-sided, and marked by an intrinsic, consistent ambiguity. As James

Hay has demonstrated, sentiments of both hostility and admiration were combined in establishing the contradictory Fascist policy towards Hollywood.[27] The ambivalence stemmed both from economic concerns about the protection of the Italian industry (between 1925 and 1930 80 per cent of the films seen in Italy were American) and from the political desire to defend a national cultural image. As Victoria De Grazia points out, behind the admiration for Hollywood cinema lies a 'logica che p[uò] giustificare sia un servile americanismo sia un veemente anti-americanismo, o come si verific[a] negli anni '30, entrambi contemporaneamente.'[28] Such a twofoldness, which entails a logic of attraction/rejection – is literally embodied by Vittorio Mussolini, one of the Duce's sons and the director of *Cinema* magazine. As Umberto Eco recalls, Vittorio was an enthusiastic fan of American movies:

> Vittorio apparteneva a un gruppo di giovani leoni affascinati dal cinema, come arte, come industria, come modo di vita [e] ... voleva essere il pioniere dell'americanizzazione del cinema italiano. Nella sua rivista 'Cinema' egli criticava la tradizione cinematografica europea e asseriva che il pubblico italiano si identificava emotivamente solo con gli archetipi del cinema americano.[29]

After returning in 1937 from a visit to Hollywood – where he was received with no great enthusiasm – Vittorio Mussolini was convinced that the future of Italian cinema lay in the emulation of Hollywood.[30] And, in fact, Cinecittà, inaugurated by the Duce himself in 1937, aspired to be both a replica and a competitor of Hollywood.

That young people overtly nourished themselves on American movies is a fact recalled by writers/intellectuals as different as Italo Calvino (1925–86) and Giaime Pintor (1919–43).[31] In 'Autobiografia di uno spettatore' Calvino – who had been cinema reviewer for the daily Il giornale di Genova – remembers how important the cinema was to his own formation: '[Ne]gli anni tra diciamo il Trentasei e la guerra ... il cinema è stato per me il mondo.'[32] Further, the cinema he craved for was American: 'Non ho ancora detto, ma mi pareva sottinteso, che il cinema era per me quello americano, la produzione corrente di Hollywood.'[33] For Calvino, American cinema shared those same utopian qualities that Pavese looked for in American literature, and again American cinema was read as an alternative to the official culture of the time. Within Fascism, as Calvino states, American cinema 'risponde[va] a un bisogno di distanza, di dilatazione dei confini del reale.'[34]

For Giaime Pintor, too, American cinema was a true discovery, and a pivotal episode in the formation of his own *Weltanschauung*.[35] In an article entitled 'La lotta contro gli idoli,' published posthumously in *Aretusa* in 1943 in support of the anthology *Americana*, Pintor acknowledged that, after the 'forced abstinence' from American film due to the 1938 embargo, it was now possible to assess its impact on his generation: 'Ora che un'astinenza obbligatoria ci ha guariti dagli eccessi di pubblicità e dal fastidio dell'abitudine si può forse ricapitolare il significato di quell'episodio educativo e riconoscere nel cinema americano *il più grande messaggio che abbia ricevuto la nostra generazione*'[36] (italics mine).

Even though one should be cautious in generalizing from Pintor's statement by extending it to his entire generation, such a statement nevertheless provides a key for reading the powerful and yet contradictory fascination that American culture provoked in the era between the two world wars.

Revisionism at Work: Cesare Pavese and Giuseppe De Santis

When Americans landed in Sicily in 1943, there was a multifaceted and yet prevalently positive myth about their culture and a mass support that clashed with Fascist directives.[37] The actual arrival of American troops seems – even though not immediately – to have negatively affected the myth. Why and how? The answer is not simple, straightforward, or univocal. First of all, no other European nation experienced, as Italy did, such a conspicuous and extended presence of America on its soil during and immediately after the war. Having landed in Sicily and facing the population's diffidence and the Badoglio government's confusing policy, American troops started their journey north. They headquartered in Naples – where their presence was consistently felt and created a 'culture of occupation' destined to leave lasting traces – and then headed north towards Rome, which they occupied in 1944.[38] In the process, Americans provisionally transformed Italy into their own land. They placed their own street signs along the roads (see, for example, in *La vita ricomincia* [Mattoli, 1945]: 'Speed limit 25 miles') and fostered a sort of *lingua franca* that mixed basic English and Italian words. They distributed cigarettes, chocolate, and canned food and also promoted a side 'leisure industry' for their troops that included theatrical shows and exhibits along with the services of 'segnorine,' the euphemistic name given to prostitutes. They targeted not only their own internal audience, but also the Italian one, actively trying to construct a culture

of consent apt to promote a strong philo-Americanism, which should have influenced Italian political choices.[39] In America at this time there was an increasingly stricter and more dogmatic anti-communism that reflected upon American foreign policy. In the U.S. strategy of control, one of the privileged instruments to elicit consent was Hollywood production in itself. Along with it went the media campaign organized by ERP (the European Recovery Program, or Marshall Plan). While, with the end of the embargo in 1946, 600 American movies arrived on Italian screens – that is to say, 80 per cent of the imported production – thereby flooding Italian screens and assuring conspicuous revenues for American producers, the United States also orchestrated, through ERP, a multifaceted strategy of propaganda that aimed at penetrating Italian society at different levels.[40] As David Ellwood remarks:

> Oltre ai media tradizionali c'erano concerti dell'ERP, gli spettacoli di varietà alla radio dell'ERP, i treni ERP, i cerimoniali ERP. C'erano calendari, fumetti, francobolli e atlanti. C'erano cantastorie che raccontavano i miracoli sponsorizzati dall'ERP nei villaggi siciliani, e perfino spettacoli mobili di burattini, 'per portare il messaggio del piano Marshall apparentemente ai bambini,' ma in realtà attraverso loro ... agli adulti semianalfabeti.[41]

The oscillation between approval and rejection that characterized the Italian attitude towards 'America' in the prewar period – though not as noticeable – was still alive in the postwar period, notwithstanding American efforts to erase it. Alongside Calvino's and Pintor's enthusiasm, I have mentioned Rossellini's anti-Americanism – which is actually more than anything else anti-Hollywoodism – in *Roma città aperta*. Rossellini also directed *Paisà* (1946/7), the film that deals in a more striking, straightforward, and powerful way with the presence of Americans in Italy. The film is composed of six episodes; in each the director explores one feature of the American presence, and by the end constructs a mosaic of American culture that is opposed to and paired with the Italian one. Further, he studies the interaction between the two cultures through the lens of language, which serves mainly two purposes: it highlights the variety of idioms spoken by Italians of different regions, often dialects, and also underlines the progressive rapprochement between Italians and anglophones – both Americans and British – thanks to the reciprocal learning of a foreign language. Italy and the United States thus come to be united in a syncretistic portrait that combines Italy's liberation and its imminent democratic future, as we can evince from each individual story.

In the first episode, Joe of New Jersey meets Carmela, the Sicilian girl who guides the soldiers to a nearby castle on the sea whence they can spy on the Germans' arrival. Framed by a window-like opening in the rocks, the two try to communicate, through gestures more than verbally, running into comical misunderstandings. Joe is a simple-minded boy, attached to his family and his land, and so carried away by nostalgia that he switches his lighter on to show Carmela a picture of his sister. Such carelessness costs him his life, since the Germans shoot at the light and kill him. What is at stake in this first episode is not only cultural difference focused through language, but also the possibility of bridging the difference through empathy. The second episode offers a bitter social commentary. A drunken African American soldier is dragged around, to the diegetic sound of a harmonica, by a *scugnizzo*, or street kid. Finally at rest on a heap of ruins, the soldier launches himself into a humourous performance: he mimics an airplane attack, then imagines he will be received as a hero in his country and admitted into the Waldorf Astoria; then, he will take the train to go back home. Admittedly, he is very happy to go home, but then he asks himself what home is like. Home means just a shack and utter poverty, and the soldier confesses to himself that he no longer wants to go home. Once out of his role as a rescuer, and once out of his uniform, he will encounter only racism. Rossellini here renders problematic the image of America, hinting – through Joe – at its social predicaments.[42]

The third episode focuses on the American troops in Rome, and the director uses a dismayed soldier to make a social commentary on Italy. This drunken soldier picks up a prostitute and complains that all Roman girls are now probably alike, similarly loose. When he first arrived, girls were innocent, fresh, and joyful. He remembers the girl he met then – Francesca – whom he would have liked to encounter again, but never had the chance. The prostitute he runs into is in fact Francesca, whom he does not recognize. Attempting to revive the old feelings, she leaves the room and tells him to meet her the following day at her old address. Francesca waits in vain. Rossellini uses the diegetic point of view of the American soldier to judge negatively Italian women whose behaviour is exemplified by Francesca. However, their behaviour is nothing less than a side effect of the Allies' arrival, and seems to be caused by hunger and misery. The fourth episode takes place in Florence, where American Red Cross nurses tend to wounded Partisans. One of these nurses is in a relationship with Guido, a Partisan commander nicknamed Lupo. Eager to see him, she leaves the hospital with

a man who wants to reach his family, defies all obstacles, and crosses the city occupied by the Germans, only to learn from a dying Partisan that Guido has been shot that very morning. In this case Rossellini pictures a strong, wilful, and unconventional Anglo-Saxon woman – a model of femininity he admired and that he will develop in his films with Ingrid Bergman.

The fifth episode takes place in a monastery in Emilia Romagna, where three American chaplains come for a visit and ask to spend the night. The monastery is immersed in the quiet and serene atmosphere of the Franciscan *regola*, or rule. The friars' modesty and genuineness are opposed to the Americans' more cerebral approach to religion. When the friars in deep dismay discover that one of the chaplains is Jewish and the other Protestant, they fast, hoping that God will prompt the two to convert. Here Rossellini praises the simplicity and 'naturalness' of Franciscan Catholicism while also exposing – through the 'tolerance' of the Catholic chaplain – the richness of positions that a multicultural nation like America encompasses – a richness that Italy does not possess. What stands out in the end, however, is the peaceful simplicity of the friars, whose community is far removed from modernity and anchored in a rural and archaic setting. In the final episode we see an American captain isolated from his army, who tries to help the Partisans as best as he can and remains deeply respectful of their political commitment, since, as one of his soldiers says, 'These people are not fighting for the British empire.' Again, the extremely poor peasants of the Comacchio Valley are pictured as innocent victims of a brutal violence imposed by war.

In constructing his image of America as seen from Italy, with the help of authentic newsreel footage that enhances the documentarist quality of his Neorealist style, Rossellini is trapped in the usual contradictory attitude. For instance, in the figure of the nurse, he admires an independent, determined, and passionate woman who represents a model of femininity that stands out from and is opposed to the Italian one portrayed by Carmela and Francesca. Rossellini singles out a few features of American society: the problem of racism, the 'stereotypical' simplemindedness of Joe, the canned food already popular in the United States and virtually unknown in Italy, the efficiency of the captain along the Po. In effect, Rossellini does much more than portray America through his soldiers: he links – this is the important implication – the formation of a democratic image of Italy to the presence of Americans on Italian soil.[43]

The presence of Americans in the film is not only required by the

diegesis of the Neorealist style, since the film is a narrative of Italy's lib-
eration, but acts on a deeper, subtler level. It has both metaphorical and
ideological connotations. The image of post-Fascist Italy, of the new
democratic country, is fostered, accompanied, and elicited by the pres-
ence of Americans. Thus, the constructed image of Italy is inevitably
interlaced with American culture. After the arrival of the American GIs,
women – for better or for worse – will no longer be the same. Having
dismissed the subservient, chaste image promoted by certain Fascist ide-
ology and by the Church, they now relate to their male companions in a
more provocative – but not necessarily better – way. Women have
learned how to use their bodies to express, elicit, and manipulate desire.
Parallelly, cigarettes, chocolate, and chewing gum – all signifiers of
wealth and modernity – become part of everyday life, to the point that
their use underlines people's degree of modernization.

Another element that comes to the foreground is, as I have already
indicated, language. In all six episodes people speak various languages
or dialects, with a different degree of mastery; sometimes they mumble
a few words in a foreign language, sometimes they know it properly, and
sometimes they completely ignore it. In any case, they try hard to com-
municate with one another. Communication is the result of various
efforts that entail gestures, mimicry, intuition, and, basically, an attempt
at learning the language of the other. In this case, 'other' means the
Allies and, more specifically, once again, the army that helped Italy to
free itself from the Germans.

Besides women, men, too, seem irremediably attracted to the Ameri-
can myth of the lone, uprooted hero. Significantly, there is no episode
in the film concerning a mother–son relationship, no trace of this Oedi-
pal narrative that constitutes an eminent feature of Italian culture and
self-representation.[44] Instead, relationships between different kinds of
heterosexual couples – Joe and Carmela, Francesa and the soldiers, the
British nurse and Lupo – are presented or hinted at. Between the nurse
who crosses Florence in search of Lupo and the silent peasant women of
the Po valley there is an abyss – an abyss that modernity promises
to bridge. The difference between the British nurse and the Italian
peasants has to do with one's agency towards the realization of one's
desire: be it sexual, emotional, or other. The British nurse makes free
choices, opposing the will of authoritative figures, while the Italian
women, poverty-stricken, do not even seem able to envision such a
possibility: they do not have a voice. At the beginning of the Republic,
Rossellini thus keeps alive the myth of America and his own intrinsic

fluctuation with reference to it, torn as he is between an admiration for American women and the disapproval of American consumerist ideals. And, again, *Paisà* acts as a powerful statement about the massive impact of America in Italy's liberation and then reconstruction.

That the American myth turns, after the war, into something different and slightly sour, is manifest with Pavese. The translator once fascinated by American culture starts to deconstruct the myth, realizing that after the war, Italy no longer needs 'America.'[45] Indeed, Pavese offers a most striking example of revisionism. In 'Richard Wright' and 'Ieri e oggi' – respectively, a radio script and an article published in *L'Unità* in 1947 – he tears the American myth apart piece by piece.[46] Quite dismissingly, he writes that nothing which comes from the United States is now of any interest: 'A esser sinceri insomma ci pare che la cultura americana abbia perduto il magistero, quel suo ingenuo e sagace furore che la metteva all'avanguardia del nostro mondo intellettuale.'[47] And, further, he adds, 'nè si può non notare che ciò coincide con la fine, o sospensione, della sua lotta antifascista.'[48] In saying that Italy no longer needs 'America,' he actually implies something far more radical: that there is no longer a need for a political utopia. Retrospectively, Pavese shows how 'America' functioned as a myth of the *immaginario* with which to oppose Fascist rhetoric. He claims that America is now the packaged heritage of a given period, since the good things that come from there are the ones produced in the thirties and forties: 'Ora l'America, la grande cultura americana, sono state scoperte e riconosciute, e si può prevedere che per qualche decennio non ci verrà più da quel popolo nulla di simile ai nomi e alle rivelazioni che entusiasmarono la nostra giovinezza prebellica.'[49] There might be another, less evident reason for Pavese's sudden dismay at America: his loyalty to the Communist party – in which he enrolled in 1945 – and his sincere inner struggle between political orthodoxy and artistic freedom.[50]

In order to understand Pavese's position better, we need to briefly recall the sociopolitical situation of the times. In postwar Italy the forces that were influential in shaping a new politics and in bringing forth the new constitution (1948) were the Church, the Christian Democrats, and the Communists.[51] In the immediate postwar period the collective enthusiasm made doctrinal differences among leftists and centrists blur (thanks to the communal attempt at electing a government). Yet starting as early as 1946 the ideological differences between the groups – polarized around the two leaders Alcide De Gasperi (1881–1954, Christian Democrat) and Palmiro Togliatti (1893–1964, Communist) –

became more evident, causing the progressive marginalization of the Left. Such a course of events went along with the American intervention in Italy. The American government, which reserved substantial financial aid for Italy (later organized as part of the Marshall Plan), was eager to support a democratic government in the 1948 elections and tied its own economic patronage to an explicit control of Italian politics aimed at counterbalancing Communism.[52] In that circumstance, American influence was not exactly exerted underground, as the historian Paul Ginsborg illustrates.[53]

Thus, on the one hand, the Church and the Christian Democrats – who shared the same religious assumptions and sociopolitical agenda – favoured the influence of the United States, while, on the other, the Communists opposed it. Particularly from 1948 on, when the Communists were expelled from the government and passed officially to the opposition, their anti-Americanism increased and developed into an outspoken anti-American campaign. Pavese, who suffered the contradictions emerging from his desire to be both a full-time writer and a militant Communist actively engaged in the creation of a new culture and consciousness, was somehow – and not completely consciously – cornered in his interaction with the American myth, as will become clearer below with my analysis of *La luna e i falò*.[54]

The Communist party, excluded from the government and thus deprived of direct political impact, focused its efforts on *società civile*, or civil society, while also trying to oppose the full integration of Italy within the Western block. It was in this situation that, as Stephen Gundle claims, 'il cinema guadagnò per la prima volta un posto di rilievo nella politica culturale comunista.'[55] From 1948 on, when the American choice to favour the Christian Democrats became more overt, the Communist press – which reached its highest peak of circulation between 1948 and 1953 – consistently criticized Hollywood productions. The Communists tried to finance their own films: Vergano's *Il sole sorge ancora* (1946), De Santis's *Caccia tragica* (1948), Visconti's *La terra trema* (1948), Lizzani's *Achtung! Banditi!* (1951) and *Cronache di poveri amanti* (1953), and chose Neorealism and its masterpieces, *Roma città aperta* and *Ladri di biciclette* in the first place, as their own sociopolitical flag and aesthetic canon for film production.[56]

The Communists, however, were not immunized against the cunning, unconscious appeal of Hollywood. With a trajectory that runs opposite that of Pavese, some of its most orthodox and dedicated representatives show that they were – notwithstanding their ideological belief – infil-

trated by it. On the one hand, they stigmatized as negative a cinema based on the myths of money and success; a cinema that advertised the lifestyle of capitalism and lured people into consumerism, and into privileging, egoistically, personal satisfaction over class struggle. On the other hand, these intellectuals or directors were subliminally attracted to those very pictures they denounced. Even when they claimed that they used Hollywood strategies to condemn the star system, they fell into the net they were pulling in – their moralistic stigma turning into a spectacle advertising Hollywood's behaviours. The most evident case is perhaps that of Giuseppe De Santis, one of the 'most doctrinaire of the neorealists in his militant commitment to the PCI.'[57]

In 1949 De Santis (1917–),[58] who attended the Centro Sperimentale di Cinematografia and later became a film critic for the journal *Cinema*, was given the opportunity to film *Riso amaro*. In the film – an epic portrayal of *mondine*, or female rice harvesters, in the fields of Vercelli – a thieving couple, Walter and Francesca, stalked by the police, hide by mixing with a crowd of rice harvesters who are taking the train. Francesca finds a job in the rice fields while Walter flees. He returns to the rice fields later, but his lover – who is now trying to redeem herself through hard work and with the help of class solidarity – is no longer attracted to him. She has met Marco, a sergeant, and has been inspired by his honesty and ideals and wishes to change her life. Marco, however, is in love with Silvana, who is instead attracted to the mysterious and abusive Walter. Silvana, seduced by an illusion of wealth and by Walter's 'fictional' appeal, becomes his lover. Walter, who has resolved with accomplices to steal the rice crop by loading it into trucks, prompts Silvana to flood the rice fields so as to distract the *mondine* during the theft, which happens the last evening of their stay at the farm, during the party in which Miss Mondina is going to be chosen. Silvana floods the rice fields and afterwards she and Walter are confronted by Francesca and Marco, who try to stop them from stealing the rice. Having realized that she has been deceived – the jewellery Walter had previously given her is false – Silvana kills Walter in a slaughterhouse. Later, feeling guilty for the damage she has caused her co-workers, she jumps to her death.

De Santis's agenda in *Riso amaro* is manifold: most importantly, he means to attack the myths of the silver screen fostered by photo-romances such as *Grand Hotel* (which is repeatedly shown and referred to in the film), to denounce the exploitation of the *mondine*, and to emphasize the solidarity that exists among the lower classes and, as Vis-

conti demonstrates in *Bellissima*, the intrinsic, 'genuine' – a Communist ideological a priori assumption – morality of those classes. While in *Bellissima* Maddalena, by the end, comprehends the falseness of the myth created by the cinema, Silvana succumbs to her photo-romance fantasies and brings to completion the melodrama conceived by De Santis. On the one hand, De Santis aimed at condemning the lures of capitalist culture and the American way of life. On the other, he also wanted to make a didactic film informed by Marxist guidelines about rural social struggle. With his monumental cast of extras, extended use of high-angle and crane shots, and magisterial choreography, the director succeeded in portraying the life and exploitation of the *mondine*, and added many other elements to the picture as well, mixing these different aspects in a quite heterogeneous way.[59]

As Peter Bondanella, Millicent Marcus, and other critics of Italian cinema have shown, the film presents a mixture of genres copied from Hollywood production, particularly melodrama, gangster films, and westerns, and reflects the tawdry influence of the photo-romance.[60] Indeed, the social denunciation ended up being washed over by the prevalence of the erotic melodrama, catalysed by the disruptive beauty of the female lead, Silvana Mangano. Precisely the insistence upon the erotic element differentiates De Santis from 'core' Neorealism, adding to his cogent and amply analysed social concerns an authentic fascination with the female body. The director also explores the boundaries between fiction and reality – a theme dear to female writers such as de Céspedes – in the relationship of Silvana and Francesca. Indeed their stories intersect, since Francesca's life seems to Silvana to be full of events and somehow 'fictional,' while Silvana's life seems to Francesca to be more naive, and morally healthy. The two women desire to imitate each other's life, and this is what happens in the film.

Millicent Marcus has sharply pointed out[61] that Francesca and Silvana are visually interchanged, through frame composition and montage, in the episode in which Francesca tells her story to a morbidly curious Silvana. The two women sit on a bed. As Francesca starts to talk – she is filmed in a medium close-up – she occupies the left side of the screen, while Silvana, in profile, occupies the right. Their conversation is interrupted by the request of one of the *mondine* to be given an injection shot by Francesca. When she returns to the bed, Silvana is on the left of the screen and Francesca sits by her side, on the right. Their next interruption happens when Francesca gets up to assist a woman who is nauseous.

On her way back she takes the left side of the screen and Silvana the right one. The last and most meaningful exchange happens when Francesca talks to Silvana about the sergeant she has just met: 'Hai sentito quel sergente? Gli voglio ancora parlare. Ci ho pensato tanto' ('Did you listen to that sergeant? I want to talk to him again. I thought about it a lot'), Francesca says. 'E il tuo amico, credi che verrà a riprenderti?' ('And your friend? Do you believe he will come back to pick you up?'), Silvana replies. The two women, who remain seated in their original .positions, simply change the inclination of their torsos, respectively from left to right and from right to left, thus exchanging their places. From then on, the one takes up the foreseeable future of the other, as they exchange the men they are attracted to. The bad woman turns into a good one, thanks to the social awareness gained on the rice fields, while the good one turns into a fallen one, because of the confusion between reality and illusion generated by her reading of the photo-romance, plus her attraction to wealth and adventure, and therefore thanks to what is depicted as a dangerous superficiality.

Notwithstanding his ideological agenda and his desire to reproach the models of modernity belonging to America, De Santis could not restrain himself from constructing his action around a spectacularized female body, much like the Hollywood star system used to do. He could not avoid being carried away by a genuine camera voyeurism – a voyeurism highly criticized and stigmatized by Communist militants.[62] The major confrontation in the film, whose scenario is almost completely female, is not, as we have seen, between the two male characters (Vallone/Gassman), but between the two female protagonists (Dowling/Mangano).[63] De Santis himself explained his interest in women as the outcome both of his own 'peculiar sensitivity' rooted in the fact that he was a man of the *centro sud* (central South), born in a peasant environment particularly attentive to the theme of women, and of his political convictions:

> L'erotismo nei miei film è attribuibile, credo, alla mia natura, di una sensibilità particolare. Sono un uomo del centro sud, nato a Fondi, una cittadina di ceppo contadino ... E' indubbio che la donna cominciò a interessarmi parecchio fin dalla giovanissima età ... Aggiungiamo poi che all'epoca in cui cominciai a lavorare nel cinema sviluppai la precisa coscienza politica che la donna dovesse contare per quello che doveva contare, valere per quello che doveva valere, e mi resi conto che aveva una

grande necessità di rispetto ma non di quel rispetto e quell'amore che in genere le veniva offerto dal maschio nostrano tipico. Quindi mi divenne impossibile ignorare la problematica femminile.[64]

De Santis elucidated his 'peculiar' cinematic gaze as just a symptom of his deep respect and commitment to the female universe – a feature increasingly prevalent in postwar film production, as we have seen in chapter 2.

For leftist intellectuals, though, *Riso amaro* not only displayed an unorthodox interest in women's bodies – and it is not just Mangano, but also the rice harvesters as a group, who are filmed in the rice fields with their skirts rolled up or washing themselves half naked in the water – but it included too many references to icons of Hollywood America: chewing gum, the boogie woogie, the musical sequence of the rice harvesters who sing in the rain to communicate with each other, a beauty contest to choose 'Miss Rice Worker,' the reading of the photo-romance *Grand Hotel*, Silvana's gramophone, and the like. De Santis's unconscious fascination, both with American cinema,[65] which peeps through the lines of his ideological commitment – the mixture of genres I have alluded to – and its way of life – music, chewing gum, the photo-romance – was so evident that it stirred up polemic responses in the pages of the Communist press. In a famous critique in *Vie Nuove*, Antonello Trombadori demolished the film. An anonymous reviewer in *Bianco e Nero* stated that 'il personaggio di Silvana ... annebbia ancor più le idee' ('Silvana's character ... makes ideas foggy') and that her body is exploited 'nella più ampia misura possibile, con un'insistenza che addirittura rasenta il compiacimento fine a se stesso' ('to the most degree possible, with an insistence that borders on self-complacency').[66] The famous cinema critic Guido Aristarco also claimed that 'workers cannot be educated with the bare legs of Silvana.'[67]

The heavy, dogmatic attacks of leftist critics show that American images were perceived quite negatively, but that they had, nevertheless, imbued Italian society to such an extent that it was no longer possible, even in anti-Yankee leftist intellectual circles, to clearly assess their influence.[68]

The Rossellini-Bergman Affair: *Stromboli terra di Dio*

The fascination for the female world, for the beauty of an overtly eroticized body, and also for the nuances of a complex sensibility, lured, as

we have seen, many directors, and not in the least Rossellini. Already in 1948 with 'La voce umana,' the first episode of the film *Amore* (an adaptation of Jean Cocteau's 'La voix humaine') the director dedicated thirty minutes to a solo performance by Anna Magnani,[69] thus underlining his interest in the psychological treatment of his characters. In *Stromboli terra di Dio*, filmed a year later, Rossellini combines his interaction with America and his interest in the psychology of women. The Roman director had already provided one of the most striking examples of collusion between America and Italy in the postwar period – *Paisà*. Yet, there was a fundamental event that was going to affect deeply his life and career. Through an intertextuality that links not so much his different works as his work and personal life, Rossellini generates one of the most captivating as well as intriguing episodes in the history of the America/Italy relationship. This episode is promoted by the arrival in Italy of one of the prominent Hollywood stars of the time: Ingrid Bergman.

Bergman (1915–82), in a delicate moment of both her professional and private life, was looking for an element of novelty in her career, and when she saw *Roma città aperta* in a New York movie theatre, she wrote to Rossellini asking to make a film with him.[70] The professional rapport soon turned into an emotional one when Bergman and Rossellini, both married, fell in love. The affair between the two promoted a negative press campaign and signalled a temporary lapse in Bergman's American career. Not only was she ostracized by producers and negatively targeted by the media, but she also became, in the increasing xenophobia that characterized McCarthyism, a metaphoric element of the dispute between the United States and (potentially Communist) Italy.[71] In American eyes, she was then dutifully punished with the box-office failure of her six films with Rossellini.

The first film Bergman made with Rossellini was *Stromboli terra di Dio*, which moulded her in the new role she acquired in her work with the Italian director.[72] The film narrates the story of Karin, a Lithuanian refugee who lives in a camp for displaced prisoners. She is trying to go to Argentina, but having been denied an entry visa to that country, she resolves to marry Antonio, a Sicilian fisherman who has fallen in love with her. Antonio brings Karin to Stromboli, where he has a house and where he plans to resume his fishing job and start a family. A sophisticated woman used to a rich life before to the war, Karin is horrified by the poverty, backwardness, and isolation of the island. She is terribly angry at and frustrated with her husband. They have constant fights

fuelled by cultural misunderstandings, and Karin resolves to leave the place as soon as possible. She tries to seduce first the priest, and then another fisherman, in order to get help for her escape. Not even the news that she is pregnant changes her mind. She finally climbs the volcano, planning to reach the other side of the island. Getting close to the top she faints. She wakes up the next day and is in awe of the beauty around her: she perceives the presence of God as a sudden revelation and resolves to stay.

Bergman's arrival in Italy sets up a direct, open comparison between two cinematographies – the American and the Italian. Such comparison complicates the image of America that had dominated in the thirties, and provides a face-to-face testing of some of its *topoi*. The role in which Bergman is cast in *Stromboli* denies her the star *persona* she has constructed in her Hollywood career.[73] In this film, her beauty is not an asset that is going to be valorized in creating an attractive, seductive image. The lighting she had been given in her American films, which aimed at creating the usual halo of glamour, is gone and, more often than not, she is dressed in simple, unappealing outfits. The denial of her 'exotic' appeal thus becomes a denial of Hollywood itself, thanks to the widely accepted metonymy through which the star represents the system.[74] It is as if Rossellini focused on maintaining the core of her acting abilities without borrowing the paraphernalia she was usually presented with. However, such a process is not without consequences, for it generates a problem of 'reception': who is she?

The viewers, her passionate fans, cannot forget who Bergman is. No matter how she is cast by Rossellini, Bergman carries within herself the shadow of her previous American roles; she is the mysterious and sophisticated beauty of *Casablanca* and *Notorious*; a dangerous femme fatale. Spectators would not mistake Bergman for a non-professional and pair her up, for instance, with Mario Vitale, the fisherman from Salerno who plays Antonio. She is inevitably, intertextually, linked to her professional past, and cannot create for herself either a new persona or a new identity. In a film that still carries many Neorealist features and that is, particularly for its choice location and landscape, 'canonically' Neorealist – it suffices to recall the scene of the collective tuna spearfishing, an authentic masterpiece – she clearly defies some of the basic criteria of Neorealism. These criteria imply – as we have already seen – that actors are untrained individuals often found on the streets, that Neorealism is a 'national' cinema that defines a style markedly 'Italian,' and that Neorealism focuses on issues important to the collectivity, privileg-

ing the group over the individual. Some of these Neorealist features are
present in the film, though mixed with other, heterogeneous traits.

Rossellini had started to distance himself from strict Neorealism
already in 1948 with *Germania anno zero*. Even more clearly, in *Stromboli*
he dedicates himself to the analysis of the interaction between different
cultures and to the anatomization of female psychology. The novelty
that Bergman brings to Rossellini's narrative is to be read precisely in
terms of her own 'difference,' which becomes an element to be heuristi-
cally explored in terms of gender. By casting Bergman in his film, Ros-
sellini seems to believe that he can prompt the audience to focus simply
on the very image of a both Nordic and 'American' woman.[75] He is
interested in studying a foreigner, but not simply a foreigner: a foreign
woman who is, by general consensus, more modern than an Italian one
– at least more modern than Stromboli's islanders. In so doing he joins
the group of directors who, in the postwar period, look at women with a
more sympathetic eye, and are taken by women's emotions and internal
world. In her unhappy relationship with Antonio, Karin's strong person-
ality and Lithuanian (read 'American') identity come to the surface.[76]
Karin herself is fully conscious of her diversity, as she says to her hus-
band, to an older man who helps her to rehab the house, to Antonio's
aunt, Rosaria, and to the priest.

Apart from her clothes, which openly announce their novelty in
colour and fashion (the women on the island wear only black and cover
their faces with veils), her difference is apparent in the way she interacts
with people: both males and females. She does not hesitate to speak her
mind, and is unconcerned by what she perceives as the oppressive
behavioural rules respected on the island. For instance, she innocently
goes to visit the dressmaker, who is a prostitute, she paints flowers on
the inside walls of the house and embellishes it with palm branches, she
goes looking for Antonio out in the open sea when he is fishing with his
companions, and she lies in the sun, simply enjoying it and playing with
the children of the island like an adolescent. As the black-veiled women
– who come to look at her doorstep and refuse to talk to her – claim, she
is, truly, 'different.' In addition, Karin knows that she is a sophisticated
woman whose needs cannot be compared with the ones of the poor
women of the island: 'You need plenty of money for a woman like me'
('Hai bisogno di molto, molto denaro, per una come me'), she repeat-
edly tells her husband.

However, the most remarkable feature of Karin's difference, what
marks her exogamic status with reference to the island, is her indepen-

dence – independence from her husband, from the Church, and from the village – and the fact that she trespasses the invisible, but solid barrier that separates the world of men from that of women. Actually, women other than Karin hardly appear in the film, which is instead dominated by the rugged landscape, Karin and Antonio, and the fishermen. In a very traditional environment such as this small Sicilian island, Karin's 'foreign' characteristics are thus extremely emphasized. Perhaps the Sicilian island is only a microcosm that offers Rossellini an opportunity to study closely romantic relationships – relationships increasingly marked by psychological complexity in their filmic representations.

It is the film's ending that indicates a possible, syncretic solution. While trying to escape, Karin has a revelation of the presence of God in the beauty of the landscape and decides to stay. Her decision, prompted by a 'vision' and embraced in order to defend the child she is carrying, amounts to a desire to accept the life on the island, and those values she had previously disregarded as unbearably backward. Her surrender is not easy, though, and she imperiously demands of God that he help her; she demands that he show her his face. Once she has surrendered to God's will, Karin will then be integrated into the island's life, and thus into the Italian system. In fact, while her assimilation brings an element of modernity and novelty to the national image, it also hints at the 'taming' powers that a more traditional culture such as the Italian one holds over America, over a woman who undoubtedly has a mind of her own, and not exactly a submissive attitude towards her husband, whom she slaps before resolving to leave. We can infer that, as Neorealism affects Bergman, she also affects Neorealism, and that while Rossellini undoes Bergman's Hollywood façade, he is also influenced by Bergman in a way that modifies his increasingly less 'orthodox' Neorealist mode. Far from being merely a documentary style focused on social issues, Neorealism acquires in *Stromboli* a different, markedly psychological, connotation. Rossellini induces a process of rapprochement between the camera and the individual that transcends both the artificiality of the Hollywood star and the documentarist input of the Neorealist camera.

Bergman thus acts within the Neorealist tradition as a centrifugal element that points to the dissolution of Neorealism's original sociopolitical core. The ambience remains strictly Neorealist, and yet Bergman enforces a change in the narrative's diegetic point of view, as she – much like Edmund in *Germania anno zero* – catalyses attention on the subjective history of the character she portrays. The viewers are indeed

co-opted into embracing her point of view, rather than Antonio's. Unlike what happens, for instance, in the aestheticized Neorealism of Visconti's *La terra trema* (1948), where the protagonist is the entire village of Acitrezza, in *Stromboli* the life of the fishermen provides only a geographical and sociological landscape that serves the exploration of Karin's psychology and emotions. The environment functions as a magnifying lens that helps explore Bergman's moods, reactions, and expectations. By the end she herself – a magmatic mixture of pride and ambition, a potential explosion of unrestrained, untamed femaleness – comes to identify with Stromboli, the volcano. The only way in which her explosive independence can be brought back to normal – after her attempted escape, parallel to the volcano's eruption that causes the islanders to seek refuge on boats – is through pregnancy, Rossellini suggests. The director's thought is not exactly progressive since, for all his interest in a more modern and psychologically complex woman, he resorts to motherhood as the final, almost necessary, element to assess a woman's social status and personal identity.[77]

The arrival of Bergman signals, then, a moment of transition in the history of Italian cinema. Neorealism too, this all-Italian style, is 'colonized' by America; at the same time, it colonizes one of its most famous and beloved stars, Bergman. The result of this reciprocal colonization is *Stromboli*, which marks a turning point in the relationship between Italy's and America's cinema. The road taken by *Stromboli* is nevertheless destined to remain a secondary route. The highway soon to be travelled by Americans as well as Italians is that of co-productions.

The Lost Train of Cultural Blending: De Sica's *Stazione Termini*

The Italian government tried to protect the underproductive and shaky national film industry from the inundation of Hollywood products with a law passed in 1949. As we have seen, in the postwar period Italy suffered the largest invasion in Europe of American films, an invasion that reached its peak in 1948 with 668 American films imported, against a national production of only 49 (the lowest ever in the 1946–53 period). Also in 1949, American film revenues amounted to 73.3 per cent of the Italian total, against a meagre 17.3 per cent provided by the national ones.[78] The law sanctioned, among other things (such as the mandatory dubbing of American films), that revenues of American films shown in the country had to be reinvested in Italy. This law – strongly resented by American producers, who could not find a way around it – promoted a

surge of co-productions that brought the Cinecittà studios to their full postwar bloom. Cinecittà inaugurated an interregnum of about fifteen years, accompanied by huge box-office successes such as *Quo Vadis* (1950), *Ben Hur* (1957–8), and *Cleopatra* (1960–1).[79] As Lietta Tornabuoni and Oreste del Buono report, there were several reasons for such a large-scale emigration of American actors and directors:

> Gli americani producono film in Italia perchè è conveniente. Debbono utilizzare i propri fondi bloccati; vogliono sfruttare il cambio favorevole della moneta, la mano d'opera a basso costo e brava, i vantaggi del clima, la piacevolezza del vivere in colonia da padroni e in una libertà maggiore di quella sorvegliata, moralista e maccartista della Hollywood d'epoca; rientra nel disegno di mercato americano penetrare in ogni settore delle attività economiche europee.[80]

Thus, there were several elements that turned Cinecittà into a famous and glamorized 'Hollywood on the Tiber,' whose stories were aggressively recorded by *paparazzi*, the ruthless photo-reporters: the blockage of American funds in Italy, the cheap labour, the favourable climate, the good professional level of technicians and of the available infrastructures. Cinecittà further represented for Hollywood an occasion to recycle stars who were on the downslide, to exploit a historical *romanità* enhanced by the environment, and to capitalize on the American presence in Italy during the war. In addition, co-productions represented an important chapter in the history of Italian cinema because they offered Italian operators a chance to work closely with Americans and familiarize themselves with American methods of shooting and organizing a film: they constituted a learning experience for directors as well as for technicians and actors.[81] One of the co-productions that focuses precisely on the Italy–America interaction is *Stazione Termini*, filmed by Vittorio De Sica in 1953.

De Sica was not looking for two stars as popular as Jennifer Jones and Montgomery Clift to realize a film on a script by Neorealist scriptwriter Cesare Zavattini. He had no choice, though, since David Selznick, the producer, imposed for the leading female role his wife, Jennifer Jones, and, of course, influenced the production of the film, whose action takes place in less than two hours at Stazione Termini in Rome, where Mary (Jones) is waiting to catch her train to Paris. Mary, a wealthy housewife from Philadelphia, has had an affair in Rome with Giovanni (Montgomery Clift), a young Italian-American professor. Passionately in

love with him, but bound by duty to her older husband, Howard, and young daughter, Kathy, she has not been able to say her last goodbye to Giovanni. In fact she is running away from him, but Giovanni, equally in love, reaches her at the station just as she is getting on her 7 p.m. train. She misses it and he hopes they can still spend some time together. Mary walks by Giovanni's side, incapable of facing this last goodbye and its emotional charge, and is determined to take the next train at 8.30, when she suddenly spots her nephew, Paul, in the crowd. Mary actively engages with him, inviting him to drink a hot chocolate. Exasperated by the deprivation of intimacy and by her formal goodbye, Giovanni slaps Mary and runs away. Trying to pull herself together after her public humiliation, Mary goes to sit in a third-class waiting room. There she helps a poor woman, a pregnant mother of three, who feels sick. Mary takes her to the emergency room and comforts the woman, her husband, and her children. Meanwhile, Giovanni has come back looking for her. He finally sees her in the distance and crosses the tracks just as a train pulls in, thus jeopardizing his own life in order to reach her. Reunited after such a climactic event, the two now look for a place where they can be more intimate and get on an empty, isolated train cart. A worker sees them and, after a little while, a police officer finds them while they are hugging and kissing in the compartment. The officer takes them to the Commissariato and files a criminal charge against them for immoral behaviour. Asking the woman if she still plans to take her train – obviously implying it – the Commissioner finally tears up the document that incriminates her and Giovanni and lets them go with no charge.

Like Rossellini, De Sica (1901–74) is one of the founding figures of Neorealism. He started an acting career in the thirties and became particularly famous with Camerini's *Gli uomini che mascalzoni* (1932) and *Il Signor Max* (1937). In 1942 he directed *I bambini ci guardano*, a forerunner of Neorealism, and soon after the war, always in tandem with Zavattini, made two Neorealist masterpieces: *Sciuscià* (1946) and *Ladri di biciclette* (1947). In *Stazione Termini*, De Sica, much like Rossellini with Bergman, is working with two famous American stars. Unlike Rossellini, though, he can count on an American crew and generous finances, and yet – probably because of the American McCarthyist influence – he puts together a much more conventional product than Rossellini's. As De Sica himself declared, he had several problems with censorship: what was acceptable for the Italian censors did not find the favour of the Americans, and the other way around.[82] The film thus ended up having

'una posizione morale incerta'[83] (an uncertain moral position) and, I would add, a blurred focus that damaged its overall cohesiveness. In addition, by the time De Sica filmed *Stazione Termini* (in 1953) almost a decade had passed since Rossellini's *Roma città aperta* or his own Neo-realist masterpieces, and Italian society was distant from the rough emotionality of the immediate postwar period. Italy was now looking ahead, towards its economically promising future, and did not want to be reminded of the past.

De Sica's original Neorealist concerns thus made way for *bozzetto* (sketch), and sincere sentiments were replaced by cheap sentimentalism. In *Sciuscià* or *Ladri di biciclette*, the director succeeded in stirring up powerful emotions because he portrayed an objective, real situation: the truly disadvantaged classes of the postwar period, which suffered because of unemployment, hunger, shame; the numerous young orphans abandoned to themselves, the violence perpetuated within a prison, utopia crushed and trampled upon by economic drives. In *Stazione Termini*, Neorealism turns into a sort of scenographic motif and gets depleted of its emotion-stirring original strength. The film's message primarily concerns the role of women in society – evidently a hot issue for both Italian and American audiences – and restores for them a traditional role of (wealthy) wives and, especially, mothers. In so doing, the film addresses a problematic encroachment between two spheres, whose interaction becomes, as we have already seen, more and more problematic after the war: the public and the personal. The dichotomy between the two spheres is emphasized by the open setting of the central station, where masses of anonymous people move around the two protagonists. One of the most explicit ways – a truly indexical indicator – for assessing which of the two spheres is being interrogated is offered by the score, which functions both diegetically and extra-diegetically. When there is a strong sentimental connection between Mary and Giovanni, there is a refrain with full orchestra and solo violin, and, when Mary is reminded of her role as mother, there is a carillon kind of music reminiscent of a village fair or of the children's music in Puccini's operas. A third, diegetic component of the score is provided by the noises of the station: trains coming and leaving, announcements, songs of soldiers, and voices. De Sica alternates and mixes these three elements, negotiating through them – their fading into each other – the interaction of the personal sphere of love as passion and the public sphere of motherhood as a socially constructed institution. He also uses the score in a quite Neorealist way, that

is to say, he delegates to it the roles both of stirring up strong emotions as well as of underlining those emotions from an extra-diegetic point of view.

De Sica's use of Neorealism or, rather, its integration within the co-production framework, is, at this point, much less inventive than Rossellini's. Instead of collapsing the Hollywood style and its star system with Neorealism in order to create a new product – as Rossellini does in *Stromboli* – De Sica, possibly too restricted by Selznick's supervision, and also for chronological reasons (we are in 1953), disseminates Neorealist features here and there, thus reducing them to mere stylistic devices, to mere reminders of his earlier work. This is particularly evident in the episode with the mother and her children. De Sica shows the children and their destitute mother and father according to Neorealist criteria: they all wear 'conventional' Neorealist outfits – basketry and *fiasco* (bottle), included – and they move about according to Neorealist choreography in a packed second-class waiting room. They are filmed all together, showing a subservient attitude towards the rich lady. They speak broken Italian, and manifest gratefulness towards her mixed with, not exactly servility, but perhaps a far too excessive modesty. Yet De Sica does not inquire at all into their history, and thus this family of emigrants returning from England stands out as a simple emblem of Neorealism. The characters are thoroughly emptied of that forceful social commentary they would have had in the director's previous production, since they are used simply as a device to move the plot, and not as characters to be studied in themselves. Even the location, Stazione Termini, an optimal locality for a Neorealist setting, is completely reconstructed (most of the shooting was done at night from 12 to 5 a.m.), and functions as the simple background for Giovanni's and Mary's parting.

But it is, as I stated earlier, the role of the woman in society that is highly scrutinized in this setting. The unfolding of the plot aims at forcing Mary to submit to her marital and motherly duties: in fact it strives to reinscribe 'her' libido within the institutionalized boundaries of marriage. What is at stake is her repentance and renunciation, not Giovanni's. Perhaps the free, untamed expression of female libido creates a fear of social disorder, and needs then to be placed within social practices controlled by the juridical system. The intention to restrain female libido in the film is made even clearer in the American version, since the title, quite neutral in Italian – *Stazione Termini* – is changed to *Indiscretion of an American Wife*. Here the term 'wife' qualifies Mary's social

persona, while the noun 'indiscretion' hints at the trespassing of some boundary and at her incapacity to appropriately discern and discriminate. These boundaries are of legal nature.

One of the ways in which *Stazione Termini* inquires into a possible negotiation between private and public spheres is by opposing the individual to institutions. As soon as Mary and Giovanni start to recollect their encounter, an encounter ruled by desire,[84] a sharp, long close-up focuses on their hands, showing Mary's glittering wedding ring. The music is also especially emphatic at this moment. Mary's marital ring is emphasized at the very beginning of the film in the short introductory sequence in which we see her go up the stairs of Giovanni's building and then hesitate to ring his bell: the camera zooms up on her left hand – she just touches the bell – and on the wedding ring (the only one she is wearing). In addition, the toys in a shop window remind Mary of her daughter – the carillon-like music begins precisely at this moment – as do the little destitute children she helps out. One of the most direct and powerful messages is conveyed to her through the husband of the woman she helps. Referring to his companion he states: 'She good wife, good mother, always, always for family, never for her.' What the man really intends to communicate is the implicit positivity of his wife's giving attitude and his approval of her continuous self-sacrifice or, better, sacrifice of self. Mary seems to internalize the man's discourse as an allusion to analogous duties she has towards her husband.

Furthermore, the environment at the station is full of groups, which continually remind the audience of institutions, and of their power in shaping people's lives. All sorts of organized groups are passing by: there are soldiers, sailors, carabinieri, alpini, boy scouts, priests, nuns, and a group of deaf-mute boys. These people seem to be there just to offer a cue to the way people function in society by being affiliated to groups and by having their life organized according to the rules of the institutions to which they belong and which, in turn, ensure their welfare. Another way in which a primary institution such as the family exerts its control on Mary is exemplified here by her nephew Paul. Having intuitively grasped something about the interaction between his aunt and Giovanni, Paul 'checks' on her aunt. He first innocently provides her with an excuse to withdraw from Giovanni, then witnesses the shame of his aunt being slapped, and finally, when Giovanni spots him in the crowd and asks him where Mary is, he refuses to give him any information. He is always around. Paul even passes in front of the police

station where Mary and Giovanni are waiting for the Commissioner. When Mary spots him, from inside the office, she bows her head and covers it with her arm: to be seen by her nephew in the Commissioner's office would amount to an unbearable humiliation.

A judgmental/evaluating male gaze throughout the film continually and consistently scrutinizes Mary. There are at least a dozen instances in which she is the object of male scrutiny: at the phone booth, when she gets on the train, when she passes among three different groups of soldiers who whistle at her and make hot comments, when she and Giovanni are found in the empty train cart, in this case by one of the two policemen, who wears the lusty expression of an accomplice. She is gazed at by photo-reporters who are at the station waiting for a parade, by an old man who follows her and Giovanni to the police station and even peeps through the window, and by the thief who is being charged at the police office, and who, looking at Giovanni and then at Mary, quickly realizes their situation, and turns from accused into accuser. In the midst of these oppressive, multiple gazes, there emerges a most powerful gaze: that of the Commissioner.

The Commissioner's gaze is overpowering because it is legally sanctioned and thus carries all the weight of the patriarchal order that informs the Italian legal system of the time. Unlike other viewers, the Commissioner has a true right to enforce his judgmental gaze on women. It is interesting that, when the Commissioner watches Mary, her eyes flicker in disappointment and shame, whereas when the Commissioner watches Giovanni, he keeps his eyes steady, openly defying the Commissioner's gaze. This gaze is compassionate (or patronizing?) – what Mary and Giovanni did in the train cart does not seem very obscene: they simply kissed – but only insofar as Mary is willing to take her train and thus give up her passion for Giovanni. The Commissioner can excuse the passing whims of a (foreign) woman, but she has to repent.

The way private and public spheres mediate one another in *Stazione Termini* is shown through the interaction between Italy and America we see at work in the affair between Giovanni and Maria.[85] Giovanni is obviously proud of his Italian blood and of the inherent virility it seems to guarantee. As he says to Mary: 'Because my mother comes from America, it doesn't make me less Italian. In this country it is the men who count.' It is clear that Giovanni is claiming some primacy in the gender relation, as he underlines even when he talks about his small place at

Marina di Pisa and speaks of what it would be like to spend his time there with Mary. Their dialogue, which summarizes a series of worn-out stereotypes, is worth quoting at length:[86]

> GIOVANNI: 'When the wind blows from Africa it is very hot, it gets on your nerves, everybody quarrels ... We will probably have a lot of quarrels.'
> MARY: 'Why?'
> GIOVANNI: 'Same reason my father and mother quarreled.'
> MARY: 'Why? I thought they were very happy.'
> GIOVANNI: 'They were, very. But my father was an Italian and he behaved like one. He liked leading his own life and he would go off in the evening, he would go to a café and play cards and my mother wanted him to be with her.'
> MARY: 'So do I! I mean, I wouldn't like ...'
> GIOVANNI: 'To mend my clothes and cook my dinner? Don't forget I am an Italian too, and if you don't behave yourself I'll beat you.'
> MARY: 'Oh Giovanni you wouldn't, would you?'
> GIOVANNI: 'I would.'

As we witness later on, he would. While Giovanni is an extremely passionate man, and violently so – Montgomery Clift's intense performance enhances these qualities – Mary is the model of an emancipated, though very gentle, American woman. She answers Giovanni, who remarks that American women are much too emancipated: 'If I were not emancipated would I have done what I did then?' Yet, it is the disquieting, socially upsetting quality of this emancipation that needs to be controlled. The fear of a scandal, represented by the episode at the Commissariato, brings Mary completely back to her duties. This episode represents a massive intrusion of the public sphere into the personal one. The fact that the episode only serves a diegetic need and is not scrutinized in itself, and that it not only does not provide the occasion for a critique of social intrusion in the private sphere but also turns de facto into an apology for the condescending male gaze, shows the heavy reactionary message the film intends to convey. Rome, the 'Eternal City of Culture, of Legend ... and of Love,' as the viewers read after the credit sequence, might offer the opportunity for a transgression or, rather, an 'indiscretion.' Such transgression, though, has to be temporary, since, as the diegesis clarifies beyond any doubt, Mary's duty is that of returning to be, as she herself tells Giovanni, 'her husband's future.' Such a statement confirms and reinforces the film's message: the sphere

of (female) sexuality needs to be brought back within the reassuring, legally sanctioned, boundaries of the nuclear family. However, if it is possible to control a person's behaviour, it is difficult to see how the same control could be exerted on that whimsical and subjective realm constituted by desire: a question the film leaves unanswered.

The Myth Is Over: Pavese's La luna e i falò

The greater impact of the America/Italy interaction in the postwar period is, undoubtedly, that recorded by the cinema. The impact on literature is not analogously robust, disruptive, or pervasive. There are a few works that analyse such an interaction, but they do so with a less enthusiastic, heuristic way than the one expressed by Vittorini and Pavese in the thirties. An exception to this moderate attention to America is provided by Guido Piovene's De America, a journalistic book published in 1953.[87] Among the novels that specifically refer to America are Pavese's La luna e i falò (1950) and Soldati's Le lettere da Capri, which won the 'Premio Strega' in 1954. As we have seen, both authors had their first encounter with America in the thirties. They both revisit the American myth after the war, but with different attitudes. Pavese is deeply dismayed by the myth and dismantles it, possibly as part of a broader existential pessimism, which eventually induced him to commit suicide; Soldati is more receptive and apparently eager to synthesize the two worlds. For both, 'America' is no longer something that has a utopian life of its own, a culture or a land separate and far away, but something that has become deeply connected with Italy. For them, as for most authors of the postwar period, it is no longer possible to see America as a metaphor, for America symbolizes a modernity that has been both literally – the presence of American troops on Italian soil – and figuratively – through literature and the cinema even more – internalized by Italians: it represents a tamed, domesticated 'otherness' that, precisely because it has been tamed, is no longer 'other,' and therefore, in the case of Pavese, no longer appealing.

In Pavese's La luna e i falò, such otherness is framed, once again, in the familiar and yet unsettling terms of time. Much like Banti in Artemisia, in La luna e i falò Pavese interweaves the personal recollection of his protagonist, Anguilla, and the recent events of the Resistenza, and ends up privileging the 'subjective' sphere of recollection over the 'objective' one of history. Though childhood and the rural landscape of Piedmont, both surrounded by a mythic halo, always constituted important

thematic elements of Pavese's writing, the author starts to be interested more anthropologically in myth towards the end of his life, and gives way productively to such an attraction by editing a series on anthropological, religious, and psychological studies, with Ernesto De Martino, for the Einaudi publishing house.[88] The writer's fascination with myth demonstrates a strong attraction to the irrational, to those mysterious forces that underlie life's events, and from which poetry originates. In pursuing such an understanding of poetry, Pavese follows Vico's theories, which maintain that the poetic word is, intrinsically, mythic, while myth, conversely, in and of itself is poetic. Sharing these assumptions, the writer sets himself a very difficult, almost impossible, task: to unify a rationalist understanding of history and its events with a mythical perception of those irrational, unpredictable forces that drive a person's or, more amply, a community's existence. Notwithstanding his attempt at synthesizing these two conceptual frameworks, in *La luna e i falò* Pavese expresses his preference for the world of myth. He does so not only with his thematic choices – memory, infancy, and woman – but also with the very elliptical structure of the book, which is composed of thirty-two short chapters, narrated in the first person by the protagonist Anguilla.

Anguilla, now a well-to-do adult, comes back from America, where he emigrated when he was in his teens. Most of his contemporaries are dead, in particular three beautiful girls, Irene, Silvia, and Santina, daughters of Signor Matteo, his boss during his adolescent years, when he, a bastard, had to earn his living. The three girls, portrayed as 'victims' of their sexual impulses, met miserable deaths: Irene, the most ethereal, was beaten to death by her husband, Silvia died of a post-abortion hemorrhage, and Santina was shot by Partisans. The only person left from Anguilla's past is Nuto, the carpenter who used to play the clarinet at village celebrations and with whom Anguilla re-establishes a friendship. Through his interaction with Nuto and Cinto – a limping, ungraceful fellow *bastardo* who lives in an extremely poor and violent peasant family – Anguilla comes to recover his childhood; in effect, he evaluates his life, assessing the goals he has achieved, what he has lost and won. In the end, he realizes that all the world is, indeed, the same, and that there is no need to run away, as implied by the following statement: 'Anche l'America finiva nel mare, e stavolta era inutile imbarcarmi ancora, così m'ero fermato tra i pini e le vigne.'[89] With this book Pavese sanctions his changed feelings towards 'America,' and writes a novel about being rooted, about belonging, and,

finally – almost foreseeing his own suicide – about returning, cathartically, to the earth.

The very title, *La luna e i falò*, indicates the centrality of these two images – moon and bonfire – and of the *immaginario* they involve in the book. The moon, connected to the sphere of the unconscious, the night, and the feminine, evokes fecundity and the possibility of birth and rebirth – an image strongly reiterated by its association with the bonfire, often utilized to fertilize the soil in agricultural practices still alive in the first decades of the twentieth century. Bonfire and moon are thus associated because of their 'birth-inducing' qualities, an element that also ushers in the image of the woman. However, the moon image, as well as the bonfire's, is intrinsically problematic, since Anguilla perceives it differently in different moments and geographical contexts.

When he is in California, working as a bartender, the protagonist talks to a customer who has entered his bar in Oakland. As soon as he acknowledges the customer's being Italian, he says: '[qui] Non c'è niente ... è come la luna' ('Here there is nothing ... it is like the moon'). With this statement he equates America and the moon on the basis of their analogous emptiness/bareness. In the case of America such emptiness is perceived as a 'cultural vacuum,' since Anguilla's remark comes after noting[90] that there is not even a bottle of wine available. The opposition that is set up is between modernity, epitomized by urban (and suburban) America, and tradition, embodied by rural Piedmont and one of the symbols of its agrarian culture: wine. With this statement, Anguilla, Pavese's alter ego, seems to indicate that the only possible and real culture is the rural one, a way of life steeped in the earth and governed by succeeding seasons, measured by a mysterious, not always predictable, timing. The lack of wine indicates a more radical lack of tradition and, ultimately, of roots.[91] Later in Gaminella, talking to Nuto, who plays the role of the guardian of traditions, and who mentions the fertilizing – and almost mystical – power of the *falò*, Anguilla remarks incredulously by saying: 'Questa è la nuova ... Allora credi anche alla luna?' ('This is new ... You believe in the moon too?'). At the beginning, Anguilla himself is sceptical about peasants' beliefs about the power of the moon to affect the rhythms of agriculture; perhaps he is not ready to break away from his still-rationalist frame of mind, from the calculating attitude that stands behind his economic success in the States, and his surrender happens gradually in the book, as a newly found closeness with his origins, roots, the earth. Nuto's answer to Anguilla's incredulity is that there is no option but to believe in the moon ('La luna bisogna crederci per

forza'), and he lists a series of activities one has to do – such as cutting wood, washing barrels, grafting, etc. – following precise phases of the moon, if one wants to be successful. To believe in the moon implies, then, a resignation to the unconscious, and the concurrent burial of a logically oriented attitude.

The moon is the ambivalent icon that embodies both America and Piedmont alike,[92] and thus the choice between the two worlds is up to the protagonist. It is the way in which the protagonist perceives and positions himself in front of the moon that indicates his choice between the two countries and the two societies. The choice is, doubtlessly, for the agrarian one, as the following quote – Anguilla is lost in California's vast terrain – indicates: 'C'era una luce rossastra, scesi fuori intirizzito e scassato; tra le nuvole basse era spuntata una fetta di luna che pareva una ferita di coltello e sanguinava. Rimasi a guardarla per un pezzo. Mi fece davvero spavento.'[93] The unfamiliarity of this American moon, which induces fear and stirs up bloody impressions, epitomizes the extraneousness of a world that is no longer appealing for Pavese, a place to which he no longer belongs. Earlier in the novel Anguilla had also stated that 'quelle stelle [americane] non erano le mie' (17) ('those [American] stars were not mine').

For what matters to Pavese now is the return to that time of wonder represented by a childhood that is not only no longer metaphorized by America but that also comes to replace the American myth *tout court*. *La luna e i falò* thus brings us back to a concern with time very similar to that analysed in the first chapter. Here, too, we are faced with the problem of bridging two different times, 'before' and 'after': before and after the war, before and after having gone to America, before and after the political orthodoxy represented, for Pavese, by his novel *Il compagno* and by a series of didactic articles, published mostly in 1946.[94] Even though the Partisan fight is an integral part of the narration, its impact is, but for the final section of the book, feeble. There are quite a few instances in which the Partisan fight is openly remembered,[95] although one theme does recur throughout the novel: the discovery of corpses buried here and there in the fields. Corpses are part of a necrophilic theme that flows like an underground stream through the book and also includes the death of the three sisters and of Cinto's father, the fire at Anguilla's house where two women are burned alive, and the mention of soldiers' corpses. The corpses, which have become 'naturalized' since they enter the earth's cycle of renewal, now belong to a mythical, a-historical time. The *Resistenza*, recalled mainly through corpses, thus

ends up being pictured as part of a History that touches the protagonist – who was at the time in America – only tangentially (Pavese himself did not actively participate in the civil armed insurrection): it constitutes an important, contextualizing element, but slides into the background, while sentimental concerns come to the foreground.

The prevalence of these concerns is underlined by the treatment of Santina, the youngest daughter of Signor Matteo. After her liaison with the local Fascist *gerarchi*, she offers her cooperation to the Partisans: she is actually a double agent, and when she is discovered she is killed. Santina, like her two sisters Irene and Silvia, is an integral part of Anguilla's past, of the house where he used to live as a servant, where he came of age as an adolescent, and where he first experienced erotic desire. In the figure of Santina, Anguilla thus fuses his own past – the recollection of childhood – and the recent historical past – the *Resistenza*. The girl was still a child when Anguilla left for America, but Nuto saw her coming of age, was probably secretly in love with her, and witnessed her blossoming into a beauty. ('Tu, Santa a vent'anni non l'hai vista. Valeva la pena, valeva. Era più bella d'Irene, aveva gli occhi come il cuore del papavero.')[96] Though Nuto is always almost inexplicably reticent, in Anguilla's eyes, to talk about the Partisan fight on the hills, by the end he decides to tell Anguilla what truly happened to Santina: 'Tanto vale che te lo dica, – fece Nuto d'improvviso senza levare gli occhi – io so come l'hanno ammazzata. C'ero anch'io.'[97] Santina, a spy, was finally discovered, judged, and shot to death while trying to escape. Anguilla clarifies that, because Santina was such a beautiful woman, they could not simply bury her: even buried she could stir up the desire of many men. They gathered branches over her corpse, poured gas over it, and lit it. 'L'altr'anno c'era ancora il segno, come il letto di un falò.'[98] These are the last words of the book, which ends by recovering the image of the title: the bonfire, a sort of purifying, sacred fire in which all the mythical elements dear to Pavese – moon, earth, woman, cathartic fire – are addressed and summed up.

Nuto's recollection of Santina is imbued with nostalgia, shame, and a desire to forget. Through Nuto's presentation, the reader connects with a sentimental, emotional dimension. It is not that Santa is not judged for her betrayal, and with a misogynist tinge[99] peculiar to Pavese; but she is nevertheless, presented as a confused girl, somebody who deserved more and better from life. Her death carries away the past, or at least part of the past, connected to the survivors' lives. It thus signals a rupture, a loss. Santina's death crushes that sense of the continuity and

thoroughness of one's life that both Nuto and Anguilla had experienced. She also belonged to their past – their childhood and youth – hence to their memory as adults. With the recounting of Santina's killing, Pavese does something analogous to what Germi does in *Gioventù perduta*. In Germi's film the nostalgia for a mythicized 'before' – before the war – wipes away the fact that such a 'before' also meant Fascism. Here, from a different angle, the 'before' – Santina and what she represents – is emotionally more significant and powerful than the 'after' – the recent past or the fight for Italy's liberation. 'Before' signifies one's past, one's sense of continuity with oneself. The death of Santina is not evaluated through the eyes of that 'justice' that the Partisans could provide, but through the eyes of a lover at a distance, with the condensed pregnancy of Nuto's unrevealed feelings and Anguilla's empathy. The reason for her death – betrayal – is, indeed, almost incidental, and not 'politically' relevant for Nuto and Anguilla. This is why Santina deserves to be burnt in a bonfire, being thus offered a rite that entails both dissolution and a possible regeneration. The bonfire returns Santina to the earth through a ritual belonging to prehistorical times; a ceremony possibly attributed to a chthonic deity. As Vincenzo Binetti has pointed out in his analysis of one of Pavese's poems ('Sei la terra e la morte'), the earth to which Santina returns is an earth-death: 'La terra dunque come luogo mitico di rivisitazione delle proprie esperienze memoriali, come *spazio metastorico* di un eterno quanto irrealizzabile ritorno diventa necessariamente la terra-morte che attende inesorabilmente il concludersi ciclico di una vicenda assolutizzata e ormai al di fuori del tempo e dello spazio' (italics mine).[100]

The earth is thus that 'metahistorical' (I would suggest, again, mythical) place that contains a beginning and an end, and that signs a Vicoan cycle of annihilation and renewal whose ritual is the bonfire, as we can infer from the following lines of another of Pavese's poems – 'Un acceso silenzio/ brucerà la campagna/ come i falò la sera' (125) – where silence (death?) annihilates the earth much as the bonfire burns it. But not just the earth is associated with death. In Pavese's late poetry woman as well becomes death, an unreachable entity, an absent being who engages the author in an impossible dialogue and, finally, turns him over to himself, and therefore to his own solitude and silence.[101]

With *La luna e i falò* Pavese chooses a mood and/or style – recollection through the subjective category of memory – that I have associated (as in the case of Banti and de Céspedes), specifically in this time, with female authorship, and that turns out to be opposed to a more objec-

tive, or also (neo) realistic or politically engaged, kind of narration.[102] The duality between the impact of *logos*, rational discourse and there-fore history, and the fascination of *mythos*, poetic word or fantasy, cre-ates a contraction at the level of Pavese's political engagement, since he sincerely feels that he cannot subordinate his art to the Party's dogmatic requests. He thus, interestingly, and not without consequences, creates an annoying disturbance in the – then prevalent and yet questioned – canon of gender. As a male prose writer and intellectual, he chooses to identify with a 'female' persona, one who narrates mainly through recollection in an elliptic, fragmentary, and methonymical way, thus generating a problem of reception among male and Communist literary critics.

The problem is clearly readable in Mario Alicata's review of the book, published on *Rinascita* in 1950. Even though the critic hastily praises the novel, he sees the protagonists weakened by the excessive use of *monol-ogo interiore* (interior monologue). Further, he holds Pavese responsible for indulging in a sort of caprice:

> Peccato insomma che il Pavese, il quale pure si è sbarazzato di tanti altri vezzi tecnici e stilistici, che erano poi malvezzi, d'impostazione americana, e il quale dimostra in tante pagine di *La luna e i falò* di possedere oramai una lingua capace di dare un corpo consistente e schietto ai movimenti della sua fantasia, in un vezzo indugi ancora: in quello, cioè, di non affron-tare direttamente gli uomini, i loro sentimenti, le loro passioni, ma di *'filtrarli' attraverso la memoria* di un personaggio fittizio e ambiguo, che è e non è lui stesso, l'Autore.[103] (italics mine)

For Alicata, telling through memory undermines the realism of the characters and weakens the integral rendering of their feelings and pas-sions. He considers the inclination towards memory confusing since the indulgence in it prevents the expression of a clear 'judgment' and pro-vides out-of-focus pictures.[104] As a male subject entrapped in, as well as operating by, the forceful androgyny of the neuter universal, Pavese can also express his own female aspects – or rather a sensitivity at the time commonsensically associated with the feminine – only as a denied other-ness for which there is no possible or available symbolization. And not even a language: 'Non parole. Un gesto. Non scriverò più,' writes Pavese in his journal just before killing himself.[105]

THE COUNTRY AT HAND

Proprio in quegli stessi anni, grazie ad una imponente motorizzazione privata di massa, mutarono anche le proporzioni geografiche del paese. Ricoperta di autostrade e di distributori di benzina l'Italia si rimpiccioli, e mentre cambiava il senso dello spazio cambiò anche la sua misura.

In those years, thanks to a great, massive private motorization, the geographical proportions of the country changed too. Covered with highways and gas stations, Italy got smaller and, while the sense of space changed, the way to measure it changed too.

<div align="right">ERNESTO GALLI DELLA LOGGIA</div>

The Journey

In the late forties and early fifties, the idea of modernity was consistently associated with a concept that was quite recent, in its large-scale application, for Italian society: that of leisure time. On the one hand, the increasing distance from the war and the *Ventennio*, both chronological and emotional, depleted of moral urgency the need to process one's involvement in Fascism. On the other, Italians were entangled in their present – meaning a reconstruction that seemed to erase, at a fast pace, the poverty the war had left behind. The result was that narratives referring to Fascism, or which took place in that period, did not usually voice the painful contradictions Italians had gotten accustomed to in the years 1945–49; for, as time went by, it became easier and less problematic to forget. Forgetting was also eased by the fact that leisure time – a

period free of work, devoted to personal enjoyment, relaxation, and eva-
sion – became, though unevenly distributed, nevertheless a commodity,
increasingly marketed towards and valorized among, urban middle-class
Italians.[1] However, leisure time was not a postwar invention: Fascism,
too, had implemented a notion as well as a practice of leisure time, but
under Fascism leisure time was mostly institutionally organized.[2] There
were summer camps for children, after-work organizations – *Dopolavoro*
– for different categories of workers, popular entertainment, a massive
organization of sports through CONI (Comitato Olimpico Nazionale
Italiano), and other analogous recreational and cultural activities. All of
these practices, though, served an ideological, centralized notion of
how and when leisure time was to be assigned to people. They were
often enforced as a patronizing recognition of loyalty to the regime, as
well as the regime's propagandistic tool.

The fifties offer a different scenario.[3] Particularly with the large-scale
production and diffusion of television (1954), the Vespa motorscooter
(1946), and the compact Fiat Seicento (1955)[4] and the Cinquecento
(1957), leisure time started to become a privatized commodity that
escaped the control of those centralizing agencies – such as the govern-
ment and the Church – that had controlled it until then.[5] Of course
leisure time was, then, a luxury that could be afforded only by certain
kinds of workers – apart from professionals, prevalently clerks and state
employees, salesmen, single young women working as secretaries, ser-
vants who had their Sundays off (though perhaps for only three hours,
as Risi shows in his episode of *Amore in città*, 'Paradiso per tre ore'), spe-
cialized factory workers, and the like – and in specific, limited areas of
the country, usually the urban settings of Italy's northern regions or the
capital, Rome. Leisure time was of course spent in different ways and
according to different budgets – it could consist of a simple window-
shopping expedition to the city or a motorcycle ride – but one of these
ways became fundamental in the process of piecing together a new cul-
tural image for the country: the journey.

Journeying became increasingly textualized in films and novels of the
late forties and fifties. Films that deal with journeying include Emmer's
Domenica d'agosto (1951) and *Parigi è sempre Parigi* (1951), Antonioni's
Cronaca di un amore (1950) and *Le amiche* (1955), and Germi's *Il cammino
della speranza* (1950). Books addressing this topic include Anna Maria
Ortese's *Il mare non bagna Napoli* (1953), Rocco Scotellaro's *Contadini del
Sud* (1954), Ernesto De Martino's *Il mondo magico* (1948) and *Sud e magia*
(1959), and Piovene's *Viaggio in Italia* (1953–57). In these texts the jour-

ney functions as the informative practice through which a country already distant from the rough emotionality of the war and of its aftermath is now eager to learn about itself. This chapter studies how the journey became, around the fifties and well into that decade, a major icon to represent the changing sociocultural landscape of Italy.

I will begin with the 'discovery' of the South, a part of the country that had remained largely unknown to the majority of Italians. What comes to the foreground is the South's 'otherness,' framed in terms of irrationality and a-historicity, and stigmatized by an anthropological interest that makes it 'primitive' and pre-Christian. I will then consider the thousands of immigrants who moved from the South to the industrialized North and how a major dichotomy – in itself a remarkable aspect of postwar Italy – was set up between the 'productive' Milan and the 'lazy' Naples. Rossellini's *Viaggio in Italia* and Antonioni's *Le amiche* both provide important contributions to the process of knowledge and self-knowledge that the trip puts into action, for they both portray the psychology of the protagonists and the nuances of their personal relationships with an intensity quite novel to Italian cinema. In the case of these two films, the journey offers the opportunity for an in-depth immersion into the inner world of the characters. Further in the fifties, Italy seems to connect on a larger, more 'modern' scale to European culture and to the incipient epistemological crisis of postmodernism, as it is foreshadowed in the work of anthropologist Ernesto de Martino.

The journey then consists both of a physical venture – the actual exploration of the country – and, even more, of a metaphoric quest – the discovery of the country's great sociocultural and economic diversity. Such a diversity entails the emergence of a variety of aspects and topics that were censored – even though, again, not always successfully – under Fascism, such as homosexuality and lesbianism, and were now explored by Arbasino, Bassani, or Pavese.[6] A vast female dissatisfaction is voiced by Gabriella Parca's *Le italiane si confessano* (1959),[7] and there is even space for a vocal political dissent on the left, as seen in Arpino's unflattering portrayal of Togliatti (*Gli anni del giudizio*, 1958). Journeying, both directly and indirectly – that is to say, the actual travelling through the country as well as the uncovering of its heterogeneity – becomes one of the heuristic procedures through which a class of intellectuals tries to learn more about Italy and about itself. It is with bewilderment, anxiety, pleasure, and disbelief that writers, directors, journalists, and people who would later be defined as *operatori culturali*, or cultural facilitators, ascertain that they live in a nation which they barely know. The journey

embodies a figure of both national and self-discovery. The reality that comes to be revealed is in fact at once geographical and personal/subjective. It includes the peculiarities of each Italian region, and it frees the access to the individual's unconscious. Such an unconscious announces its complex and problematic nature, for it shows the traces of the alienation induced by industrial settings – an alienation powerfully portrayed in Antonioni's and, later, Pasolini's work.

Travel was neither an upper-middle-class prerogative nor exclusively a leisure activity. Not only intellectuals and rich people traversed the country: hundreds of thousands of poor *braccianti* and artisans looking for a job did it too. According to Goffredo Fofi, between 1952 and 1962 at least ten million Italians, the overwhelming majority coming from the South,[8] changed residences: that is, 20 per cent of the entire population. While travel could be, for intellectuals and wealthy people alike, an entertaining activity, it became a dramatic necessity for most immigrants who moved to the foggy cities of the industrial triangle, in particular Turin and Milan, from the southern rocky and dry regions, and who faced miserable and often inhuman living conditions, not to mention a radical cultural uprooting.

The journey, performed in these various fashions, constitutes a central icon, metaphor, and actual practice in the fifties; so much so that I suggest using it as a fundamental key to analyse the decade. It is through the knowledge that journalistic reportage, novels, and films made accessible, along with first-hand experience, that Italy came to terms with its own centrifugal heterogeneity, thus heading towards the radical sociocultural revolution in which it was soon to plunge via the *miracolo economico* (1958–63).

What stands out as a result of these numerous and different kinds of journeys is the extreme regionalization of the country. After the war, Italy discovered its bewildering and puzzling variety.[9] Marginalized regions and underrepresented, or even unknown, classes of workers – such as the tuna fishers of Rossellini's *Stromboli terra di Dio* – come to the forefront. Regional dialects and inflections, along with local habits and traditions, are proudly recorded in books and films. This trend, which started with Neorealism, was reinforced and emphasized in the fifties. It also functioned as an oppositional response to the linguistic policy of the prewar period. Fascism, which wanted to rejuvenate the myth of *romanità*, repressed dialects and even languages (as happened in South Tyrol) and also prohibited their use in movies.[10] In the postwar period, that process of homogenization was openly defied. Paradoxically enough, while Italy was searching for an identity that might unify the

country under the aegis of a new republican constitution, it nevertheless had to confront the massive fragmentation of its linguistic and literary canon.

The trend is widespread and represented by authors who use dialect in its different varieties.[11] What is most important is not the origin of these authors per se, but the fact that they either write in dialect or that they use a cadence or syntax moulded after their own dialect, and that they usually investigate the customs and habits of their own cities. In so doing they also contribute to broadening the definition of the established literary code.[12]

A clarification nevertheless needs to be made. As Gian Luigi Beccaria claims in his preface to *Letteratura e dialetto*, 'la dialettica lingua-dialetto è stata in Italia una delle strutture portanti dell'espressione letteraria ... sin dalle Origini.'[13] Beccaria states that, unlike France, for instance, whose linguistic and cultural identity centred around Paris and where a clear hierarchy was instituted between language and dialect (*patois*), 'in Italia è mancata una capitale linguistica e culturale accentratrice'[14] and that, therefore, 'il contrasto dialetto lingua non si è mai evidenziato come opposizione socio-linguistica di cultura/incultura, come criterio e segno esteriore di una situazione socioculturale di inferiorità.'[15] Rather, the dialect had been an instrument used to valorize local heritage or to oppose a literary tradition that was considered as too refurbished and formalized. But even poets who wrote in dialect in this century – for instance, Marin, Pasolini, Zanzotto, Noventa, and Pierro – are extremely refined and sophisticated masters of style. Beccaria continues: 'Anche quando, negli anni Cinquanta il dialetto assume quella *funzione di ricerca e di denuncia sociale*, e la "caratterizzazione locale voleva dare sapore di verità," ebbero importanza quasi preminente "il linguaggio, lo stile, il ritmo" (Calvino).'[16] Dialect therefore enjoys a status not so much as a non-literary language, but rather that of another literary language which is juxtaposed, sometimes in a dialectical fashion and sometimes in a syncretistic one, to the official literary language. Therefore we can conclude that, particularly in the fifties, the use of dialects functioned as an exploratory 'journey' through the country: as a means to further inspect and, ultimately, discover it. The area that emerged most violently in this investigation of Italian regions was the South.[17]

The South: Ernesto De Martino and Rocco Scotellaro

The South is a generic, and not necessarily accurate, term from a geographical standpoint, since it designates an area that includes the *Ciocia-*

ria, or Roman inland territory, as well as the central region of *Basilicata*, usually referred to as Lucania – a name now forgotten. It also includes the insular areas of Sardinia and Sicily – which identifies a sociocultural reality associated with economic underdevelopment and (this will be at the core of a heated debate) perceived as a backward, primitive civilization. The area had been 'problematic' since Italy's unification, with its strong resistance to a state perceived as colonizing and exploitative.[18] The situation of the South and of southern intellectuals had also been – during Fascism – one of Gramsci's main concerns. Gramsci – and Croce before him – was one of the first intellectuals to address it, unifying cultural and economic issues under the heading of the *questione meridionale*, or southern question. He linked the *questione meridionale* to the role of intellectuals in society – one of the cores of his thought.[19] Even though Gramsci (1891–1937) had written his major works – a series of notes, thoughts, reviews, etc. later collected in volumes – while in prison during the *Ventennio*, his books did not start to become popular until 1946, when Einaudi published *Lettere dal carcere*. In 1947 the book won the important Viareggio Literary Prize. The vast popularity Gramsci enjoyed, particularly on the left, caused his analysis of subaltern classes to become respected guidelines, or at least orientations, in some local attempts at modifying class relationships.

In the postwar period, the South made it to the front pages of the newspapers, mainly through its agrarian battles, which reignited after the Communist defeat in the 1948 elections.[20] Particularly in Calabria, Basilicata, Abruzzi, and Sicily, but also in the *pianura padana*, by the Po River, many *braccianti* occupied the lands of absentee owners, who, in turn, called the national police (*carabinieri*) for assistance. There followed a series of violent confrontations such as the well-known episodes of Melissa (1949) or Bronte (1950) that left many dead and wounded. These tumults forced the government to draft a *Riforma Agraria*, or Agrarian Reform, in 1950. The Reform remained largely inadequate and affected the power structure between owners and peasants only superficially, resulting in minimal land redistribution.[21]

Another important element with reference to the South is the institution in 1950 of the *Cassa per il Mezzogiorno*, a state fund whose purpose was to foster economic development as well as employment in the South.[22] Further, in 1953, fifteen volumes of a survey sponsored by the government, *Inchiesta parlamentare sulla povertà*, were published. The shocking findings showed, among other data, that a substantial minority of Italians – two and a half million – were still *senzatetto* (homeless), liter-

ally without a roof, living in extremely poor conditions in ex-*caserme* (barracks), schools, cellars, and *baracche* (huts).[23]

On the literary side, the South powerfully emerged on the national scene with Carlo Levi's autobiographical novel *Cristo si è fermato a Eboli* (1945). The author (1902–75), who had been confined to Lucania for political reasons between 1935 and 1936, describes the life of the local *cafoni*, or peasant workers, with deep respect and consideration for their belief system, and he launches the idea of an economic development that should free them from the incredible harshness of their everyday life while also honouring their civilization. Levi's attitude marks an important difference from previous and contemporary works about the South – works usually retrospectively referred to as *Letteratura meridionalistica*, or Literature of and about the South. While many texts – with the exception perhaps of Silone's – collapse into the same concept poverty and backwardness, generally adopting a patronizing point of view, Levi does not assume that his own cultural formation as a (Jewish) northern, urban intellectual is inherently better or more valuable than that of these *cafoni*, even though he tries to render their situation mythic and somehow a-historical through the use of a diffuse lyricism. Precisely because of its un-presumptuous, naked adherence to a poverty-stricken reality, *Cristo si è fermato a Eboli* stirred up a great interest, even internationally, in the Italian South.[24]

Many American sociologists, anthropologists, and researchers soon discovered – thus betraying Levi's own attitude – the 'primitive' within Italy. G. Peck, D.S. Pitkin, R. Redfield, F.G. Friedmann, L.W. Moss, E.C. Banfield, A. Cornelisen, and many others came to southern Italy and particularly to areas of Lucania, Tricarico, and Matelico to study village and family organization. At the same time, a group of Italian intellectuals, technicians, researchers, and writers gathered around the journal and press *Comunità*, sponsored by the industrialist Olivetti.[25] *Comunità*, the journal edited between 1946 and 1947, and then from 1949 on, strove to study and promote 'forme di intervento mirate ad una modernizzazione guidata dall'utopia dell'incontro tra città e campagna, tra civiltà urbana e civiltà contadina.'[26] The South was also the place where the Neapolitan scholar Ernesto De Martino (1908–65) conducted his fascinating anthropological surveys.

De Martino – who, when starting his research, had read widely the available scholarship about primitivism – came to the 'South' from an abstract, literary point of view. Linking the areas he visited to other indigenous areas in the world, he saw in the local magical practices one

of the few tools peasants had in order to cope with existential anxiety. For De Martino the villagers resorted to magic in order to recompose that *presenza*, or presence – unity of and within the individual – whose cohesiveness is constantly threatened by the unbearable harshness of everyday life. De Martino follows Croce's theories of *storicismo idealista*, or idealist historicism. The scholar's preface to the first edition of *Il mondo magico* clearly praises Croce and shows the intellectual gratitude De Martino felt for the Neapolitan philosopher as well as his indebtedness to Croce's speculation. However, even though rooted in the Crocean teachings, De Martino attempted to do something that amounted to a paradox from a Crocean point of view: to inscribe in history precisely those 'irrational' phenomena that for Croce could only have had an anecdotal value – phenomena that Croce would not have considered worthy of being studied or taken into account in writing history. For De Martino a historiography of magic would offer scholars new scenarios and an opportunity to grow intellectually, as he indicates in the preface to *Il mondo magico*: 'Una interpretazione storicistica del magismo deve costituirsi come reale i n c r e m e n t o della nostra consapevolezza storiografica in generale, e pertanto deve essere pronta e aperta *alla conquista di nuove dimensioni spirituali, e alla ulteriore articolazione o addirittura alla totale riplasmazione della metodologia storiografica alla luce delle nuove esperienze.*'[27]

The Neapolitan ethnographer challenges the assumptions of historiography as a scientific discipline and strives to broaden its boundaries, thus facing a problem of an epistemological nature: namely, what could be considered a feasible object for writing history. In so doing he questions Croce's historicism or, more precisely, not Croce but what he himself defines as the 'storicismo pigro, sermoneggiante (o addirittura salmodiante)' ('the lazy, sermonizing – or even preaching – historicism') of Croce's followers. De Martino pushes his ethnographic 'journey' further South. In fact – and much earlier than many postmodernist thinkers – he comes to question the primacy of Western culture and the fact that its blind faith in rationality is used de facto as the central parameter against which to measure all other cultures. Referring to the thinking process that underlies the history of magic, De Martino states that such a process 'sottopone ad analisi non soltanto il mondo magico, m a anche il modo occidentale di accostarsi ad esso.'[28] De Martino, by openly questioning the presuppositions of his own ideological and scholarly formation, enhances a centrifugal move that anticipates a critique of Western culture to be massively embraced, in the next

decade, by intellectuals and fiction writers alike. While, when he wrote *Il mondo magico* (1948), De Martino 'sembra[va] muoversi nel mondo intellettuale – senza classi sociali ma aristocratico – di Benedetto Croce e Adolfo Omodeo,'[29] he later opened up, in various articles as well as in *Morte e pianto rituale nel mondo antico* (1958) and *Sud e magia* (1959), to the influx of Gramsci's thought and to a sympathetic reflection on the *classi subalterne*, or subaltern classes. He therefore adds a sociopolitical, Marxist element to his previously idealist analysis, thus exemplifying a process undergone by many thinkers who came of age during Fascism and under Croce's influence and later embraced Marxism.

Within this cultural atmosphere and within the wide political as well as cultural debate about the South – a debate accused from many parts of anachronistic Rousseauism – there emerges a particularly interesting figure, that of the *poeta-contadino*, or peasant-poet, Rocco Scotellaro.[30] Scotellaro, whose work is considered linked to Carlo Levi's, won the Viareggio Literary Prize posthumously in 1954 with *E' fatto giorno* (a collection of poetry) and *Contadini del Sud*, thus attracting, once again, national cultural attention to the subject of the Mezzogiorno.[31] Born in Tricarico into a family of peasants and artisans, Rocco Scotellaro (1923–53) seems to embody perfectly the Gramscian notion of *intellettuale organico* (integral intellectual), that is to say, a cultural activist who has a historical awareness of the class from which he comes and devotes himself to its full political representation. The *intellettuale organico* mediates consensus between his class and the ruling class and thus helps to elaborate new forms of class-consciousness. At the age of twenty-three, Scotellaro became the mayor of his small village and participated in its agrarian fights. Contemporaneously, he collaborated on journals and magazines dealing with the South, and was at the centre of a rich intellectual network that included – besides his mentor Levi – Manlio Rossi Doria, De Martino, and a few American anthropologists.

His autobiography, *L'uva puttanella*, which recounts his childhood in Tricarico, his attending a Jesuit school (the only way in which his family could provide him with a higher education), and his incarceration because of a political vendetta, is written in a style not exactly 'literary.' The book depicts a local reality similar to that investigated by Carlo Levi. Scotellaro evokes his land and his people with nostalgia, underlining their emotional attachment to the land, and their almost sacred respect for, as well as panic fusion with it. Particularly in the figure of his father, the writer notices an almost thorough identification between man and landscape. The attributes of the landscape – essential, archaic,

dry, and harsh, but at the same time productive – come to define the people who inhabit it and their psychology. In order to reproduce his village's life, Scotellaro uses a language full of regional syntactic structures. For instance, he resorts to expressions such as 'mettersi la via sotto i piedi' ('put the street under your feet') for *camminare* (to walk), and places his qualifiers in unusual positions; he also uses anacoluthons. He immediately gives an overall 'spoken' quality to his writing, as one can could observe in the following sample: 'Mi stavo appunto avviando, *in prima*, verso il Cimitero, che è di fianco al paese, sulla grande strada, nella piega di due colline: da tutte le finestre e i balconi si può vederlo di fianco con pudore, lì stanno i nostri morti nudi, di lì misurano *loro* puntualmente la nostra fedeltà'[32] (italics mine).

Here *in prima* is an unusual expression, since one would customarily use *dapprima*, or *per prima cosa*, and *loro* is positioned after the verb *misurano* in a similarly uncommon position, which is nevertheless customary in the South. In standard Italian it should go before the verb, *loro misurano*. Similar grammatical choices occur in the following passage: 'Ma anche per questa direzione io dovevo *stupire* se vedendomi le donne mi chiedevano: – E che? – tacendo il resto. Io dicevo subito: – Alla vigna – e le *faccie* si distendevano, rimanevano però le *voci loro* dietro le mie spalle.'[33]

In this case *stupire* is not used as a reflexive verb, and is not, as it should be, accompanied by the reflexive pronoun -*mi* (*stupirmi*). *Faccie* is spelled incorrectly; it should be *facce*. In *voci loro*, the possessive pronoun *loro* would usually go before the noun *voci* (i.e., *le loro voci*). Notwithstanding his challenge to the established linguistic as well as literary code, Scotellaro and his supporters such as Levi claim an artistic legitimacy for his work.[34] Further, the peasant-poet turns – more or less consciously, and more or less voluntarily – into a spokesman for the South, to which he seems to give voice both through the dialect-inflected language he uses and by the telling of his own history. Scotellaro embodies, in some respects naively, the myth of the *poeta-contadino*, since he tells a personal story that shows an attempt to write, in Carlo Levi's interpretation, something more than a simple autobiography and, namely, 'una storia generale poetica del Mezzogiorno' ('a general poetic history of the Mezzogiorno.') Scotellaro goes even further in this representative, Neorealist-agrarian direction with *Contadini del Sud*, a collection of five stories of peasants and artisans of his village based on these peoples' actual testimonies.[35] By selecting them as narrators of their lives, Scotellaro validates their point of view, giving legitimacy and authoritativeness

to their protest against legislators, the state, and its institutions and representatives.[36]

Scotellaro, De Martino, and the *Comunità*'s team represent only one of the ways in which the South forcefully came to national attention and through which intellectuals dealt with 'the problem of the South.' While, on the one hand, there was the dramatic, tragic reality of a South that was desperately poor, isolated, and forgotten, there existed, on the other hand, a myth of lightness, joy, and nonchalance. This myth was constructed principally around Naples and its (assumed) carefree attitude towards life.

Naples: Ortese's *Il mare non bagna Napoli* and Rossellini's *Viaggio in Italia*

The dichotomy between the industrialized North and the agrarian South came to be increasingly polarized around two main cities, Milan and Naples. While Milan provided a grey working environment marked by both productivity and lack of moral scruples, Naples became the source of a highly folklorized *élan vitale*, of a sort of unproblematic and always happy way to face life's hardships.[37] Thanks to its privileged climate, its closeness to the sea, the inherent 'good disposition' of its inhabitants, not to mention their presumably irresistible inclination to singing – thanks then to a conspicuous series of stereotypes – Naples embodies the abstract, de-historicized and unproblematic category of the *pittoresco*, or picturesque.

Naples's legend, which goes back to the tradition of the nineteenth-century Grand Tour, was revived in the fifties by various authors and also by the *gran signore* (gentleman), Bernard Berenson (1865–1959). During his extensive radio reportage, later published as *Viaggio in Italia*, Guido Piovene visited Berenson at Villa I Tatti, in Florence. Berenson told him that he liked 'la vitalità pura, Napoli, per esempio, come gli apparve oltre sessant'anni fa: un groviglio di vita sincero e caldo e capace di simpatia.'[38] Even though Berenson refers to the city of sixty years earlier, he continues by stating, with a certain degree of abstraction that renders his statement chronologically unspecific, that 'proprio il quartiere povero, quello ... in cui l'uomo è costretto a uscire ogni mattina a caccia dell'incerto cibo, sia il luogo in cui l'uomo vive felice.'[39] Berenson's point of view is clearly aristocratic and unrealistic. The art critic situates his perception of the city outside any sociological analysis: he avoids taking into account class relations and ultimately aestheticizes

poverty, almost attributing to it a positive value. He claims that poverty guarantees freedom and even happiness.

The same Piovene, though, later in his journey, gives voice to the other side of the coin: the dismay of southern intellectuals.

Ammirare troppo il folclore, il colore napoletano (e meridionale in genere), estasiarsene, farsene un idolo, oggi è poco gradito anche ai meridionali più intelligenti. I giovani liberali, d'origine crociana, che redigono la più importante rivista napoletana, 'Nord e Sud,' sono espliciti su questo punto. 'Bisogna inserire il Sud' mi dice il direttore, Francesco Compagna, 'in un sistema occidentale, nelle sue idee, nei suoi costumi. Perciò combattere l'idea di una civiltà del Sud da lasciare incontaminata, una entità ondeggiante fra il mistico, il mitico e il magico, un venerabile miscuglio di anacronismi e di stranezze.'[40]

However, notwithstanding the resentment towards the 'picturesque' felt by southern intellectuals, Naples was mainly represented as the city able to laugh at itself, never taking life too seriously, and trying to cope with difficulties through the *arte di arrangiarsi,* or 'art of getting by,' that its inhabitants had brought to a high level of sophistication. An example of such an attitude is provided by Eduardo De Filippo (1900–84), the famous comedian and scriptwriter, who, after the war, was also active in the cinema.[41] De Filippo represents, in his works published soon after the war in semi-vernacular – *Napoli milionaria!* (1945), *Questi fantasmi!* (1946), and *Filumena Marturano* (1946) – the life of the *bassi,* or poor dwellings, and their destitute people, with a sharp and biting humour that somehow reinforces the picturesque element.[42] The lively, gesturing, good-hearted people of Naples are foregrounded, while their weaknesses are generously accepted and forgiven. All tensions come to be played out and resolved within the family – which De Filippo considers the core of every human interaction. He offers the stereotypical description of Neapolitans in an almost forgotten film produced in 1953 called *Napoletani a Milano,* in which he explores the interaction between North and South by giving his own account of southern immigration to Milan.

The film plot is fairly simple: a group of northern industrialists want to develop a Neapolitan area that is covered by shacks and slums and therefore need to evict the poor who live there. While most of the people move out, five people remain, and are killed when their homes are torn down. De Filippo, who is the adviser to this small community, notices that almost everyone in the group has the same three or four last

names, Cuppiello, Esposito, etc. Realizing that these names are also those of the deceased people, he plans – here comes the *arte d'arran-giarsi* – to sue the industrialists by asking for money for the now quite enlarged group of the victims' relatives. A massive group of Neapolitans thus comes to Milan. The industrialists offer them jobs instead of money, assuming that the Neapolitans, stereotyped as unwilling to work, will refuse the offer. But the southerners accept. Thus begins a close interaction between the Milanese and the Neapolitans in which all the major stereotypes about North and South are shown to be inconsistent and caused mainly by the fact that people do not know one another. Perhaps, De Filippo says at the end of the film, summarizing its rather superficial optimism, instead of having a train from Naples to Milan, there could be 'un tram direttissimo Duomo–Posillipo' that would abolish the geographical (and sociocultural) distance between North and South.

While De Filippo aims at bridging the cultural gap between North and South, he remains quite simplistic in the strategy he proposes. It is in fact merely the goodwill of the workers and their increasing solidarity with one another that allows things to go smoothly, even during a major strike when northerners and southerners band together against the owners. In this way, there is no possible denunciation of the lack of either the state's or private groups' economic as well as social responsibility, or even, as in Visconti's *Rocco e i suoi fratelli* (1960), an analysis of the problems generated by the syncretistic encounter of two different *Weltanschauung*. De Filippo washes out, with humour and by resorting to an easy sentimentalism, what is a tragic and complex reality. Nevertheless, the film amounts to a journey through Italian society and its different cultural assumptions and offers a contribution to their exploration.[43]

This generic sentimentalism, this appeal to the individual's good qualities and good intentions, this focus on the individual's effort to get by, on a day-by-day basis, is elicited by many Neapolitan writers; for instance, by Giuseppe Marotta (1902–63), who is one of the authors most responsible for Naples's pre-packaged emotional appeal.[44] Within the group of 'sentimental' Neapolitan writers – which also includes Raffaele La Capria and Michele Prisco – there emerges an author who rejects the enticing glamour of the city and instead casts a disillusioned, pessimistic look and shamelessly questions the squalor and desperation of the Neapolitan lower classes. Such an author is Anna Maria Ortese, whose *Il mare non bagna Napoli* won the Viareggio Literary Prize in 1953.

Anna Maria Ortese (1914–2000) was born in Naples. Her family emigrated briefly to Libya and then returned to Italy. Haunted, since childhood, by the spectre of poverty, she started her literary career with *Angelici dolori*, published in 1937, and after the war continued to publish both as a writer and as a journalist. Her writing began to tend more and more towards surrealism as she privileged a sort of oneiric, metaphysical approach to reality, all the while making inquiries into fundamental questions such as the relationship between Good and Evil. These two ethical and/or philosophical categories come to be personified in strange, anomalous characters, often half-human and half-beastly, that clearly echo mythological creatures. These figures move Ortese's narrative even further into the realm of fables, apologues, and 'mannerist' visions, making it difficult to categorize, and confining Ortese to a quite solitary position in Italian literary history. Her book *Il mare non bagna Napoli* is a collection of five pieces: two short stories and three journalistic essays. Even if these last three resemble journalistic articles, however, the basic documentary element is merely a pretext to write a visionary account of Naples. Ortese journeys so deeply into the miserable reality of the city that she turns it into a surrealistic hell. This hell is inhabited by hallucinations as well as by real people, or, rather, by the distortion of human beings those people have become. The protagonists are all to some degree victims: people destined to suffer either physically or emotionally, or both – all chained to the nonsense of an everyday life whose purpose is mere survival.

In the first story, Eugenia, an almost blind child, receives a pair of glasses from her aunt, an unmarried and embittered woman, only to get sick and vomit when she finally puts them on. In the second story it is again a female character that battles against her bitter fate. Anastasia Finizio is a withered woman approaching forty who has dedicated herself to her family. One day, she hopes she can still, though rather belatedly, fulfil a dream of love, since a young man she had thought about when she was younger has come back to Naples; but she renounces her aspirations. The third short story recounts the 'Monte di Pietà', and the crowd of poor people that congregates there, with the usual disillusionment tinged with cynicism. But it is particularly in the fourth one, 'La città involontaria,' that Ortese creates a portrait of wretchedness that reaches a desperate grandeur.

In this story, the writer goes to visit the 'III and IV Granili,' a huge building three hundred metres long and fifteen to twenty metres high, with three hundred and forty-eight rooms where thousands of people

live, often packed twenty-five or thirty to a room. The Granili is a true *Inferno* steeped in a damp darkness and inhabited by human beings reduced to larvae; the place is truly a Dantesque abyss deprived of hope, where those creatures who move to the lower floors seal their destiny, since the obscure womb of the earth will never allow them to go up again or to escape from the building.[45] This is a cursed world of starvation, where – unlike in Berenson's interpretation – poverty does not bring happiness, only illness and dispossession; a place where human beings are reduced to their beastly, instinctual side. For the world they inhabit is inhuman to such a degree that the perception of the passing of time has been blocked too: it is a world where children are adults and no day differs from the previous or the following one.[46] Time is suspended while the consummation of an endless human misery takes place.[47] The only thing left, the only indication as well as expression of being alive, is sex.

Ortese reaches this impressive result by setting up a major light/darkness dichotomy paired by the human/beastly dichotomy and, as will be clearer with the next short story, the rationality/nature dichotomy where, not unproblematically, nature is also associated with femininity. Only little by little does Ortese reveal journalistic data about the building (how many people live there, how they got there, what is the disposition of the rooms), thus granting little or no importance to the data and focusing instead on a picture that amounts to a terrible and surrealistic vision. The tragic thing is that such a vision, which seems surrealistic, corresponds to reality. As one goes down from the upper levels the light becomes more and more tenuous. Ortese sees '*ombre,*' '*piccol[i] fuoch[i],*' '*piccolissime lampade*' '*barlum[i],*' '*grigiore,*' '*buio,*' '*minuscol[e] lampad[e],*' '*impercettibili lampade,*' '*[un'] oscurità ... quasi assoluta.*'[48] The lower levels are places where a ray of light is *imprevedibile* (unforeseeable), and where sharp, acrid smells of human feces and urine overwhelm the visitors.

The threshold that separates humans from animals – according to the rationalist tradition behind Ortese's thought – has been trespassed. This is made evident by the numerous similes between men and animals, as well as metaphors adopted by the author: 'Gli uomini che vi vengono incontro non possono farvi nessun male: *larve* di una vita in cui esistettero il vento e il sole, di questi beni non serbano quasi ricordo. *Strisciano o si arrampicano o vacillano.*'[49] Here men are seen as larvae, that is, at a stage in evolution that precedes even individuation as insects, and are thus reduced to otherwise unspecified 'beings'; such men move around as if they were animals, not men: they slide or climb or vacillate. Earlier

on Ortese, approaching the Granili, had compared the huge building to 'una collina o una calva montagna, invasa dalle termiti, che la percorrono senza alcun rumore nè segno che denunci uno scopo particolare.'[50] This is another image where the world of insects and that of humans fuse in denoting an analogous activity, denouncing, in a parallel manner, the same merciless and somehow – for Ortese – terribly grandiose lack of meaning.[51] In this Naples, which – by tolerating the existence of the Granili – tolerates, as the writer claims, 'la putrefazione di un suo membro' ('the rotting of one of its members') and, even worse, without even feeling uncomfortable about it, life amounts to 'un inerte orrore' – or inert horror.

In such a tormented vision reason seems to remain silent for Ortese, who entitles her last short story precisely 'Il silenzio della ragione' (The Silence of Reason). In this piece, the narrator has to write an article about young Neapolitan writers and comes back to her city to interview them. Once again, reality and vision mingle in Ortese's description, but vision, in the surrealist sense of a hallucinating transfiguration, overpowers and disintegrates reality, as the same author suggests in the preface to a 1994 reprint of the book, where she states that 'da molto, moltissimo tempo, io detestavo con tutte le mie forze, senza quasi saperlo, la cosiddetta *realtà*: il meccanismo delle cose che sorgono nel tempo, e, nel tempo, sono distrutte.'[52] Therefore the author tries to evade the prison that reality represents by escaping into a timeless world of fantasy. The encounter with her city thus happens, for Ortese, in the light of an excess, a *nevrosi* (neurosis) of which she is, retrospectively, quite conscious and that is evident in the book.[53] The images of decay constructed in the previous story still linger in the reader's mind, providing a quite gloomy framework within which to situate this last piece. And, in fact, a general sense of failure, hopelessness, and even self-hatred radiates from these authors.

Ortese starts her interviews with Luigi Compagnone (1915–98), who now works for a radio station. He is the first, among Neapolitan writers, to have had the courage to tear open the veil of the picturesque.[54] The narrator-writer arrives at Compagnone's door and imagines seeing his house animated by the same crowd of young intellectuals who used to collaborate in the magazines *Sud* and *Voce*, and who, after the war, nurtured enthusiastic hopes of shaking up the city. Ortese's vision is only a hallucination, and she will be brought back from it when Compagnone opens the door and lets her in. The discussion with him – Ortese would like information about other writers and particularly the rising star,

Rea – is painfully embarrassing and full of silences and unanswered questions. Compagnone is, tragically, a dead man: a man haunted by the ghosts of past hopes who no longer desires to write. He is immobilized by his fate, a mesmerizing, malevolent spell that has been cast on Naples and its people.

Ortese's concept of fate is central to the book and to her poetics, and constitutes a key element in her short stories. It resembles that of Greek tragedy (that is, fate is an inscrutable divine will that cannot be opposed by men) rather than the anthropological notion that was circulating at the time with De Martino and Pavese (fate is an a-historical dimension that transfigures reality). Ortese maintains the idea that fate is a force which cannot be opposed by humans, who are simply its victims. Further, she seems to draw on a literary tradition rooted in Leopardi's and Foscolo's – two great writers of the early nineteenth century – sceptical mechanicism,[55] as she interprets fate as a tremendously hostile, terribly negative, and yet alluring, force opposed to reason. Nature and reason – which are, for Ortese, incompatible elements – fight continually against one another and, ultimately, it is nature that wins. 'Esiste, nelle estreme e più lucenti terre del Sud, un ministero nascosto per la difesa della natura dalla ragione; un genio materno, d'illimitata potenza, alla cui cura gelosa e perpetua è affidato il sonno in cui dormono quelle popolazioni.'[56]

Nature is responsible for *il sonno della ragione*, or reason's sleep. Not only does nature forcefully prevent, in these southern lands, the lucid use of reason – to which Ortese grants the faculty of analysing reality and therefore, perhaps, of acting upon it – but nature is also responsible for all the problems of the region, even the economic ones.[57] Nature amounts, simply, to a lethal and toxic force. The hermeneutic problem faced here resides not so much in the sharp opposition of 'nature' and 'reason' that Ortese sets up – according to a dichotomous framework that has shaped the Western thinking process and guided it for centuries – but rather in the explicit gendering of the first element. Nature is, in fact, not only feminine, but also 'mother' – a mother who makes men drowsy and incapable of rebelling against their tragic situation. Further, 'mother'/nature devours rationality: she is an evil entity that prevents men from accessing the only element that differentiates them from animals, and that, Ortese implies, would help men shape their destiny.[58] With Ortese, at least in these stories, we are thus faced with the problem I considered in the second chapter when I analysed Diotima's writing and examined how the female subject who is trying to express herself

remains trapped in the conceptual network of the neuter universal. Here the female genealogy that both Banti and de Céspedes tried to construct in individual cases – Artemisia and the author, Eleonora and her daughter – is impossible to conceive of as a positive event. Ortese inscribes herself, as author, within the neuter universal, but chooses a *male* persona, thus both denying and disclaiming the feminine.[59] What Compagnone and the other writers – Prunas, Gaedkens, La Capria, Rea, Montefusco – cannot rebel against is in fact (mother) nature. It is then nature (the feminine) that sanctions their status as walking dead, for, as Ortese reinstates, '[q]uesta natura non poteva tollerare la ragione umana, e di fronte all'uomo muoveva i suoi eserciti di nuvole, d'incanti, perchè egli ne fosse stordito o sommerso.'[60] Nature then assaults men *and* women alike.

Ortese's journey to Naples turns into an adventure that, while unveiling the desperate, tragic misery of the city, also shows the powerful patriarchal subtext that structures men *and* women's perception of reality. Her journey combines different aspects: a cynical display of what lies beneath the 'picturesque,' carefree Naples, the poignant disillusionment of southern intellectuals, and, once again, the misogynous imagery that Ortese has – notwithstanding her gender – adopted. Her writing also brings to the forefront a Dionysian, pre-Christian element that comes to be associated with the South and, further, turns into one of its most significant emblems. What comes foreward in this period is not only the South's backwardness but its 'otherness' in terms of being thoroughly extraneous to the Christian tradition, its being steeped into a cultural code that has to do with paganism: with a mesmerizing, chthonic reverence for the earth.

In the works of Ortese, De Martino, and American anthropologists, as well as in the films of Rossellini or in Soldati's *Le lettere da Capri*, we are faced with the insurgence of an Orphic Dyonisian sensitivity that appeals to instincts and discards rationality. This aspect seems to erase centuries of Christian civilization and to restore to or, rather, to unveil, once again, the pagan culture of classicism still so alive in the South – an element that reinforces the feeling of the South being alien to the Italian nation. It is explored in depth in Rossellini's *Viaggio in Italia*, since the film investigates the journey as an adventure of self-discovery through, and thanks to, the encounter with a cultural 'otherness' – Italy – here stigmatized, as in *Stromboli*, by its south Mediterranean setting.

Alexander and Katherine Joyce (played by George Sanders and Ingrid Bergman) are a wealthy English childless couple travelling to Capri in

order to sell a house inherited from their Uncle Homer. Already on their way to Naples, they seem to be quite bored with each other, and their interaction brings about continuous misunderstandings and escalates to an open, sharp aggressiveness. While Katherine goes by herself to visit different sites such as the Archeological Museum, the cave of the Cumean Sybil, the Catacombs and the eruptions of sulphur steam, Alexander goes to Naples and attempts, unsuccessfully, to have an affair. Because of a basic lack of communication and their entanglement in their own egos, any attempt that Katherine or Alexander make at improving their interaction is misunderstood by the other. A final, nasty quarrel prompts the two to decide to get a divorce. They cannot discuss the issue, though, because as soon as they have violently voiced the word divorce, they are invited to go to Pompeii to see some excavations. On their way back, while they are in a tense emotional and quarrelsome state, their car is stopped by a religious procession taking place in a small village. They get out of their car and Katherine is suddenly driven away by the crowd. While she is literally 'incorporated' into a group of people, she calls Alexander for help and the two, surrounded by the crowd, hug each other and are finally reconciled.

With *Viaggio in Italia* Rossellini goes on a double journey: he travels through a South that is by now quite established as synonymous with cultural 'otherness,' and he also wanders through the relationship of an estranged couple.[61] In so doing, he interlaces two different categories of time, synchrony and diachrony, thus appealing more and more, in his works, to a psychological dimension. I refer here to the concepts of French philosopher Henry Bergson, who, in his *Essai sur les données immédiates de la conscience* (1889), defines synchrony as a moment in which individuals perceive themselves in their wholeness – in a sort of time suspension – without any separation that might divide moments of the past from moments of the present or, even, of the future (*durée*).[62] Therefore, within synchrony (through which Bergson defines the *moi intérieur*, or inner self) the idea that time might be divisible into different, discrete moments does not apply. In this state, which is eminently subjective, individuals perceive themselves in the richness of their totality; but precisely because they cannot separate different moments of their being – and therefore situate them in space as discrete entities distinct from one another – they cannot communicate the contents of those very moments. In the inner self people experience themselves 'from within' in a wholeness of being that cannot be communicated. In order to communicate they have to resort to diachrony (the time frame

of the *moi superficielle*, or superficial self). Diachrony unwinds in a chronological sequence, which includes past, present, and future as discrete moments that are separated from one another. Their very separation, which for Bergson consists in their objectification, allows communication between individuals. Communication, in order to happen, necessitates that people isolate some moments within the undivided continuum of their inner self, bring them to the surface, and then exchange them. Thus, Bergson claims, communication can only be partial, as it takes place at the expense of 'chopping up' the inner self. In order to explain diachrony Bergson recurs to a spatial metaphor: what makes the moments separate from one another is the fact that they are situated in space and that an empty space exists between one moment and the next one. What is interesting in Bergson's concepts – and is of interest for this analysis – is the interdependence that he institutes, via psychology, between time and space. Bergson very tightly links the perception of a discrete time (and the communication such a time framework makes available) to the perception of space or to the lack of it. The interdependence of time and space is particularly apt for investigating the journey both as a practice and as a metaphor; as an adventure of the (inner) self and a knowing practice of the (superficial) self.

To return to Rossellini: the Joyces did not know how much they had drifted apart from one another. It is the journey that dramatically unveils the emptiness and monotonous customariness of their interactions. By presenting them with a different spatial setting, the journey suspends or rather affects their usual perception of time, thus challenging the identity they had forged for themselves in the metaphoric space of their London everyday life – an identity that reveals itself to be mainly a social self structured around their profession, their acquaintances, and their social interactions. In order for this challenge to happen, however, they have to be faced with a different scenario. The dynamic of self-knowledge is set in motion by the dialectic of 'same' and 'other.' In the film the 'other' is symbolized, jointly, both by one's partner and by the South.

The film opens by suggesting a stereotypical notion of the picturesque South. While the credits are rolling, we hear a sweet and melancholic Neapolitan song, accompanied by a guitar. Then we see the road unfolding in front of us from the Joyces' point of view through the windscreen, and then, still through the car's side window, a train running parallel to the car.[63] Alexander and Catherine fit the stereotype of the northern European or Anglo-Saxon couple who comes to visit southern

Italy. They are clearly wealthy, as is indicated both by the car and by Bergman's leopard fur coat. Katherine, who reads a guide entitled 'Italy,' has a sort of elitist 'grand tourist' interest in the archaeological sites. Already, at the very beginning, their conversation seems quite stifled and uninteresting. Alexander thinks he should not have come by car to this lazy and noisy corner of the world and Katherine asks herself if she should write to her mother. Further, from the very beginning, Rossellini stigmatizes their cultural difference and the presumptuousness that goes along with it. The Joyces run into a buffalo herd a couple of times. These meetings juxtapose very sharply – through close-ups of a buffalo and of Katherine's face – their urban, technological society, which is metonymically represented by the car, and the rural and 'primitive' South.[64] Between these two encounters Katherine notices a blood spot on the car's windshield and, quite disgusted, asks if there is a danger of catching malaria (not by coincidence a 'colonial' illness for the British). Sitting inside the car, which identifies them as wealthy foreigners, they seem to protect themselves also from the culture and landscape that surrounds them. They maintain a – nevertheless exploratory – distance from the landscape through their gaze. It is the protagonists' as well as the director's gaze, which plays off, inquires about, and measures the gap existing between the Joyces and the South, as well as between Katherine and Alexander.

While critics have extensively analysed the various stylistic innovations of the film, I want to consider in particular the way Rossellini uses, or rather does not use, the shot/reverse shot.[65] According to classical Hollywood film syntax, when people are talking to one another, they should be filmed in shot/reverse shot, with a shot of a character looking at the other, then a cut to the other character, who is looked at and who looks back at the first one. Through editing the filmic syntax thus establishes a dialectical interaction between the characters, which is linked – here we recall Bergson's theory – to a spatial discontinuity. What is remarkable in Rossellini is that when he is dealing with the Joyces he almost never uses this device. At the beginning of the film the couple sit in the car and Rossellini films them together; he juxtaposes them, without positioning the characters' gaze along those imaginary diagonal lines that give the impression of their dialectical interaction. In effect, there is no articulation of space and this fact suggests that no real communication can take place between Katherine and Alexander.

The same unsettling interaction happens later on, when the two are on the terrace. They are filmed together, side by side, with no alterna-

tion of shot/reverse shot. Further, when one of the two starts talking, the camera remains on him or her. Only later does it switch to the other, who, at that moment, is not necessarily looking at the character who is talking, and is usually silent. There is, in effect, a mismatch between the visual and sound elements – for instance, when Katherine is talking and we see Alexander, or when Alexander is talking and we see Katherine – that underlines the characters' isolation. Such a problematic and painful isolation becomes even more explicit in the scene at the window, when Katherine waits for Alexander. Here Rossellini achieves a quite powerful effect of estrangement through editing. He juxtaposes four different moments. First, Katherine is framed sitting at the window looking out towards the sea and, as we diegetically infer, waiting for her husband to come back. Second, there is a shot of the open sea, where two ferries are advancing in opposite directions, but parallel to each other, and then crossing at a distance always heading in opposite directions. Third, there is a medium close-up of Alexander, sitting on one of the ferries, looking out towards the sea; and fourth, we come back to Katherine sitting at the window.

The lack of communication between the couple is therefore embodied in the very syntax Rossellini uses and, in addition, is emphasized by the couple's interaction with the surrounding landscape: the South. The South means both the people and the land. On the one hand, people are stigmatized by Alexander as 'lazy' and later, at the Ladispoli's reception, by Neapolitans themselves as given to 'dolce far niente,' or, as one of the nobles at the party translates the phrase, 'How sweet it is to do nothing.' They express an exuberant sexuality, made evident by the incredible number of pregnant women one sees along the streets. On the other hand, the land itself is impregnated with an ancient pre-Christian heritage. In fact, Rossellini's land, with his generative excess – exemplified by the 'living' volcano – and the eruptions of sulphur steam shares some of the feminine, maternal qualities Ortese attributed to it, but without partaking of its negative associations. It is particularly through Katherine and her 'cultural' interest in Naples's artistic patrimony that we are confronted with the city's Dionysian, pre-Christian heritage.

Katherine's encounters with Naples's archeological treasures turn into a true epiphany: a *kairos* – the sudden, harmonious revelation of a hidden truth. In each of the four encounters with the ruins, the movie score changes, suggesting wonder and enigma. We no longer hear Neapolitan songs, street noises, or the disturbing, dizzying humming of the

Joyces' car. For instance, when Katherine goes to visit the National Archeological Museum, there is background music of string instruments in which a flute solo stands out. The choice of the flute is particularly significant because such an instrument was sacred to Pan, the Greek god who inhabited woods and pastures.[66] The flute thus evokes the disquieting presence of ancient gods, suggesting an uninterrupted continuity between past and present and, therefore, the possibility that those same gods and their archaic power might come alive once again. Such a continuity is also inferred by the custodian when he says that one of the statues resembles his daughter Marianna; earlier, the same custodian had said, pointing to a faun, that it was 'a good thing that he exists no longer,' since he was a dangerous creature. In this case the man grants credibility, and therefore reality, to mythical creatures. The classical heritage is seen in all its terrible Dionysian disruptive force through the series of emperors that the custodian indicates to Katherine: Nero, Caracalla, Tiberius, and so on – all equally prey to, behind a serene and sometimes beautiful face, one kind of craziness or another. The Orphic element of classical times – concealed under a peaceful appearance, is reiterated in Katherine's later visit to the Cumean Sybil, where the theme of love is interlaced with that of Eros and rape. The old custodian shows Katherine how women were tied to rocks by Saracen pirates, thus repeating a quite intimate gesture that disturbs Katherine. In the visit to the Catacombs of Fontanelle it is the living presence of that which upsets Katherine: the fact that the dead are worshipped and cared for as human beings – thus underlining, once again, the uninterrupted continuity between past and present. Finally, during her visit to the sulphur-steam eruptions, the entire earth seems to come alive, inflamed as it is, and so pervasively, by the simple puff of a cigarette (which the custodian has put close to the steam source). Through the phenomenon of ionization, the earth is suddenly ignited by a passion that can easily be associated with sexual arousal.

The Dionysian side of Naples, with its – in Katherine's words – 'thorough lack of modesty,' questions the woman's identity and set of cultural beliefs and emphasizes the crisis with her husband, since Katherine is forced to question a life that 'at home seemed to be so perfect,' but which was also based upon a fundamental misunderstanding: the assumption that she and her husband knew each other. Alexander, too, is caught by the hedonistic aspect of the area: food, wine, and women. However, his attempts at having an affair are all in vain thanks both to bad luck and bad timing. The woman he is interested in has just

made up with her husband, and the prostitute he picks up just out of a bar is in the middle of an existential crisis. He, too, perceives the South as disquieting and, more than once, suggests to Katherine that they leave this 'poisonous' place. In effect, he feels under a magical spell that he is unable to break.

As I have anticipated, the Joyces' acrimony towards one another ends with a sudden reconciliation in the midst of a crowd. This reconciliation, which follows their decision to get a divorce, has been stigmatized by critics as inconclusive, incoherent, and very improbable.[67] It seems to me, however, that the interpretative framework I have proposed does not read inconsistencies in the ending. The film is an exploration of the misunderstandings, lack of communication, frustrations, and aggressiveness of a couple testing itself in a very unfamiliar setting and time frame, where ordinary time (his diachrony) and epiphanic moments (Bergson's synchrony) alternate in an unfamiliar, different space: southern Italy. It is evident throughout the film that both Katherine and Alexander still love each other, but do not know how to overcome the barrier of their individual egos and touchiness.

The final episode, the reconciliation, happens during a religious moment, which is Christian only at the surface. In reality it is an Orphic magmatic event that prompts all the most instinctual and repressed aspects of a rational individual ('They are like children,' Alexander says) to arise. Taken by surprise, Katherine and Alexander do not have the time to rationalize their embrace and fully surrender to their emotions. That this might be just a temporary, and not a long-term, reconciliation (as Truffaut has suggested) does not matter at this point and amounts to an uncalled-for speculation.

By the end, Rossellini's film acquires a didactic quality: the journey to and through Italy is truly a journey of discovery. What is discovered, though, is not the country but, through it, one's unexplored, unknown selves. As Peter Bondanella claims: 'Rossellini's *Viaggio in Italia* helped to move Italian cinema back toward a cinema of psychological introspection and visual symbolism where character and environment served to emphasize the newly established protagonist of modernist cinema, the isolated and alienated individual.'[68]

With *Viaggio in Italia* Rossellini then paved the way for the emergence of a psychological realm centred on the couple.[69] From this point of view, namely, that of an individual trapped in his or her own subjectivity or interaction with a significant other, the social and political concerns that were so prevalent in Neorealist films are usually marginal. In the

film production of the early fifties, the social critique starts to fade away or, rather, starts to be more increasingly subsumed into the protagonists' subjective, psychological perception of the world. Individuals as alienated and isolated, not to mention rich, as the Joyces are also at the centre of Michelangelo Antonioni's metaphoric journey in the bourgeois and prevalently female universe of his 1955 feature *Le amiche*.

Towards a Postmodernist Paradigm: Antonioni's *Le amiche*

Michelangelo Antonioni was part of the *Cinema* circle so fundamental in creating a new cinematography and critical sensitivity during and after the Second World War.[70] Born in Bologna in 1912 to a wealthy family, he remained always emotionally and visually attached to the landscape of his youth. He never privileged a politically committed cinema, as De Santis, Pietrangeli, or the earlier Visconti did, and instead developed a growing interest in psychological issues, exploring in depth the individual's solitude and his or her lack of harmony with the environment. Antonioni's point of view evokes a particularly modern ambience through his choice of either an urban – *Cronache di un amore* (1950), *La signora senza Camelie* (1952/3), *Le amiche* (1955) – or industrial setting – *Il Grido* (1957). The director's inclination to privilege contemporary/modern topics thus entails a 'relocation' to Northern Italy.

Antonioni's stories usually take place in northern areas, either the Po estuary or large cities such as Milan and Turin. The director links an introspective and at times investigative mood to a contemporary setting, thus taking us away from the agrarian South, where Dionysian elements are ready to erupt from under an Apollonean surface. Instead, he prompts us to look at the neurosis of contemporary society, where the environment – city or countryside – does not evoke primordial forces but rather the characters' existential malaise.[71]

Le amiche is a film that presents itself not as much as a physical, but rather as a psychological, journey through the life of a group of women friends in Turin. Antonioni was inspired by one of Pavese's short novels, *Tra donne sole*, and worked on the script with two women writers, Suso Cecchi D'Amico and Alba de Céspedes. On the whole the resemblance to Pavese's text is minimal.[72] I wish only to underline the change of the title from Pavese's *Tra donne sole* (Among Lonely/Alone Women), which emphasizes the solitude of these women portrayed with a tinge of misogyny and cynicism, to Antonioni's *Le amiche* (Girlfriends), where the emphasis is put on these women's bond – no matter how superficial it

might be – of solidarity with one another, as we can evince from the plot.[73]

Clelia has just arrived in Turin from Rome to oversee the opening of a new fashion atelier. Ready to take a relaxing bath in her hotel room, she is disrupted by the discovery of an attempted suicide, that of Rosetta Savona, who occupies the room next to hers. Soon the police come to the hotel and question Clelia. Momina, a friend of Rosetta, comes looking for her and meets Clelia. Momina wants to know more about Rosetta's action, and takes Clelia with her to visit Nene, a pottery artist, and her husband Lorenzo, a painter who has just finished Rosetta's portrait. While supervising the work at the atelier, Clelia meets Carlo, the assistant of her architect, who gives her concrete as well as emotional support. Gradually Clelia becomes more and more involved in the lives of her new upper-middle-class friends, among them a fifth woman, the flirtatious Mariella. Clelia joins the group on a Sunday for a trip to the seaside. The group includes Rosetta, who has come back from the hospital. While people linger around in a boring and inconclusive waste of time, Mariella brings up Rosetta's attempted suicide. Rosetta, who was walking towards the women, overhears their comments, feels judged and rejected, and runs away in tears. Clelia volunteers to take her back to Turin by train and offers her a job at the atelier. As it turns out, Rosetta had fallen secretly in love with Lorenzo during the painting of her portrait. Lorenzo now calls Rosetta and the two start seeing each other. Nene, who has understood what is going on, talks to Rosetta and tells her that she will go to America – where she had been invited to exhibit her work – to free Rosetta and Lorenzo. Lorenzo did not know about Nene's invitation to America and, as the relationship with Rosetta evolves, he seems to be less and less secure about it. At a dinner party that follows the atelier's successful opening, Lorenzo gets very defensive about some remarks Cesare, the architect, makes. The two start to fight and Lorenzo leaves the *trattoria*. Rosetta runs after him. She believes Lorenzo needs her, but Lorenzo tells her that he has to confess something to her: that, indeed, he does not need anyone ('Io non ho bisogno di nessuno'). The next day, Rosetta's body is found drowned in the river. Clelia confronts Momina at the atelier and calls her an assassin, holding her and her cynicism responsible for Rosetta's death. The film ends with Clelia leaving for Rome to go back to her job, also leaving behind a possible life with Carlo.

Antonioni sets up the very first sequence of the film as a detective story.[74] Rosetta has been found, nearly a corpse; now we must look for

the story behind the woman's action. We have to look for what 'really' happened, and it is the elegant, pretty, and cynical Momina who plays the role of the detective. For Antonioni, as in *Cronaca di un amore*, the present is just an enigma that can be solved only by exploring the past. It is not possible to know or make sense of an action in the present if we do not understand what lies behind it and do not launch ourselves into an inquiry – a true 'journey' – into the past. In order to uncover Rosetta's past, Antonioni needs to disentangle the network of interactions in which she is enmeshed. These interactions are essentially with a group of wealthy women and their rich but unsatisfactory life. The metaphoric journey into Rosetta's past then becomes a horizontal crossing, an unfocused meandering through these women's existence and the existence of the men who happen to be, by virtue of an analogous meaningless chance, their husbands or lovers.

It is interesting that, at the beginning, Antonioni prevents us from achieving a close visual and psychological identification with all these characters and with the fluid intermingling of the couples. His use of the camera impedes the creation of an emotional, dramatic climax and fosters instead a continuous, self-referential consideration of the visual elements.[75] As Lorenzo Cuccu has indicated, summing up and analysing with originality the work of other critics, Antonioni tends to produce an effect of 'de-dramatization' by shifting his interest from the plot – meant as a well-crafted storyline that points to a narrative resolution – to the vision – meant as the act of viewing that Antonioni performs and offers to his audience as an element worthy of being explored in and of itself. Cuccu defines Antonioni's way of seeing as *visione estraniata*, or estranged vision, as suggested by his method of representation, which 'strutturalmente esclude identificazione, partecipazione patetica, commozione da parte dell'autore nei confronti delle situazioni agite dai personaggi: perché queste, appunto, non rappresentano la forma di espressione della concezione del mondo dell'autore, ma la materia sulla quale si posa il suo sguardo per decifrarne, in forme diverse, il senso.'[76]

According to Cuccu, Antonioni achieves the *visione estraniata* by using the camera to distance himself from the fundamental conventions of a dramatic cinematography, which privileges plot and narrative cohesiveness while also provoking a strong emotional response from the audience. Antonioni's refusal of a canonical use of the camera comes from the fact that he rarely uses close-ups to enhance emotional identification with the character, his editing is not articulated in order to support the diegesis, he uses low-contrast lighting, he uses the actors as 'matter,'

and even in traditionally composed shots he tries to decentre the subject.[77] Like Rossellini in *Viaggio in Italia*, for instance, Antonioni almost never resorts to the shot/reverse shot. Instead, he films two or more characters together in the same space without articulating their dialogue or interaction through editing. Unlike Rossellini, though, he rarely uses close-ups, thus re-establishing, as we have seen, a distance between the characters and the audience. Such a distance entails a lack of emotional colouring: it keeps the audience in the position of an unaffected and dispassionate viewer. And yet, the lack of articulation brought about by the absence of shot/reverse shot has two results: on the one hand, it enhances a certain diegetic shapelessness, which underlines Antonioni's de-dramatizing tendency and his fascination with the visual per se;[78] on the other hand, it hints at the construction of a generic space of female solidarity. Even though it may seem to contradict what I stated above, I wish to posit that, within the emotional plainness produced by his *visione estraniata*, and notwithstanding it, Antonioni succeeds in creating a space of tight female interrelations that turn into a bond of affectionate connectedness. On the one hand, then, Antonioni does not create emotional identification with the look of the camera, and yet, on the other, he 'genderizes' the screen, thus prompting, precisely through visual means, the creation of an all-female universe.

The first instance in which this female bonding is constructed, by means of stylistic features, occurs soon after the opening shots, when Momina enters Rosetta's hotel room. A policeman is questioning Clelia, then questions Momina too, and tells her that Rosetta is at the hospital. 'Ha voluto suicidarsi!' ('She tried to kill herself!'), Momina exclaims, bewildered, and looks towards Clelia. Then there is a cut to a shot of both women looking at each other with an immediate understanding. Later, Momina asks Clelia to become her 'accomplice' in finding out facts that might explain Rosetta's decision. When the two discover, through the hotel operator, that Rosetta had tried to call Lorenzo the very night she took sleeping pills, Momina takes Clelia to Lorenzo's gallery. It is in the gallery that one of the key scenes takes place. Now the two women are framed in front of Rosetta's portrait, which hangs on the wall facing them, and are filmed from behind. They occupy a large part (the entire foreground in fact) of the frame and generate a powerful, all-female gaze. The gaze is, in this shot, doubly female: it is the gaze of Rosetta looking out towards the viewers from the portrait and, more importantly, the gaze of the spectators, which is mediated by the two women who are positioned, with their backs to us, like spectators within

the scene. At a certain point Lorenzo comes into the frame and positions himself in the middle of this gaze, his back to Rosetta while he looks towards Clelia and Momina and therefore towards the audience. He appears trapped in the middle of a powerful and all-female energy field.

On this occasion Momina introduces Clelia to Nene. The three women start talking to each other in a quite friendly manner, and Clelia is filmed by the side of a huge painting, possibly an eighteenth-century picture, with women semi-standing in a pastoral, natural setting. Momina apologizes to Clelia and says to Nene: 'E' da stamattina che sente parlare di gente che non conosce e che non la interessa.'[79] But Clelia promptly replies by saying: 'Ma no perchè anzi, mi sembra di avervi sempre conosciute. E' difficile spiegare. Io sono andata via da Torino che ero bambina. Ho sempre lavorato, non ho avuto tempo per le amicizie. Ecco, mi sembra logico che ci dobbiamo fare delle confidenze.'[80]

Clelia, who has come into this group by accident, soon becomes friends with these women and finds this fact 'natural.' The unarticulated – from the editing point of view – fluidity with which the camera here pans around, primarily in medium shots that include the three women filmed from different angles, and so as to create a circular motion, mirroring the figures in the painting, enhances a sort of undiscrete, almost enveloping, female presence. Seymour Chatman notices this impressive and pervasive presence and interprets it in terms of social critique. As he states: 'The women are difficult to distinguish: they dress too much alike and resemble each other physically. Antonioni seems to overemphasize the homogeneity of the group of friends: perhaps he wanted to show that a decadent society is also a homogenizing one.'[81]

The fact that Chatman is disturbed by such an overwhelming and indiscrete female presence, and that he interprets it in ideological terms rather than in terms of 'vision,' proves the point I want to make about Antonioni's genderizing of the screen. Chatman gets annoyed with what he perceives as the impossibility of following a story due to the unclear delineation of its characters, and comes up with his 'moralistic' interpretation. Unlike Chatman, I do not believe that Antonioni implied a judgment of any kind; the director himself has often confessed in his interviews that moral judgment does not interest him. Rather, what he is really trying to convey here is a pervasive female presence, and by homogenizing, as Chatman claims, the protagonists, he almost points to

the creation of a quintessential 'femaleness,' which is only posited descriptively, not analytically. Two episodes – the scene by the sea and the one at Momina's apartment – are, in this regard, particularly significant. In the first case, the five friends are filmed all together. There is a tracking shot of the landscape from right to left that stops on the women, who, by being positioned in a natural, open setting, and filmed at a distance like statues on a terrace, suggest an image of unstructuredness and, ultimately, of freedom.[82] This lingering impression of a fluid and unrestrained freedom is later verbalized by Mariella.

Mariella, Clelia, Nene, and Momina are all at Momina's place, waiting for Rosetta. They casually move around, this time in a domesticated space – which, as Tinazzi has remarked, is constructed in a theatrical fashion and articulated and re-articulated through venetian blinds – when Momina mentions that she might go back to her husband. In effect, the scenes are composed, destroyed, and re-composed by the women, who mark out and separate different actions as scenes from a play. Mariella comments: 'Che peccato! In una casa dove vive una donna sola c'è sempre un'aria. Sembra sempre di fare qualcosa che non si deve.'[83] The audience, unusually, is brought to share Mariella's positive assessment. Such an attitude is prompted, though, according to Antonioni's aesthetics, not by an emotional but by a visual element, and precisely through a female *mise en scène*.

Much has been said about the scene at the atelier where Clelia publicly attacks Momina, accusing her of having induced Rosetta to commit suicide. Most critics stress the moralistic evaluation of this empty upper-middle-class world into which Clelia flees and wherefrom she withdraws by chance. But my impression is that Antonioni does not radically crush the female world he has constructed and explored, and that, therefore, the title *Le amiche* has to be interpreted as a statement about the female world he has created and not merely as a neutrally descriptive or, worse, ironic tag. The scene takes place in the atelier, an ambience where a quite superficial femininity – a world of mere appearance – is on display. The wealthy women who sit on the elegant couches and armchairs are not different from the five friends we have come to know and are here precisely to show off, fully adhering to that ideal of elegant but empty sophistication they have to embody in accordance with their status. But unlike Clelia, Nene, Mariella, Rosetta, and Momina, these women are simply figures that we, as spectators, do not really know, and it is here, in this aestheticized and de-familiarized setting, that Antonioni throws his feeble moralistic darts. These women embody the external, social shell

of that more intimate substance (or even lack of it) – 'Tu manchi di vita interiore' ('You lack an inner life'), Cesare says to Momina – that we have been looking at through the five friends. Clelia accuses Momina of having encouraged Rosetta to enjoy her relationship with Lorenzo, but indeed Rosetta had already made her choice by herself. What makes Clelia explode into her verbal assault is a remark made by one of these ladies: 'Cose dell'altro mondo' ('things of another world'). 'No, di questo mondo' ('No, they are things of this world'), she replies. Ultimately what is at stake is these characters' existential and meaningless drifting in a morass where it is difficult to assess responsibilities.

After the 'little scandal' at the atelier, Clelia goes back to Rome to resume her job there, thus giving up her potential relationship with Carlo.[84] The film ends with Clelia's departure at the train station. Her journey, which allowed Antonioni and us to explore a feminine – upper-middle-class – universe, continues. It is a journey that now – after Clelia's discussion with Carlo in which she says that 'working is also my way of being a female' – reveals itself to be about her own way of being a woman and about constructing her female identity independently of traditional roles. 'Io sono una donna sola' ('I am a woman who is alone'), she says to Carlo earlier in the film. But her being alone does not entail merely the acknowledgment of a painful solitude; rather, it is the condition – maybe just temporary – from which she can, as subject of her own sexual desire, heuristically explore her position in the world. Clelia, then, along with the other women, and more than them, sketches a new self-portrait for the urban woman of the fifties: she is self-reliant, economically self-sufficient, dedicated to her job, and does not give priority to her feelings over her career. She is not defined either by motherhood or by being attached to a man. In fact, she does not 'depend' on a man, and yet she is desirable as a woman, a partner, or even a wife. Her psychological complexity and her assertiveness in the workplace (albeit in the 'feminized' version offered by fashion and tailoring) come together in proposing a female persona quite novel in Italian society and difficult to think about just a decade before. Indeed, Clelia contributes to designing a diversified and multifaceted female world not yet familiar to the Italian public.

CONCLUSIONS

Between the maternal, overwhelmingly emotional Pina of *Roma città aperta* and the refined, independent, and economically self-reliant Clelia of *Le amiche* there is a huge, unbridgeable gap; and yet only a decade separates the two characters. The different ways in which Pina and Clelia live their womanhood – one as a mother, in a role that appears still influenced by Fascist rhetoric and the Catholic church, the other as a single woman focused on her career – reveal the transformations that affected Italy in the postwar years. These transformations were numerous, varied, and, for the most part, irreversible: they plunged the country into its new, modernized version. And yet they had been in part foreshadowed if not fostered by Fascism, since, as we have seen, Fascist social and cultural practices had been de facto characterized by a strong ambiguity and ambivalence that left room for the coexistence of contradictory attitudes and behaviours.

Immediately after the war, Italian intellectuals and artists struggled to overcome the shameful heritage of the *Ventennio*, some of them forcefully denied any previous allegiance with the regime, while many others fell victim to a convenient 'amnesia.' Besides, the fact that a purge of Fascist officials did not take place in Italy also affected the newly constituted Republic, making room for a not so evident and yet substantial continuity between some institutions and authoritative figures of the interwar and postwar years. We should also take into account an obvious but nevertheless meaningful element: the fact that intellectuals attended schools, universities, or even the Centro Sperimentale di Cinematografia during and under the Fascist regime, thus being brought up in, not to say forged by, a Fascist cultural milieu. Some of these intellectuals – of course I am not referring to open adversaries of the regime,

who were exiled or sent to confinement – started to become critical towards Fascism at the time of the Ethiopian war, or just later, around 1937, a pivotal year for the regime's loss of mass consensus. Others kept their outward agreement up to 1943.

In any case, the intellectuals' and artists' 'removing' demeanour with reference to their Fascist past left room for a foggy, unclear interpretation of the *Ventennio*. Trapped within the intricate, sticky webs of guilt, denial, or personal advantage, authors and intellectuals were also prey to a painful relationship with time, since they nostalgically hung on to a sort of innocence that the war had destroyed: paradoxically, and in a quite uncritical manner, the past they were longing for was Fascism itself. Since they were not able to look discerningly into their previous complacency with the regime, they ended up picturing themselves as individuals being acted upon by external and uncontrollable forces, and indulged in representing themselves as people who had been guided by events they could not possibly oppose.

After the war – as I have shown in the first chapter – the younger generation rebelled against their fathers and trampled upon the values – family and the motherland and, to a lesser extent, the Church – the fathers had transmitted to them. They also undermined the power of the household head, and referred instead to the group of peers for self- and generational validation. Such rebellion is exemplified by the protagonist of Germi's *Gioventù perduta*, Stefano, the son of a university professor, who embraces a criminal path, and by Edmund Koeler, who – in *Germania anno zero* – poisons his father. The authors suggest that these youngsters' transgressions of ethical rules originate in the lack of moral strength that characterized the education they were given. This element implies, in turn, an attack against the Gentilian school reform. Edmund's action also evokes another dramatic, albeit in its metaphorical value, killing: that of Mussolini, the symbolic father of all Italians. The killing of the father – real or symbolic – points, soon after the war, to a questioning of that patriarchal system Fascism had fostered and implemented and to a questioning of those sociopolitical structures that had supported Fascism. Thus, perhaps as a side effect of the destruction of a politics as well as of a cultural politics centring upon, and revolving around, a charismatic, 'virile' Dux, male writers and directors turned to the world of women. They questioned and sometimes attacked, as in the case of Pietrangeli's *Celestina*, or in that of the cine-documentary *Amore in città*, the order supported by a traditional notion of gender, and started to look at female characters with a sympathetic eye.

Some women writers went even further in that direction. Banti and De Céspedes, for instance, endeavoured to create a powerful female genealogy that could validate women's existence from within and struggled to avert their characters from a stereotypical, patriarchal representation. Not all women writers shared their stance, however. As we have seen, Anna Maria Ortese *does* espouse a 'male' point of view and expresses herself as a writer who disavows the feminine, seeing in it a dangerous, irrational force that brings death to humankind. Espousing a male point of view amounts, as we have seen, to a blind adoption of the concept of the 'neuter universal' that the Diotima group has theorized. Thus, (Mother) Nature is, for Ortese, a toxic, lethal force. Notwithstanding Ortese's position, quite a few women writers tried to legitimate the different modes in which women's existence was expressed outside the customary roles of wife and biological mother. These women authors strove to establish a notion quite novel for the times: that of a female subjectivity. In their attempt they had to come to terms with language itself, with its grammatical and syntactical structures that only accounted – according to Diotima's framework – for one subject: the neuter universal. Woman was in effect at the centre of a wide psychological and sociological interest that intrigued male writers and directors as well. Film directors such as Visconti, Antonioni, or Pietrangeli paid novel attention to female psychology and to women of different ages, classes, and occupations. They also examined the ways in which traditional practices and assumptions turned women into victims. Such a renewed notion of woman became perhaps the most important metaphoric space where a renegotiation and redefinition of social interactions took place. So much so that the rendering of woman, and I am referring here to cinema, was also at the centre – albeit not exclusively – of that major experience which shaped postwar Italy: the encounter with 'America.'

For post-Fascist and still prevalently rural Italy, the encounter with America marked a major step towards modernization. Already in the thirties, America had embodied a utopia for Italian writers: an authentic, though not universally accepted, myth of youth and freedom. Not universally, for America's youthfulness was at times negatively stigmatized as carrying within itself a lack of both cultural complexity and intellectual refinement, and a too simplistic and Manichean political praxis. But for most of its enthusiastic supporters, such as the writer Italo Calvino, assertive and dynamic America seemed not to be as burdened by the weight of tradition and rhetoric as Italy was, and was considered by artists and intellectuals as a sort of privileged locus in which

to exert the intellectual freedom the regime officially, though not always effectively, had denied them. The interest towards America was strong and entailed both its literature and Hollywood films, which were widely distributed in Italy. Cinema constituted one of the main avenues for the diffusion of American icons. American films, which literally 'flooded' the nation in 1946, showed a quite luxurious and glamourized lifestyle, along with a society in which gender roles – although fairly codified – were also rapidly changing. Unlike what customarily happened in Italy, where individuals' choices were often determined by family pressure and by tradition, American characters seemed not to be as strongly determined by family obligations. American movies also supported and actively promoted a consumerist culture, as De Santis's *Riso amaro* tried to expose – he was victim, though, to a critical fallacy, for he remained fascinated by the culture he wanted to criticize. With their allure and explicit eroticism American films also seduced or enraged (or both) a resistant Communist spectatorship.

During the period 1943–5, America became Italy's political ally. The arrival of American troops on Italian soil promoted a close encounter between Italy and the United States, which later resulted in the USA's massive political interference in Italian life. At the same time, Italy underwent a process of rapid Americanization that was set in motion by Hollywood productions, pop culture, music, photojournals, dance, and the like. The interaction between the New and the Old World was masterfully exemplified by a professional as well as personal encounter: that between Ingrid Bergman and Roberto Rossellini. Particularly in the latter's *Stromboli, terra di Dio*, cultural differences, scrutinized through gender, come to the forefront. The (companionate) couple, an entity that in itself seems to be progressively more and more detached from the patriarchal system, is also the privileged locus – an isolated and self-enclosed cell – in which directors start to scrutinize the psychology of individuals with an increasingly expanded interest. This will become even clearer in Rossellini's *Viaggio in Italia*, whose 'exotic' setting, southern Italy, helps to sharpen the Joyces' portrait. The couple is also at stake in a prevalently negative evaluation of marriage as social contract, as is evident in de Céspedes's *Dalla parte di lei*, Soldati's *Le lettere da Capri*, Rossellini's *Viaggio in Italia*, Antonioni's *Le amiche*, and even in Pratolini's *Un eroe del nostro tempo*. What these authors question is the legitimacy, *in time*, of an act that belongs almost entirely to the public sphere and that is doomed to clash, sooner or later, with the emotional and/or sexual needs of the private sphere.

The choice of a southern fisherman in Rossellini's film foreshadows the pivotal role the South will play in Italy's new, postwar self-representation. After the war, particularly in the early fifties, Italian artists and intellectuals discover an unknown world: a southern rugged landscape inhabited by *cafoni* (peasants) and shepherds. The South, an extremely poor land from which thousands of workers emigrate to the urban, industrialized North, expresses a social reality largely unknown to the majority of Italians. Furthermore, the southern set of beliefs and social practices reveals itself to be connected to a pre-Christian cultural substratum, linked to a classical heritage. Such a set of beliefs is virtually untouched by Catholicism. Very rapidly the South comes to symbolize 'otherness,' in relation both to the United States and to Italy itself. In effect, the South serves as a point of reference for discovering Italy's 'self' – in this case, the way in which intellectuals and artists both configure where they stand in the cultural arena, and how they define their agenda – the latter being, at the time, heavily informed by political orientations. The South also hints at a larger critique of the (urban and industrial) West, as is evident in the works of the anthropologist Ernesto De Martino.

My 'journey' in postwar Italy has brought to light some unresolved dichotomies that keep surfacing in different chapters under different headings, thus revealing their own intrinsically problematic status. Such dichotomies, which seem to be deeply set in the Italian consciousness of the postwar years, provide the (quite problematic) hinges upon which the construction of a new identity weighs. The primary opposition is between the personal and public spheres. This opposition is particularly evident from 1945 to 1948, when people are torn between the necessities of a militant social engagement and the need to fulfil their emotional lives – two elements that are seen, in this historical moment, as contradictory. In the light of these findings, Pavese's suicide should be re-examined. His death, rather than being seen only as the desperate act of a deeply unhappy individual – an extreme action generated by unrequited love – should be situated within a series of broader political issues and concerns. The relationship between the PCI's cultural policy and intellectuals and artists is, indeed, at the core of a quite dogmatic and often excruciating negotiation between the personal and public spheres.

Such opposition – where 'personal' also entails the sphere of subjectivity and 'political' that of objectivity – surfaces again in the opposition

between memory and history. We have seen these two categories at work particularly in Banti's *Artemisia* and Pavese's *La luna e i falò*. Memory and history turn out to be 'genderized' modes of narration, the former corresponding ultimately to a female subjective mode and the latter to a male objective one. Such genderizing entails a sort of a priori validation of one's narrative, when this is easily codified as *history* (events that can be told according to a clearly recognizable, teleological storyline) and an equally aprioristic lessening of it, when it is presented as *memory* (in the case of a narrative that unfolds by recollecting unrelated fragments, distant in time from one another). We have seen these two categories, which I have first established thanks to Violi's argument, at work in Alicata's criticism of Pavese. And, again, the negotiation between the personal and public spheres happens on the female body. Thus, the assumption that, in the postwar period, the redefinition of woman and of her social role engenders a series of epistemological problems – as I foreground in the preface – does not seem too extreme.

One of these problems – probably the main one – is the relation to, as well as the use of, language. Language itself and its conventional use is both questioned and challenged in concrete writing practices: that is to say, language *becomes* the problem. And it is not by chance that a major, disruptive reflection on language will be at the core – in a few years – of the avant-garde Gruppo 63 or, even, at the core of Pasolini's reflection about the role of culture and his rediscovery or, better yet, reappropriation of *la lingua materna* – the maternal tongue. Female authors attempted to modify language so that it could express and 'accommodate' female subjectivity/subjectivities. But since female subjectivity is denied at a conceptual level – there is no possible symbolic for it – language reveals its insufficiency in fulfilling the task. Thus, unusual and above all 'illogical' syntactical constructions that try to inscribe themselves in language indicate both the implicit 'gendering' of language and its insufficiency in accounting for a female point of view. Banti, de Céspedes, and even Pavese (who struggled against a *soggetto forte*) work their ways through grammatical inconsistencies and figurative contradictions; as, for instance, in de Céspedes's use of the iconology of *Dolce Stil Nuovo*. Language is at stake in a more 'universal' way as well: it is the locus where the displacement of one's responsibility from oneself to a generic group or entity takes place, thanks to the use of the grammatical passive voice, as we have seen with Germi's *Gioventù perduta* and Rossellini's *Germania anno zero*. The status of language (standard Italian), or rather its canonicity, is also implicitly questioned by the emergence of

dialects and regional inflections in film and literature, which parallels the rise of the South to national attention.

The renewal of language also applies to films that adopt a new grammar and different styles. Rossellini's *Paisà* offers, in this sense, a quite paradigmatic example, since it teaches its spectators about the different dialects, or even about the languages, spoken in Italy soon after the war. *Paisàti's* journey from the South to the North is also a journey through different speech styles, accents, dialects, and, ultimately, foreign languages that the war has, nevertheless, rendered familiar to the Italian people. Both Rossellini and Antonioni, each in a different way, work at creating a style that challenges the orthodoxy of classical Hollywood cinema by defying the traditional use of basic syntactic devices such as editing, shot/reverse shots, point-of-view shots. In so doing they also implicitly create a different kind of spectatorship, endowing such a spectatorship with more than one possibility of looking. They prevent the audience from having a total visual and emotional identification with the look of the camera. They induce viewers to reflect in a more detached way on the characters and the scenes, thus implementing a consideration of the visual element per se. Ultimately, these directors cooperate to set in motion that ample self-reflexive mood which would establish itself in some European cinematography of the mid- to late fifties and of the sixties.

I want to recall here the main thesis of my study; that is, the continuity existing between the cultural practices and icons of the *Ventennio* and those of the postwar period. As I have tried to show, the continuity between 'before' and 'after' the war – albeit contradictory and unclear – is strong and tends to generate some confusion. In particular, the methodological criteria used to define Neorealism reveal themselves to be insufficiently accurate and somehow unsatisfactory. Since recent and not so recent scholarship has shown how some of the features customarily considered as innovations introduced by Neorealism did in fact exist before, the specificity of Neorealism should then be looked for, apart from the sociological input fostered by the experience of the war, once again (albeit not exclusively) in language. While Fascism prohibited the use of dialects, Neorealism widely recorded different dialects, inflections, and regional varieties of the Italian language (*Paisà* includes Sicilian, Neapolitan, Roman, Emilian, and Veneto dialects, along with American English). It also utilized a less literary and less formal style, favouring instead the emergence of spoken language. Another direction that seems promising in assessing the specificity of Neorealism is, as

Farassino has pointed out, that of analysing how Neorealism constructs de facto a new socio-geographical mapping of the country. And, along this line, we come across, once again, the emergence of the South and the importance of the Gramscian approach to it.

Along the line of continuity between the pre- and the postwar period, it also seems necessary to look more closely into Croce's legacy – an element I have not inquired into in my book, but which I feel is useful to propose here as a promising direction of study. All the intellectuals who came of age under Fascism and subsequently worked towards Italy's reconstruction were exposed to and influenced by Croce's thought, starting with Gramsci. Croce was also quite often their first exposure to Marxist thought. Most of these intellectuals, as we have seen for instance with De Martino, Vittorini, and Pratolini, later consciously and somehow forcefully detached themselves from Croce's teachings. Nevertheless, Croce remains the point of reference for their formation. Most intellectuals, particularly within the Left, carved their theoretical position 'against' Croce's idealism, though these positions were nevertheless still informed by Crocean categories. A lot of the cultural debates of the late forties and early fifties happened in the shadow of Croce's theoretical hegemony during the *Ventennio*, and it seems difficult and somehow philologically incorrect to assess their impact without contextualizing them within Croce's cultural legacy.[1] In order to understand what these intellectuals strove for and the nature of the changes they wanted to enforce, we need to know the genesis of their – and to a large extent the country's – cultural formation.

In concluding, I want to underline the presence of Rossellini throughout the postwar decade. There are surely other directors who might have been very significant in assessing Italy's changes, but from the particular points of view I have selected in my journey through postwar Italy, I continue to run into Rossellini. He is always there, at the right time and at the right spot: a scrutinizing eye, as well as a mirror, who anticipates for Italian viewers the sociological and emotional problems Italy was to embrace in the postwar era.

NOTES

Preface

1 Angelo d'Orsi, *La cultura a Torino tra le due guerre* [*Culture in Turin between the Two World Wars*] (Turin: Einaudi, 2000).

2 The polemic is chronicled in an appendix to an article published by d'Orsi himself in *Corriere della Sera*, 25 May 2000. A series of articles concerning the book was published between 17 and 23 May in the pages of *Il Corriere della Sera, La Stampa*, and *Il Foglio*. An article published in *L'Indice* at the end of the year reviews the controversies stirred up by the topic of culture and fascism. It also lists recent books published on the subject. See Bruno Bongiovanni, 'Cultura e fascismo,' *L'Indice*, December 2000, 40.

3 As he says in the above-mentioned article: 'Una volta sottolineato che nessuno degli intervenuti nella discussione ha letto il libro *incriminato*.' ('Once I have underlined that nobody among the ones who participated in the discussion has read the *charged* book.')

4 See, e.g., the polemic between the journalist Indro Montanelli and the historian Angelo del Boca, with reference to the use of toxic gases by Italian troops in Ethiopia in the pages of *L'Unità* and *Repubblica*, September 1995. Also in 1995, a broad journalistic debate accompanied the publication of two books that re-examine the Fascist period: Giorgio Bocca's *Filo Nero* (Milan: Mondadori, 1995) and Renzo de Felice's *Rosso e Nero* (Milan: Baldini e Castoldi, 1995). See also the polemic over a letter written by Norberto Bobbio to Mussolini in 1933, and the consequent debate reported in Norberto Bobbio, *Autobiografia* (Bari: Laterza, 1997), 26–37.

5 'In France and Germany, the desire to create new visions of national identity unencumbered by recollections of the Nazi and Vichy regimes has led intellectuals on the Right to adopt a variety of tactics designed to alter historical

memory ... At the same time, partly in response to these trends, the production and utilization of memory has emerged as a central issue in the work of historians of modern France and Germany. In these recent studies, which explore the contextual elements that have influenced the manner in which the Nazi and Vichy regimes have been represented in the postwar period, scholars have begun to examine not only what is remembered but also the mechanisms that encourage us to forget.' Ruth Ben-Ghiat, 'Fascism, Writing and Memory: The Realist Aesthetic in Italy, 1930–1950,' *Journal of Modern History* 67 (1995): 628–9.

6 See Mirco Dondi, 'The Fascist Mentality after Fascism,' in Bosworth and Dogliani, eds, *Italian Fascism: History, Memory and Representation* (London: Macmillan, 1999), 141–60.

7 See Ruth Ben-Ghiat, 'The Politics of Realism: *Corrente di Vita Giovanile* and the Youth Culture of the 1930s,' *Stanford Italian Review* 8.1–2 (1990): 139–64; 'Neorealism in Italy 1930–1950: From Fascism to Resistance,' *Romance Languages Annual* 3 (1991): 155–9; 'Fascism, Writing and Memory'; and 'Liberation: Italian Cinema and the Fascist Past, 1945–50,' in Bosworth and Dogliani, *Italian Fascism*, 83–101. Very important is the recent volume *La cultura fascista* (Bologna: Il Mulino, 2000). Her research has been preceded by that of various scholars, among them Pier Giorgio Zunino, Mario Sechi, Mario Isnenghi, Marina Addis Saba, Luisa Passerini, Emilio Gentile, and Michel Beynet. See also J. Dunnage, ed., *After the War* (Market Harborough: Troubadour Press, 1999).

8 This thesis is supported by most of the contributors to the volume of essays edited by R.J. Bosworth and P. Dogliani, *Memory and History* (New York: St Martin's Press, 1999).

9 See Dondi, Bosworth, Ben-Ghiat, Ward in Bosworth 1999.

10 Debates about 'contents' in literature date back to the 1930s. See Ben-Ghiat 2000, 83–205, and Mario Sechi, *Il mito della nuova cultura* (Manduria: Lacaita, 1984).

11 See Silvio Lanaro, *Storia dell'Italia repubblicana* (Venice: Marsilio, 1992), 5–36.

12 See Sechi 1984.

13 See Robin Pickering-Iazzi, *Politics of the Visible: Writing, Women, Culture and Fascism* (Minneapolis: U of Minnesota P, 1997), and *Unspeakable Women* (New York: Feminist Press, 1993).

14 Cesare Segre maintains, 'I sistemi di significazione sono istituiti all'interno di una cultura e ne fanno parte integrante ... Più che condannare una lettura che consideri il testo in sé, mettendo tra parentesi il contesto, si deve consta-

tare che essa è impossibile.' ('The systems of meaning-production are instituted within a culture and constitute an integral part of it ... More than just condemning a reading that considers the text in itself, putting the context aside, we have to acknowledge that such a reading is impossible'.) *Avviamento all'analisi del testo letterario* (Turin: Einaudi, 1985), 132.

15 Analogously, he states, 'nel meccanismo semiotico il singolo testo è per certi aspetti isomorfo al mondo testuale' ('in the same way in the semiotic mechanism the individual text is isomorphic to the textual world'). Yurij Lotman, *La Semiosfera*, ed. Simonetta Silvestroni (Venice: Marsilio, 1985), 66.

16 See Diane Ghirardo, 'City and Theater: The Rhetoric of Fascist Architecture,' *Stanford Italian Review* 8.1–2 (1990): 165–93, and Karen Pinkus, *Bodily Regimes* (Minneapolis: U of Minnesota P, 1995).

17 James Hay, *The Passing of the Rex: Popular Film Culture in Fascist Italy* (Bloomington: Indiana UP, 1987), 6. Such a statement obviously extends to literary texts.

18 See Jurij Lotman, *Testo e contesto: Semiotica dell'arte e della cultura* (Bari: Laterza, 1980) and Ivanov, Lotman, Pjatigoroskij, Todorov, and Upsenskij, *Tesi sullo studio semiotico della cultura* (Parma: Pratiche Editrici, 1980).

19 Homi K. Bhabha, *The Location of Culture* (London: Routledge, 1994), 1–3.

20 Ibid., 13.

21 An extremely useful introduction to the history of Italian feminism is Patrizia Cicogna and Teresa de Lauretis, eds, *Non credere di avere dei diritti* (Turin: Rosenberg e Sellier, 1987), now available in English translation as The Milan Women's Bookstore Collective, *Sexual Difference* (Bloomington: Indiana UP, 1990). Consider also the fundamental Paolo Bono and Sandra Kemp, eds, *Italian Feminist Thought: A Reader* (Oxford: Basil Blackwell 1991) and, for a recent overview of actual studies in Italian feminism see Giovanna Miceli Jeffries, ed., *Feminine Feminists: Cultural Practices in Italy* (Minneapolis: U of Minnesota P, 1994).

22 On this aspect see Claudio Pavone, *Una guerra civile, saggio sulla moralità nella Resistenza* (Turin: Bollati Boringhieri, 1991).

23 See Ruth Ben-Ghiat 1995.

24 On this topic see Maria Sechi, ed., *Fascismo ed esilio: Aspetti della diaspora intellettuale di Germania, Spagna e Italia.* 2 vols. (Pisa: Giardini Editori, 1988).

25 An exception is constituted by Vincenzo Binetti's study, *Cesare Pavese, una vita imperfetta* (Ravenna: Longo, 1998). See also Grazia Sumeli Weinberg, 'Pavese e la donna e il discorso sulla voluttuosità' in *Italica* 77.3 (2000): 386–99.

1: Time Has Changed

1 For a historical overview of Italy's postwar period see Paul Ginsborg, *Storia dell'Italia dal dopoguerra ad oggi* (Turin: Einaudi, 1989) and Silvio Lanaro, *Storia dell'Italia repubblicana: Dalla fine della guerra agli anni novanta* (Venice: Marsilio, 1992).

2 I have not taken into account the followers of the RSI, who also took part in Italy's reconstruction. The topic deserves a study of its own.

3 This implies almost all the people involved in cultural production during the *Ventennio*, since dissidents usually resided abroad and published their journals there. See 'La cultura degli esuli italiani di fronte all'espansione coloniale del fascismo (1935–39)' in Maria Sechi 1988, 1: 13–38.

4 Giuliano Manacorda accurately reconstructs the various moments of the dispute in his *Storia della letteratura italiana (1940–1975)* (Rome: Editori Riuniti, 1975), 3–27.

5 'Non siamo capaci di elevare barriere artificiose od ipocrite tra le sfere diverse dell'attività – economica, politica, intellettuale – di una nazione. Non separiamo e non possiamo separare le idee dai fatti, il corso del pensiero dallo sviluppo dei rapporti di forze reali, la politica dall'economia, la cultura dalla politica, i singoli dalla società, l'arte dalla vita reale.' ('We are unable to build artificial and hypocritical walls between the different spheres – economic, political, intellectual – of a nation. We do not separate, and we cannot separate ideas from facts, the process of thinking from the development of relationships among real forces, politics from economics, culture from politics, individuals from society, art from true life.') Quoted in Manacorda 1977, 4.

6 See S. Robert Dombroski, *L'Esistenza Ubbidiente* (Naples: Guida, 1984), 10.

7 'Shall we then condemn all the art, literature and Italian culture under the Fascist Ventennio? ... From a broad historical point of view the answer does not leave any doubt. Art, literature, Italian culture have done nothing to oppose Fascism.' Quoted in Manacorda 1977, 5.

8 'We have to acknowledge our guilt: the sin of omission, it was no time to go on vacation, and for too many people it was no less than a time of leisure and dissipation.' Carlo Bo, 'Che cos'era l'assenza,' in *Scandalo della speranza* (Florence: Vallecchi, 1957), 35.

9 *Il Politecnico*, 29 September 1945. An article of Catholic Felice Balbo followed Vittorini's polemical statement. In his 'lettera di un cattolico,' published in the 13 October issue, Balbo too sent out a call for an active engagement of Catholics in the sphere of culture.

10 For a collection of Giame Pintor's writings see Pintor, *Il sangue d'Europa*

(Turin: Einaudi, 1975). See also the very informative 1949 introduction by Valentino Gerratana.

11 'In reality the war, the last phase of a triumphant fascism, acted upon us more deeply than one would think at first glance. The war materially distracted men from their habits, forced them to recognize with their hands and eyes the dangers that threatened every individual life, *persuaded them that there was no possibility of safety in neutrality and isolation* ... Without the war, I would have remained an intellectual with prevalently literary interests ... and the encounter with a girl or whatever impulse of my imagination would have counted for me more than any party or doctrine.' Pintor 1975, 186.

12 'At a certain moment intellectuals must be able to transfer their experience to the matter of common utility, each one has to take his own place in a combat organization ... We musicians and writers have to renounce our privileges in order to contribute to everybody's liberation.' Ibid., 187.

13 See Ben-Ghiat 1995, 644.

14 Ibid., 644.

15 See Patrizia Ferrara, 'La voce del padrone,' in *Storia e Dossier*, anno X, no. 99 (1995): 57.

16 See Ben-Ghiat 1995, 665.

17 On virility under fascism see Barbara Spackman, *Fascist Virilities* (Minneapolis: U of Minnesota P, 1996).

18 'If we assume, a posteriori, the hypothesis that in the culture engagé of the years after the Resistenza the *notions of engagement, popularity, realism and the search for a tradition adequate to them* are fundamental and characteristic, it is not difficult to demonstrate that *these four elements existed before the political events with which writers and intellectuals had to confront themselves more immediately between 43 and 47.*' Alberto Asor Rosa, 'Lo stato democratico e i partiti politici,' in *Letteratura italiana contemporanea*, 9 vols. (Turin: Einaudi 1982), 1: 550.

19 'Se si prescinde perciò dalle risonanti dichiarazioni di rinnovamenteo universale e totale – quasi una creazione *ex nihilo* di una nuova cultura, di una nuova arte e di una nuova letteratura – il problema critico nostro consiste esattamente nel misurare l'influenza esercitata dalla guerra e dalla Resistenza ... sulle tendenze già in atto della letteratura italiana contemporanea.' ('If we abstract then from the resounding declaration of universal and total renewal – almost an *ex nihilo* creation of a new culture, of a new art and a new literature – our critical problem consists precisely in measuring the influence exerted by the war and the Resistenza ... upon the tendencies already active within Italian contemporary literature.') Ibid., 550.

20 See Marla Stone, 'Staging Fascism: The Exhibition of the Fascist Revolution,' in *Journal of Contemporary History* 28 (1993): 215–43.

21 See, e.g., Emilio Gentile, *Il culto del littorio* (Bari: Laterza, 1995); Mario Isnenghi, *L'Italia del fascio* (Florence: Giunti, 1996); and Zunino 1985.

22 See Diane Ghirardo, 'City and Theater: The Rhetoric of Fascist Architecture,' *Stanford Italian Review* 8.1–2 (1990): 165–93. The issue is entirely dedicated to Fascism and culture.

23 As Ruth Ben-Ghiat maintains, 'la censura agì meno attraverso pesanti interventi repressivi e più attraverso la collaborazione con gli autori, che negoziarono con le autorità a proposito di un tono o un giro di frase censurabile.' ('Censorship acted less through heavy repressive actions and more through a cooperation with the authors. Authors did negotiate with authorities issues regarding a style or a kind of phrase that could be censored.') Ben-Ghiat 2000, 85.

24 The Fascist control was particularly heavy on the press. See Paolo Murialdi, *La stampa del regime fascista* (Bari: Laterza, 1986).

25 See Ferrara, 'La voce del padrone.'

26 See Gabriele Turi, *Giovanni Gentile: Una biografia* (Florence: Giunti, 1995), 426.

27 See Zunino 1985.

28 See Renzo De Felice, *Mussolini il Duce* (Turin: Einaudi, 1974), vol. 2, 237–8.

29 See Victoria De Grazia, *How Fascism Ruled Women* (Stanford: Stanford UP, 1992), 1.

30 In Luisa Passerini, *Fascism in Popular Memory: The Cultural Experience of the Turin Working Class*, trans. Robert Lumley and Jude Bloomfield (Cambridge: Cambridge UP, 1987), 150.

31 See Elisabetta Mondello, *La nuova italiana: La donna nella stampa e nella cultura del Ventennio* (Rome: Editori Riuniti, 1987). She also suggests a chronology. 'Queste diverse fasi (1919–1924, 1925–1936, 1937–1940, alle quali va aggiunto il periodo della guerra), come tutte le periodizzazioni, hanno semplicemente la funzione di evidenziare differenze e trasformazioni, in questo caso quelle attraversate dalla politica fascista sotto il profilo della concezione del ruolo della donna' (61). ('These different phases (1919–1924, 1925–1936, 1937–1940, to which we should add the war-period), like any chronology, simply have the function of making evident differences and transformations, in our case the ones that fascist politics underwent under the aspect of its conception of the role of women.') See also Marina Addis Saba, ed., *La corporazione delle donne* (Florence: Vallecchi, 1988).

32 See Robin Pickering-Iazzi, *Politics of the Visible: Writing, Women, Culture and Fascism* (Minneapolis: U of Minesota P, 1997).

33 For the position of the Church regarding women during the *Ventennio* see Cecilia Dau Novelli, *Sorelle d'Italia: Casalinghe impiegate e militanti nel Novecento* (Brescia: A.V.E., 1996).

34 See P. Meldini, *Sposa e madre esemplare* (Florence: Guaraldi, 1975), 76.

35 Ibid., 72–3.

36 De Grazia 1992, 166.

37 Ibid., 154.

38 For the account of a young student's experience in a Fascist university see Norberto Bobbio, *Autobiografia* (Bari: Laterza, 1977).

39 See Ben-Ghiat 1990, 139–64.

40 For *Primato* see Luisa Mangoni, *'Primato' 1940–1943* (Bari: De Donato, 1977). In his article 'Lo stato democratico e i partiti politici' Asor Rosa provides a complete list of all the writers who cooperated in the journal: 'Aleramo, Alvaro, Angioletti, Bacchelli, Bargellini, Barilli, Benedetti, Bernari, Betocchi, Bilenchi, Bini, Bocelli, Bonsanti, Bontempelli, Brancati, Buzzati, Cardarelli, Cecchi, Comisso, Contini, Cordiè, De Libero, De Robertis, Dessì, Emanuelli, Falqui, Gadda, Galvano, Jovine, La Cava, Linati, Lisi, Luzi, Macchia, Monelli, Montale, Montanelli, Negri, Pancrazi, Pandolfi, Pasquali, Patti, Pavese, Pea, Pellizzi, Penna, Pintor, Piovene, Pratolini, Praz, Quasimodo, Raimondi, Ricci, Bruno Romani, Seroni, Sinisgalli, Socrate, Solmi, Stuparich, Tecchi, Tobino, Trompeo, Ungaretti, Vigolo, Vigorelli.' Asor Rosa 1982, 569.

41 For Vittorio Mussolini's position – he used to sign his own articles with the anagram Tito Silvio Mursini – see Umberto Eco, 'Il mito americano' in Carlo Chiarenza and William L. Vance, eds, *Immaginari a confronto* (Venice: Marsilio, 1992), 15–28, and Oreste del Buono and Lietta Tornabuoni, eds, *Era Cinecittà* (Milan: Bompiani, 1980), 51–9. See also Luigi Freddi, *Il cinema*, 2 vols. (Rome: L'Arnia, 1949), 1: 297–322.

42 About the political manifestos before and after the war, see Adriana Sartogo, *Le donne al muro* (Rome: Savelli, 1977) and Karen Pinkus, *Bodily Regimes: Italian Advertising under Fascism* (Minneapolis: U of Minnesota P, 1995).

43 Lucia Re describes *L'Agnese va a morire* thus: 'The novel exploits a range of conventional moral assumptions about the natural role of women as maternal, faithful, and above all selfless beings. (Agnese's figure and physiognomy are associated throughout the text with images of earth and water from the Po valley landscape in which the story is set, and the recurrent association becomes a symbolic motif, suggesting Agnese's naturality as an archetypal mother figure.)' *Calvino and the Age of Neorealism: Fables of Estrangement* (Stanford: Stanford UP, 1990), 117.

44 'Seriously threatened is the healthy moral sense of our people, which, up to now had particularly found its manifestations within the family.' In *Rinascita* (1946; reprint, Rome: Editori Riuniti, 1976), 224.

45 'The family presents itself, now more than ever, as the primordial nucleus upon which citizens and the state could and must rely for the moral and material renewal of Italian life.' Ibid., 224.

46 'The state will be in charge of the moral and material protection of maternity, infancy, and youth, and will institute the necessary organisms to achieve such a goal.' Ibid., 225.

47 See Pavone, 1991, 560–75.

48 'The nexus between both antifascism and fascism was experienced by people of the resistance also as a relationship between generations.' Ibid., 551. On Fascism's emphasis on youth, see Laura Malvano, 'Il mito della giovinezza attraverso l'immagine,' 311–48, and Luisa Passerini, 'La giovinezza metafora del cambiamento sociale. Due dibattiti sui giovani nell'Italia fascista e negli Stati Uniti degli Anni Cinquanta,' 383–459, both in Giovanni Levi and Jean-Claude Schmitt, eds, *Storia dei Giovani*, vol. 2 (Bari: Laterza, 1994).

49 'A historical and cultural fact, not a biological one.' Ibid., 551.

50 On Germi see Mario Sesti, *Tutto il cinema di Pietro Germi* (Milan: Baldini e Castoldi, 1997).

51 See David Bordwell, Janet Steiger, and Kristin Thompson, *The Classical Hollywood Cinema: Film Style and Mode of Production to 1960* (London: Routledge, 1985).

52 J.A. Place and L.S. Peterson, 'Some Visual Motifs of Film Noir,' *Film Comment*, January 1974, 21–6.

53 All the italics in quotes in this section are mine. Father: '*You never have any time*; these are *hard times. Once* we lived well in this house. *Today ...*' Stefano: 'Did you change your hairstyle?' Maria: 'You *once* liked me with this hairstyle.' Stefano: 'And you are *still in those times?*' Maria: 'Wouldn't you like *to be as we were then?*' Stefano: 'I don't know, *I don't remember the way we were then.*'

54 Stefano: '*Time has passed*, there was the war.' Maria: 'What does that matter? *Time passes but we have to remain the same. I don't feel I have changed and you?*' Stefano: '*I am no longer the same.*'

55 Under Fascism, the family was one of the most formalized institutions. Financial subsidies encouraged large families and a 'bachelor tax' was imposed on state employees who did not marry. See De Grazia, 1992.

56 On the religious aspect of Fascist patriarchy see Emilio Gentile, 'Fascism as Political Religion,' *Journal of Contemporary History* 25.2–3 (May–June 1990): 229–51.

57 'It is strange, why are children not asked their opinion before they are

brought into the world? In any case, I do not complain'; 'I do not know if, in my times, I would have been able to make such remarks to my father.'

58 'There is in today's youth a strange mélange of cynicism and pessimism that frightens me.'

59 'From ciphers many lessons can be learned. They are like the mirror in which the image of a society is reflected ... Your generation at times stirs in me a certain pity. And the most terrible thing about the war is not the loss of human lives or of wealth, but the loss of moral sense, the collapse of all values, the indifference, the cynicism that it generates ... The middle class is perhaps the class most widely represented in criminal reports. The bases of society are thus the ones which are undermined, and it is time that the forces of good, the individuals, the families, the State, wake up and fight for the common salvation.'

60 Frank Krutnick, *In a Lonely Street: Film Noir, Genre, Masculinity* (London: Routledge, 1991) provides an exhaustive analysis of the noir. Particularly in chapter 5 Krutnick considers the problem faced by returning GI's and the renegotiation of sexual roles in a society in which women in the workplace had largely supplanted men. 'By 1945 there were almost 20 million women workers in the USA. A wide scale and rapid redefinition of their place within culture matched the new prominence of women in the economic realm. These changes set in motion a temporary confusion in regard to traditional conceptions of sexual role and sexual identity for both men and women' (57).

61 'The postwar era required a reconstruction of cultural priorities, and one can see the postwar noir "tough" thrillers as being one of the principal means by which Hollywood, in its role as a cultural institution, sought to tackle such a project, by focusing attention upon the problems attending to the (re)definition of masculine identity and masculine role.' Ibid., 64.

62 'I think I know you well enough. You are not the kind of person who gives up at the first obstacle, one of those who lets things go, one who drops plans ... For us the war is not over yet.' The 'commissario' thus introduces an interesting element of continuity, which parallels, and also helps to institute, the above-mentioned connection between 'before' and 'after' the war. Marcello Mariani will paradoxically continue his service to the Fascist 'patria,' but instead of serving Italy in the army as he did in Africa, he will serve her as a policeman.

63 The rhymes are 'La donzelletta si nascose il viso/ con esitante trepido sorriso,' 'Un sinistro pensiero / agita il petto al nostro condottiero,' and 'parafrasando un vecchio detto / libro e moschetto bandito perfetto.'

('The young woman hid her face / with a hesitant, quivering smile'; 'A sinister thought beats in our warrior's chest'; 'Paraphrasing an old saying / weapon and book perfect scoundrel.') Interestingly enough, 'Libro e moschetto' was the title of the Balilla's periodical; and one of the sayings of the period was precisely 'Libro e moschetto, fascista perfetto.' By substituting 'bandito' for 'fascista' Germi instates a strong link between the group's wrongdoings and their Fascist education.

64 On leftist Fascism see the chapter 'Il Neorealismo' by Alessandra Briganti in Gaetano Mariani and Mario Petrucciani, eds, *Letteratura Italiana* (Rome: Lucarini, 1984), vol. 4: 3–49.

65 *Repubblichina/o* was an adjective derogatorily used to label Fascists faithful to the regime when Mussolini moved to northern Italy and founded the 'Repubblica di Salò.'

66 '*Society made him what he is now.* He was only a troubled boy, full of passions, full of life' (175); 'For us Sandrino was *an example of the ruin to which Fascism had driven the youth*: a young boy who needed to be saved' (italics mine, 136).

67 On the continuity between pre- and postwar periods in Pratolini, see Ellen Nerenberg, *Love for Sale* or *That's Amore*: Representing Prostitution during and after Italian Fascism,' *Annali d'Italianistica* 16 (1998): 213–35.

68 The macho, colonialist aspect is particularly evident in Marinetti's *Mafarka il futurista.* See Spackman 1996, 49–76.

69 For an overview of Fascist ideology about women see the first chapter of Mafai 1987.

70 'The upbringing she had been given had suppressed her instinct to the point of almost annihilating it ... She grew up modelling herself on her mother's character ... and submitting to the domination, and to surly paternal affection until she was twenty-two. For the following ten years, her husband's will had been her own will' (52).

71 '*The past came at him all of a sudden.* The shadow of a woman came a step forward on the other part of the sidewalk' (italics mine, 268).

72 The full quote reads as follows: 'Se pensavo all'avvenire c'erano letto e fornelli anche per me, con la differenza che per me erano condizionati alla fine del fascismo' (135). ('If I thought about the future there was bed and oven, for me too, with the difference that for me they were subordinated to the end of Fascism.') Bruna here seems to suggest, problematically, that her way of being a woman ('letto e fornelli') will not be much different from Virginia's. Only – for the moment – her self-definition along traditional gender lines is secondary to her political engagement.

73 'Faliero loves me, there are no screens between the two of us, and he consid-

ers me *his best friend*. Beyond our intimate life, *we are tied by our ideas*. It is
something that maybe you cannot fully understand. A fixation maybe, but
one that helps us be what we are. *We consider reticence the worst of betrayals. And
he who lies*, even just for unimportant things, *is plagued. Faliero is not only a man
who shares my own ideas, he is also my husband*' (147–8).

74 'How much of what is individual, private, secret, remains unresolved in the
collective experience of political activism and cultural education' (Gian
Carlo Ferretti, *L'Editore Vittorini* [Turin: Einaudi, 1992], 53).

75 The girl discusses how her interest in workers (she is a university student)
has the characteristics of an aesthetic pleasure. What her letter voices is a
sincere desire to participate in the world 'out there' and, at the same time,
her inability to do so. Her letter echoes an attitude that had also been
shared by Giaime Pintor and by a series of young intellectuals immersed in
their studies. At a certain point they realized that their literary interests
were too private and solipsistic. The girl's desire, though, clashes with her
own private subjective sphere. Unlike Pintor, the young student from
Parma lacks enthusiasm and a deep ethical commitment. She can approach
the masses only through an act of volition, not through her heart. 'Il mio
vivere era stato un girare attorno a me stessa: tutto partiva da me per ritor-
nare a me. Ci fu l'8 settembre, la lotta per la liberazione. Fu una soffer-
enza, un entusiasmo. Non per me ... E' stato per il convincimento della
giustezza di un' idea, che sono diventata comunista ... ma forse non
sarebbe bastato. Ho voluto ricercare un'umanità negli uomini. Vivere negli
uomini. Fare che ciò che io ero non fosse per me. Che il mondo cessasse di
vivere in funzione mia. Vado all' università. Vado tra gli operai. Parlo volen-
tieri, mi trovo bene con loro. Ma, anche se talvolta lo credo, in realtà non
riesco ad interessarmi dei loro problemi. E' sempre qualche cosa di voluto.'
('My life had been a winding about myself: everything started from me and
came back to me. On the 8th of September there came the fight for libera-
tion. It was anguish, it was enthusiasm. But not for me ... It was because I
was convinced of the righteousness of an idea that I became a Communist
... But maybe it would not have been enough. I wanted to look for human-
ity in men. To live among men. I wanted to act in such a way that what I
was would not have been for me; that the world ceased to live because of
me. I attend university. I go among workers. I talk freely and feel at ease
with them. But, even though at times I believe it, I cannot actually succeed
in getting interested in their problems. It is always something artificial.')
Ferretti 1992, 90–1.

76 'I think that people cannot entirely want the good of humanity ... if they do
not also physically love somebody. See, I would be frightened ... if I had to

persuade myself that *there are "compagni" who do not nurture their faith* with love, *"compagni" who arrived to faith only through the books they have read, or through the exploitations they had to suffer or through their sweat'* (173–4).

77 Quoted by Teresa de Lauretis, *Technologies of Gender* (Bloomington: Indiana UP, 1987), 87.

78 This is what Vittorini wrote in the pages of *Il Politecnico* (35, January–March 1947), in his letter to Togliatti: 'Dunque io non aderii ad una filosofia iscrivendomi al nostro Partito. Aderii a una lotta e a degli uomini. Io seppi che cosa fosse il nostro Partito da come vidi che erano i comunisti ... erano i migliori tra tutti coloro che avessi mai conosciuto, e migliori anche nella vita d'ogni giorno, i più onesti, i più serii, i più sensibili, i più decisi e nello stesso tempo i più allegri e i più vivi. Per questo ho voluto essere nel Partito Comunista.' ('When I joined our Party, I did not join a philosophy. I joined a fight and a group of men. I knew what the Party was like because I saw its men ... They were the best I had ever known, the best even in everyday life, the most honest, the most rigorous, the most sensitive, the most decisive, and yet, and at the same time, the most lively and light. This is why I wanted to enrol in the Communist Party.')

79 Soon after the war, the 'letter' took on the privileged, symbolic status of a testament. See, e.g., the letters by Gramsci, Pintor, and the *Lettere dei condannati a morte della Resistenza* published by Einaudi in 1952.

80 'Always honour your mother. But most of all honour in each of your daily acts and thoughts, and with your blood if necessary, the greater Mother which is the Motherland. Hate and fight her enemies, all the ones who would like to reduce her to a weak and renunciatory democracy, stealing the imperial destiny that belongs to her' (126).

81 'Nobody ever talked to me in the way you did, as an equal to an equal ... And I understand above all one thing: that *both you and me aren't doing anything else but repeating things that we have been taught. Why don't we talk only about ourselves?'* (260).

82 'I ask you to renounce to your father ... He showed to you a path that you are beginning to realize is wrong' (264).

83 'He had the impression of being tied to Virginia as if a rope held them tight and united, with their limbs immobilized by its coils' (italics mine, 60).

84 '*She had blocked time with* her presence and had to bring time to its end' (italics mine, 286).

85 'One cannot escape from oneself ... Dad used to say that we always carry ourselves along, as we carry our face. And you would like to be another altogether, with all that you have not yet uncovered behind you' (61).

86 Both films were presented at the Mostra Internazionale del Cinema di Vene-

zia in 1941 and in 1942, respectively, and awarded a prize. The first won the Cup of the National Fascist Party and the second the national Cinematography Prize for the Best War or Political Film.

87 Rossellini always associates moral worth or integrity with a concept of orthodox (heterosexual) sexuality. In fact he connects the Nazis, as is evident both in *Roma città aperta* and in *Germania anno zero*, with homosexuality and lesbianism and, in the case of adolescents, their lack of moral sense with sexual precocity and promiscuity. His attitudes thus state, once again, the survival, in the postwar period, of values prevalent during Fascism: in this case, that rhetoric of (heterosexual) manhood whose champions were Mussolini and D'Annunzio, and whose purpose was that of reproducing the race. As Ruth Ben-Ghiat maintains: 'Neorealist films made use of a typology of "foreign" figures who functioned as emblems of the physical, social and moral brutality of the regime. These ranged from the obviously foreign – Nazi soldiers – to Italian civilians, whose embrace of practices such as drug usage, homosexuality or sadism, made them "foreign" to the national body politic' (Bosworth and Dogliani, eds, 1999, 84–5). On 'normative' sexuality in Neorealist films see Terri Ginsborg, 'Nazis and Drifters: The Containment of Radical (Sexual) Knowledge in Two Italian Neorealist Films,' *Journal of the History of Sexuality* 1 (1990): 241–61.

88 For an analysis of Fascist politics towards youth, see Tracy H. Koon, *Believe, Obey, Fight: The Political Socialization of Youth in Fascist Italy* (Chapel Hill: The U of North Carolina P, 1985). On Germany see Dietlev Peukert, *Inside Nazi Germany: Conformity, Opposition and Racism in Everyday Life* (London: Batsford, 1987).

89 'In *Germania anno zero* I sued a boy as protagonist, in order to underline *the contrast betweeen the mentality of a generation born and grown up in a specific political milieu, and that of an older generatin represented by Edmund's father.*' Roberto Rossellini, *Il mio metodo*, ed. Adriano Aprà (Venice: Marsilio, 1987), 60.

90 A pivotal moment for the revision of Neorealism was the monographic Mostra del Cinema held in Pesaro in 1974. Since then, there has been much critical reconsideration of the movement; a new conference was held in Turin in 1989, during the 7th International Festival Cinema Giovani. Both events were followed by the publication of a collection of essays: Lino Miccichè, ed., *Il neorealismo cinematografico italiano* (Venice: Marsilio, 1975) and Alberto Farassino, ed., *Neorealismo, cinema italiano 1945–1949* (Turin: EDT, 1989). See Peter Bondanella, *The Films of Roberto Rossellini* (Cambridge: Cambridge UP, 1993), 3–11. The introductory chapter of Millicent Marcus, *Italian Film in the Light of Neorealism* (Princeton: Princeton UP, 1986) provides an extremely

useful reconstruction of the meaning of the term and of the debate around it. See also Ben-Ghiat 1995 and 1999 for recent, thought-provoking analysis of Neorealist films.

91 These different positions are presented by Farassino 1989, Miccichè 1975, Re 1990, and the excellent work of Ruth Ben-Ghiat, to which I have already referred.

92 In Marcus 1986, 22.

93 The criteria are universally accepted even though recent criticism has demystified some of them or, better, the assumption that they are completely innovative features. Among the prevalent misconceptions are the fact that most of the shooting was done on location (even *Roma città aperta*, the quintessential Neorealist film, utilizes extensively a studio setting) and that the characters were non-professionals. While extensive use of non-professional actors goes back to the *Ventennio* movies, Anna Magnani and Aldo Fabrizi, the two protagonists of *Roma città aperta*, were also fairly well-known and established theatre performers. Furthermore, the fact that the soundtrack was added to the film at a later time – a feature still prevalent in Italian film production – surely defies a realist intention.

94 See Alberto Farassino's chronology: 'Meno ideologica e più storicistica la tesi che vede il neorealismo come un prodotto specifico del dopoguerra, dunque limitato negli anni ma fornito, come ogni storicista vuole, di anticipazioni e tardivi proseguimenti o completamenti ... fuori dal quinquennio 1945–49 i film che si possono sinceramente giudicare neorealisti sono davvero assai pochi.' ('Less ideological and more historicist is the thesis that sees Neorealism as a specific product of the postwar period, then limited in years but equipped, as every historicist would claim, with anticipations and late developments ... [O]utside of the 1945–49 span of time the films that can honestly be considered neorealist are truly very few.') Farassino, 1989, 30.

95 See Rossellini 1987, 88.

96 The comparison that comes to mind is with De Sica's *Sciuscià* (1946), which also tells a story about children. In this film, though, the two main protagonists are continually surrounded by dozens of other kids. Rossellini's previous film, *Roma città aperta* (1945) is also concerned with 'chorality,' as is Visconti's *La terra trema* (1948). The way Rossellini scrutinizes Edmund's face anticipates the way in which Antonioni scrutinizes his characters.

97 'The country in the new cartography born in the afterwar period and during the Liberazione.' Farassino 1989, 23.

98 'Not only is there *Paisa*'s great journey through Italy, there is an entire shifting of gazes and initiatives that lead Italian filmmakers to travel throughout the peninsula.' Ibid.

99 Other Neorealist films that partially take place abroad usually follow the life
of emigrants in a foreign country (Fabrizi's *Emigrantes*) or that of a prisoner
(Francisci's *Natale al campo 119*).

100 'Shot in Berlin during the summer of '47, it does not pretend to be any-
thing other than an *objective* and faithful picture of this huge, half-destroyed
city ... It is neither an act of accusation against the German people nor a
defense [it is] a *serene assessment of facts*' (italics mine). In her reconstruction
of the history of Neorealism, Marcus (1986) sharply points out how the
desire for objectivity is part of the literary heritage of 19th-century realism,
upon which Neorealism feeds. See in particular Giuseppe De Santis and
Mario Alicata, 'Verità e poesia: Verga e il cinema italiano,' *Cinema*, 10 Octo-
ber 1941, 216–17.

101 'But if somebody, after having seen Edmund Koeler's story, would think
that there is a need to do something, that there is a need to teach German
children to love life again, then the effort of the person who did realize this
film will be paid back.'

102 With the term docufiction or 'truth-bound' fiction I refer to those (literary)
works produced between 1945 and 1948, which 'share a strictly documen-
tary intent and are written to bear witness to the recent history of Italy and
to contribute to its rebirth.' See Re 1990, 88–91.

103 'We too ... want to take our camera in the streets, in the fields, in the mead-
ows, in the factories of our nation.'

104 'Do you realize that it is not possible for poor Edmund, at his age, to pro-
vide for us all? He is still a child.' 'It is not possible that that child by him-
self ...' 'Was it I who sent Edmund to work?'

105 'Everything has been taken from me, my money by the inflation. My chil-
dren by Hitler.'

106 'We saw the disaster coming and we did not stop it and today we bear the
consequences.'

107 Rossellini insists here upon an attitude already present in *Roma città aperta*:
that of linking the Nazis and homosexuality, thus doubling a 'moral' dis-
credit towards the Germans. Note also that the General, who lives in the
same building as Mr Ennings, is a pedophile.

108 'Mister Ennings can I talk to you?' 'Of course. Come up.' 'It's all done.'
'Everything is done?' 'I killed my father.' 'You? How could you do that?'
'Wasn't it you who ordered me to do it?' 'Me, I never told you anything. You
are crazy, you are a monster ... You know that if somebody finds out about it
... I never told you anything, look, I never told you anything.'

109 Examples include: 'A Voi che siete il Padre di noi tutti, mandiamo per i vos-
tri figliolini più colpiti più che un dono un pensiero di solidale affetto e la

nostra preghiera perchè Dio vi dia la forza di guidarci verso la vittoria e la giusta pace' (1942). ('To You, who are the father of us all, we send for your most disadvantaged children, more than a mere gift, a thought of sympathetic affection and our prayer so that God might give you the strength to guide us all toward victory and a just peace' [53].) '... alla fine Duce, ho imparato a dare le prime bracciate e ora so quasi nuotare. Duce devo la mia gioia a Voi, e lo dirò ai miei genitori e nell'abbracciarli sarà un poco come abbracciare anche Voi che ci fate da padre affettuoso, preoccupato della nostra salute e della nostra crescita' (1935). ('... by the end, Duce, I learned my first strokes and now I almost know how to swim. Duce, I owe my joy to you, and I will tell my parents and when I hug them I will feel as if I am hugging You, who are for us an affectionate father, worried only about our health and growth' [98].) '... il mio pensiero si rivolge a voi che siete da me considerato un secondo padre' (1936) ('my thought goes to you whom I consider my second father' [68].) See also pp. 100 (1943) and 134 (1938) in Camilla Cederna, ed., *Caro Duce, lettere di donne italiane a Mussolini* (Milan: Rizzoli, 1989). For the Duce's hagiography see also Victoria De Grazia, 'Il fascino del priapo. Margherita Sarfatti biografa del duce,' *Memoria* 2.4 (June 1982): 149–94.

110 Interestingly, Ruth Ben-Ghiat reads Vittorini's novel *Conversazione in Sicilia*, written 1937–38, as a revolt against his metaphorical fathers and mentors, Bottai and Mussolini: 'In un momento in cui Vittorini era stato espulso dal Pnf per le sue simpatie repubblicane, la sua asserzione letteraria di indipendenza filiale può essere letta come una ribellione nella vita reale contro Bottai, Mussolini e altre figure paterne che gli avevano trasmesso un legato di falsità nella lingua e nella coscienza.' ('In a moment in which Vittorini had been expelled from the Pnf for his republican sympathies, his literary statement of filial independence could be read as a true rebellion against Bottai, Mussolini and other fatherly figures, who had transmitted to him a heritage of falsehood both in language and conscience.') Ben-Ghiat 2000, 307.

2: From Mother to Daughter

See Pickering-Iazzi 1997, 164–88 and Ben-Ghiat 2000, 301–5. For women writers at the turn of the century and in the first decades of 1900 see Antonia Arslan, *Dame, galline e regine* (Milan: Guerini, 1998).

2 By 'naturality' I refer to the nurturing qualities that should come to women from their biologically greater proximity to Mother Earth. Alberto Moravia's *La Ciociara*, a 1957 novel set during the Second World War, provides one

good example of such naturality. I wish to point out that, while the perspective of some male writers remains quite traditional, this is not the case with filmmakers, whose work, on the contrary, presents more modern and complex female protagonists.

3 Women writing in the aftermath of the war are not the first ones to address issues of female genealogy. Scholars such as Schiesari, Weiwer, Finucci, Rosenthal, and so on have conducted fascinating studies on women in the Renaissance.

4 I use the expression *ordine simbolico* with the meaning that contemporary feminist philosopher Adriana Cavarero attributes to it, i.e., the 'language, culture and social code' by which patriarchy symbolically structures the world. See A. Cavarero, 'Dire la nascita,' in Diotima, *Mettere al mondo il mondo* (Milan: La Tartaruga, 1990), 93.

5 See the chapter 'Motherhood' in De Grazia 1992, 41–76.

6 Another very important text of what I consider a trilogy on female genealogy is Morante's *Menzogna e Sortilegio* (1948).

7 'Diotima' is a group of women philosophers and teachers who work at the University of Verona. Not all of them hold academic positions, but most work as researchers or teachers, either at the university or in high schools. The group began to meet informally in 1984. From the very beginning Diotima planned to gain visibility within academia, thus trying to constitute a public and powerful, as well as empowering, place from which to elaborate and communicate *un sapere femminile*, or female knowledge. Since the late 1980s the group has been holding workshops, open to the public, that have become an integral part of the students' academic curriculum. The most accredited figures of the group are Luisa Muraro and Adriana Cavarero, although Cavarero is no longer part of the group. For a history of the group see Luisa Muraro and Chiara Zamboni's 'Appendice' in Diotima's *Mettere al mondo il mondo* (191–214). In the last decade, Diotima has become more known in U.S. academic circles – a fact that has engendered more direct and dialectical exchanges with Anglo-Saxon feminism. See Lucia Re, 'Feminist Thought in Italy: Sexual Difference and the Question of Authority,' *Michigan Romance Studies* 16 (1996): 61–86, as well as Serena Anderlini-d'Onofrio, 'I Don't Know What You Mean by "Italian Feminist Thought." Is Anything Like That Possible?' and Renate Holub, 'Between the United States and Italy: Critical Reflections on Diotima's Feminist/Feminine Ethics,' both in G. Miceli-Jeffries, ed., *Feminine Feminists* (Minneapolis: U of Minnesota P, 1994).

8 The erasure of female sexual difference as well as its lack of symbolization is evident even at a purely linguistic level itself, since it is embedded within Italian grammatical categories, as Patrizia Violi convincingly argues in her

L'infinito singolare (Verona: Essedue, 1986). In order to make her point clearer, Violi provides examples such as 'L'uomo allatta i suoi piccoli' ('Man breastfeeds his little ones'), where 'uomo' is, grammatically, a neuter universal that includes both categories of maleness and femaleness, while also continuing to signify only male. In a later short essay, 'Language and the Female Subject,' in *Off Screen* (ed. Giuliana Bruno and Maria Nadotti [London: Routledge, 1988], 139–48), Violi elaborates on Benveniste's concept of 'subject' and the relation the scholar institutes between subject and language. For Benveniste, 'there is no subject, and no subjectivity, outside of language ... [T]he subject ... is founded on the act of uttering "I."' According to Violi, though, the subject thus constructed by Benveniste eludes any consideration of gender and prevents the inscription of gender within itself, since such a subject 'is nothing more than the transcendental ego, an empty space, an abstract principle' (141). Violi also underlines the erasure of gender issues in Eco's semiotic theory (143).

9 Within Western culture, postmodernist and poststructuralist thinkers had to face the crisis of the 'subject,' intended as the privileged, metaphorical place for the elaboration and expression of knowledge. Such a crisis turned into a major hermeneutical impasse that questioned the tradition inherited by the European (French) Enlightenment and the absolute primacy granted, within the Enlightenment, to rationality. In Italy such a crisis was represented by the thinkers of *pensiero debole*, or weak thought, such as Gianni Vattimo and Aldo Rovatti. The adjective *debole*, weak – which describes a particular thinking process as well as the subject constituted within and through that 'weak' theoretical framework – is significantly opposed to *forte*, strong, which indicates a subject whose cohesiveness and wholeness is not questioned or doubted. Within this hermeneutic impasse feminists found themselves at a loss, since the problem of female subjectivity – the symbolic existence as well as the representation of a female subject – had not been addressed within Western thought. Such a problem has been tackled by Adriana Cavarero, Patrizia Violi, Rosi Braidotti, and other feminists, who claim that subjectivity is given 'in' gender and is not an abstract notion that precedes one's embodiment either as a male or as a female (see Braidotti: 'I believe that the redefinition of the female feminist subject starts with the revaluation of the bodily roots of subjectivity, rejecting the traditional vision of the knowing subject as universal, neutral and consequently gender-free' [182]). On *pensiero debole* see Alessandro Dal Lago and Pier Aldo Rovatti, eds, *Elogio del Pudore* (Milan: Feltrinelli, 1989).

10 'In the discourse which says, for instance, man is mortal, the man we are referring to is also a woman. Further, it is neither a man nor a woman but

their neutral universal ... man means first of all male sexed, but it also means, and exactly because of this first meaning, the neutral universal of male and female sex' (1: 43–4).

11 'Woman is not the subject of her language. Her language is not *hers*. She thus speaks herself ... through the categories of the language of the other.' Ibid., 49.

12 As Cavarero says, 'La nostra lingua è per noi una lingua straniera appresa non però per traduzione dalla nostra lingua' (1: 52). ('For us our language is a foreign language that we learned, but not however by translating from our own language.')

13 The 'symbolic' is a concept that has been made popular by Lacan and his followers. However, Cavarero uses it, via Irigaray, by attributing to the concept a philosophical rather than psychoanalytic value. See note 3 above.

14 See Sandra Petrignani, *Le signore della scrittura* (Milan: La Tartaruga, 1984).

15 'una commozione personale troppa imperiosa per essere obliterata.' *Artemisia* (Milan: Mondadori, 1947), 1.

16 Banti too addresses the reader – lettore – as male or, rather, neuter universal.

17 'She was born in Rome in 1598 to a family of Pisan origin. Daughter of Orazio, an excellent painter. Her honour and her love were violated on the threshold of womanhood. The reviled victim in a public rape trial. She established an art school in Naples. And bravely set off, in or about the year 1638, for heretical England' (ix).

18 'One of the first women to uphold, in her speech and in her work, the right to do congenial work and the equality of spirit between the sexes' (ibid.).

19 As Deborah Heller maintains, 'In *Artemisia*, the narrative presents itself as something at once more personal, more imaginative, and more arbitrary. In various instances, Banti will deliberately alter known facts about the life of the historical Artemisia Gentileschi. Moreover, throughout the narrative she invents what no historian can ever know: a complex, consistent and rich inner life for her protagonist, thereby conferring a sense of reality on Artemisia's imagined moment-to-moment experiences – her thoughts, motives, actions – as she interacts with her world' (100). D. Heller, 'Remembering Artemisia,' in Ada Testaferri, ed., *Donna: Women in Italian Culture* (Ottawa: Dovehouse, 1989).

20 Patrizia Violi, 'Gender, Subjectivity and Language,' in Gisela Bock and Susan James, eds, *Beyond Equality and Difference* (London: Routledge, 1992), 172.

21 'Now my sobs are for myself and her alone; for her born in 1598, old in death, the death that is all around us, and now buried in my fragile memory' (6).

22 'If only the dark would last forever, no one would recognize me as a woman, such hell for me, woe for others' (32–3).

23 According to the *Dizionario della Lingua Italiana*, ed. Battisti and Alessio (Florence: Barbera, 1950), we find the feminine forms *pittora* (by Vasari) and *pittoressa*, while Tommaseo and Bellini, eds, carry *pittoressa* and *dipintoressa*.

24 'Just as, moreover, no matter how much thought she gives to it, she has not managed to recognize and define herself in terms of any exemplary figure approved of by her century ... She is a woman who wants to mould every gesture on a model of her own sex and time, a respected, nobel model – but cannot find one' (110).

25 'Look at these two women ... *two of the best, the strongest, two who most resemble exemplary men.* See how they have been driven to being false and disloyal to one another in the world that you have created for your own use and pleasure. We are so few and so besieged that *we can no longer recognize or understand or even respect each other*, as you men do' (118).

26 'And *back into Artemisia's* mind came the ungainly, makeshift husband she had married.

 '*I was on my own (this commemoration often slips from the third person)* I was on my own in Florence for most of the day. My room in the inn looked onto a small courtyard where there was no light; neither good, nor bad' (46).

27 'My daughter,' Artemisia bursts out at dawn, *waking up in a flood of hot tears incubated in her sleep*, 'my daughter who is now a woman and does not understand her mother ...'

 '*This awakening of Artemisia's is also my own awakening*' (119).

28 'Whether it is a self-portrait or·not, a woman who paints in sixteen hundred and forty is very courageous, and this counts for Annella [De Rosa] and for at least a hundred others, right up to the present. *"It counts for you too,"* she concludes, by the light of a candle, in this room rendered gloomy by war, a short, sharp sound' (213).

29 I thank Rebecca Messbarger for having brought this consideration to my attention.

30 On de Céspedes see the recent volume *Writing beyond Fascism: Cultural Resistance in the Life and Works of Alba de Céspedes*, ed. Carole G. Gallucci and Ellen Nerenberg (Teaneck, NJ: Fairleigh Dickinson UP, 2000).

31 For her archive see the article 'Un'alba piena di sorprese' by Natalia Aspesi in *Repubblica*, 1 February 1999.

32 'When I was born, a few months after his death, I was given the name of Alessandra, in order to keep his memory alive and in the hope that some of those virtues which had left an unforgettable memory of him would manifest themselves in me. This tie to my young dead brother weighed a lot on the

first years of my childhood. I could not free myself from it: when somebody
yelled at me it was in order to make me realize that I had betrayed, *my name
notwithstanding,* the hopes that have been entrusted to me' (9) (italics mine).

33 I would point out that while angels might have a body they do not have a sex:
they are not gendered creatures, and thus suggest, through their own config-
uration, the deletion of the sexual sphere. As Luce Irigaray states, linking
sexuality, or rather the lack of it, to angels: 'The consequences of the nonful-
fillment of the sexual act remain, and there are many. To take up only the
most beautiful, as yet to be made manifest in the realm of time and space,
there are angels ... Between God, ..., man, ... and woman, ... angels would cir-
culate as mediator of that which has not yet happened, of what is still going
to happen, of what is on the horizon. Endlessly reopening the enclosure of
the universe, of universes, identities.' Luce Irigaray, *An Ethics of Sexual Differ-
ence* (Ithaca: Cornell UP, 1993), 15; first published in French (1984) as
Éthique de la différence sexuelle.

34 'It seemed to me that we had a saint within the walls of our house: with her
ecstasies, her blushes, her divine colloquia' (88).

35 For a general introduction to courtly love see Mario Mancini, *La gaia scienza
dei trovatori* (Parma: Pratiche Editrice, 1984).

36 De Céspedes hints at a syncretism that the semiotician Julia Kristeva explores
in her article 'Stabat Mater' in *Tales of Love* (New York: Columbia UP, 1978),
234–63. According to Kristeva, the Marian and Courtly streams of the con-
cept of love come together very early in the history of the West: '[A]t the very
dawn of a "courtliness" that was still very carnal, Mary and the Lady shared
one common trait: they are the focal point of men's desires and aspirations.'
The syncretism between the Virgin and the Lady was fully achieved by the
mid-thirteenth century, when 'the Virgin explicitly became the focus of
courtly love, thus gathering the attributes of the desired woman and of the
Holy mother in a totality as accomplished as it was inaccessible' (247). See
also Irigaray 1993, 15.

37 The hint to Hervey's homosexuality is given towards the end of the book by
Fulvia, who recounts to Alessandra some gossip she heard: 'Dicevano che è
un pazzo, un maniaco: che soffre di fissazioni. Anzi mi parve di intendere ...
Dicevano, insomma, che è un tipo anormale. Non ... come dire? Non gli
piacciono le donne' (396). ('They say that he is crazy, a maniac: that he is
fixated. In fact, I seemed to understand ... They said, then, that he is an ab-
normal type. He does not ... How should I say this? He does not like
women.')

38 A clear statement about the direct genealogy occurs when Alessandra asks
for help from her grandmother, calling her 'Nonna,' and the grandmother

answers her, 'Figlia.' '"Nonna" la chiamai perchè mi soccorresse nello smar-
rimento che mi vinceva. "Figlia" ella rispose, posandomi la mano sui capelli'
(189). ('"Grandmother" I called her so that she could help me in the sense
of helplessness which overwhelmed me. "Daughter" she answered, laying her
hands on my hair' [189]).

39 'It is beautiful, though, to be a woman. It is women who possess life, as the
earth possesses flowers and fruits' (89).

40 'The consciousness of my condition as a woman suggested to me a feeling of
shame. With shame I discovered on my body every sign that would reveal this
condition and would make it evident not just to me but also to others' (66).

41 'Only once, I was just little older than eleven, I feared I was very sick ... And
she told me that I was not sick: she only told me that I had turned into a
woman' (134).

42 'Meanwhile she hugged me. She did not know it, but she had a desperate
way of hugging me. I shivered, lost in sudden compassion for my condition
as a woman. We were, it seemed to me, a gentle and unlucky species. *Through
my mother, and her mother, and the women of the tragedies and novels, and the ones
who faced themselves on to the yard and through the prison's bars, and the other ones* I
met along the streets and had sad eyes and huge bellies; through all of them
I felt weighing upon me a centuries old unhappiness, an inconsolable soli-
tude' (49).

43 'Stavo leggendo la storia di Emma Bovary. Era un libro che mia madre
doveva aver riletto più volte perché appariva molto usato e alcuni passi erano
sottolineati' (117). ('I was reading the story of Emma Bovary. It was a book
that my mother must have read several times because it looked worn and
some passages were underlined.')

44 Benjamin, *The Bonds of Love* (New York: Pantheon Books, 1988), 218.

45 Ibid., 197.

46 While some female friends, like Fulvia, do not understand her gesture – in
their opinion Alessandra should have been happy to have such a loving hus-
band – the only one who fully understands her at the trial is the *Nonna*: 'Fu la
sola persona che depose in mio favore' (547). ('She was the only person who
testified in my favour.')

47 On women and the law see Annamaria Galoppini, *Il lungo viaggio verso la
parità: I diritti politici delle donne dall'Unità ad oggi* (Bologna: Zanichelli, 1980).

48 'I believe, therefore, that no man would have the right to judge a woman
without knowing of what different matter from men women are made. I do
not consider it right, for instance, that a tribunal composed exclusively of
men could decide if a woman is guilty or not' (95).

49 Although women did participate in the public sphere, particularly in sports

and public parades, as I have showed in the first chapter, they were not, to their dismay, elected to pre-eminent political positions. For instance, they also did not participate in the *littoriali della cultura* up to 1938 and, even in that case, were separate from men and on different schedules. Only in 1941 were the meetings held together (de Grazia 1992, 162–3). For the definition of resistential political sphere as 'male' see Ben-Ghiat 2000, 306, and Pavone, 1991.

50 Brunetta underlines the exceptional contribution of the female scriptwriter Suso Cecchi D'Amico, who, 'con il suo lavoro assume un ruolo determinante nella creazione di una grande galleria di ritratti femminili, puntando soprattutto l'attenzione su una tipologia di donna che, lentamente, si sta emancipando e paga – spesso in maniera dura – la sua lotta e la sua ricerca di un diverso ruolo sociale' ('with her work assumes a determining role in the creation of a new gallery of female portraits, focusing her attention particularly on a kind of woman who, slowly, emancipates herself and pays – often quite a high price – for her fight and for her search for a different social role'). Gian Piero Brunetta, *Storia del cinema italiano* (Rome: ERI, 1982), 2: 274.

51 See how Patrizia Carrano describes them: 'I personaggi femminile del Ventennio – tutti connotati da un perbenismo caro al Regime – obbediscono quasi sempre alla regola così riassunta da Carlo Castellaneta: 'Tutto doveva essere edulcorato e candido, anche se c'era di mezzo un figlio illegittimo o un licenziamento in tronco. La virtù più divulgata è la sottomissione femminile' (*La Stampa* 25/10/76). A parte il filone – peraltro esiguo – dei film di propaganda e la riduzione cinematografica dei melodrammi più celebri, prosperavano i film "di collegio," che riunivano le più diverse tipologie femminili e si chiudevano in bellezza con il matrimonio della protagonista' (Carrano 1977, 65). ('The female characters during the Ventennio – all connoted by a "propriety" dear to the Regime – almost always obey a rule that has been summarized by Carlo Castellaneta as follows: "Everything had to be golden glaze and pure, even though there was an illegitimate child or an unexpected firing"' (*La Stampa.* 25/10/76). Apart from the quite exiguous trend of propaganda films and the screen adaptation of the most famous melodramas, the most prosperous films were the films about "boarding schools," which reunited the most different female typologies and which ended happily with the protagonist's wedding.') For a summary of plots see 'trame' in Oreste del Buono and Lietta Tornabuoni, eds, *Era Cinecittà* (Milan: Bompiani, 1979), 75.

52 See Miccichè, quoted in Giuliana Bruno, *Streetwalking on a Ruined Map* (Princeton: Princeton UP, 1993), 330 n. 6, and Miccichè, 'L'ideologia e la forma il gruppo "Cinema" e il formalismo italiano,' in Andrea Marini, ed.,

La bella forma, Poggioli i calligrafici e dintorni (Venice: Marsilio, 1992). On film under Fascism see Marcia Landy, *Fascism in Film: The Italian Commercial Cinema, 1931–1943* (Princeton: Princeton UP, 1986); Hay, 1987; Elaine Mancini, *The Free Years of the Italian Film Industry 1930–1935* (Ann Arbor: University Microfilms, 1981); the above-quoted Bruno; Alberto Farassino and Tatti Sanguinetti, *Lux Film: Esthéthique et système d'un studio Italien* (Locarno: Éditions du Festival International du Film de Locarno, 1984); and Ben-Ghiat 2000, 121–55.

53 David Forgacs, *L'industrializzazione della cultura italiana (1880–1990)* (Bologna: Il Mulino, 1992), 106.

54 See Bruno, 1993. For a history of film in the period see Gian Piero Brunetta, *Storia del cinema italiano 1895–1945* (Rome: Editori Riuniti, 1979).

55 'Fascist films showed precisely that cosmopolitan glamour that the populist arm of the regime had vowed to defeat, and projected models of sexual and social behaviours that openly challenged the ones advertised in the official press' (Ben-Ghiat 2000, 122).

56 See Victoria De Grazia, 'Mass Culture and Sovereignity: The American Challenge to European Cinemas, 1920–1960,' *Journal of Modern History* 61.1 (March 1989), 53–87, and Gian Piero Brunetta, 'Il cinema, cattedrale del desiderio,' in Simonetta Soldani and Gabriele Turi, eds, *Fare gli italiani* (Bologna: Il Mulino, 1992), 2: 389–440.

57 See films such as *Sole* (1929), and *Terra Madre* (1931), and *Quattro passi tra le nuvole* (1942), all by Blasetti. For an overview of film genres during the *Ventennio* see Hay 1986.

58 See *Grandi Magazzini* (1939), *T'amerò sempre* (1933), and *Il Signor Max* (1937), all by Camerini.

59 See *La segretaria privata* (Alessandrini, 1931).

60 See *Ore nove lezioni di chimica* (Mattoli, 1941).

61 See *Zazà* (Castellani, 1942), *Stasera niente di nuovo* (Mattoli, 1942), and *La Signora di tutti* (Ophuls, 1934).

62 As in the case of Marina di Malombra, protagonist of the homonymous film directed by Mario Soldati in 1942 (an adaptation of Fogazzaro's novel *Malombra*).

63 This production included war films such as *L'Assedio dell'Alcazar* (Genina, 1940) and *Luciano Serra Pilota* (Alessandrini, 1938), and movies regarding the Ethiopian conquest, including *Scipione l'Africano* (Gallone, 1937) and *Abuna Messias* (Alessandrini, 1939).

64 For the popularity of American movies in the 1930s, see Brunetta, 'Il cinema, cattedrale del desiderio.' For data about their circulation see Forgacs 1992, 73–80, 100–7.

65 An overview of the history of Italian women in the last century is provided by Michela De Giorgio, *Le italiane dall'Unità ad oggi* (Bari: Laterza, 1992). On the fifties see also Rebecca West, 'Lost in the Interstices: A Postwar, Pre-Boom *Enciclopedia della donna*,' *Annali d'Italianistica* 16 (1998): 169–94.

66 'Don't you remember when you were doing the demographic campaign at my expense? It's something that if July 25 [date of Italy's Liberation] hadn't come, I'd still be making babies like a machine' (Brunetta 1982, 327).

67 See Peter Bondanella, *Italian Cinema from Neorealism to the Present* (New York: Continuum, 1988), 101.

68 The year 1953 also signals the peak of Italian postwar production, with 155 films produced. As Lorenzo Quaglietti writes, 'è l'anno dell'apogeo che, negli ambienti della produzione fece assumere contorni perfino al sogno, se non di soppiantare, di creare seri fastidi all'industria hollywoodiana' ('it is the year of apogee in which, in the realm of producers the dream, if not of winning over the Hollywood industry, at least of creating serious problems for it, surfaced'). L. Quaglietti, *Storia economico-politica del cinema italiano* (Rome: Editori Riuniti, 1980), 74.

69 Only a decade before, in *Quattro passi tra le nuvole* (1940), considered among the forerunners of Neorealism, a young, unmarried girl who remains pregnant has to 'invent' a husband for herself – actually a man she meets on the bus – in order to be able to go back home and be accepted by her family. On this topic see also Marta Boneschi, *Senso* (Milan: Mondadori, 2000), 113–200.

70 The episodes are Dino Risi's 'Invitation to Love' ('Paradiso per tre ore'), about the encounters in a *balera*, or dancing room; Antonioni's 'When Love Fails' ('Tentato suicido'), about a teenager who tries to cut her veins; Fellini's 'Love Cheerfully Arranged' ('Un'agenzia matrimoniale'), about arranged marriages; Lattuada's 'Italy Turns Around' ('Gli italiani si voltano'), a look at extremely eroticized and turned-into-spectacle women's bodies, in which Lattuada searches buttocks, breasts, armpits, legs, ankles, necks, etc. with his intrusive and self-complacent lens; Zavattini's 'The Love of a Mother' ('La storia di Caterina'), the true story of Caterina Rigoglioso; and Lizzani's 'Paid Love' ('L'amore che si paga'), about prostitutes and their life. In the American version, the latter episode has been cut by Italian censors since the government did not want to convey a bad image of the country. See Bondanella 1988, 101.

71 A film that deals with an analogous problem and in which the protagonist, for social convenience, hides the fact that she has a child is *T'amerò sempre* by Mario Camerini, with Alida Valli and Gino Cervi (1943).

72 Isa Miranda introduces the viewer to a house whose walls are covered with her portraits, pictures, posters, newspaper clippings, and the like. There is a

feeling that her house has been turned into a museum in order to keep her myth alive. She recounts a car accident in which a young boy gets hurt. Having being present at the accident, she brought the boy back to his house and waited until his mother came back.

Alida Valli is invited to the engagement party of her masseuse. When she gets to the girl's modest apartment she is conquered by the simplicity of the people there and by their apparent happiness. She dances with her masseuse's fiancé and is intrigued by his youth and enthusiasm. In fact, she almost flirts with him, having been seduced by his spontaneousness.

Ingrid Bergman describes her battle against a rooster. The neighbour's rooster has the habit of strolling through Bergman's garden and ruining her roses. One afternoon, mad at the animal, Bergman captures it. At that very moment, some friends come to visit her, and she has the maid lock the bird in a closet. When the neighbour, not finding the rooster, comes to look for him, the rooster crows, revealing his presence in the closet.

Anna Magnani is going to the theatre for rehearsal and stops a cab. She carries a small dog with her. When she arrives at the theatre the cab driver asks her to pay a supplement for the dog, but Magnani strongly protests. The cab driver reads aloud a price list according to which only a 'cane da grembo' (a dog to keep in one's lap) does not pay. Magnani claims that her dog is, in fact, a 'cane da grembo' and, running around in the same cab, starts searching for a policeman, guard, or public official who could solve her problem. She ends up at the *Commissariato*, where several policemen read a dictionary, which carries the proper definition of 'grembo.'

73 For the connotations of these actresses see Brunetta's chapter 'Attori e divi' (1982, 247–60). Other films that deal with Cinecittà, cinema productions, and/or photojournals are Lattuada-Fellini's *Luci del varietà* (1950), Bragaglia's *L'eroe sono io* (1951), Fellini's *Lo sceicco bianco* (1952), Risi's *Il viale della speranza* (1952), and Antonioni's *La signora senza camelie* (1953). (In *Luci del varietà*, interestingly, Carla del Poggio, who in *Gioventù perduta* plays Luisa, plays a soubrette who uses her beauty and sexuality to assert herself in show business. Her radical change of role, from strong and chaste sister to seductive showgirl hints at the changes in Italian society and women's position in it.)

74 '"Devi scegliere. Quello non è un lavoro. Se vuoi andare via vai, ma bada che qui non metterai più piede." Il motivo delle liti con mia madre era sempre lo stesso, ma questa volta forse la porta di casa mia si era chiusa dietro le mie spalle per sempre.' ('"You have to choose. That is not a job. If you want to go go, but be aware that you'll not put your foot here again." The reason for the fights with my mother was always the same, but this time the door of my home had maybe shut behind my shoulders forever.')

75 Parallel to this trend – and not exactly in opposition to it – runs also the triumphant eroticization of the female body that *maggiorate* such as Sophia Loren, Silvana Mangano, and Gina Lollobrigida overwhelmingly imposed on Italian screens around the early and mid-fifties. These *maggiorate*'s unrestrainable sexual appeal contributes to cast a different light on desire and eroticism. Even though women remain the object of the male gaze, they are also allowed to show their desire and sexual satisfaction – see Sophia Loren in *L'Oro di Napoli*, 1953 – without necessarily being categorized as 'bad' or potential prostitutes simply for doing so. The male gaze is both desiring and admiring and somehow triggered by what turns into women's combative and aggressive self-reliance, to the point that Marcello Mastroianni can compliment Sophia Loren precisely on her great luck: that of being a woman (*La fortuna di essere donna*, 1953).

76 Rossellini's choice of a lower-class woman as his heroine is 'ideological,' inasmuch as it is connected to the Resistance and later leftist idea of *popolo*, or people as the source of regeneration for Italian democracy. The notion of 'popolo' is inherently ambivalent, since – as we saw in the previous chapter – it is linked to one of the most rhetorically loaded expressions of Fascist propaganda: that of 'popolo italiano.'

77 Ben-Ghiat maintains that 'neorealist films also facilitated the displacement of collective responsibility for Fascism by consistently shifting culpability away from ordinary Italians. Both critics and directors conceived of Neorealism as a "return to honesty" after years of Fascist rhetoric and a rediscovery and celebration of a "real Italy" that had been suppressed by the dictatorship. In many films of the movement, the subjects who represent this "authentic Italy" come from spheres of purity (childhood, the countryside, the working class), and are portrayed as *brava gente* who were little affected by the two decades of Fascism. Moreover, neorealist films made use of a typology of "foreign" figures who functioned as emblems of the physical, social and moral brutality of the regime' (Ben-Ghiat 1999, 84).

78 As one of the women of the crowd she heads says: 'Bisogna che questi uomini la piantino di fare i prepotenti, adesso il voto ce l'abbiamo pure noi.' ('It is time that these men stop being so arrogant, now we have the vote too.')

79 'I have realized that I am good for nothing. One of these days I'll leave home.'

80 'In order to do politics my family was going to pot and I do care for my kids; the family is a great thing.'

81 'The number of movie theatres that were still functioning at the end of the war was around five thousand; in 1948 it is at 6,551 units and in 1956 it

reaches 10,500 units (a number to which we have to add the 5,449 movie the-
atres run by parishes, which provide a million seats). The increase tends to
ensure that all towns with at least 5,000 inhabitants have a movie theatre ...
1948 is a pivotal year for the race towards investment in movie theatres. With
reference to 1938 we can see a number of theatres that is now doubled and
an increase of 75% in ticket revenues' (Brunetta 1982, 54).

82 Inaugurated in 1937, in the presence of Mussolini, as one of the best-fur-
nished facilities of its kind in Europe – and overtly in competition with Holly-
wood – Cinecittà soon enjoyed a well-deserved fame both in Europe and
America. In 1943, it was bombarded and reduced, in a few months, to a pro-
visional camping space for *sfollati*, or homeless people. It was only in 1947
that the studios were rehabbed and that the first film, *Cuore* by Duilio Coletti,
was filmed there. Already in 1948, though, foreign producers showed inter-
est in Cinecittà, its sets, spaces, and highly qualified technicians. After Henry
King's *Il principe delle volpi* (1948) with Tyrone Power, the most significant co-
production filmed here was Mervyn Le Roy's *Quo Vadis?* in 1950, with Robert
Taylor and Deborah Kerr. In the late 1940s and in the 1950s the productions
and co-productions multiplied to the point that Cinecittà became known as
the 'Hollywood on the Tiber.' Famous actors and actresses such as Audrey
Hepburn, Gregory Peck, Rock Hudson, Jennifer Jones, Ava Gardner, Hum-
prey Bogart, and John Wayne became familiar faces of Cinecittà's entourage.
Cinecittà probably reached the peak of its international fame with *Ben Hur*
(1958), starring Charleton Heston, and *Cleopatra* (1960), starring Elizabeth
Taylor and Richard Burton. See Franco Mariotti, *Cinecittà tra cronaca e storia
(1937–1989)*, 2 vols. (Rome: Presidenza del Consiglio dei Ministri, 1991);
Peter Bondanella, *The Films of Roberto Rossellini* (Cambridge: Cambridge UP,
1993), 3–17. See also Peter Bondanella, *The Eternal City* (Chapel Hill: U of
North Carolina P, 1987), 215–18; and Hank Kaufman and Gene Lerner, *Hol-
lywood sul Tevere* (Milan: Sperling and Kupfer, 1982).

83 For an analysis of the genre see Maria Teresa Anelli and Paola Gabrielli, eds,
Fotoromanzo: Fascino e pregiudizio (Milan: Savelli, 1979) and Giuliana Muscio,
'Tutto fa cinema: La stampa popolare del secondo dopoguerra,' in Vito
Zagarrio, ed., *Dietro lo schermo* (Venice: Marsilio, 1988), 105–15. Lorenzo Pel-
lizzari suggests the importance that the printed image acquired: 'Essere in
prima pagina, avere una foto in copertina, far cronaca a tutti i costi, esibire
ed esibirsi: fra i miti degli anni '50 che alimentano soprattutto le illusioni di
un mondo piccolo-borghese il quale torna ad emergere dopo la parentesi
unificante della guerra e del primo dopoguerra, il mito della stampa – di
una stampa rinnovatasi e che dà incredibile spazio all'illustrazione, di cine-
ma anzitutto – è fra i più consistenti' (60). ('To be on the front page, to have

a picture on the cover, to be part of news-making at all costs, to exhibit and to be exhibited: among the myths of the fifties that fuel prevalently the illusions of a petit-bourgeois world that is emerging after the unifying parenthesis of the war and of the postwar, the myth of the press – of a press that has renovated itself and provides an incredible space for pictures, prevalently film pictures – is among the more consistent ones'.) In Lorenzo Pellizzari, *Cineromanzo: Il cinema italiano 1945–1953* (Milan: Longanesi, 1978).

84 'The photo-romance allowed to happen what neither the press nor the radio had ever been able to achieve in Italy: it penetrated the strata of the population that had never been even touched by the mass media, in particular the South and women. Thousands of women that had never read anything started to read passionately and frenetically the incredible stories in photograms of "Grand Hotel," "Bolero," "Sogno," "Tipo."' Evelyn Sullerot, quoted by Lietta Tornabuoni, 'La stampa femminile,' in *La stampa italiana del neocapitalismo* (Bari: Laterza, 1976).

85 See Franca Faldini and Goffredo Fofi, *L'avventurosa storia del cinema Italiano*, 2 vols. (Milan: Feltrinelli, 1979), 1: 147–57.

86 'I want my daughter to become somebody. Yes, I want my daughter to become somebody. Do I have such a right or is that a crime? She doesn't have to become an unhappy woman. She does not have to depend on anybody.'.

87 On Blasetti see Alessandro Blasetti, 'Cinema italiano ieri,' in Adriano Aprà and Patrizia Pistagnesi, eds, *I favolosi Anni Trenta* (Milan: Electa, 1979), 34–49.

88 Visconti succeeded so well that, when Blasetti saw the film, he became furious at Visconti: he rightly felt he had been used for a satire against the Italian Hollywood, Cinecittà. See Faldini and Fofi 1979, 1: 248–9.

89 'If I would believe now that I am somebody else, if I pretended that I was someone else, here I am acting.'

90 In his essay on *Bellissima* Miccichè proposes to read the film as an open critique of Neorealism and as an attack against the utopia of social redemption that Neorealism seemed to promise. In his last footnote, 37, he also convincingly signals that, at the beginning of the fifties, a few directors (Visconti, Fellini, Antonioni) made films that focus on the media, addressing the problem of the false illusions they create. 'Vi è indubbiamente in questi autori, tutti profondamente connessi con la dinamica neorealista, non solo la consapevolezza del potere delle immagini, ma anche la coscienza di come la fame di verità del dopoguerra, e l'impegno morale di molti, se non di tutti a servirla, non abbiano sostanzialmente modificato quel potere e le sue leggi' (213). ('There is undoubtedly in these authors, all deeply connected to the

Neorealist dynamic, not only consciousness of the power of images, but also consciousness of how the thirst for truth of the postwar years and the engagement of most people, if not all, to serve it, had not substantially modified that power and its laws.') On the film see also Francesco Casetti, 'Cinema in the Cinema in Italian Films of the Fifties: *Bellissima* and *La signora senza camelie*,' *Screen 33* (1992): 375–93.

91 Pio Baldelli, *Luchino Visconti* (Milan: Mazzotta, 1973), 113–23.

92 Lino Miccichè, *Visconti e il neorealism* (Venice: Marsilio, 1998), 202–3.

93 Miccichè does a thorough reading of the film in *Visconti e il neorealismo*, 193–213.

94 'Ah, this is it, you poor one. But it is not going to be the same for everybody, my young girl, is it? It would be a disaster, truly, a big disaster, yes, with no remedy. I put all my stakes on her. I would be sorry ...'

95 It would be interesting to investigate if there is any connection between Visconti's homosexuality (which, according to the patriarchal codes, indicates a deviant or a 'weak' subject) and his empathy for women.

96 'And how do you want the little girl, with curly or straightened hair, with a lisp or with a stutter. You did not have enough of a good time, all of you. What a pity, because ... because we keep our daughter with us. I did not bring her into this world to amuse anybody. For me and her father she is so beautiful.'

97 As Miccichè has illustrated (1998), the ending is, in this respect, fairly normative.

3: The Myth of America

1 See Emilio Gentile, 'Impending Modernity: Fascism and the Ambivalent Image of the United States,' *Journal of Contemporary History* 28.1 (1993): 7–29.

2 Ibid., 7.

3 On this aspect see Laura Malvano, 'Il mito della giovinezza attraverso l'immagine,' 311–48, and Luisa Passerini, 'La giovinezza metafora del cambiamento sociale. Due dibattiti sui giovani nell'Italia fascista e negli Stati Uniti degli Anni Cinquanta,' 383–459, both in Giovanni Levi and Jean-Claude Schmitt, eds, *Storia dei Giovani*, vol. 2 (Bari: Laterza, 1994).

4 For a thorough analysis of the various representations of, and different relationships to, America during Fascism see Michel Beynet, *L'image de l'Amérique dans la culture italienne de l'entre deux guerres* (Aix en Provence: Publications de l'Université de Provence, 1990), 3 vols.

5 Actually the myth is older and has to do with the extensive emigration that took place, particularly between 1880 and 1920, and prevalently from south-

ern Italian regions, to the United States. For the literary relationship between America and Italy see the extremely informative Donald Heiney, *America in Modern Italian Literature* (New Brunswick, NJ: Rutgers UP, 1964) and Angela M. Jeannet and Louise K. Barnett, *New World Journeys* (Westport, Conn.: Greenwood Press, 1977). The latter book also contains a brief history of the Italian emigration to the United States and of its sociocultural profile; see esp. xiii–xxiii.

6 'Toward 1930 ... it happened that some young Italian men discovered America in its books, a pensive and barbarous, happy and argumentative, dissolute, fertile America, a land heavy with the entire past of the world and, at the same time, young and innocent.' Pavese 1986, 173.

7 On translation in Fascism's earlier years, see Valerio C. Ferme, 'The Translator under Fascism: The Linguistic Subversion of Culture,' *Forum Italicum* 31.2 (1997): 321–42. As Emilio Gentile has indicated, between 1930 and 1940, 51 books were published concerning the United States (Gentile 1993, 7).

8 Actually it was the Fascist party who 'dismissed' Vittorini. For his early adherence to Fascism, see Francesco De Nicola, *Introduzione a Vittorini* (Bari: Laterza, 1993), 3–55. The book also shows how Vittorini, who comes from a family of middle bourgeoisie, exaggerated the myth of being a self-taught man, and of his family's poverty.

9 For the myth of *romanità* and its political and cultural practices, see Romke Visser, 'Fascist Doctrine and the Cult of *Romanità*,' *Journal of Contemporary History* 27 (January 1992): 5–21, and Peter Bondanella, 'Mussolini's Fascism and the Imperial Vision of Rome,' in *The Eternal City*, 172–206.

10 'The expressive richness of that people was born ... out of a severe, and already century-old aspiration to squeeze everyday life into words.' Pavese 1986, 174.

11 'Language for the new reality of the world, in order to effectively create a *new* language, material and symbolic, that would justify itself uniquely in itself and in no other traditional complacency.' Ibid., 174.

12 During the *Ventennio* and soon after the war Einaudi provided one of the richest and most challenging environments for a militant culture. Only recently have the activities of Einaudi Publisher begun to be studied. See Severino Cesari, *Colloquio con Giulio Einaudi* (Rome: Theoria, 1991); Giulio Einaudi, *Frammenti di memoria* (Milan: Rizzoli, 1988) and *Cinquant'anni di un editore* (Turin: Einaudi, 1983); and Gabriele Turi, *Casa Einaudi: Libri, uomini, idee oltre il fascismo* (Bologna: Il Mulino, 1990).

13 The authors were Sinclair Lewis, Sherwood Anderson, Edgar Lee Masters, Herman Melville, John Dos Passos, Theodore Dreiser, Walt Whitman, and William Faulkner.

14 On this aspect see Mario Sechi, *Il mito della nuova cultura: Giovani, realismo e politica negli anni trenta* (Manduria: Lacaita, 1984).

15 Recent scholarship has showed how, particularly at the beginning, Vittorini was consistently helped in his work by a sort of 'ghost translator' in the person of Lucia Rodocanachi. A Triestine Jew, extremely cultivated and knowledgeable in several literatures, Rodocanachi was introduced to Vittorini by Montale. The 'négresse inconnue' – as Montale defined her – provided at first literal translation of the texts later adapted by Vittorini in his own style. See Ferretti 1992, 3–28, and De Nicola 1993, 44–5.

16 Beginning in 1933, he first translated British authors D.H. Lawrence and John Galsworthy and then moved to the Americans: Poe, Faulkner, Roberts, Saroyan, Theodore Francis Powys, Thornton Wilder, John Steinbeck, and Hemingway – whom he met and befriended, while nourishing a great admiration for his work. The myth is criss-crossed: in particular Hemingway and Dos Passos, who had both been in Italy during the Second World War, created, in their literature, an analogous myth of Italy for an American readership. See Giovanni Cecchin, *Con Hemingway e Dos Passos sui campi di battaglia della Grande Guerra* (Milan: Mursia, 1980).

17 An exemplary instance of Vittorini's editorial intervention on the original is with *God's Little Acre.* Writing to Pavese, Vittorini mentioned that he had transformed Griselda's 'boobs' into legs: 'per esempio le poppe di Griselda sono diventate gambe. Ma come scrivere poppe in italiano? Griselda sarebbe diventata una serva.' ('For instance Griselda's boobs became legs. But how could we write boobs in Italian? Griselda would turn into a servant.') To Pavese, who replied by suggesting the use of *mammelle*, or breasts, Vittorini wrote: 'Ah, mammelle! Non è pressapoco come poppe? ... Io non vedo che nella balia il bel seno. Griselda è gambe, in italiano.' ('Ah, breasts! But it is not more or less like boobs? ... I see beautiful breasts only in a wet nurse. Griselda is legs in Italian.') De Nicola 1993, 80.

18 On *Il Politecnico* there is now an ample bibliography. See Marina Zancan, *Il Progetto Politecnico* (Venice: Marsilio, 1984), a text that provides further references.

19 'Americana,' which exerted quite an influence on young intellectuals during the war, has an interesting history. After the censorship, Bompiani tried to have the book published, by asking someone better liked by the regime to preface it. The choice fell on a writer beyond any suspicion, Emilio Cecchi, who had himself been to America as a visiting professor in 1930 and 1938, and who had become head of Cines (Italian film production company) in the early thirties. Nevertheless the regime still tried to oppose the book's distribution. According to Luciana Castellina, '*L'Americana* ... portava allora,

nell'Italia dominata dal fascismo il messaggio, appunto, del mito democratico americano.' ('*L'Americana* ... then brought the message of the myth of American democracy to an Italy dominated by Fascism.') In 'Fine del mito americano,' Saveria Chemotti, ed., *Il mito americano: Origine e crisi di un modello culturale* (Padua: CLEUP, 1980), 38.

20 'The flavour of scandal and facile heresy that surrounded the new books and their arguments, the furor of upheaval and sincerity that even the most thoughtless ones felt pulsating in those translated pages, succeeded in being irresistible to a public not yet completely numbed by conformism and academia ... For many the encounter with Caldwell, Steinbeck, Saroyan and even the old Lewis disclosed the first light of freedom, the first suspicion that not everything in world culture ended with Fascism.' Pavese 1986, 173.

21 For both authors see the extensive and informative discussion of Donald Heiney (1964, 29-40). Heiney divides Italian authors who write about America into 'travellers' – Soldati, Cecchi, Prezzolini (who held the chair of Italian literature at Columbia University and directed the Casa Italiana from 1930 to 1950), Guido Piovene, and, in the early sixties, Corsini, Spini, and Soavi; and 'americanisti' – Pavese, Vittorini, Pintor and, later, Fernanda Pivano. In 1936 Giuseppe Antonio Borgese published *Atlante Americano*. Borgese left Italy because of his anti-Fascist ideas and taught in different American universities from 1931 to 1948. Another book, published in 1937, is *L'America, ricerca della felicità*. The author is, interestingly, Margherita Sarfatti, hagiographic biographer of Mussolini, his former lover, and editor-in-chief, up to 1934, of the Fascist magazine *Gerarchia*. Under the racial laws, Sarfatti, a Venetian Jew, was expelled from the Association of Journalists. See N. Tranfaglia, P. Murialdi, and M. Legnani, *La stampa italiana nell'età fascista* (Bari: Laterza, 1980), 208.

22 See Denis Mack Smith, *Mussolini* (New York: Knopf, 1982), 217-23.

23 If we are to credit Heiney, Cecchi's and Soldati's books 'were important enough in influencing what the average Italian in those years thought about the United States' (1964, 29).

24 See the extremely informative James Hay, *The Passing of the Rex: Popular Film Culture in Fascist Italy* (Bloomington: Indiana UP, 1987), 66–97; Philip V. Cannistraro, *La fabbrica del consenso: Fascismo e mass media* (Rome, Bari: Laterza, 1975), 293. For cinema during Fascism see Luigi Freddi, *Il cinema* (Rome: L'Arnia, 1949), 2 vols.

25 'Even in the cases of more violent war propaganda, the hated enemy was English, not American.' In 'Il mito americano,' in Carlo Chiarenza and William L. Vance, eds, *Immaginari a confronto* (Venice: Marsilio, 1993), 19.

26 See Franco Minganti, 'Quale Hollywood per il fumetto?' in David W. Ell-

wood and Gian Piero Brunetta, eds, *Hollywood in Europa* (Florence: Usher, 1991), 159–71.

27 Hay 1986, 64–98. See also Ben-Ghiat 2000, 121–55.

28 'A logic that m[ight] justify both a servile Americanism and a vehement anti-Americanism, or, as it happens in the thirties, both at the same time.' V. De Grazia, 'La sfida allo "star system,"' in *Quaderni Storici* 58, nova serie, anno xx, no. 1 (April 1985): 112.

29 'Vittorio belonged to a group of young lions fascinated by cinema, as art, as industry, as a way of life [and] ... wanted to be the pioneer of the American-ization of Italian cinema. In his magazine "Cinema" he criticized the Euro-pean filmic tradition and asserted that the Italian public identified itself emotionally only with the archetypes of the American cinema.' In 'Il mito americano' in Chiarenza and Vance 1992, 18. Eco quotes Mussolini: 'E' forse eresia affermare che spirito, mentalità e temperamento della giovinezza italiana, pur con le logiche e naturali differenze imprescindibili in un'altra razza, siano molto più vicine a quelle della gioventù d'oltreoceano che non a quella russa, tedesca, francese e spagnola?' (19). ('Is it perhaps a heresy to affirm that the spirit, mentality and temperament of Italian youth, even con-sidering the logical and natural differences not to be ignored in another race, are much closer to those of the youth overseas than to those of the young people of Russia, Germany, France, and Spain?')

30 For a thorough account of Italian/American relationships at the time, and the attempt at constructing an accord about Italian American co-produc-tions see the chapter 'Il "caso" Vittorio Mussolini' in Freddi 1949, vol. 1: 297–322.

31 See Gian Piero Brunetta, 'Il cinema, cattedrale del desiderio,' in Simonetta Soldani and Gabriele Turi, eds, *Fare gli italiani* (Bologna: Il Mulino, 1993), 2: 389–440.

32 'Between '36 and the war ... the cinema became the world for me' (43). In Italo Calvino, *La strada di San Giovanni* (Milan: Mondadori, 1990), 43–71. All the translations are from the English version, *The Road to San Giovanni*, trans. Tim Parks (New York: Pantheon Books, 1993).

33 'I haven't said it yet, though I felt it would be understood, that for me the cinema meant American cinema, the Hollywood production of the time.' Referring to Italian films Calvino writes: 'I film italiani d'allora se non erano doppiati, era come se lo fossero. Se non ne parlo, pur avendoli visti quasi tutti e ricordandomeli, è *perchè contavano così poco*, in male o in bene, e in questo discorso sul cinema come altra dimensione del mondo non potrei proprio farceli entrare' (italics mine, Calvino 1990, 56–7). ('The Italian films of the time, for that matter, although not dubbed, might just as well have

been. And if I do not mention them here, despite having seen and still remembering almost all there were, it's because, for better or worse, *they made so little impression*, and hence there is simply no place for them in an essay presenting the cinema as another dimension of the world.')

34 'A need for distance, an expansion of the boundaries of the real.' Ibid., 61.

35 See Heiney 1964, 71–8.

36 'Now that a mandatory abstinence healed us from the excesses of publicity and the boredom of habit, we can perhaps sum up the meaning of that educational episode and recognize in American cinema the greatest message that our generation might have received' (Pintor 1975, 156).

37 Victoria De Grazia suggests that Hollywood movies were more appealing to European audiences than their national products since 'American movies were more responsive to consumer desires than European films. Beyond appealing images of consumer abundance, they presented novel and attractive social identities to the increasingly socially mixed publics of interwar Europe – thus the companionate couple, the tough working girl, and the hero-entrepreneur. American movies also offered practical lessons about fashion, makeup, and courtship, as well as the "art of the artistic embrace" – all useful skills in societies where women were going out more and in which social mores were undergoing rapid changes.' De Grazia, 'Mass Culture and Sovereignty,' *Journal of Modern History* 61.1 (1989): 60.

38 See reference to the Americans in De Filippo's comedy *Napoli milionaria!* (1945) and Curzio Malaparte's *La pelle* (1949).

39 See Paul Swann, '"Il piccolo dipartimento di Stato": Hollywood e il dipartimento di Stato nell'Europa del dopoguerra,' in Brunetta and Ellwood, eds, *Hollywood in Europa*, 40–5.

40 In the same year Italy produced 62 films. The total of imported films was 850. See Brunetta 1982, 2: 29.

41 'Beyond the traditional media there were ERP CONCERTS, ERP variety shows on the radio, ERP trains, ERP ceremonies. There were calendars, cartoons, stamps and atlases. There were storytellers, sponsored by the ERP, who told of miracles in Sicilian villages and even mobile puppet shows, "to take the Marshall plan's message," apparently to children, but in reality, through them ... to illiterate adults.' David Ellwood, 'Il cinema e la proiezione del modello americano,' in Brunetta and Ellwood, *Hollywood in Europa*, 23.

42 The problem of racism is explored also, under the magnifying lens of an interracial relationship, in Lattuada's *Senza pietà* (1948) and De Sica's *Miracolo a Milano* (1951). See also the Black American soldier of Zampa's *Vivere in pace* (1946). A close encounter with American society is provided by *Harlem*

(Gallone), a film produced in 1942, still under Fascism and informed by Fascist anti-Americanism.

43 I do not find reference to this particular issue in the works of critics such as José Luis Garnier, *Roberto Rossellini* (New York: Praeger, 1970), 19–24; Gianni Rondolino, *Rossellini* (Turin: UTET, 1989), 100–10; Robert P. Kolker, *The Altering Eye* (Oxford: Oxford UP, 1983); and Peter Brunette, *Rossellini* (New York: Oxford UP, 1987). Peter Bondanella analyses in detail the interaction between Italy and America, claiming that Rossellini focuses, not on the socioconomic situation traditionally studied by critics, but 'on a far more philosophical theme: the interaction and enrichment of two quite alien cultures, Italian and American' (Bondanella 1993, 69).

44 There is an exception: in the fourth episode a dying soldier invokes his mother.

45 Things work differently, for instance, with Vittorini. As Brunetta says, 'ancora nell'immediato dopoguerra il mito è operativo positivamente in Vittorini: si pensi ai suoi interventi apparsi a più riprese sul "Politecnico" ... Basterà citare solo un passo come questo del n. 33–34 del "Politecnico": "la letteratura americana è l'unica che coincida, dalla sua nascita con l'età moderna e possa chiamarsi completamente moderna"' (Brunetta 1992, 2: 231). ('Still in the immediate postwar period the myth is positively operating in Vittorini: think of his articles published at different moments on the pages of the *Politecnico* ... It suffices to quote just one passage like the following one in the 33/34 issue of *Politecnico*: "American literature is the only one that coincides, from its birth, with the modern era and that could call itself completely modern."'

46 The articles are now collected in Cesare Pavese, *La letteratura americana e altri saggi* (Turin: Einaudi, 1990), 169–75.

47 'To be sincere, it seems to us that American culture has lost its mastery, that naive and penetrating furor that used to put it at the vanguard of our intellectual world.' Ibid., 175.

48 'Nor can we fail to notice that this coincides with the end or suspension of its antifascist fight.' Ibid., 175.

49 'Now America, the great American culture, has been discovered and recognized, and we can foresee that, for a few decades, nothing similar to the names and revelations that enthused our prewar youth will come from there.' Ibid., 169.

50 On this aspect see Vincenzo Binetti, *Cesare Pavese, una vita imperfetta* (Ravenna: Longo, 1998), 73–103.

51 See Paul Ginsborg, *Storia d'Italia dal dopoguerra a oggi* (Turin: Einaudi, 1989), 47–159. For the Communist party see the extremely informative Nello Ajello, *Intellettuali e PCI 1944–1958* (Bari: Laterza, 1979).

52 For the Marshall Plan see Pier Paolo d'Attorre, 'Anche noi possiamo essere prosperi,' *Quaderni Storici* 58, nova serie, anno xx, no. 1 (April 1985): 55–93.

53 'L'intervento americano lasciò senza fiato per la sua ampiezza, la sua astuzia, il suo flagrante disprezzo per tutti i principii di non ingerenza negli affari interni di un altro paese. L'amministrazione di Washington concesse nei primi tre mesi del 1948 aiuti all'Italia per 176 milioni di dollari. Dopo di allora entrò pienamente in funzione il piano Marshall. L'ambasciatore americano a Roma, James Dunn, si assicurò che questo massiccio intervento di aiuti non passasse inosservato all'opinione pubblica italiana. L'arrivo di ogni centesima nave che portava cibo, medicine, ecc. costituì l'occasione di particolari festeggiamenti ... Nell'eventualità che il messaggio non fosse abbastanza chiaro, il 20 marzo 1948 George Marshall ammonì che nel caso di una vittoria comunista tutti gli aiuti all'Italia sarebbero stati sospesi.' ('The American intervention left [Italy] breathless for its width, its shrewdness, its flagrant contempt for all principles of non-interference with the internal affairs of another country. The Washington administration gave 176 billion dollars in aid to Italy in the first three months. After that, the Marshall plan was put into place. The American ambassador in Rome, James Dunn, made sure that such a huge amount of aid would not go unnoticed by Italian public opinion. The arrival of every hundredth ship that brought food, medicine, etc. constituted the occasion for particular feasts ... In the eventuality that the message was not going to be clear enough, on the 20th of March 1948 George Marshall threatened, in the case that the Communists should win, to suspend all the aid to Italy.') Ginsborg 1989, 152.

54 See Vincenzo Binetti, 'Dal *Compagno* ai *Dialoghi col Compagno*: Assertività e incoerenze di un "Discorso" politico-ideologico,' *Rivista di Studi Italiani* 11.2 (December 1993): 13–30; Paolo Spriano, *Le passioni di un decennio* (Milan: Garzanti, 1986); and Ajello 1979.

55 'For the first time, the cinema earned a privileged position within Communist cultural politics.' Brunetta states, though, that immediately after the war the Communists failed to understand the potential of the cinema as a tool of both the mass's control and education. They were in fact unable to come up with a cohesive and aggressive cultural program where the cinema was concerned. Unlike the Communists, Catholics organized very soon – through their parishes – a capillary distribution of films 'adapted' to a Catholic audience. See Brunetta 1992, 2: 135–60.

56 See Faldini and Fofi 1979, 119, 121, 138, and Ellwood and Brunetta 1991, 119, 120.

57 See Millicent J. Marcus, *Italian Film in the Light of Neorealism* (Princeton: Princeton UP, 1986), 76.

58 On De Santis see Antonio Vitti, *Giuseppe De Santis and Postwar Italian Cinema* (Toronto: U of Toronto P, 1996).

59 Another film that deals with the same issues of rural social struggle is Lattuada's *Il mulino del Po*, which was distributed the same year, 1949. Even though Lattuada's film is an adaptation of Riccardo Bacchelli's novel, it presents the same issues as *Riso amaro*. By comparing the two films it is easy to see how dominant De Santis's (erotic) interest in the female body is.

60 See Peter Bondanella, *Italian Cinema from Neorealism to the Present* (New York: Continuum, 1988), 82–5, and Marcus 1986, 76–95. They both provide additional bibliographies.

61 See Marcus 1986, 90. Also, compare this film with *Actung! Banditi*, by Lizzani, a film about Partisans, in which not the least concession is made towards women and their beauty. Gina Lollobrigida is cast in the film in the unromantic role of a sister always chastely clad in a raincoat.

62 Referring to De Santis's eroticism Elio Petri says, 'Secondo me, nell'invenzione del suo particolare erotismo cinematografico, De Santis dovette reprimersi. Questa è un'altra delle cose che il moralismo comunista e il moralismo della critica di sinistra e di destra devono ascrivere a proprio demerito. *Perchè De Santis è un uomo che, nel suo sistema di archetipi e di miti, aveva al centro la donna. La donna era il centro di tutto questo sistema, intorno alla donna si muoveva tutto il resto, anche la socialità. In un certo senso anche la politica se uno guarda bene ai suoi film*' (italics mine). ('According to me in the invention of its particular cinematographic erotism, De Santis had to repress himself. This is another of the things that Communist moralism and the moralism of the leftist and right-wing critics have to acknowledge as their negative input. *For De Santis is a man who, at the centre of his system of archetypes and myths, had Woman. Woman was at the core of all this system, and around the Woman moved all the rest, even socialization, and in a certain sense even politics if one considers his films in detail.*') Faldini and Fofi 1979, 156.

63 Here too the immediate reference seems to be to the western, and seems to foreshadow in particular Johnny Guitar's diegesis. In *Johnny Guitar* (1954), the confrontation between the two male leads, Sterling Hayden and Scott Brady, is overpowered by the opposition between the two females, Joan Crawford and Mercedes McCambridge.

64 'The eroticism in my films is attributable, I believe, to my nature, to a particular sensibility. I am a man of the South, born in Fondi, a small town of agrarian roots ... It is indubitable that women started to interest me a lot from a very early age ... Add to that the fact that when I started to work in the cinema I developed a precise political consciousness that woman had to count for for what she should have counted for, had to be worthwhile for the

reasons she was worthwhile, and I realized there was a great necessity that she be respected; she did not need, though, that kind of respect and that love that usually was offered to her by the typical national male. Thus, it became impossible for me to ignore the female problematic' (Faldini and Fofi 1979, 155).

65 In a provocative and stimulating article, 'Liberation: Italian Cinema and the Fascist Past, 1945–50' (in Bosworth and Dogliani 1999), Ruth Ben-Ghiat proposes to read the film as 'a coded symbol of the exploitative and immoral world of Fascism.' For her, the Americanized gangster Walter, and the photo-romance-fascinated Silvana could be stands-in for, respectively, Mussolini and Italy. Ben-Ghiat reads the film as another instance of that desire to deny the past Italians collectively felt in the postwar years. She claims that 'at a time of crisis in national identity and widespread shame about the Fascist regime, the films of De Santis offered Italians a vision of a nation that was cohesive and purposeful. Along with many other texts of the reconstruction period, they laid down a path for the collective memory of the dictatorship that exonerated ordinary Italians who had "just been following others" and projected responsibility for Fascism on to foreign powers.' Even though I find this interpretation engaging, and challenging, I don't fully support it.

66 *Bianco e Nero*, anno IX, no. 2, 55.

67 Quoted in Vitti 1996, 36.

68 Victoria De Grazia theorizes that one of the most important results of Hollywood cinema in Europe is the change it fosters in the traditional construction of consent. She suggests that 'la cultura di massa americana, come il più prolifico disseminatore di immagini della storia, abbia posto una sfida alle concezioni europee di sovranità, basate originariamente sulla stampa, con un nuovo modello culturale.' ('American mass culture, as the most prolific disseminator of images in history, had constituted a challenge to the European notion of sovereignty, originally based on the press, with a new cultural model.') In 'La sfida allo "star system"' (123).

69 The actress's exceptional talent shows during a phone call in which, being dropped by her lover, she gives way to a variety of feelings: anger, depression, desperation, helplessness. The camera focuses persistently on Magnani in a series of inquisitive close-ups and is used to unveil the psychology of the character and to study in detail the experience she is having.

70 For the history of the interaction between Rossellini and Bergman see Bergman's biography by Joseph Henry Steele, *Ingrid Bergman, An Intimate Portrait* (New York: McKay Co., 1959) and the video 'Ingrid: Portrait of a Star.'

71 The dispute assumed the character of a national scandal. In 1950 Edwin C. Johnson, a Democratic senator, in fact asked in front of the Senate that Berg-

man be denied entry into the United States. Bergman had done much more than follow a passion, which put an end to an already shaky marriage: she had betrayed the official Hollywood code of behaviour and, moreover, had done so for an Italian director.

72 The other films made with Bergman are *Europa* (1951), *We the Women* (1953), *Journey to Italy* (1954), *Joan at the Stake* (1954), and *Fear* (1954).

73 Brunetta indicates how Rossellini, with Bergman, goes precisely against the postwar revival of the Italian diva system. 'Interessante notare come proprio in questo periodo, Roberto Rossellini tenta da solo un esperimento di laboratorio opposto sul corpo di Ingrid Bergman, per distruggere l'aura mitica creatale dal cinema americano, far emergere e portare sullo schermo, come in una sorta di psicodramma, gli aspetti più autentici della sua personalità.' ('It is interesting to notice how, precisely in this period, Roberto Rossellini tries, alone, a contrasting experiment on Ingrid Bergman's body, that of destroying the mythical aura created around her by American cinema, of causing to emerge and to bring to the screen as if in a psychodrama, the most authentic aspects of her personality.') Brunetta 1992, 2: 257.

74 See Edgar Morin, *Les Stars* (Paris: Éditions du Seuil, 1957); *I divi* (Milan: Garzanti, 1977).

75 The fascination with this model of femininity proposed by American women is also shared by Calvino: 'Dalla spregiudicatezza monellesca di Claudette Colbert all'energia puntuta di Katherine Hepburn, il modello più importante che i caratteri femminili del cinema americano proponevano era quello della donna rivale dell'uomo in risolutezza e ostinazione e spirito e ingegno; in questa lucida padronanza di sé di fronte all'uomo, Myrna Loy era quella che metteva più intelligenza e ironia ... ma in fondo per una società come la nostra, per il costume italiano di quegli anni, soprattutto in provincia, questa autonomia e iniziativa delle donne americane poteva essere una lezione, che in qualche modo mi raggiungeva.' ('From the cheeky opportunism of Claudette Colbert to the pungent energy of Katherine Hepburn, the most important role model the female personalities of American cinema offered was that of the woman who rivals men in resolve and doggedness, spirit and wit ... Deep down, for a society like ours, for the Italians as they were then, especially out in the provinces, this American woman's independence and initiative was an instructive example, and one that to some extent got through to me.') Calvino 1990, 55.

76 Bergman is Swedish, but perceived as American, inasmuch as she is a Hollywood star. A reader of this text indicated that to identify Bergman 'as' just American is somehow simplistic, since – though she surely represented Hollywood – she was also perceived, by an American public, as 'foreign'

(meaning northern European) – a fact that was diegetically played out in her roles both in *Casablanca* and *Notorious*, adding a disturbing, mysterious quality to her characters. My sense is that such subtlety was not perceived by the Italian public, who scarcely had a chance to see movies other than Italian or American ones – and perhaps a few French or German and, in the late years of the *Ventennio*, Hungarian ones. Further, the fact that Bergman was dubbed – as it is the custom for any foreign film shown in Italy up to this day – didn't provide the Italian audience with a linguistic clue available instead to Americans. This reader's indication, though, surely deserves further analysis.

77 It is necessary to call attention to this traditional and, to a certain extent, reactionary idea of Rossellini. Analogously, in *Viaggio in Italia*, Rossellini links the emotional sterility of the British couple with their being childless.

78 See Quaglietti 1980, 74–106.

79 Dozens of restless, unquiet souls flocked to Rome: Robert Taylor, Gregory Peck, Audrey Hepburn, Errol Flynn, Ava Gardner, Alan Ladd, Jennifer Jones, Humprey Bogart, Clark Gable, Charlton Heston, Rock Hudson, Rita Hayworth, Anthony Franciosa, Liz Taylor, Frank Sinatra, Kirk Douglas, David Niven, Richard Burton, Anita Eckberg, and Jayne Mansfield.

80 'Americans produce films in Italy because it is more convenient. They have to utilize their own blocked funds; they want to take advantage of the favourable exchange rate, the cheap skilled labour, the advantages of the climate, the ease of living in a colony as if they were the bosses, and with a greater freedom than that of the controlled, moralist, and McCarthyist Hollywood of the time; it is within the span of the American market to penetrate every sector of European economic activities.' Oreste del Buono and Lietta Tornabuoni, eds, *Era Cinecittà* (Milan: Bompiani, 1979), 23.

81 These co-productions – for instance, *Quo Vadis*, *Ben Hur*, or *War and Peace* – left behind a huge amount of material in scenographies, clothing, furniture, and the like that was to be recycled over and over in later, less pretentious, Italian productions. They also stimulated the establishment of new genres and their later 'Italianized' versions. Prevalent were genres that drew on ancient Roman and classical history, such as the myth of Hercules and analogous bodybuilders such as Maciste, or that narrated the vacation of American tourists in Italy, or, at a later time, the spaghetti western.

82 In Faldini and Fofi 1979, 306.

83 Ibid.

84 'Why did you invite me?' Mary asks Giovanni, remembering when she first asked him for some information, and he consequently invited her for a coffee. 'Because I knew what wanting was,' he answers.

85 In 1954, Mario Soldati published *Le lettere da Capri*, a novel in which he tells the love story of Harry and Jane. While in Italy during wartime, they both had an adulterous relationship, with Dorothea and Aldo, respectively. Soldati's analysis is particularly interesting because through the adulterous couples he confronts two cultures, in a way similar to that pursued by De Sica.

86 The quotes are in English because I could only see the American version of the film.

87 Piovene was commissioned by *Il Corriere della Sera* to travel by car through the United States and write his reportage along the way. The journey ultimately took him ten thousand kilometres. He gathered material to sketch a portrait of the United States filtered, first of all, through its wonderful and extremely varied landscapes: full of empirical impressions, interviews, political analyses, and attempts to understand American cultural life, by recounting historical data, anecdotes, local folklore, and visits to industrial sites and by providing figures about the mechanisms of cultural sponsorship supported by foundations. *De America* follows the line of *America, primo amore* and *America amara* and a style of lyric impressionism still indebted to Cecchi's *prosa d'arte*, but with a more optimistic and truly enthusiastic – maybe even too much so – overview of the country, and a huge amount of information. Count Piovene in fact approaches America as a (slightly elitist) traveller of the Enlightenment fascinated by Progress, which has reached its highest achievements in the United States. His writing is certainly influenced by his political views, which could be defined as those of a moderate liberal – in the Italian sense usually indicating a layman and cultured professional.

88 In this respect see Binetti 1998, 105–31. See also Turi 1990, 231–52.

89 'America too ended in the sea, and this time it was not useful to embark once more, so I stopped amidst pinetrees and vineyards.' All quotes are taken from Pavese, *La luna e i falò* (Turin: Einaudi, 1995).

90 'Mica da dire, riscalda [whisky], ma un vino da pasto non c'è.' ('There is nothing to say, [the whisky] heats you up, but you do not find a wine to drink with food here'.)

91 The theme of roots and rootedness is fundamental in the book and appears in the very first page: 'Ho girato abbastanza il mondo da sapere che tutte le carni sono buone e si equivalgono, ma è per questo che *uno si stanca e cerca di mettere radici, di farsi terra e paese*, perchè la sua carne valga e duri qualcosa di più che un comune giro di stagione' (italics mine). ('I did go around enough to know that all meats are good and are the same, but this is why *one gets tired and tries to put roots down, to have a land and a village*, because his own meat could have some value and could last more than just a season'.)

92 While recalling the first time he left the countryside for Genova, and his later departure for America, Anguilla tells himself: 'Anche la storia della luna e i falò la sapevo. Soltanto, m'ero accorto, che non sapevo più di saperla' (40). ('I knew the tale of the moon and of the bonfire too. Only, I realized, I no longer knew I had known it.')

93 'There was a reddish light, I went out cold and worn out; among the low clouds a slice of moon had appeared: it looked like a knife wound and it bled. I stayed there and stared at it for a while. It was quite frightening' (48).

94 The articles, now collected in Pavese, *La letteratura americana e altri saggi*, 5th ed. (Turin: Einaudi, 1962) are 'Il comunismo e gli intellettuali,' 'Di una nuova letteratura,' 'L'influsso degli eventi,' 'Dialoghi col compagno,' 'Dove batte la storia,' and 'Guerriglia nei castelli romani.'

95 See pp. 21, 28, 30, 44, 49, 51, 55, 103, and 132.

96 'You didn't see Santa when she was twenty. It was worth it; it was worth it. She was more beautiful than Irene, her eyes were like the heart of a poppy' (125).

97 'It's a good thing that I tell you – Nuto nodded at once without lifting his eyes – I know how they killed her. I was there' (126).

98 'Last year a trace was still there, like the bed of a bonfire' (132).

99 'Ma una cagna, una cagna del boia' (125) ('But a bitch, a rotten bitch').

100 'The earth then as a mythic place to revisit one's memories, as a metahistorical place of an eternal as much as unrealizable return, becomes, necessarily, the earth-death that inexorably awaits the cyclic conclusion of an event that has been absolutized and is now beyond time and space.' Binetti 1998, 124.

101 See, in particular, the poem 'Verrà la morte e avrà i tuoi occhi,' in C. Pavese, *Poesie* (Milan: Mondadori, 1961), 201.

102 On this aspect see also Simona Wright, 'La guerra al femminile,' in *Forum Italicum* 32.1 (Spring 1998): 63–85.

103 'It is too bad that Pavese, who nevertheless got rid of many other technical and stylistic caprices that amounted, by the way, to bad habits, copied from America, and who, nevertheless, shows in many pages of *The Moon and the Bonfire* that he possesses a language that is capable of giving a consistent and authentic body to the movements of his fantasy, still indulges in a whim, that is to say, that of not facing directly men, their feelings, and passions. He rather 'filters' them through the memory of an invented and ambiguous character who is and who is not he, the Author.' In Mario Alicata, *Scritti letterari* (Milan: Mondadori, 1987), 266.

104 '[La memoria] nuoce un poco al racconto ... perchè consente all'Autore di

assumere di fronte a quelli che pure sono i suoi personaggi un atteggia-
mento un po' ambiguo, gli consente di non impegnarsi fino in fondo in un
giudizio dei fatti rappresentati, in quel *giudizio* s'intende, non estraneo ed
espositivo, ma intimo, tutto riassorbito nel ritmo oggettivo del racconto,
che ha sempre costituito in passato e secondo noi ancora oggi dovrebbe
costituire il sigillo d'ogni compiuta narrazione' (italics added, 267). ('Mem-
ory is somehow negative for the writing ... for it allows the author to assume
towards his own characters a slightly ambiguous attitude, it allows him not
to engage to the very end in a *judgment* of the events he represents, in a
judgment, of course, not extraneous or descriptive, but intimist, all sub-
sumed in the objective rhythm of the story, that has always constituted, in
the past and according to me up to now, the emblem of every accomplished
narration.') A literature that indulged in the idea of irrational forces was
condemned as not useful for the Party's' policy and cultural agenda, and
was blamed as the survival of D'Annunzio's *panismo* (ego-less fusion with,
and annihilation within, nature).
105 'No words. No actions. I will no longer write.' In Binetti 1998, 129. See also
Grazia Sumeli Weinberg, 'Pavese e la donna e il discorso sulla voluttuosità,'
Italica 77.3 (2000): 386–99.

4: The Country at Hand

1 For the emergence of a consumer culture in the twentieth century see Gary
Cross, *Time and Money* (London: Routledge, 1993). The book deals in partic-
ular with England, but reviews also the theoretical approaches that connect
time, money, and leisure in industrial societies.
2 See Victoria De Grazia, *The Culture of Consent: Mass Organization of Leisure in
Fascist Italy* (New York: Cambridge UP, 1981) and Achille Starace, *L'Opera
Nazionale Dopolavoro* (Milan: Mondadori, 1933). See also Jacqueline Reich,
'Consuming Ideologies: Fascism, Commodification, and Female Subjectivity
in Mario Camerini's *Grandi Magazzini*,' in *Annali d'Italianistica* 16 (1998):
195–212.
3 The chronology here is only approximate. The early fifties are different from
the late ones and various phenomena overlap with the previous or following
decade, while 1956 – when Russian tanks marched on Hungary – constitutes
a major turning point for Italian intellectuals, particularly PCI affiliates. As
Sebastiano Martelli claims, '[O]ccorre operare una certa scansione tra gli
anni 1949–1955 e gli anni che precedono e soprattutto che seguono. Quella
che possiamo definire la grande *glaciazione*, con i suoi dogmatismi e steccati
politico-ideologici, lo svuotarsi del dibattito culturale, l'inaridirsi ad esempio

della produzione letteraria ed in particolare della narrativa legata alla sco-
perta del Mezzogiorno d'Italia, non esauriscono lo spettro culturale degli
anni Cinquanta. Gli anni 1953–1954–1955 sono, credo, tra i più ricchi di ini-
ziative e fermenti culturali dell'ultimo quarantennio' (169). ('It is necessary
to draw a certain line between the years 1949–1955 and the years which pre-
cede and, particularly, which follow. The moment that we can define as the
great glacial epoch, with its dogmatism and political-ideological fences, the
emptying of cultural debate, the drying up, for instance, of the literary pro-
duction and in particular of the production connected with the discovery of
the South of Italy, does not exhaust the cultural spectrum of the fifties. The
years 1953–1954–1955 are, I believe, amongst the richest for their cultural
initiatives and fervor of the last four decades.') S. Martelli, 'Letteratura cat-
tolica e civiltà contadina: Il dibattito degli anni Cinquanta,' in Florinda M.
Iannace, ed., *Il filone cattolico nella letteratura italiana del secondo dopoguerra*
(Florence: Bulzoni, 1989), 165–91.
4 'La "600" ... [S]egnò una svolta ... nello sviluppo del paese, dando un con-
tributo significativo al mutamento avvenuto nell'utilizzazione del reddito,
nel corso del decennio. Per acquistarla, ci voleva molto meno delle dicias-
sette mensilità di salario necessarie per acquistare una *Topolino*. Il suo imme-
diato e rapido successo avviò anche una vistosa trasformazione nel costume e
nella mentalità collettiva. Erano ormai finiti, con l'arrivo della '600,' i tempi
in cui la maggioranza degli italiani si spostava una sola volta nella vita, per
emigrare o per prestare servizio militare. Con questo nuovo balzo in avanti
della motorizzazione, molti italiani cominciarono a far esperienza della
libertà e del piacere di muoversi e di comunicare, di uscire dal perimetro
geografico e psicologico della routine quotidiana. Cominciò per molti la
"scoperta dell'Italia."' ('The "600" ... marked a turning point ... in the coun-
try's development, providing a significant contribution to the change that
took place in the use of income during the decade. In order to buy it, you
needed much less than the seventeen instalments needed to buy a *Topolino*.
Its immediate and rapid success started also a quite visible transformation in
the collective customs and mentality. With the arrival of the "600," the times
in which Italians moved only once in their life, either to emigrate or for mili-
tary service, were over. With this new jump forward of motorization, many
Italians started to experience the freedom and the pleasure of moving and of
communicating, of exiting from the geographical as well as psychological
perimeter of daily routine.') In Piero Bairati, *Vittorio Valletta* (Turin: UTET,
1983), 270.
5 In 1954 there were 88,000 subscribers to TV, in 1958 a million; between 1950
and 1964 private cars rose from 342,000 to 4,670,000 and motorcycles from

700,000 to 4,300,000 (Ginsborg 1989, 325). As Ginsborg stresses: 'Progressiva-
mente il carattere fondamentalmente atomizzante della televisione si
impose. Man mano che le famiglie si dotavano di un proprio apparecchio,
l'abitudine di guardare la televisione al bar o dal vicino di casa tendeva a
scomparire; nei nuovi palazzi alle periferie delle città, ognuno guardava la
televisione a casa propria ... per i ceti medi e gli strati superiori della classe
operaia settentrionale, le scampagnate domenicali in macchina divennero
presto un'abitudine.' ('Gradually the basically isolating character of TV
imposed itself. As families bought their own set, the habit of watching televi-
sion at the bar or at the neighbour's tended to disappear; in the new build-
ings in the outskirts of the cities, everybody watched television at his own
place ... [F]or the northern middle class and upper middle working class, the
Sunday trip by car soon became a habit' [Ginsborg 1989, 328–9]). In the fif-
ties Guido Pioven visits the Piaggio factory in Pontedera and sees that '[n]e
uscivano ogni giorno quasi 400 *vespe*, e l'80 per cento di esse per il mercato
interno, senza riuscire a soddisfarlo' ('[e]very day almost 400 *vespe* came out
of it, 80 per cent of it destined to the domestic market, without succeeding in
satisfying all the requests'). G. Pioven, *Viaggio in Italia* (Milan: Baldini e
Castoldi, 1993), 413. For data about Italian consumerism, see Paolo Quirino,
'I consumi in Italia dall'Unità ad oggi,' in Romano Ruggero, ed., *Storia
dell'economia Italiana* (Turin: Einaudi, 1991), vol. 3, 201–49.

6 The works I am considering are Bassani's *Cinque storie ferraresi* (1956),
Arbasino's *Le piccole vacanze* (1957), and Pavese's *Tra donne sole* (1949). De
Céspedes's *Dalla parte di lei* (1949) also superficially deals with homoerotic
attractions.

7 The volume collects the letters sent to the lovelorn columns of various
women's weekly magazines (around five million in a decade). Women of
every social extraction and age, 13 to 60, write in order to receive some
advice, a word of comfort, or simply to confide their anxieties. Thus, as the
author says in the preface: 'It is a minor and secret Italy which is discovered
in this way: the Italy of the great housing developments in the suburbs and of
the little house in the country, of the long lines of factory workers returning
from work by bicycle and of the endless walks down the main street of the
small towns in the provinces.' Gabriella Parca, *Italian Women Confess* (New
York: Farrar, Straus and Co., 1963), x. See Laura Lilli, 'Prigioniere del
grande harem: *Le italiane si confessano* di Gabriella Parca,' in *Memoria* 6, anno
II (1982): 101–6. The entire volume is dedicated to the fifties.

8 Goffredo Fofi, *L'immigrazione meridionale a Torino* (Milan: Feltrinelli, 1964), 9.
The immigrants, arriving mainly from Puglia, Sicily, and Calabria, were usu-
ally young males, usually members of large families, and were employed at

first as unskilled workers, usually in construction, and only later in factories. For their integration in the city they usually relied on the social network provided by their relatives. A dramatic portrayal of southern immigrants to Milan is offered by Luchino Visconti's *Rocco e i suoi fratelli* (1960); a more unproblematic, humorous one, by De Filippo's *Napoletani a Milano* (1953).

9 It is interesting to recall here that an analogous phenomenon happened after the unification of the country (1870), with the emergence of a cultural polycentrism, rooted in the history of cities such as Milan, Bologna, Naples, Turin, Trieste, or Catania. This attitude reiterates the strong municipal tendency of Italian culture. The regionalization is so pervasive that is mirrored also by literary studies. Carlo Dionisotti, for instance, published, at the beginning of the fifties, a work that he significantly entitled *Geografia e storia della letteratura Italiana* (1951).

10 For *romanità* see Bondanella 1987, 172–206. An example of such customary linguistic 'purism' can be seen in Luigi Chiarini's *La bella addormentata* (1942), which takes place in a Sicilian village. Every character in the film, from the *solfataro* Nazzari, to the servant Ferida, speaks strictly Italian. However, the rule was not universally applied, since we find films, particularly in the early forties, in which different dialects are used to characterize people (see De Robertis's *Marinai senza stelle* or Rossellini's *La nave bianca*).

11 There are authors like Tonino Guerra (from Romagna), Albino Pierro (from the Abruzzi), Pier Paolo Pasolini (Friulan), the group of Neapolitans, Marotta, Rea, La Capria, and Prisco, Bassani (Ferraran), Arbasino (Lombardan), Arpino (Piedmontese), and Sciascia (Sicilian). Further, directors like Antonioni and De Santis focus on peripheral areas such as the northern *pianura padana* and Ciociaria. Visconti too chooses the South in *La terra trema* (1948), and the Po area earlier with *Ossessione* (1943).

12 This phenomenon is also not new, even though the fact that it re-emerges at this moment is particularly significant. There had been 'regional' cadences in writers such as Verga, Deledda, and Svevo. The attack against the literary code involves not only language per se but also literary genres, and implements their innovative use. This is evident for instance with the genre *epico cavalleresco*, which is reinscribed by Calvino and others within the canon of 'popular' literature. See Maria Lombardo, 'Beyond the Literary Past: Literary Experimentation and the Return to the Distant Past in the Novels of Calvino, Malerba, and Celati,' PhD diss., University of Chicago, 1994.

13 'The language-dialect dialectic in Italy has been one of the main structures of literary expression ... since its Origins.' In Luigi Beccaria, *Letteratura e dialetto* (Bologna: Zanichelli, 1975). The present and the following quotations are from the introduction, 1–19.

14 'Italy lacked a linguistic and cultural capital that could function as a centre.' Ibid., 2.

15 'The contrast dialect/language never connoted itself as a socio-linguistic opposition of culture vs un-culture, as a criterion and external sign of a sociocultural situation of inferiority.' Ibid.

16 Italics mine. 'Even when, in the fifties, the dialect took upon itself that *function of research and social protest*, and the "local characterization aimed at providing a taste for truth," even then "language, rhythm, and style" held a prevalent importance.' Ibid., 15.

17 The way dialects are used or incorporated in language is multifarious: 'Assistiamo dunque nella narrativa contemporanea a momenti dialettali puri, a momenti di lingua miscedata con intenti ancora documentari; a momenti in cui l'italiano è riprodotto come lingua di incolti; a momenti in cui il dialetto è qualcosa di fuso nel discorso, non troppo sollevato da esso, quasi ritmo interno della parlata più che rappresentazione di un personaggio' (ibid., 16). ('We see then in contemporary fiction moments in which solely dialect is used, when it is mixed with Italian with documentary intents; moments in which Italian is reproduced as the language of the uneducated; moments in which dialect is fused with the discourse, not too distanced from it, as if it represented the internal rhythm of the speech rather than the description of a character.')

18 In 1877 the government ordered a survey of the economic situation of the country, the *Inchiesta Jacini*, which brought to light the extreme poverty of southern peasants.

19 See his seminal essay 'Alcuni temi della questione meridionale,' written in October 1926, just before his arrest, and now collected in Antonio Gramsci, *La costituzione del Partito Comunista: 1923–1926*, in *Opere* (Turin: Einaudi, 1971), vol. 12: 137–58. See also the treatment of the *questione meridionale* in *Lettere dal carcere* and *Quaderni del carcere*. Also useful are Eugenio Garin, *Intellettuali italiani del ventesimo secolo* (Rome: Editori Riuniti, 1987), 289–342, and Mario Alicata, 'Benedetto Croce e il Mezzogiorno,' in *Scritti letterari* (Milan: Mondadori, 1968), 301–4.

20 As Ginsborg reports: 'Le riforme rimasero un momento fondamentale del dibattito politico anche all'indomani della secca sconfitta della sinistra' Ginsborg 1989, 160. ('Reforms remained a fundamental moment in the political debate even after the harsh defeat of the Left'.)

21 See Rosa Vaccaro, *Unità politica e dualismo economico in Italia (1861–1993)* (Padua: Cedam, 1995), 206–40, and R. Lumley and J. Morris, eds, *Oltre il meridionalismo* (Rome: Carocci, 1999), 11–29; original English version is Lumley and Morris, eds, *The New History of the Italian South: The Mezzogiorno Revisited* (Exeter: U of Exeter P, 1997).

22 The Cassa, though, served mainly the interest of northern industrial classes and promoted a gargantuan bureaucratic apparatus, while also implementing patronizing practices. The bibliography on the topic is vast. For a quick reference see Ginsborg 1989, 217–18, and Giovanni Russo, 'La questione meridionale e le regioni,' *I problemi di Ulisse* 13, Anno XXVIII (September 1974): 70–88.

23 See Paolo Braghin, *Inchiesta sulla miseria in Italia (1951–1952)* (Turin: Einaudi, 1978); Marianella Pirzio Biroli Sclavi, 'L'inchiesta sulla miseria in Italia,' *Memoria* 6 (1982): 96–100; and Ginsborg 1989, 252. See also Spriano: 'L'inchiesta parlamentare sulla miseria rivelerà, all'inizio degli Anni Cinquanta, che più di due milioni e mezzo di famiglie vivevano ancora in case sovraffollate, che l'Italia era all'ultimo posto nel consumo giornaliero di calorie e grassi e al penultimo per le proteine, prima soltanto della Grecia.' ('The parliamentary survey on poverty reveals, at the beginning of the fifties, that more than two and a half million people live in over-crowded apartments, that Italy ranks last in the daily consumption of calories and fats and second to last for proteins, just ahead of Greece.') Paolo Spriano, *Le passioni di un decennio* (Milan: Garzanti, 1986), 70.

24 As Peter Bondanella indicated to me, the book was a best-seller in the United States. It was probably the most popular Italian novel before the publication of Tomasi di Lampedusa's *The Leopard* and then Barzini's *The Italians.*

25 Adriano Olivetti is a peculiar figure of a progressive industrialist who believed in the essential role of the community in any economic planning and was also very attentive to his workers' cultural background. He promoted sociological inquiries and studies, being often accused of unrealistic utopianism. See Giuseppe Berta, *Le idee al potere: Adriano Olivetti e il progetto comunitario tra fabbrica e territorio sullo sfondo della società italiana del 'miracolo economico'* (Milan: Edizioni di Comunità, 1980), 125–62, and Valerio Occhetto, *Adriano Olivetti* (Milan: Mondadori, 1985). For journals of the mid-fifties see Spriano 1986, 177–193, and Alberto Asor Rosa 1982, vol. 1: 598–617. For American anthropologists' interest in the South see Martelli 1989, Cesare Musatti, *La via del Sud e altri scritti* (Milan: Edizioni di Comunità, 1972).

26 'Forms of intervention that aimed at a modernization guided by the utopia of the encounter between city and countryside, between urban and agrarian civilization.' Martelli 1989, 169.

27 Italics mine. 'A historicist interpretation of magic has to constitute itself as a true growth of our historiographical consciousness in general, therefore it has to be ready and *open to the conquest of new spiritual dimensions, and to a further articulation, or even total restructuring, of the historiographic methodology, in the light of the new experiences.'* E. De Martino, *Il mondo magico* (Turin: Einaudi, 1948), 15.

28 'Puts under scrutiny not only the world of magic but also the occidental way of approaching it.' Ibid., 16.

29 'Seem[ed] to move in the intellectual world – without social classes but aristocratic – of Benedetto Croce and Adolfo Omodeo.' Di Donato 1990, 25.

30 For the dangers of Rousseauism see the well-known article by Mario Alicata, 'Il meridionalismo non si può fermare a Eboli,' in *Scritti letterari*, 309–30. For the debate about the South see Francesco Compagna et al., *Il Mezzogiorno davanti agli anni Sessanta* (Milan: Comunità, 1961) and Russo 1974. For Scotellaro see Anna Angrisani, *Rocco Scotellaro* (Naples: Società Editrice Napoletana, 1982); Mario Alberto Cirese, *Intellettuali, folklore, istinto di classe* (Turin: Einaudi, 1976), 47–64; Martelli 1989, 619–41; Mario Alicata, 'I contadini del Sud,' in *Scritti letterari*, 331–6; and Mario Rossi Doria, ed., *Il sindaco poeta di Tricarico* (Rome, Matera: Basilicata Editrice, 1974).

31 As Pompeo Giannantonio indicates, the Viareggio Literary Prize contributed to bringing the South to national attention: 'L'apparizione di *Cristo si è fermato a Eboli* di Carlo Levi nel 1945 e la premiazione a Viareggio nel 1952 di *Un popolo di formiche* di Tommaso Fiore segnarono la nascita e gli sviluppi di un ampio dibattito socio-antropologico in Italia. Gli epigoni di questa utile riflessione sono rappresentati da *Contadini del Sud* di Rocco Scotellaro, premiato nell'anno della sua pubblicazione nel 1954 a Viareggio alla memoria dell'autore, e dalle inchieste di Danilo Dolci.' ('The publication of Carlo Levi's *Christ Stopped at Eboli* in 1945 and the prize given to Tommaso Fiore's *A People of Ants* in 1952 at Viareggio marked the birth and development of an ample socio-anthropological debate in Italy. The epigoni of such a useful reflection were represented by Rocco Scotellaro's *Southern Peasants*, which was assigned a prize at Viareggio in 1954 in memory of the author, and by Danilo Dolci's investigation.') P. Giannantonio, *Rocco Scotellaro* (Milan: Mursia, 1986), 50. Anna Maria Ortese won the Viareggio Literary Prize in 1953 for *Il mare non bagna Napoli*.

32 'I was precisely, in the first place, on my way to the cemetery, which is on the side of the village, on the big road, in the fold between two hills: from every window and balcony you can see it modestly on the side, there are all of our naked dead, from there they measure our fidelity with precision.' In Rocco Scotellaro, *L'uva puttanella* (Bari: Laterza, 1986), 1.

33 Italics added. 'But in this direction too I had to *become stupefied*, if, seeing me the women asked: – What? – and were silent afterward. I said right away: – In the vineyard – and their *faces* opened up, but their voices lingered behind my shoulders.' Ibid., 3.

34 For the different reactions to the book see their accurate reconstruction in Giannantonio, 75–123.

35 The people are Michele Mulieri, peasant, carpenter, and shop owner; Andrea Di Grazia, peasant and small land owner; Antonio Laurenzana, peasant and landlord; Francesco Chironna, grafter; and Cosimo Montefusco, buffalo herder.

36 There is a difference, though, between being the spokesman for a dramatic situation – namely, that of the South – as the peasants interviewed by Scotellaro are, and turning the account of their lives *tout court* into a work of literature. In this case I endorse Cesare Cases's position: 'Le autobiografie proposte e raccolte da Rocco Scotellaro e dai suoi seguaci ... interessanti come materiale sociologico, non la possono pretendere a letteratura, e l'ascrivere loro questa funzione è indizio di estetismo da intellettuali.' ('The autobiographies collected and proposed by Rocco Scotellaro and his followers ... [although] interesting as sociological material, cannot pretend to be literature, and to give them this function indicates an attitude of intellectualized aestheticism.') In 'Mezzogiorno e coscienza letteraria,' now in Cesare Cases, *Patrie lettere* (Turin: Einaudi, 1987), 126–36. On the other hand, the 'status' of *Contadini del Sud*, published unfinished and posthumously based on Scotellaro's notes, is quite problematic from the authorial point of view, as Alicata debates in his article 'Il meridionalismo non si può fermare a Eboli.'

37 Mira Lihem describes the popularity of Naples in the postwar period thus: 'The Neapolitan style was popular, with its songs, low-budget productions, and traditional formulas' (140). 'The Neapolitan production of the 1950s came into life as a reaction against American films, which had little success in Naples. Neither Marilyn Monroe, nor Kim Novak, nor Jerry Lewis attracted Neapolitan audiences, who stormed movie houses playing traditional Neapolitan comedies and melodramas. Thus, in Naples *Totò, Peppino e la malafemmina* (Totò, Peppino and the Bad Woman), a B picture, grossed 10 million lire while at the same time *Bus Stop* made only 6 million' (344). M. Liehm, *Passion and Defiance* (Berkeley: U of California P, 1984).

38 'The pure vitality, Naples, for instance, as it appeared to him sixty years before: a sincere and warm tangle of life, capable of sympathetic feelings.' Guido Piovene, *Viaggio in Italia* (Milan: Baldini e Castoldi, 1993), 376.

39 'Precisely the poor neighbourhood, that one ... in which man is obliged to go out every morning looking for the food he is not sure to find, this is the place in which man lives happily.' Ibid., 376.

40 'Admiring excessively Neapolitan (and usually southern) folklore and 'color,' being ecstatic about it, creating an idol out of it, is not liked today, even by the more intelligent Neapolitans. The young liberals, forged by Croce's thought, who publish the most important Neapolitan journal, 'Nord e Sud,' are explicit about it. 'We have to insert the South, Francesco Compa-

gna tells me, into a Western system, into its ideas and costumes. Therefore, we have to fight against the idea of a southern civilization that we must leave untouched, an entity floating between the mystic, the mythic and the magic, a venerable mixture of anachronisms and strange things.' Ibid., 427.

41 In effect Eduardo De Filippo represents one of the most loved 'souls' of Naples. His plays, broadcast by the state TV, rapidly came to symbolize, in the eyes of the Italian audience, precisely the humourous vitalism of Neapolitans. For an introductory study with good bibliography see Giovanni Antonucci, *Eduardo De Filippo* (Florence: Le Monnier, 1981).

42 In his preface to *I capolavori di Eduardo* (Turin: Einaudi, 1973) De Filippo, referring to his plays, says that '[a]lla base del mio teatro c'è sempre il conflitto tra individuo e società: Voglio dire che tutto ha inizio, sempre, da uno stimolo emotivo: reazione a un'ingiustizia, sdegno per l'ipocrisia mia ed altrui, solidarietà e simpatia umana per una persona o un gruppo di persone, ribellione contro leggi superate e anacronistiche con il mondo di oggi, sgomento di fronte a fatti che, come le guerre, sconvolgono la vita dei popoli, ecc' (vii). ('The basis of my plays is always a conflict between the individual and society. What I want to say is that everything starts, always, from an emotional stimulus: reaction to an injustice, disdain for my own or others' hypocrisy, solidarity and human sympathy for a person or a group of people, rebellion against laws that are old and reactionary for today's world, bewilderment for facts that, like wars, upset the life of nations, etc.') In fact, De Filippo, by opposing 'individual' and 'society' reduces social conflicts within the horizon of the individual's subjective sphere. He thus refrains from criticizing social structures in a more effective, over-personal fashion.

43 Ettore Giannini's *Carosello Napoletano* (1954) provides another example of such a superficial and unproblematic consideration of Naples. The film tells the history of the city through its songs. This trend was quite popular in the fifties. Along with what Brunetta terms *cineopera* – the cinematic realization of operas such as *Il barbiere di Siviglia, Lucia di Lammermoor, Rigoletto*, etc., and the plots that deal with opera, such as *Enrico Caruso, Giuseppe Verdi, Puccini, Casta Diva,* and *Casa Ricordi* – there are films constructed to illustrate songs, for instance, the works of Domenico Paolella: *Canzoni di mezzo secolo, Canzoni, canzoni, canzoni,* and *Canzoni di tutta Italia.*

44 De Sica made *L'Oro di Napoli* in 1953 from Marotta's collection of short stories by the same name, published in 1947. This film launched Sophia Loren as a national sex symbol.

45 In my opinion Ortese has a problematic rapport with a nature that is gendered as female and seen as negative and un-nurturing. I will elaborate on this aspect later.

46 'Questa infanzia non aveva di infantile che gli anni. Pel resto, erano piccoli uomini e donne, già a conoscenza di tutto, il principio come la fine delle cose, già consunti dai vizi, dall'ozio, dalla miseria più insostenibile, malati nel corpo e stravolti nell'animo, con sorrisi corrotti o ebeti, furbi e desolati nello stesso tempo' (81). ('Such children did not have anything childish about them other than their age. Otherwise, they were little men and women, who already knew everything, the beginning as well as the end of things, already worn out by vices, by laziness, by the most unsustainable misery, their bodies ill their souls twisted, with depraved and stupid smiles, shrewd and helpless at the same time.')

47 Cases also inscribes the *letteratura meridionalistica* within the frame of atemporality: 'La letteratura meridionalistica insiste infatti sulla staticità fuori dal tempo della società meridionale, in cui non succede nulla, e se qualche cosa succede si tratta di un accadimento effimero, apparente, che tosto rientra nel gran mare della vita atemporale cui sono ignote le dimensioni della speranza e della vita individuali.' ('Southern literature insists, in fact, on the southern society's static quality outside of time, where nothing happens, and if something happens, it is something ephemeral, apparent, something that right away is sucked back into that great sea of atemporal life which does not know the dimension of hope and individual life.') Cases 1987, 126.

48 'Shadows,' 'small fires,' 'tiny lamps,' 'flares,' 'greyness,' 'dark,' 'minuscule lamps,' 'imperceptible lamps,' 'an almost absolute darkness.'

49 Italics mine. 'The men who come towards you cannot harm you in any way: larvae of a life in which the wind and sun existed, they have almost no recollection of these goods. *They slide or climb, or vacillate*' (63).

50 'A hill or a bald mountain, invaded by termites, which run over it without making any noise or sign that might announce a particular goal' (61).

51 This image echoes very closely the one used by Leopardi in 'La ginestra' ('The Broom') 'Come d'arbor cadendo un picciol pomo,/ Cui là nel tardo autunno/ Maturità senz'altra forza atterra,/ D'un popol di formiche i dolci alberghi, ...' (vv. 202–5). ('As a small apple falling from the tree,/ Which late in autumn-time/ Its ripeness and no other force impels,/ Crushes the loved homes of a tribe of ants ...') *Giacomo Leopardi, Selected Prose and Poetry*, trans. Iris Origo and John Heath Stubbs (New York: New American Library, 1966), 268.

52 'For a long, a very long time, I have hated so-called *reality* with all of myself, without even knowing it: I have hated the mechanism of things that are born in time and, in time, are destroyed.' A.M. Ortese, *Il mare non bagna Napoli* (Milan: Adelphi, 1994), 10.

53 'Ebbene, la scrittura del *Mare* ha un che di esaltato, di febbrile, tende ai toni

alti, dà nell'allucinato: e quasi in ogni punto della pagina presenta, pur nel suo rigore, un che di 'troppo': sono palesi in essa tutti i segni di un'autentica 'nevrosi' (ibid., 9–10). ('Thus, the writing in *The Sea* has something of the aggrandized, the febrile, something tending towards high pitches: it gives on to hallucination. In almost every point of the page it presents, though in its rigour, something excessive. All the signs of a manifest "neurosis" are evident in it.')

54 'Non era stato un giovane come tanti ... Adesso non faceva più nulla, ma vi era stato un tempo, subito dopo il '45 a Napoli, ch'egli era stato al centro della pubblica attenzione, riconoscendo tutti nella sua prosa agile e sfrontata ... il segno di una Napoli diversa da quella che finora ci avevano rappresentata classici antichi e moderni, non più ridente e incantata, o tamrureggiante e grottesca, ma livida come una donna da trivio sorpresa da un subitaneo apparire della ragione' (99). ('He had not been an ordinary young man ... Now he was no longer doing anything, but there had been a time, soon after '45 in Naples, when he had been at the centre of public attention, since everybody recognized in his fluid and brazen prose ... the sign of a Naples that was different from the one that, up until that time, old and modern classics had represented; no longer smiling and enchanting, or noisy and grotesque, but wan as a woman of a whorehouse, caught by surprise by the sudden apparition of reason.')

55 Ortese draws on the views expressed by these two authors, particularly in 'I Sepolcri' – where, in the opening verses, humankind is swept away by the blind power of nature and of its cycles – and in 'La ginestra,' one of the most bitter poems written by Leopardi. Here Leopardi repeatedly designates nature as *matrigna*, stepmother, '... ma dà la colpa a quella/ Che veramente è rea, che de' mortali/ Madre è di parto e di voler matrigna' (vv. 123–5) ('but lays the fault on her who is indeed/ The guilty one, the Power who is our mother/ In that she brought us forth, stepmother in will'). *Giacomo Leopardi, Selected Prose and Poetry*, 264. Leopardi refers to Vesuvius's lava – which has destructive results on humankind – as being ejected by the *utero tonante*, or roaring uterus, of the volcano.

56 'It exists in the extreme and more sunny lands of the South, a hidden ministry for the defence of nature against reason; a maternal genius of unlimited power, to which has been entrusted the jealous and perennial care of the sleep in which those populations doze' (105).

57 'E' la natura che regola la vita e organizza i dolori di queste regioni. Il disastro economico non ha altra causa ... E' qui, dove si è rifugiata l'antica natura ... che la ragione dell'uomo ... deve morire' (105). ('It is nature which rules and organizes the life and sorrows of these regions. The economic disaster does

not have a different cause ... It is here, where the ancient nature hid itself ... that man's reason must die.')

58 We are faced here with an interesting reworking of the classic myth of Chronos and Rea, wherein Chronos, son of Saturn and Gaia, eats his sons (for fear of being overthrown by them), and Rea, his wife, guided by Gaia, decides to hide their sixth child, Zeus, from him. Here it is Gaia, the earth and/or Nature, who destroys her offspring.

59 It is interesting to note that Ortese makes a choice opposite to that of Pavese in *La luna e i falò*, where the male writer chooses instead a *female* persona.

60 'This nature could not tolerate human reason, and she moved before man her armies of clouds, enchantments, so that he would be overpowered and dazed by her' (165).

61 In English the title has also been *Strangers*, and *The Lonely Woman*. In this last case the choice is quite one-sided and privileges Katherine's isolation over the couple's crisis.

62 In Henri Bergson, *Oeuvres*, ed. André Robinet (Paris: Presses Universitaires de France, 1970), 1–157.

63 As José Luis Guarner has pointed out, the length of these two shots 'give[s] a curious feeling of continuance, as if the film had begun a lot earlier' (in Guarner, *Roberto Rossellini*, trans. E. Cameron [New York: Praeger, 1980], 57).

64 For an interesting analysis of the role played by the car see Peter Brunette, *Roberto Rossellini* (New York: Oxford UP, 1987), 155–71.

65 See Robert Kolker, *The Altering Eye* (Oxford: Oxford UP, 1983), 48; Peter Brunette, 'Visual Motifs in Rossellini's *Viaggio in Italia*,' in Peter Lehman, ed., *Close Viewings: An Anthology of Film Criticism* (Tallahassee: Florida State UP, 1990), 49–50; Peter Bondanella, *The Films of Roberto Rossellini* (Cambridge: Cambridge UP, 1993), 98–111; Guarner 1970, 57–67; and Gianni Rondolino, *Roberto Rossellini* (Turin: UTET, 1989), 208–16.

66 It was often in honour of Pan that shepherds held their poetic and singing contests. See, for instance, Virgil's *Bucolics*. The shepherds' instruments were both the flute and the *zampogna*, or Pan-flute.

67 For a discussion of the ending see Bondanella 1993, 109–11, and his further references; see also Brunette 1987, 169–71, and his reference to Truffaut. The French director believed that the couple's reconciliation was only temporary.

68 In Bondanella 1993, 111.

69 Couples are at the core of most of the films he did with Bergman, from *Stromboli terra di Dio* (1949), to *Europa '51* (1952), *Siamo donne* (1953, one episode), *Viaggio in Italia* (1953), and *La paura* (1954).

70 See Antonio Vitti, 1996, 7.

71 From this point of view it is interesting to compare Rossellini's use of the landscape in *Viaggio in Italia* to Antonioni's in *Le amiche* (the trip to the sea) or in *Il grido* (Aldo's wandering with his little daughter). In Rossellini's work we see herds of buffalo, carts pulled by donkeys, and, usually, a brighter light, induced by the Mediterranean setting. One thinks of this landscape in terms of the one customarily described by *letteratura meridionalista*. In Antonioni's work the landscape, as Lorenzo Cuccu suggests, is only 'uno dei termini sui quali si posa lo sguardo del regista, che il regista interroga per estrarne un senso ... ma non nel senso che ne raffiguri le emozioni e gli stati d'animo come spesso si equivoca, ma perchè per il suo stesso esistere ed entrare nel campo di esperienza dei personaggi li condiziona e costituisce comunque uno dei termini del loro modo di essere in relazione con il mondo che l'autore ha assunto come materia del proprio sguardo' ('one of the terms upon which the director's gaze rests, and that the director interrogates to extract a meaning from it ... but not in the sense that it portrays emotions and moods as is often wrongly inferred, but, because of its very existence and of its entering within the field of the characters' experience, it affects them and constitutes, nevertheless, one of the ways in which they relate to the world that the author has assumed as the object of his gaze'). In Lorenzo Cuccu, *La visione come problema* (Rome: Bulzoni, 1973), 35–6.

72 See, in this regard, Gian Piero Brunetta, *Forma e parola nel cinema* (Padua: Liviana, 1970) and, more recently, Seymour Chatman, *Antonioni: or, the Surface of the World* (Berkeley: U of California P, 1985), 33–8. I share Tinazzi's opinion, according to which 'il film ha un'articolazione autonoma rispetto al testo pavesiano; studiare oggi il rapporto con Pavese è cosa poco stimolante per un discorso generale' (71) ('the film has an autonomous articulation with respect to Pavese's text; to study today the relationship with Pavese is not very stimulating for a general discussion').

73 On the adaptation see Brunetta 1970.

74 Antonioni had used the noir, and more consistently, in his first feature *Cronaca di un amore* (1950). See Chatman 1985, 12–21, and Sam Rhodie, *Antonioni* (London: BFI Publishing, 1990), 43–56.

75 Antonioni has been widely studied, and a rich bibliography is available on his work. See Ted Perry and Rene Prieto, *Michelangelo Antonioni, a Guide to References and Resources* (Boston: G.K. Hall and Co., 1986). I support my analysis by referring particularly to Cuccu 1973; Giorgio Tinazzi, *Antonioni* (Florence: La Nuova Italia, 1989); and Rhodie 1990. Rhodie's book also contains a list of Antonioni's own critical articles published in newspapers and magazines before and after the war.

76 'structurally excludes identification, sympathetic participation, emotional

involvement on the side of the author towards the situations acted out by the characters: because these, precisely, do not represent the form of expression of the author's *Weltanschauung*, but the matter upon which his gaze rests in order to decipher, in different ways, its meaning' (Cuccu 1973, 34).

77 See Cuccu's detailed analysis, 51–113.

78 I agree with Tinazzi, however, according to whom *Le amiche* is, from the narrative point of view, one of Antonioni's most constructed films. See Tinazzi 1989, 70–1.

79 'It's since this morning that she's been hearing about people she doesn't know and is not interested in.'

80 'But why? On the contrary, it seems as if I have always known you. It's difficult to explain. I left Turin when I was a child. I always worked; I haven't had time for friends. Now it seems logical to me that we have to exchange confidences.'

81 In Chatman 1985, 34.

82 For a close reading of this scene and the one taking place at Momina's apartment, see Ian Cameron and Robin Wood, *Antonioni* (London: Studio Vista, 1968), 49–66. For the prevalence of the feminine, see Tinazzi: 'La donna è lo specchio, cioè la faccia passiva della situazione, o il chiarimento, cioè la faccia attiva della crisi. E' una presentazione a diversi livelli, una serie di variazioni (ogni personaggio femminile, una variazione) di un'unica intuizione-base, anche se poi le sfumature che permetterebbero i "travasi" da un personaggio all'altro sono spesso sacrificate da una descrizione a tutto tondo, più funzionale al congegno narrativo' (71). ('The woman is the mirror, that is to say, the passive face of the situation, or the clarification, that is to say, the active face of the crisis. It is a presentation at different levels, a series of variations [each female character a variation] of a single basic intuition, even though later the nuances that would allow "transfers" from one character to the other are often sacrificed by a well-rounded description, more apt to the narrative mechanism.')

83 'What a pity! In a house where a woman lives alone there is always a certain something. It looks like we are always doing things we should not do.'

84 'Le parti deboli sono proprio alcune articolazioni narrative, come la banalità del rapporto Clelia-Carlo, nei suoi vari momenti: l'incontro, il bacio, la visita ai luoghi di origine (la Torino popolare), il dialogo sull'impossibilità della loro situazione, il finale. Anche perchè la contrapposizione dei due *momenti* (l'integrazione di Clelia, la "sanità" di Carlo) favorisce lo slittamento del film verso un moralismo piuttosto didascalico' ('The weak parts are precisely some narrative articulations, like the banality of Clelia's and Carlo's relationship in its different moments: the meeting, the kiss, the visit to the places of

childhood [popular Turin], the dialogue on the impossibility of their situation, the end. Also the opposition of two *moments* [Clelia's integration, Carlo's "sanity"] makes the film slide towards a quite didactic moralist.') Tinazzi 1989, 73.

Conclusions

1 Consider, for instance, the importance of Croce's thought for the magazine *Officina*, founded in 1955. See Gian Carlo Ferretti, '*Officina*' (Turin: Einaudi, 1975).

BIBLIOGRAPHY

Works Cited

Addis Saba, Marina, ed. *La corporazione delle donne.* Florence: Vallecchi, 1988.

Ajello, Nello. *Intellettuali e PCI 1944–1958.* Bari: Laterza, 1979.

Alicata, Mario. *La generazione degli anni difficili.* Bari: Laterza, 1962.

– *Scritti letterari.* Milan: Mondadori, 1968.

Anderlini-d'Onofrio, Serena. 'I Don't Know What You Mean by "Italian Feminist Thought." Is Anything Like That Possible?' In Giovanna Miceli-Jeffries, ed., *Feminine Feminists: Cultural Practices in Italy.* Minneapolis: University of Minnesota Press, 1994.

Anelli, Maria Teresa, and Paola Gabrielli, eds. *Fotoromanzo: Fascino e pregiudizio.* Milan: Savelli, 1979.

Angrisani, Anna. *Rocco Scotellaro.* Naples: Società Editrice Napoletana, 1982.

Antonucci, Giovanni. *Eduardo De Filippo.* Florence: Le Monnier, 1981.

Aprà, Adriano, and Patrizia Pistagnesi, eds. *I favolosi Anni Trenta.* Milan: Electa, 1979.

Arbasino, Alberto. *Le piccole vacanze.* Turin: Einaudi, 1957.

Arfelli, Dante. *I superflui.* Milan: Rizzoli, 1949.

Arpino, Giovanni. *Sei stato felice, Giovanni.* Turin: Einaudi, 1952.

Arslan, Antonia. *Dame, galline e regine.* Milan: Guerini, 1998.

Asor Rosa, Alberto. *Vasco Pratolini.* Rome: Edizioni Moderne, 1958.

– 'Lo stato democratico e i partiti politici.' In *Letteratura Italiana*, 1: 549–84. 9 vols. Turin: Einaudi, 1982.

– *Scrittori e popolo: Il populismo nella letteratura italiana contemporanea.* Turin: Einaudi, 1988.

– *Sintesi di storia della letteratura italiana.* Turin: Einaudi, 1988.

Aspesi, Natalia. 'Un'alba piena di sorprese.' *Repubblica*, 1 January 1999.

Badaloni, Nicola, et al., eds. *Il Novecento.* Bari: Laterza, 1976.

Bairati, Piero. *Vittorio Valletta.* Turin: UTET, 1983.

Bakhtin, Mikhail Mikhailovic. *The Dialogic Imagination: Four Essays.* Austin: University of Texas Press, 1981.

Baldelli, Pio. *Luchino Visconti.* Milan: Mazzotta, 1973.

Banti, Anna. *Artemisia.* Milan: Mondadori, 1947.

Baranski, Zygmunt G., and Robert Lumley, eds. *Culture and Conflict in Postwar Italy: Essays on Mass and Popular Culture.* New York: St Martin's Press, 1990.

Barthes, Roland. *A Lover's Discourse: Fragments.* Trans. Richard Howard. New York: Hill and Wang, 1978.

Bassani, Giorgio. *Le storie ferraresi.* Turin: Einaudi, 1960.

Battisti, Carlo, and Giovanni Alessio, eds. *Dizionario della lingua italiana.* 4 vols. Florence: Barbera, 1950.

Beccaria, Luigi. *Letteratura e dialetto.* Bologna: Zanichelli, 1975.

Ben-Ghiat, Ruth. 'The Politics of Realism: *Corrente di Vita Giovanile* and the Youth Culture of the 1930s.' *Stanford Italian Review* 8.1–2 (1990): 139–64.

– 'Neorealism in Italy 1930–1950. From Fascism to Resistance.' *Romance Languages Annual* 3 (1991): 155–9.

– 'Fascism, Writing and Memory: The Realist Aesthetic in Italy, 1930–1950.' *Journal of Modern History* 67 (1995): 627–55.

– 'Liberation: Italian Cinema and the Fascist Past, 1945–50.' In R.J. Bosworth and P. Dogliani, eds, *Italian Fascism: History, Memory and Representation,* 83–101. London: Macmillan, 1999.

– *La cultura fascista.* Bologna: Il Mulino, 2000.

Benjamin, Jessica. *The Bonds of Love.* New York: Pantheon Books, 1988.

Bergson, Henry. *Oeuvres.* Ed. André Robinet. Paris: Presses Universitaires de France, 1970.

Bernardi, Adria. *Houses with Names.* Urbana: University of Illinois Press, 1991.

Bernari, Carlo. *Il gigante Cina.* Milan: Feltrinelli, 1957.

Berta, Giuseppe. *Le idee al potere: Adriano Olivetti e il progetto comunitario tra fabbrica e territorio sullo sfondo della società italiana del 'miracolo economico.'* Milan: Edizioni di Comunità, 1980.

Berto, Giuseppe. *Il cielo è rosso.* Milan: Longanesi, 1947.

Beynet, Michel. *L'image de l'Amérique dans la culture italienne de l'entre deux guerres.* 3 vols. Aix en Provence: Publications de l'Université de Provence, 1990.

Bhabha, Homi K. *The Location of Culture.* London: Routledge, 1994.

Biagini, Enza. *Anna Banti.* Milan: Mursia, 1978.

Binetti, Vincenzo. 'Dal *Compagno* ai *Dialoghi col Compagno:* Assertività e in coerenza di un "Discorso" politico-ideologico.' *Rivista di Studi Italiani* 11.2 (December 1993): 13–30.

 – *Cesare Pavese, una vita imperfetta.* Ravenna: Longo, 1998.

Briganti, Alessandra. 'Il neorealismo.' In Gaetano Mariani and Mario Petruc-
ciani, eds, *Letteratura Italiana,* 4: 3–49. Turin: Lucarini, 1984.

Bo, Carlo. *Scandalo della speranza.* Florence: Vallecchi, 1957.

Bobbio, Norberto. *Autobiografia.* Bari: Laterza, 1977.

Bocca, Giorgio. *Filo nero.* Milan: Mondadori, 1995.

Bock, Gisela, and Susan James, eds. *Beyond Equality and Difference.* London: Rout-
ledge, 1992.

Bondanella, Peter. *The Eternal City.* Chapel Hill: University of North Carolina
Press, 1987.

 – *Italian Cinema from Neorealism to the Present.* New York: Continuum Publishing,
1988.

 – *The Films of Roberto Rossellini.* Cambridge: Cambridge University Press, 1993.

Boneschi, Marta. *Senso: I costumi sessuali degli italiani dal 1880 a oggi.* Milan:
Mondadori 2000.

Bongiovanni, Bruno. 'Cultura e fascismo.' *L'Indice* 12 (2000): 40.

Bono, Paola, and Sandra Kemp, eds. *Italian Feminist Thought: A Reader.* Oxford:
Basil Blackwell, 1991.

Bordwell, David, Janet Steiger, and Kristin Thompson, *The Classical Hollywood
Cinema: Film Style and Mode of Production to 1960.* London: Routledge, 1985.

Bosio, Gianni. *Giornale di un organizzatore di cultura.* Milan: Avanzi, 1962.

Bosworth, R.J., and P. Dogliani, eds. *Memory and History.* New York: St Martin's
Press, 1999.

Braghin, Paolo. *Inchiesta sulla miseria in Italia (1951–1952).* 2 vols. Turin: Einaudi,
1978.

Brunetta, Gian Piero. *Storia del cinema italiano.* 2 vols. Rome: ERI, 1979–82; rev.
ed., 4 vols, 1993.

 – *Forma e parola nel cinema.* Padua: Liviana, 1970.

 – 'Il cinema, cattedrale del desiderio.' In Simonetta Soldani and Gabriele Turi,
eds, *Fare gli italiani: Scuola e cultura nell'Italia contemporanea,* 2: 389–440. Bolo-
gna: Il Mulino, 1993.

Brunetta, Gian Piero, and David W. Ellwood. *Hollywood in Europa.* Florence:
Usher, 1991.

Brunette, Peter. *Roberto Rossellini.* New York: Oxford University Press, 1987.

Bruno, Giuliana. *Streetwalking on a Ruined Map.* Princeton: Princeton University
Press, 1993.

Bruno, Giuliana, and Nadia Nadotti, eds. *Off Screen.* London: Routledge, 1988.

Calvino, Italo. *Il sentiero dei nidi di ragno.* Turin: Einaudi, 1947.

 – *La strada di San Giovanni.* Milan: Mondadori, 1990.

Cameron, Ian, and Robin Wood, *Antonioni.* London: Studio Vista, 1968.

Cannistraro, Philip V. *La fabbrica del consenso: Fascimo e mass media.* Bari: Laterza, 1975.

Carrano, Patrizia. *Malafemmina.* Florence: Guaraldi, 1977.

– *Anna Magnani.* Milan: Rizzoli, 1986.

Cases, Cesare. *Patrie lettere.* Turin: Einaudi, 1987.

Casetti, Francesco. *Dentro lo sguardo: Il film e il suo spettatore.* Milan: Bompiani, 1989.

– 'Cinema in the Cinema in Italian Films of the Fifties: *Bellissima* and *La signora senza camelie.' Screen 33* (1992): 375–93.

Castronovo, Valerio, ed. *L'Italia contemporanea.* Turin: Einaudi, 1976.

Cavarero, Adriana. *Nonostante Platone.* Rome: Editori Riuniti, 1990.

– 'Dire la mascita.' In Diotima, *Mettere al mondo il mondo.* Milan: La Tartaruga, 1990.

Cecchi, Emilio. *America amara.* Florence: Sansoni, 1946.

Cecchin, Giovanni. *Con Hemingway e Dos Passos sui campi di battaglia italiani della Grande Guerra.* Milan: Mursia, 1980.

Cederna, Camilla, ed. *Caro Duce: Lettere di donne italiane a Mussolini.* Milan: Rizzoli, 1989.

de Certeau, Michel. *The Practice of Everyday Life.* Berkeley: University of California Press, 1984.

Cesari, Severino. *Colloquio con Giulio Einaudi.* Rome: Theoria, 1991.

de Céspedes, Alba. *Dalla Parte di lei.* Milan: Mondadori, 1947.

– 'Lettera a Natalia Ginzburg.' In Maria Rosa Cutrufelli, ed., *Il Pozzo Segreto.* Florence: Giunti, 1993.

Chatman, Seymour. *Coming to Terms: The Rhetoric of Narrative in Fiction and Film.* Ithaca, NY: Cornell University Press, 1978.

– *Antonioni: or, the Surface of the World.* Berkeley: University of California Press, 1985.

– *Story and Discourse: Narrative Structure in Fiction and Film.* Ithaca, NY: Cornell University Press, 1990.

Chiarenza, Carlo, and William L. Vance, eds. *Immaginari a confronto.* Venice: Marsilio, 1992.

Cicogna, Patrizia, and Teresa de Lauretis, eds. *Non credere di avere dei diritti.* Turin: Rosenberg e Sellier, 1987.

Cirese, Alberto Mario. *Intellettuali, folklore, istinto di classe.* Turin: Einaudi, 1976.

Compagna, Francesco, ed. *Il Mezzogiorno davanti agli anni Sessanta.* Milan: Comunità, 1961.

Contini, Gianfranco. *L'influenza culturale di Benedetto Croce.* Milan: Ricciardi, 1957.

Convegno promosso dall'Associazione degli ex-parlamentari. *Le donne e la Costituzione.* Rome: Camera dei deputati, 1989.

Cornelisen, Ann. *Women of the Shadows*. New York: Vintage, 1977.

Cross, Gary. *Time and Money: The Making of Consumer Culture*. London and New York: Routledge, 1993.

Cuccu, Lorenzo. *La visione come problema*. Rome: Bulzoni, 1973.

Dal Lago, Alessandro, and P.A. Rovatti, eds. *Elogio del Pudore*. Milan: Feltrinelli, 1989.

D'Ardia Caracciolo, Silvia, trans. *Artemisia*. Lincoln and London: Nebraska University Press, 1988.

D'Attorre, Pier Paolo. 'Anche noi possiamo essere prosperi.' *Quaderni Storici* 58, nuova serie, anno XX, no. 1 (April 1985): 55–93.

Dau Novelli, Cecilia. *Sorelle d'Italia: Casalinghe impiegate e militanti nel Novecento*. Brescia: A.V.E., 1996.

De Felice, Renzo. *Mussolini Il Duce*. Turin: Einaudi, 1974.

– *Rosso e nero*. Milan: Baldini e Castoldi, 1995.

De Filippo, Eduardo. *I capolavori di Eduardo*. Turin: Einaudi, 1973; Bloomington: Indiana University Press, 1987.

De Giorgio, Michela. *Le italiane dall'Unità ad oggi*. Bari: Laterza, 1992.

De Grazia, Victoria. *The Culture of Consent: Mass Organization of Leisure in Fascist Italy*. New York: Cambridge University Press, 1981.

– 'Il fascino del Priapo: Margherita Sarfatti biografa del Duce.' *Memoria* 2.4 (June 1982): 149–94.

– 'La sfida allo star system.' *Quaderni Storici* 58.1, nuova serie, anno XX (April 1985): 95–133.
'Mass Culuture and Sovereignty: The American Challenge to European Cinemas, 1920–60.' *Journal of Modern History* 61.1 (March 1989): 53–87.

– *How Fascism Ruled Women*. Stanford: Stanford University Press, 1992.

De Lauretis, Teresa. *Technologies of Gender*. Bloomington: Indiana University Press, 1987.

Del Buono, Oreste, and Lietta Tornabuoni, eds. *Era cinecittà*. Milan: Bompiani, 1979.

Deleuze, Gilles. *Cinema*. Minneapolis: University of Minnesota Press, 1986.

De Martino, Ernesto. *Il mondo magico*. Turin: Boringhieri, 1948.

– *Sud e magia*. Milan: Feltrinelli, 1959.

De Matteis, Carlo. *Il romanzo italiano del Novecento*. Florence: La Nuova Italia, 1984.

De Michelis, Cesare. Introduction to Saveria Chemotti, ed., *Il mito americano: Origine e crisi di un modello culturale*. Padua: CLEUP, 1980.

De Nicola, Francesco. *Introduzione a Vittorini*. Bari: Laterza, 1993.

De Santis, Giuseppe, and Mario Alicata. 'Verità e poesia: Verga e il cinema italiano.' *Cinema*, 10 October 1941, 216–17.

Di Donato, Riccardo, ed. *La contraddizione felice? Ernesto De Martino e gli altri*. Pisa: ETS, 1990.

Dijkstra, Bram A. *Idols of Perversity.* New York: Oxford University Press, 1986.

Di Nolfo, E. 'Documenti sul ritorno del cinema americano in Italia nell'immediato dopoguerra.' In Saveria Chemotti, ed., *Intellettuali in trincea: Politica cultura nell'Italia del dopoguerra.* Padova: CLEUP, 1997.

Dionisotti, Carlo. *Geografia e storia della Letteratura italiana.* Turin: Einuadi, 1967.

Diotima. *Il pensiero della differenza.* Milan: La Tartaruga, 1990.

– *Mettere al mondo il mondo.* Milan: La Tartaruga, 1991.

– *Il cielo stellato dentro di noi.* Milan: La Tartaruga, 1993.

Dombroski, S. Robert *L'esistenza ubbidiente.* Naples: Guida, 1984.

D'Orsi, Angelo. *La cultura a Torino tra le due guerre.* Turin: Einaudi, 2000.

Duby, Georges, and Michelle Perrot, eds. *A History of Women.* 5 vols. Cambridge, Mass., and London: Harvard University Press, 1994.

Dunnage, Jonathan. *After the War.* Market Harborough: Troubador Press, 1999.

Eagleton, Terry. *Ideology.* London: Verso, 1991.

Eco, Umberto. *Le forme del contenuto.* Milan: Bompiani, 1971.

– *Trattato di semiotica generale.* Milan: Bompiani, 1985.

– *I limiti dell'interpretazione.* Milan: Bompiani, 1991.

– 'Il moto americano.' In Carlo Chiarenza and William L. Vance, eds, *Immaginari a confronto.* Venice: Marsilio, 1993.

Einaudi, Giulio. *Cinquant'anni di un editore.* Turin: Einaudi, 1983.

– *Frammenti di memoria.* Milan: Rizzoli, 1988.

Faldini, Franca, and Goffredo Fofi, eds. *L'avventurosa storia del cinema Italiano.* 2 vols. Milan: Feltrinelli, 1979.

Farassino, Alberto, ed. *Neorealismo, cinema Italiano 1945–1949.* Turin: EDT, 1989.

Farassino, Alberto, and Tatti Sanguinetti. *Lux Film: Esthétique et système d'un studio Italien.* Avec une étude de Jean A. Gili. Locarno: Éditions du Festival International du Film de Locarno, 1984.

Ferme, Valerio. 'The Translator under Fascism: The Linguistic Subversion of Culture.' *Forum Italicum* 31.2 (1997): 321–42.

Ferrara, Patrizia. 'La voce del padrone.' *Storia e dossier*, anno x, no. 99 (1995): 55–60.

Ferretti, Gian Carlo. *'Officina.'* Turin: Einaudi, 1975.

– *Le capre di Bikini.* Rome: Editori Riuniti, 1989.

– *L'Editore Vittorini.* Turin: Einaudi, 1992.

Ferroni, Giulio. *Storia della letteratura Italiana.* Turin: Einaudi, 1991.

Fink, Guido. 'Uno schermo gigante: Il cinema americano in Italia nel secondo dopoguerra.' In Saveria Chemotti, ed., *Il mito americano: Origine e crisi di un modello culturale.* Padua: CLEUP, 1981.

Finzi, Gilberto. *Come leggere la luna e i falò di Cesare Pavese.* Milan: Mursia, 1976.

Fofi, Goffredo. *L'immigrazione meridionale a Torino.* Milan: Feltrinelli, 1964.

Forgacs, David. *L'industrializzazione della cultura italiana (1880–1990)*. Bologna: Il Mulino, 1992.

Freddi, Luigi. *Il cinema*. 2 vols. Rome: L'Arnia, 1949.

Galoppini, Annamaria. *Il lungo viaggio verso la parità: I diritti politici delle donne dall'Unità ad oggi*. Bologna: Zanichelli, 1980.

Gallucci, Carole G. and Ellen Nerenberg, eds. *Writing beyond Fascism: Cultural Resistance in the Life and Works of Alba de Céspedes*. Teaneck, NJ: Fairleigh Dickinson UP, 2000.

Garboli, Cesare. *Falbalas*. Milan: Garzanti, 1990.

Garin, Eugenio. *Intellettuali italiani del ventesimo secolo*. Rome: Editori Riuniti, 1987.

Garnier, Josè Luis. *Roberto Rossellini*. New York: Praeger, 1970.

Gatt-Rutters, J. *Writers and Politics in Modern Italy*. New York: Halmer and Meyers, 1978.

Gentile, Emilio. 'Fascism as Political Religion.' *Journal of Contemporary History* 25.2–3 (May–June 1990): 229–51.

– 'Impending Modernity: Fascism and the Ambivalent Image of the United States.' In *Journal of Contemporary History* 28.1 (1993): 7–29.

– *Il culto del littorio*. Bari: Laterza, 1995.

Ghirardo, Diane. 'City and Theater: The Rhetoric of Fascist Architecture.' *Stanford Italian Review* 8.1–2 (1990): 165–93.

Giannantonio, Pompeo. *Rocco Scotellaro*. Milan: Mursia, 1986.

Ginsborg, Paul. *Storia dell'Italia dal dopoguerra a oggi*. Turin: Einaudi, 1989.

Ginsborg, Terri. 'Nazis and Drifters: The Containment of Radical (Sexual) Knowledge in Two Italian Neorealist Films.' *Journal of the History of Sexuality* 1 (1990): 241–61.

Ginzburg, Natalia. 'Discorso sulle donne.' In Maria Rosa Cutrufelli, ed., *Il pozzo segreto*. Florence: Giunti, 1993.

Gramsci, Antonio. *Lettere dal carcere*. Turin: Einaudi, 1946.

– *Il materialismo storico e la filosofia di Benedetto Croce*. Turin: Einaudi, 1948.

– *La costituzione del Partito Comunista, 1923–1926*. In *Opere*. 12 vols. Turin: Einaudi, 1971.

– *Letters from Prison*. Trans. Lynne Lawner. New York: Noonday Press, 1973.

– *Quaderni del carcere*. Turin: Einaudi, 1977.

Guarner, José Luis. *Roberto Rossellini*. Trans. Elizabeth Cameron. New York: Praeger, 1980.

Guglielminetti, Marziano. *Cesare Pavese*. Florence: Le Monnier, 1977.

Hay, James. *The Passing of the Rex: Popular Film Culture in Fascist Italy*. Bloomington: Indiana UP, 1987.

Heiney, Donald. *America in Modern Italian Literature*. New Brunswick, NJ: Rutgers University Press, 1964.

Heller, Deborah. 'Remembering Artemisia.' In Ada Testaferri, ed., *Donna: Women in Italian Culture*. Ottawa: Dovehouse, 1989.

Hochkofler, Matilde. *Anna Magnani*. Rome: Gremese, 1984.

Holub, Renate. *Antonio Gramsci: Beyond Marxism and Postmodernism*. London: New York: Routledge, 1992.

– 'Between the United States and Italy: Critical Reflections on Diotima's Feminist/Feminine Ethics.' In Giovanna Miceli-Jeffries, ed., *Feminine Feminists*. Minneapolis: U of Minnesota P, 1994.

Iotti, Nilde. 'La famiglia e lo stato.' In *Rinascita 1946*; reprint, Rome: Editori Riuniti, 1976, 224–5.

Irigaray, Luce. *This Sex Which Is Not One*. Ithaca, NY: Cornell University Press, 1985.

– *An Ethics of Sexual Difference*. Ithaca, NY: Cornell University Press 1993.

Isnenghi, Mario. *L'Italia del fascio*. Florence: Giunti, 1996.

Ivanov et al. *Tesi sullo studio semiotico della cultura*. Parma: Pratiche Editrice, 1980.

Jameson, Frederic. *The Political Unconscious*. Ithaca, NY: Cornell University Press, 1981.

– 'Postmodernism, or the Cultural Logic of Late Capitalism.' *New Left Review* 146 (1984).

– *Signatures of the Visible*. New York: Routledge, 1992.

Jeannet, Angela M., and Louise K. Barnett. *New World Journeys*. Westport, Conn.: Greenwood Press, 1977.

Kaufman, Hank, and Gene Lerner. *Hollywood sul Tevere*. Milan: Sperling and Kupfer, 1982.

Kolker, Robert P. *The Altering Eye*. Oxford: Oxford University Press, 1983.

Koon, Tracy H. *Believe, Obey, Fight: The Political Socialization of Youth in Fascist Italy*. Chapel Hill: University of North Carolina Press, 1985.

Kristeva, Julia. *Tales of Love*. New York: Columbia University Press, 1978.

Krutnick, Frank. *In a Lonely Street: Film Noir, Genre, Masculinity*. London: Routledge, 1991.

Lanaro, Silvio. *Storia dell'Italia repubblicana*. Venice: Marsilio, 1992.

Landy, Marcia. *Fascism in Film: The Italian Commercial Cinema, 1931–1943*. Princeton: Princeton University Press, 1986.

Lazzaro-Weiss, Carol. 'Stronger than Life? Autobiography and the Historical Novel.' Paper presented at annual meeting of the MLA, San Diego, December 1994.

Lehman, Peter, ed. *Close Viewings: An Anthology of Film Criticism*. Tallahassee: Florida State University Press, 1990.

Lentini, Giacinto. *Croce e Gramsci*. Palermo: Edizioni Mori, 1967.

Levi, Primo. *Se questo è un uomo*. Turin, Einaudi, 1946.

Liehm, Mira. *Passion and Defiance*. Berkeley: University of California Press, 1984.

Lilli, Laura. 'Prigioniere del grande harem: *Le italiane si confessano di* Gabriella Parca.' *Memoria* 6 (1982).

Lombardo, Agostino. 'La letteratura americana in Italia.' In A. Lombardo, ed., *La ricerca del vero*. Rome: Edizioni di Storia e Letteratura, 1961.

Lombardo, Maria. 'Beyond the Literary Past: Literary Experimentation and the Return to the Distant Past in the Novels of Calvino, Malerba, and Celati.' PhD dissertation, University of Chicago, 1994.

Lotman, Jurij. *The Semiotics of Cinema*. Ann Arbor: Dept. of Slavic Languages and Literatures, University of Michigan, 1976.

– *Testo e contesto: Semiotica dell'arte e della cultura*. Ed. Simonetta Silvestroni. Bari: Laterza, 1980.

– *La Semiosfera*. Ed. Simonetta Silvestroni. Venice: Marsilio, 1985.

– *Cercare la strada*. Venice: Marsilio, 1994.

Lumley, R., and J. Morris, eds. *Oltre il meridionalismo*. Rome: Carocci, 1999.

Mack Smith, Denis. *Mussolini*. New York: Knopf, 1982.

Mafai, Miriam. *Pane Nero*. Milan: Mondadori, 1987.

Maldini, Sergio. *I Sognatori*. Venice: Marsilio, 1992 (1952).

Malvano, Laura. 'Il mito della giovinezza attraverso l'immagine.' In Giovanni Levi and Jean-Claude Schmitt, eds, *Storia dei Giovani*, 2: 311–48. Bari: Laterza, 1994.

Manacorda, Giuliano. *Storia della letteratura Italiana contemporanea (1948–1975)*. Rome: Editori Riuniti, 1977.

Mancini, Elaine. *The Free Years of the Italian Film Industry 1930–1935*. Ann Arbor: University Microfilms, 1981.

Mancini, Mario. *La gaia scienza dei trovatori*. Parma: Pratiche Editrice, 1984.

Mangoni, Luisa. *'Primato' 1940–1943*. Bari: De Donato, 1977.

Marcus, Millicent J. *Italian Film in the Light of Neorealism*. Princeton, NJ: Princeton University Press, 1986.

– *Filmmaking by the Book: Italian Cinema and Literary Adaptation*. Baltimore: Johns Hopkins University Press, 1993.

Marini, Andrea, ed. *La bella forma: Poggioli i calligrafici e dintorni*. Venice: Marsilio, 1992.

Mariotti, Franco. *Cinecittà tra cronaca e storia (1937–1989)*. 2 vols. Rome: Presidenza del Consiglio dei Ministri, 1991.

Marotta, Giuseppe. *L'oro di Napoli*. Milan: Bompiana, 1947.

Martelli, Sebastiano. 'Letteratura cattolica e civiltà contadina: Il dibattito negli anni Cinquanta.' In M. Florinda Iannace, ed., *Il Filone cattolico nella letteratura italiana del secondo dopoguerra*, 165–91. Rome: Bulzoni Editore, 1987.

– 'Scotellaro e la cultura nelle province.' In F.M. Iannace, ed., *Letteratura e storia meridionale: Studi offerti a Aldo Vallone*. Florence: Olschki, 1989.

Masi, Stefano, and Enrico Lancia. *Roberto Rossellini*. Rome: Gremese, 1987.

Meldini, Piero. *Sposa e madre esemplare*. Florence: Guaraldi, 1975.

Miccichè, Lino. *Per una nuova critica*. Venice: Marsilio, 1989.

– *Visconti e il neorealismo*. Venice: Marsilio, 1998.

Miccichè, Lino ed. *Il neorealismo cinematografico italiano*. Venice: Marsilio, 1975.

Miceli-Jeffries, G., ed. *Feminine Feminists: Cultural Practices in Italy*. Minneapolis: University of Minnesota Press, 1994.

Mondello, Elisabetta. *La nuova italiana: La donna nella stampa e nella cultura del Ventennio*. Rome: Editori Riuniti, 1987.

Morante, Elsa. *Menzogna e sortilegio*. Turin: Einaudi, 1947.

– *La storia*. Turin: Einaudi, 1974.

Morin, Edgar. *Les stars*. Paris: Éditions du Seuil, 1957; *I divi*. Milan: Garzanti, 1977.

Muraro, Luisa. *L'ordine simbolico della madre*. Rome: Editori Riuniti, 1991.

Murialdi, Paolo. *La stampa del regime fascista*. Bari: Laterza, 1986.

Musatti, Cesare. *La via del Sud e altri scritti*. Milan: Edizioni di Comunità, 1972.

Muscetta, Carlo. *Realismo neorealismo controrealismo*. Milan: Garzanti, 1946.

Muscio, Giuliana. 'Tutto fa cinema: La stampa popolare del secondo dopo-guerra.' In Vito Zagarrio, ed., *Dietro lo schermo*, 105–15. Venice: Marsilio, 1988.

Neiger, Ada. *Maternità trasgressiva e letteratura*. Naples: Liguori, 1993.

Nerenberg, Ellen. '*Love for Sale* or *That's Amore*: Representing Prostitution during and after Italian Fascism.' *Annali d'Italianistica* 16 (1998): 213–35.

Occhetto, Valerio. *Adriano Olivetti*. Milan: Mondadori, 1985.

O'Healy, Aine. *Cesare Pavese*. Boston: Twayne Publishers, 1988.

Origo, Iris, and John Heath Stubbs, trans. *Giacomo Leopardi, Selected Prose and Poetry*. New York: New American Library, 1966.

Ortese, Anna Maria. *Il mare non bagna Napoli*. Milan: Rizzoli, 1953; Adelphi, 1994.

Parca, Gabriella. *Italian Women Confess*. Trans. Carolyn Gaiser. New York: Farrar, Straus and Co., 1963.

Parks, Tim, trans. *The Road to San Giovanni*. New York: Pantheon Books, 1993.

Pasolini, Pier Paolo. *Empirismo Eretico*. Milano: Garzanti, 1972.

Passerini, Luisa. *Mussolini Immaginario*. Bari: Laterza, 1990.

– *Fascism in Popular Memory: The Cultural Experience of the Turin Working Class*. Trans. Robert Lumley and Jude Bloomfield. Cambridge: Cambridge University Press, 1987.

– 'La giovinezza metafora del cambiamento sociale: Due dibattiti sui giovani nell'Italia fascista e negli Stati Uniti degli Anni Cinquanta.' In Giovanni Levi and Jean-Claude Schmitt, eds, *Storia dei Giovani*, 2: 383–459. Bari: Laterza, 1994.

Pautasso, Sergio. *Ermetismo.* Milan: Editrice Bibliografica, 1996.

Pavese, Cesare. *Poesie.* Milan: Mondador, 1961.

– *La letteratura americana e altri saggi.* Turin: Einaudi, 1986.

– *La luna e i falò.* Turin: Einaudi, 1995.

Pavone, Claudio. *Una guerra civile, saggio sulla moralità nella Resistenza.* Turin: Bollati Boringhieri, 1991.

Pellizzari, Lorenzo. *Cineromanzo: Il cinema italiano.* Milan: Longanesi, 1978.

Perry, Ted, and Rene Prieto. *Michelangelo Antonioni, a Guide to References and Resources.* Boston: G.K. Halland Company, 1986.

Persani, Maria Assunta, and Neria De Giovanni. *Femminile a confronto: Tre realtà della narrativa italiana contemporanea.* Rome: Lacaita, 1984.

Petrignani, Sandra. *Le signore della scrittura.* Milan: La Tartaruga, 1984.

Peukert, Dietlev. *Inside Nazi Germany: Conformity, Opposition and Racism in Everyday Life.* London: Batsford, 1987.

Pickering-Iazzi, Robin. *Unspeakable Women.* New York: The Feminist Press, 1993.

– *Politics of the Visible: Writing, Women, Culture and Fascism.* Minneapolis: University of Minnesota Press, 1997.

Pinkus, Karen. *Bodily Regimes: Italian Advertising under Fascism.* Minneapolis: University of Minnesota Press, 1995.

Pintor, Giaime. *Il sangue d'Europa.* Turin: Einaudi, 1975.

Piovene, Guido. *De America.* Milan: Garzanti, 1953.

– *Viaggio in Italia.* Milan: Mondadori, 1957; Baldini e Castoldi, 1993.

Pirzio Biroli Sclavi, Marianella. 'L'inchiesta sulla miseria in Italia.' *Memoria* 6 (1982).

Place, J.A., and L.S. Peterson. 'Some Visual Motifs of Film Noir.' *Film Comment*, January 1974.

Ponzi, Mauro. *La critica e Pavese.* Bologna: Cappelli, 1977.

Pratolini, Vasco. *Cronache di poveri amanti.* Florence: Vallecchi, 1947.

– *Un eroe del nostro tempo.* Milan: Bompiani, 1949.

Quaglietti, Lorenzo. *Storia economico-politica del cinema italiano 1945–1980.* Rome: Editori Riuniti, 1980.

Quirino, Paolo. 'I consumi in Italia dall'Unità ad oggi.' In Romano Ruggero, ed., *Storia dell'economia italiana*, vol. 3. Turin: Einaudi, 1991.

Re, Lucia. *Calvino and the Age of Neorealism: Fables of Estrangement.* Stanford: Stanford University Press, 1990.

– 'Feminist Thought in Italy: Sexual Difference and the Question of Authority.' *Michigan Romance Studies* 16 (1996): 61–86.

Rea, Domenico. *Spaccanapoli.* Milan: Mondadori, 1947.

Reich, Jacqueline. 'Consuming Ideologies: Fascism, Commodification and

Female Subjectivity in Mario Camerini's *Grandi magazzini.' Annali d'Italia-nistica* 16 (1998): 195–212.

Revelli, Nuto. *La guerra dei poveri.* Turin: Einaudi, 1962.

Rhodie, Sam. *Antonioni.* London: FIB, 1990.

Ricoeur, Paul. *Time and Narrative.* 3 vols. Chicago: University of Chicago Press, 1984.

Rinascita 1946. Rome: Editori Riuniti, 1976 (reprint).

Romano, Massimo. *Gli stregoni della fantacultura: La funzione degli intellettuali nella letteratura italiana del dopoguerra (1945–1975).* Turin: Paravia, 1977.

Rondolino, Gianni. *Rossellini.* Turin: UTET, 1989.

Rosen, Philip. *Narrative, Apparatus, Ideology.* New York: Columbia University Press, 1986.

Rossellini, Roberto. *Il mio metodo.* Ed. Adriano Aprà. Venice: Marsilio, 1987.

Rossi Doria, Mario, ed. *Il sindaco poeta di Tricarico.* Rome, Matera: Basilicata Editrice, 1974.

Russo, Giovanni. 'La questione meridionale e le regioni.' *I problemi di Ulisse,* September 1974.

Sartogo, Adriana. *Le donne al muro.* Rome: Savelli, 1977.

de Saussurre, Ferdinand. *Corso di linguistica generale.* Bari: Laterza, 1970.

Scotellaro, Rocco. *E' fatto giorno.* Milan: Mondadori, 1982.

– *L'uva puttanella, contadini del Sud.* Rome, Bari: Laterza, 1986.

Sechi, Maria, ed. *Fascismo ed esilio: Aspetti della diaspora intellettuale di Germania, Spagna e Italia.* 2 vols. Pisa: Giardini Editori, 1988.

Sechi, Mario. *Il mito della nuova cultura: Giovani, realismo e politica negli anni trenta.* Manduria: Lacaita, 1984.

Segre, Cesare. *Semiotics and Literary Criticism.* The Hague: Mouton, 1973.

– *Le strutture e il tempo.* Turin: Einaudi, 1974.

– *Avviamento all'analisi del testo letterario.* Turin: Einaudi, 1985.

Serceau, Michel. *Roberto Rossellini.* Paris: Les Éditions du Cerf, 1986.

Sesti, Mario. *Tutto il cinema di Pietro Germi.* Milan: Baldini e Castoldi, 1997.

Soldani, Simonetta, and Gabriele Turi, eds. *Fare gli italiani.* Bologna: Il Mulino, 1992.

Soldati, Mario. *Le lettere da Capri.* Milan: Garzanti, 1968.

– *America primo amore.* Rome: Einaudi, 1945.

Spackman, Barbara. *Fascist Virilities.* Minneapolis: University of Minnesota Press, 1996.

Spriano, Paolo. *Le passioni di un decennio.* Milan: Garzanti, 1986.

Starace, Achille. *L'Opera Nazionale Dopolavoro.* Milan: Mondadori, 1933.

Steele, Joseph Henry. *Ingrid Bergman, An Intimate Portrait.* New York: McKay Co., 1959.

Stone, Marla. 'Staging Fascism: The Exhibition of the Fascist Revolution.' *Journal of Contemporary History* 28 (1993): 215–43.

Sumeli Weinberg, Grazia. 'Pavese e la donna e il discorso sulla voluttuosità.' *Italica* 77.3 (2000): 386–99.

Testaferri, Ada ed. *Donna: Women in Italian Culture.* Ottawa: Dovehouse, 1989.

Tinazzi, Giorgio. *Antonioni.* Florence: La Nuova Italia, 1989.

Togliatti, Palmiro. *I corsivi di Roderigo. Interventi politico-culturali dal 1944 al 1964.* Bari: De Donato, 1976.

Tommaseo, Nicolò, and Bernardo Bellini, eds. *Dizionario della Lingua Italiana.* 8 vols. Turin: L'unione Tipografico-Editrice, 1861.

Tonetti, Claretta. *Luchino Visconti.* Boston: Twayne Publishers, 1983.

Tornabuoni, Lietta. 'La stampa femminile.' In Paolo Murialdi, ed., *La stampa italiana del neocapitalismo.* Bari: Laterza, 1976.

Tranfaglia, Nicola, Paolo Murialdi, and Massimo Legnani. *La stampa italiana nell'età fascista.* Bari: Laterza, 1980.

Turi, Gabriele. *Giovanni Gentile: Una biografia.* Florence: Giunti, 1995.

– *Casa Einaudi: Libri, uomini, idee oltre il fascismo.* Bologna: Il Mulino, 1990.

Vaccaro, Rosa. *Unità politica e dualismo economico in Italia (1861–1993).* Padua: Cedam, 1995.

Vernet, Marc. 'The Filmic Transactions: On the Openings of Film Noir.' *The Velvet Light Trap: Review of Literature,* Summer 1983 (first published as 'La transaction filmique' in R. Bellour and P. Brion, eds, *Le cinéma américain* [Paris: Flammaron, 1980], 2: 122–43).

Vettori, Vittorio, ed. *Antologia di 'Primato.'* Rome: De Luca, 1968.

Viganò, Renata. *L'Agnese va a morire.* Turin: Einaudi, 1949.

Violi, Patrizia. *L'infinito singolare.* Verona: Essedue Edizioni, 1986.

– 'Language and the Femal Subject.' In Giulina Bruno and Maria Nadotti, eds, *Offscreen,* 189–48. London: Routledge, 1988.

– 'Gender, Subjectivity and Language.' In Gisela Bock and Susan James, eds, *Beyond Equality and Difference.* London: Routledge, 1992.

Visser, Romke. 'Fascist Doctrine and the Cult of *Romanità.' Journal of Contemporary History* 27.1 (January 1992): 5–21.

Vitti, Antonio. *Giuseppe De Santis and Postwar Italian Cinema.* Toronto: University of Toronto Press, 1996.

– 'Le ragioni di un lungo silenzio: La saga di un indiscreto regista di campagna.' *Romance Languages Annual* 5 (1994).

Welle, John P., ed. *Annali d'Italianistica.* Vol. 6 (Film and Literature). Notre Dame: University of Notre Dame Press, 1988.

West, Rebecca, ed. *Annali d'Italianistica.* Vol. 7 (Women's Voices). Notre Dame: University of Notre Dame Press, 1989.

- 'Lost in the Interstices: A Postwar, Pre-Boom *Enciclopedia della donna.*' *Annali d'Italianistica* 16 (1998): 169–94.
Whitford, Margaret. *The Irigaray Reader.* Oxford: Basil Blackwell, 1991.
Wright, Simona. 'La guerra al femminile.' *Forum Italicum* 32.1 (Spring 1998): 63–85.
Zagarrio, Vito, ed. *La bella forma di un cinema dimenticato.* Venice: Marsilio, 1992.
- *Dietro lo schermo.* Venice: Marsilio, 1988.
Zancan, Marina. *Il progetto Politecnico.* Venice: Marsilio, 1984.
Zunino, Pier Giorgio. *L'Ideologia del fascismo.* Bologna: Il Mulino, 1985.

Films

Antonioni, Michelangelo. *Cronaca di un amore.* 1950.
- *Le amiche.* 1955.
- *Il Grido.* 1957.
Blasetti, Alessandro. *Amore e chiacchiere.* 1957.
Camerini, Mario. *T'amerò sempre,* 1942.
De Filippo, Eduardo. *Napoletani a Milano.* 1953.
De Santis, Giuseppe. *Caccia tragica.* 1948.
- *Riso amaro.* 1949.
- *Non c'è pace tra gli ulivi.* 1950.
De Sica, Vittorio. *Sciuscià.* 1946.
- *Ladri di biciclette.* 1947.
- *Miracolo a Milano.* 1951.
- *Umberto D.* 1952.
- *Stazione Termini.* 1953.
- *L'Oro di Napoli.* 1954.
Emmer, Luciano. *Domenica d'agosto.* 1950.
- *Parigi è sempre Parigi.* 1951.
- *Le ragazze di Piazza di Spagna.* 1952.
- *Camilla.* 1953.
Germi, Pietro. *Gioventù perduta.* 1947.
- *Il cammino della speranza.* 1950.
Giannini, Ettore. *Carosello Napoletano.* 1952.
Lattuada, Alberto. *Il bandito.* 1946.
- *Senza pietà.* 1948.
- *Il mulino del Po.* 1949.
- *Anna.* 1952.
Lizzani, Carlo. *Achtung! Banditi!* 1951.
Mattoli, Mario. *La vita ricomincia.* 1945.

– *Assunta Spina.* 1948.

Pietrangeli, Antonio. *Celestina.* 1953.

Rossellini, Roberto. *Roma città aperta.* 1945.

– *Paisan.* 1946.

– *Germania anno zero.* 1948.

– *Francesco Giullare di Dio.* 1950.

– *Stromboli terra di Dio.* 1951.

– *Viaggio in Italia.* 1954.

– *La paura.* 1954.

Rossellini, Zampa, Visconti, et al. *Siamo Donne.* 1953.

Serandrei, Mario. *Giorni di gloria.* 1943.

Steno. *Un americano a Roma.* 1954.

Visconti, Luchino. *Ossessione.* 1943.

– *La terra trema.* 1948.

– *Bellissima.* 1951.

– *Senso.* 1954.

– *Rocco e i suoi fratelli.* 1960.

Zampa, Luigi. *L'Onorevole Angelina.* 1947.

Zavattini, Antonioni, Fellini, Lattuada, Lizzani, Maselli, and Risi. *Amore in città.* 1953.

INDEX